*felt*

# felt

FLUXUS,

JOSEPH BEUYS,

AND THE

DALAI LAMA

CHRIS THOMPSON

University of Minnesota Press
Minneapolis | London

See page 305 for information on previous publications.

Portions of *The Art of War: The Denma Translation,* translation, essays, and commentary by the Denma Translation Group, copyright 2001 by The Denma Translation Group, are reprinted by arrangement with Shambhala Publications, Inc., Boston, Massachusetts. www.shambhala.com.

Portions of *The Secret History of the Mongols,* translated and edited by Frances Woodman Cleaves (1982), appear courtesy of Harvard–Yenching Institute.

Words and music of "Ghetto Defendant" by Joe Strummer and Mick Jones copyright 1982 Nineden Ltd. and EMI Virgin Music, Inc. All rights for the United States and Canada controlled and administered by EMI Virgin Music, Inc. All rights reserved. International copyright secured. Reprinted by permission of Hal Leonard Corporation.

Every effort was made to obtain permission to reproduce material in this book. If any proper acknowledgment has not been included here, we encourage copyright holders to notify the publisher.

Published by the University of Minnesota Press
111 Third Avenue South, Suite 290
Minneapolis, MN 55401-2520
http://www.upress.umn.edu

Library of Congress Cataloging-in-Publication Data

Thompson, Chris, 1975–
Felt : Fluxus, Joseph Beuys, and the Dalai Lama / Chris Thompson.
    p. cm.
Includes bibliographical references and index.
ISBN 978-0-8166-5354-6 (hardcover : alk. paper)
ISBN 978-0-8166-5355-3 (pbk. : alk. paper)
1. Fluxus (Group of artists). 2. Beuys, Joseph–Friends and associates. 3. Bstan-'dzin-rgya-mtsho, Dalai Lama XIV, 1935—Friends and associates. I. Title. II. Title: Fluxus, Joseph Beuys, and the Dalai Lama.
    NX456.5.F55T49 2011
    700.92'2–dc22                    2010044989

Printed in the United States of America on acid-free paper

The University of Minnesota is an equal-opportunity educator and employer.

17 16 15 14 13 12 11      10 9 8 7 6 5 4 3 2 1

(Remember that we sometimes demand definitions
for the sake not of the content, but of their form. Our
requirement is an architectural one: the definition is a
kind of ornamental coping that supports nothing.)

—LUDWIG WITTGENSTEIN, *Philosophical Investigations*

Robert Filliou, *Télépathique musique no. 21,* Art-of-Peace Biennale, Hamburg, 1985.
Photograph: Herstellung Druckhaus Hentrich, Berlin. Courtesy of Marianne Filliou.

# Contents

# Prefaces

## I

On January 23, 1998, I made my first visit to Amsterdam to meet with Dutch artist and writer Louwrien Wijers, who had organized the 1982 meeting between German artist Joseph Beuys and His Holiness the XIV Dalai Lama of Tibet. This meeting was the subject of my Ph.D. research, which I had just begun a few months before. In fact my first step as a researcher had been to write a long letter to Wijers in October 1997, explaining my great interest in this meeting and in her work. It was the kind of heartfelt and effusive student letter that one, in looking back on it, cannot imagine writing as a "professional scholar," and it was probably precisely for this reason that it got so prompt and warm a reply, in a way that no well-seasoned prose ever could. She wrote telling me that she was delighted that someone was actually interested in this meeting and its consequences, and she invited me to come to Amsterdam as soon as I could, to meet her and begin a conversation in person. This book is the result of that conversation; it is an indirect result, in that the project that has unfolded from that point to this has been circuitous and anarchic, but a direct result in the sense that it was from precisely that moment— my receipt of that welcoming reply from an artist I had never met— that the project started. And upon its completion, of even those parts that had nothing directly to do with her, this book reveals itself to be circumscribed by that friendship in a way that makes this at once my project and her invention.

After arriving at Schiphol Airport I took the train to Amsterdam Centraal and then, following the canals, managed to find my way to Wijers's home. Just one block from it, I passed the bar that, I would soon learn, had been the favorite haunt of her close friend the Dutch

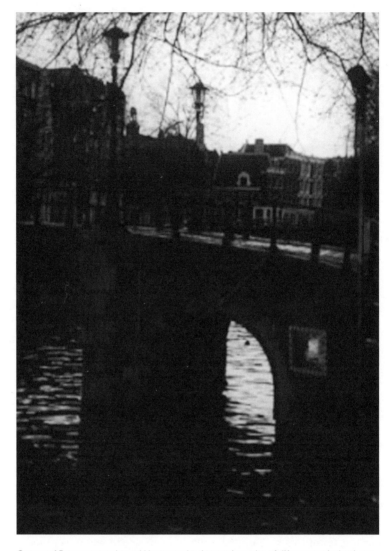

Corner of Brouwersgracht and Herengracht, Amsterdam, site of d'Armagnac's death on September 28, 1978. Photograph by Chris Thompson, 2000.

performance artist Ben d'Armagnac, of whom more below. It was the last place he had been seen alive, on the evening of September 28, 1978, moments before his accidental drowning at the corner of the canals Herengracht and Brouwersgracht. A convex mirror, attached to the wall of the canal diagonally opposite from Wijers's front door

and used by boat pilots to help them see oncoming vessels around the corner, today serves as a kind of makeshift memorial marking the site of his death.

Wijers answered the door with a smile, showed me to the living room, where we were to have our discussions, and to the tiny mattress piled high with wool blankets in the corner of that room, which would be my bed as well as my desk during that visit and the three that would follow—in January 1999, February 2000, and October 2004.

Atop the dresser at the foot of the bed were photographs of her deceased mother and of the Tibetan lama who had slept in the same bed during his visits to Amsterdam since the early 1980s. On the table at the head of the bed stood a small statue of the Buddha.

Wijers wanted to run an errand before we began our interview, so that we would not need to interrupt our discussion later. I looked forward to the opportunity to see a bit of Amsterdam, so agreed to walk along with her. We stepped out onto the pavement overlooking the canal. As we walked, to make conversation in the way one does as a first-time visitor, I asked her a question about Amsterdam. It was a question to which I already more or less knew the answer, because on the flight from London that morning I had begun to study the city map, which was marked with a number of tourist attractions and places of interest. I asked Wijers whether she lived near Anne Frank's house. She smiled and said, "Yes, it is very near." I asked whether she had ever been to see it. The air was cold and the sky was gray with the hint of a snow that never did come. "No, in fact I have never been inside there." She looked at me then, with a smile connecting her cheeks. She told me that the whole of Amsterdam was Anne Frank's house.

II

"He's drunk," his wife said as she entered the room with my wife. "He always gets drunk when you show up. . . . And when he gets drunk he thinks he's a poet or a philosopher."[1]

Years ago, when I was an undergraduate student, during one of several late-night drunken conversations with one of my good friends,

our meandering efforts at erudition led us to stumble into a discussion of a short poem he had recently written.

> I sit, motionless.
> A tree moves gently in the wind.
> What will move me?

I told him, pulling forth pearls of the wisdom gleaned from several weeks spent in my Hinduism, Buddhism, Taoism class, that it sounded like Lao-Tzu. This prompted him to tell me of a phrase he had always loved, one that he felt sure came from the writings of some obscure Taoist sage whose name he could not recall. We delighted in this uncertainty like young undergraduates: much better, much more fitting, that the author was unknown. The phrase, the jewel of Taoist insight, was: "It loves to happen." What matter who said it, we two sages said! Bottoms up!

*It loves to happen.* In one early draft of a chapter of my Ph.D. thesis, some of which has been reincarnated in this book, I used the phrase in reference to Joseph Beuys's work and its quality of late-blooming epiphany. In the encounter with his most striking work, one has the feeling of having "happened" along with it, of having been absorbed into and engaged by the materiality of an event that loved to happen.[2]

One of my professors read that draft chapter and was taken with the phrase. "'*It loves to happen.*' Where does this come from?" she asked. "It's from one Taoist text. I can't remember exactly which," I said, implying that I had read so many that my overburdened memory now faltered, when in fact the *Tao Te Ching* and *Monkey* were the only two I had ever read. Did *Monkey* even count, I wondered? "It's fantastic," said my professor, who suggested that I get rid of some of the more clunky explanatory text that I had clustered around it and leave it at that: "It loves to happen." This was 1998. I had imagined, wrongly in this instance, that my nugget of quasi-Taoist wisdom would require some savvy theoretical styling in order to survive the rigors of Ph.D. supervision in art history and visual culture at Goldsmiths College.

In May 2001, as I was coaxing that thesis toward completion, I traveled to Los Angeles to present a paper at a graduate symposium

titled Mythologies of the Everyday, at the University of California, Los
Angeles. I took exactly the same American Airlines flight from Boston
to LAX that, had it been September 11 of that year, would have been
a one-way ticket to the World Trade Center.

Titled "Eurasianausea," the paper examined the 1982 meeting
between Joseph Beuys and His Holiness the XIV Dalai Lama of Tibet.
This would eventually become the final chapter of the thesis and,
after much revision, the chapter in this book titled "What Happens
When Nothing Happens." The paper asked whether, tucked away in
the creases of the romantic utopian rhetoric of the convergence of
the material and the spiritual that frames most "East-West encoun-
ters," there might, at least in the case of this particular encounter,
be the makings of an alternative way to imagine the significance of
such encounters across cultures, disciplines, traditions—across dif-
ferences. Perhaps, I thought, and still do think, the Beuys–Dalai Lama
meeting, its promises and its failures alike, might offer up a different
way of addressing both the Western avant-garde's relationship with
Eastern philosophy and religious practices and the imbrication of
these concerns with issues of cultural difference and cultural transla-
tion more broadly.

After the meeting between Beuys and the Dalai Lama had come
and gone, Louwrien Wijers, who had invested much time and energy
in organizing it, came to feel increasingly despondent about the possi-
bility that their discussion would not lead to any substantive outcome.
Beuys and the Dalai Lama's short chat had been friendly, had touched
upon some important questions, but its results seemed vague and
inconclusive. In the days that followed the meeting, the disappointed
Beuys seemed to have lost interest in pursuing the possibility of fur-
ther dialogue with the Dalai Lama and his immediate circle of advisers
and supporters. Given that Beuys was at once uncertain about how to
proceed and also immersed in a variety of other projects, Wijers, after
working on the Beuys–Dalai Lama project for years, had to let it drop.
Months afterward, having returned home to nurse her sick mother
and finding herself without her usual working materials, which were
back at her home in Amsterdam, she decided that while her mother
convalesced she would at least transcribe the tapes she had made of
the spontaneous discussions in the hotel café following the Beuys–
Dalai Lama meeting itself. Over sixty people had come to the Hotel

Königshof in Bonn on that morning of October 27, 1982, to be present for Beuys's talk with the Dalai Lama. Although the talk itself was private, Wijers, Beuys, and these dozens of friends and supporters, including French Fluxus artist and Tibetan Buddhist Robert Filliou and his wife, Marianne Filliou, spent the hours following the meeting talking about a variety of issues, ideas, and initiatives. Although Wijers had been at the café table when Filliou proposed to Beuys that all of them channel the excitement and energy drummed up by this meeting to organize his nascent project that would later be known as the Art-of-Peace Biennale, not until she heard his voice repeat the idea on her tape did she realize the full implications of his suggestion.

That day in the café in Bonn months before, Beuys hadn't taken to the idea of the project when Filliou posed it, and the conversations drifted on to other things. But months later, Filliou's words helped Wijers, now alone with her typewriter and tape recorder, to realize that the Art-of-Peace project was the vehicle for mobilizing all of the energy and interest that the Beuys–Dalai Lama meeting had summoned. Despite the many interesting ways in which the Beuys–Dalai Lama meeting proved to be abortive, it nevertheless became the catalyst for a number of compelling projects that staged interdisciplinary, intercultural, interfaith dialogues among artists, religious figures, scientists, and economists—notably the Art-of-Peace Biennale in Hamburg (1985–86) and the Art Meets Science and Spirituality in a Changing Economy conferences in Amsterdam (1990) and Copenhagen (1996). It could be argued that many of these discussions and the fertile connections they have provoked would have happened without Wijers's moment of epiphany in front of her tape player; the time was ripe for these dialogues, even though historians and critics would take two decades to begin to understand why. What is certain is that the remarkable unfolding of events that did in fact transpire in the wake of her revelation could not have happened without it.

To drum up something of the mysterious elegance of this kind of revelation when presenting my paper at UCLA, I hauled out the Lao-Tzu surrogate:

> There is a Taoist saying: "It loves to happen." As Wijers sat alone and listened to the tape recordings of the meandering discussions that took place over those hours at the café

tables, she picked up on Filliou's comment, and suddenly it hit her.

Many revisions later I still wonder at how to address this "it"—this it that hit her, that hits us all in those moments that we look back on as significant ones in the history of whatever it is that we will have done afterward. This "it" operates as a transpersonal agency, something that cannot be willed but only prepared for.

Physicist and philosopher David Bohm, one of the participants in the 1990 Art Meets Science and Spirituality in a Changing Economy conference, in Amsterdam, defines art in a way that helps elucidate the nature of this quasi-metaphysical "it" in terms of a notion of an uncanny but ubiquitous "fittingness" of phenomena. He writes, "I think that fundamentally all activity is an art. Science is a particular kind of art, which emphasizes certain things. Then we have the visual artists, the musical artists and various kinds of other artists, who are specialized in different ways. But fundamentally art is present everywhere. The very word 'art' in Latin means 'to fit.' The whole notion of the cosmos means 'order' in Greek. It is an artistic concept really."[3]

My symposium paper had a decent reception. I was asked one or two questions, and then we all moved on to lunch. After the symposium, as is customary, a party was to be held at the home of one of the professors in the department. While I waited for one of my Ph.D. student hosts to clear up the extra programs and unused Styrofoam coffee cups, put away the slide trays, and sort through the rest of the detritus of the academic encounter, I sat down to check my e-mail. There was one new message waiting for me. It was from my NYU friend, whom I had not heard from in well over a year.

Hi Chris—

Long time no speak. I made a discovery the other day that sheds some light on a question you asked me a few years ago. You asked me to find a quote I had repeated to you a long time ago, something along the lines of "It loves to happen." I looked through all my various Buddhist and quasi-Buddhist books, even a few Hindu books and one *Popular Mechanics* magazine. But I could not find the source of that quote. I quit, figuring it would pop up again in time.

About a month ago it did, as I was re-reading *Franny and Zooey* by J. D. Salinger. Except, I realized that I had misquoted. In fact, it is a quote attributed to Marcus Aurelius, who stated that:

IT LOVED TO HAPPEN

past tense.

Strange source for Zennish words, huh? No wonder I couldn't find it. (In the book the main character is looking at a wall of quotes compiled by his two older brothers in their youth, one of whom has since committed suicide.) In case you didn't read it. Sorry for the delay.

Otherwise, I hope all is well. Hope to talk to you soon.

J

Not a Taoist, present sense, but Marcus Aurelius, past tense. My friend's e-mail was dated the day before, Friday, May 4, and had been sent at around 4:00 P.M. from New York—1:00 P.M. in Los Angeles. Had I checked my messages before the conference on Saturday, I would have had the chance to fix the reference in the text or even to remove it. But as it turns out, I had stood before a room full of fellow Ph.D. students—and the UCLA Art History Department's illustrious professors: Albert Boime, Miwon Kwon, Anthony Vidler, and visiting plenary speaker Martha Rosler—and misled us one and all. None of us seemed to notice.

When I got home I read *Franny and Zooey,* for the first time. Near the end of the book, Zooey wanders into his elder brothers' old bedroom. His plan is to use the telephone to call his sister Franny, disguising his voice in order to convince her that he is actually their still-surviving elder brother, Buddy, whose consoling words she might be persuaded to listen to as she lies in a kind of ecstatic despondency on the living room sofa in the family apartment, working her way through her first serious spiritual crisis. But before he makes his rescue call, he stumbles upon his brothers' long unread wall of handwritten quotes.

No attempt whatever had been made to assign quotations or authors to categories or groups of any kind. So that to read the quotations from top to bottom, column by column, was

rather like walking through an emergency station set up in a flood area, where, for example, Pascal had been unribaldly bedded down with Emily Dickenson, and where, so to speak, Baudelaire's and Thomas à Kempis' toothbrushes were hanging side by side.

You have the right to work, but for the work's sake only. You have no right to the fruits of work. Desire for the fruits of work must never be your motive in working. Never give way to laziness, either.

Perform every action with your heart fixed on the Supreme Lord. Renounce attachment to the fruits. Be even-tempered [underlined by one of the calligraphers] in success and failure; for it is this evenness of temper which is meant by yoga.

Work done with anxiety about results is far inferior to work done without such anxiety, in the calm of self-surrender. Seek refuge in the knowledge of Brahman. They who work selfishly for results are miserable.

— "Bhagavad Gita"

It loved to happen.                    —Marcus Aurelius

O snail
Climb Mount Fuji,
        But slowly, slowly!                    —Issa[4]

Aurelius. I hastened to read his *Meditations*. The oldest copy I could get my hands on immediately was the 1964 Penguin Classics edition, translated by Maxwell Staniforth. *Franny and Zooey* appeared serially in the *New Yorker*, "Franny" in January 1955, "Zooey" in May 1957. They were published together as a book in September 1961.

After poring over the *Meditations* text, I still couldn't find "It loved to happen," which Zooey and my NYU friend had cited, but was surprised to locate the missing Taoist insight in its "original" form: "loves to happen." I considered searching through earlier translations for the occurrence of the phrase in the past tense. But had I succeeded, what would be next? Tracking down the reclusive Salinger and asking in which translation he had come across it? The possibilities seemed

increasingly perverse—but of course they remain in play; the life of a scholar is long, and I may well one day be desperate enough to turn this into a grant application, or a sabbatical at any rate.

So, there "it" was, in the twenty-first entry of Book X of the *Meditations*, where Aurelius contemplates a line from Euripides:

> "Earth is in love with the showers from above,
> And the all-holy Heaven itself is in love"
> [Euripides, Frag. 890]
> —that is, the universe is truly in love with its task of fashioning whatever is next to be; and to the universe, therefore, my response must be, "As thou lovest, so I too love." (Is not the same notion implied in the common saying that such-and-such a thing "loves to happen"?)[5]

I began to see the wisdom in my professor's suggestion that my thesis could do without the effort to contextualize this phrase.

Much, much more important, though, Seymour had already begun to believe (and I agreed with him, as far as I was able to see the point) that education by any name would smell as sweet, and maybe much sweeter, if it didn't begin with a quest for knowledge at all but with a quest, as Zen would put it, for no-knowledge. Dr. Suzuki says somewhere that to be in a state of pure consciousness—*satori*—is to be with God before he said, Let there be light. Seymour and I thought it might be a good thing to hold back this light from you and Franny (at least as far as we were able), and all the many lower, more fashionable lighting effects—the arts, sciences, classics, languages—till you were both able at least to conceive of a state of being where the mind knows the source of all light. We thought it would be wonderfully constructive to at least (that is, if our own "limitations" got in the way) tell you as much as we knew about the men—the saints, the arhats, the bodhisattvas, the jivanmuktas—who knew something or everything about this state of being. That is, we wanted you both to know who and what Jesus and Gautama and Lao-tse and Shankaracharya and Hui-neng and Sri

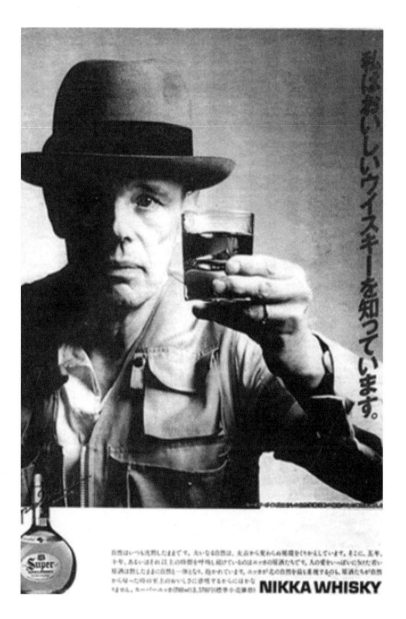

Joseph Beuys, commercial message for Nikka Whisky, 1985, Dentsu/Japan. The English translation of the Japanese characters on the right of the image is "I know tasty whiskey." Reproduced by permission of Dentsu Young & Rubicam, Inc.

Ramakrishna, etc., were before you knew too much or any-
thing about Homer or Shakespeare or even Blake or Whit-
man, let alone George Washington and his cherry tree or the
definition of a peninsula or how to parse a sentence. That,
anyway, was the big idea. Along with all this, I suppose I'm
trying to say that I know how bitterly you resent the years
when S. and I were regularly conducting home seminars, and
the metaphysical sittings in particular. I just hope that one
day—preferably when we're both blind drunk—we can talk
about it.[6]

### III

Beuys's multiple *Cosmos and Damian 3D* is named after Cosmas
and Damian, the early Christian martyrs and Arab physicians whose
acts of healing and their refusal to accept payment for them became
legendary.[7] The legends have it that these two performed the first
limb transplant, known as "the Miracle of the Black Leg," by remov-
ing the diseased leg from a Roman and replacing it with the leg of
a recently deceased North African. While it is generally agreed that
this could not in fact have taken place, the story has lived on as the
founding myth of organ transplantation, and Cosmas and Damian are
today the patron saints of healers, druggists, physicians, and surgeons.
In Beuys's work, he images the transformation of the Twin Towers
of the World Trade Center into two giant sculptural objects that can
be read as blocks of either sulfur or butter, or both. Sulfur was, along
with salt and mercury, considered by the fifteenth-century healer and
philosopher Paracelsus, one of Beuys's important influences, to be
one-third of the material triad out of which the whole world was
fashioned. Butter appears often in Beuys's works, serving much the
same function as fat: an illustrator of the way love and compassion,
an admixture of physical and spiritual warmth, alter the materiality
of things.

For Beuys, the continuum of temperature change, the movement
from cold to warm, implied a move from a highly ordered state to
a chaotic one. Beuys, in his 1965 *And in Us ... beneath Us ... Land
Under* action,[8] rested his cheek against a block of tallow until the

warmth of his flesh began to melt it, demonstrating the capacity for creating a different kind of chaos, one brought about and sustained by human warmth or compassion. Beuys once said:

> Suffering and compassion should not arise in man because of biographical events, but every person should in himself be able to suffer and show compassion, that is, he should be so penetrable and open that he can. For example, when one speaks about the sociableness of man, one has to know that suffering and showing compassion are the actual prerequisites for becoming a social being.[9]

Wijers has explained this Gallery Parnass action with the following anecdote. When she and Beuys visited Japan together in 1984, at the invitation of the Watari family and the Seibu Museum, in Tokyo,[10] Wijers was interviewed by a Japanese television crew who asked her to sum up Joseph Beuys's work in one word. "One word?" she asked. She thought for a moment and gave it to them.

"Well, if you want only one word, I would say that word is *love.*"[11]

IV

In 1982, one year after the Brixton riots in London, the Clash released their album *Combat Rock*. The songs from the first side of the LP— such as "Rock the Casbah" and "Should I Stay or Should I Go?"—are by far the most well known; the album's B-side is terra incognita by comparison. The album's tenth track, "Ghetto Defendant," is an anthem for history's lost urban resistances; its refrain,

> Ghetto defendant
> It is heroin pity
> Not tear gas nor baton charge
> Will stop you taking the city

is an echo of Sid Vicious's recent death.[12] But beneath the wail of the main lyrics is a soft and measured American accent:

> Starved in megalopolis
> Hooked on necropolis
> Addict of metropolis
> Do the worm on Acropolis
> Slamdance cosmopolis
> Enlighten the populace.

The voice belongs to Allen Ginsberg. As the song unfolds the words spoken by him and those sung by the Clash coil around each other in a tangled cadence:

> CLASH: The ghetto prince
> Of gutter poets
> Was bounced out of the room
> GINSBERG: Jean Arthur Rimbaud
> CLASH: By the bodyguards of greed
> For disturbing the tomb
> GINSBERG: 1873
> CLASH: His words like flamethrowers
> GINSBERG: Paris commune
> CLASH: Burnt the ghettos in their chests
> His face painted whiter
> And he was laid to rest
> GINSBERG: Died in Marseilles

The refrain begins again:

> CLASH: Ghetto defendant
> GINSBERG: Buried in Charleville
> CLASH: It is heroin pity
> Not tear gas nor baton charge
> That stops you taking the city
> GINSBERG: Shut up in eternity

And here Ginsberg takes over:

> GINSBERG: Guatemala
> Honduras

Poland
100 Years War
TV rerun invasion
Death squad Salvador

His own voice begins to split off from itself. As the map of military-media invasion continues, a replicant Ginsberg begins to chant, so nearly inaudibly that his words seem never to have been picked up in any of the reproductions of the song's lyrics:

*Aahm*
Afghanistan meditation
*Om*
Old
*Aah*
Chinese flu
*Om*
Kick junk, what else
*Gate*
Can a poor
*Gate*
Worker do?
*Paragate*
*Om Om*
Ghetto defendant
*Bodhi svaha*

And here the remainder of Ginsberg's chanting and his recitation interrupt each other to such an extent that they become indistinguishable, with Sanskrit's sacred syllables and the Clash's spiraling refrain becoming inextricable from each other:

> In heroin pity*svaha* . . . not tear gas*gate gate*nor baton charge*paragate parasamgate*has stopped you taking*svaha bodhi svaha*the city*gate gate*ghetto defendant*paragate*it is heroin pity*parasamgate svaha*not tear gas nor baton charge*gate svaha.*

The sound swims off into the silence separating it from *Combat Rock*'s eleventh track. In one of postpunk's most celebrated albums, Ginsberg recited the last line from what is doubtless the most widely known Buddhist sutra in the West. Interestingly, although the lyrics for the rest of his spoken word performance are recorded on *Combat Rock*'s album jacket, as are all of the lyrics for all of the other songs on the album, Ginsberg's recitation of the Heart Sutra is not included. Neither is a single Sanskrit word included in the list of the lyrics for "Ghetto Defendant" on the Web site that provides the lyrics for every song on every Clash album. The most likely explanation is that Ginsberg's meditation was an improvisation on his part in the recording studio, perhaps with the prior consultation of the band, perhaps not, but one that clearly made their final cut, even though it was either accidentally or intentionally left out of the script of the lyrics that they sent to print for the album jacket. Nevertheless, the online archivists' failure, all these years later, to have picked up on the Heart Sutra's absence is somewhat surprising.

The Bhagavatiprajñaparamitahrdayasutra, translated as the Bhagavati Heart of the Perfection of Wisdom Sutra and most commonly known as the Heart Sutra, contains what are probably the two most well-known snippets of Indian Buddhist wisdom. The first is the mantra chanted by Ginsberg: "[Om] gate gate paragate parasamgate bodhi svaha." Buddhist scholar Donald S. Lopez Jr. provides, along with the cautionary note that Sanskrit mantras are usually not translated, a loose English translation: "The mantra seems to mean 'Gone, gone, gone beyond, gone completely beyond, enlightenment, svaha.'"[13]

Even more famous in the West is the Heart Sutra's much-contested statement "form is emptiness, emptiness is form." The controversy lies between two different Sanskrit phrases: *rupam sunyata sunyataiva rupam* and *rupam sunyam sunyataiva rupam,* which can be translated as "form is emptiness, emptiness is form" and "form is empty, emptiness is form," respectively. While the version "form is emptiness" has "wide currency and fame in English," most Indian and Tibetan texts favor "form is empty." Lopez points to an apparent philosophical difference between the two: the "form is empty" alternative could perhaps be intended to avoid the seeming circularity of "form is emptiness, emptiness is form."

Yet in keeping with the sutra's teaching, the last word is that "form" does not have an essential or constant form; in his 1984 audience with Lopez, the Dalai Lama told him that between the two alternatives, "there is no significant difference in meaning."[14]

## V

Evoking the meshwork of mutual misperceptions that have characterized the history of Western culture's encounters with Tibet and Tibetan Buddhism, Donald Lopez begins his book *Prisoners of Shangri-La* by imagining himself amid a series of "mirror-lined cultural labyrinths that have been created by Tibetans, Tibetophiles, and Tibetologists, labyrinths that the scholar may map but in which the scholar must also wander. We are captives of confines of our own making," he muses. "We are all prisoners of Shangri-La."[15] Almost three decades earlier, in his *Teaching and Learning as Performing Arts,* French Fluxus artist and later Tibetan Buddhist Robert Filliou had imagined a similar maze when he forecast the art of the future: "always on the move, never arriving, 'l'art d'être perdu sans se perdre,' the art of losing oneself without getting lost."[16]

In a footnote to his recent study *Kant after Duchamp,* Thierry de Duve suggests, "The writing of art history always presupposes an anthropology, albeit a deceivingly simple one, as is shown by H. W. Janson, who chooses this starting point to his *History of Art:* 'We might say that a work of art must be a tangible thing shaped by human hands.'"[17] Playfully postulating de Duve's thesis that "what art is" is produced as a form of jurisprudence, his book begins by posing the strange scenario of an extraterrestrial ethnographer charged with the task of theorizing the bewildering collection of objects, practices, and events that are used at various times in far-flung locations to exemplify "art." Not surprisingly, the alien researcher is unable to coax such a complex mix of factors into the cogent categories that would be necessary for a definitive study. De Duve's imaginary extraterrestrial researcher then takes a step that has significant implications for the way that art history might understand itself: "Without really leaving your watchtower, you now give your attitude as an anthropologist a twist of humanism, and so, you become an art historian."[18]

In his *Teaching and Learning as Performing Arts,* Filliou has also used the figure of the imaginary ethnographer to put forward a somewhat more radical vision of the relationship among art, anthropology, and their respective methodologies for engaging with the dynamism of human experience. In his book, this experimental ethnographer finds himself facing the following question from his objects of study: "Hey, instead of studying us, why not come over here and have a drink with us?"[19] If de Duve is correct to say that any art history is always a kind of anthropology, then I am tempted to wonder what kind of scholarly nonknowledge might emerge if we were to open ourselves fully to the challenge Filliou issued when he asked his ethnographer and, by implication, all practitioners of that discipline, to drop the notebook and tape recorder and come have a drink. Part of what gives Filliou's work its unique combination of criticality and gentle humor was his ability to create a practice that, in effect, let him operate as an alien ethnographer for his generation—one for whom hanging out and drinking could always enter into the process of the life's work that he called "research on research."[20]

In his Artists-in-Space and Art-of-Peace projects—interrelated initiatives that he began in 1983 and that occupied him until his death in 1987—Filliou and a number of his students and fellow artists (anyone who cared to take up his invitation) explored the question of what exactly "peace" is, if it is to be imagined as something other than merely the absence of or pause between wars. If the space between a history of art and an anthropology of art has to do with one's position with respect to a notion of "humanism," Filliou's question of how to articulate and produce a substantive and dynamic notion of peace, over and against simply the absence or opposite of war, has never been more urgent for either field or for the imagining of the humanism that links them.

Its allegiance to the experimental and intimate spirit of Filliou's brand of ethnography makes this book, *Felt,* a strange kind of art history. It is something of a mapping of a constellation of individuals, ambitions, failings, ideas, initiatives, works, and doesn't-works, and also a scripting of the theoretical machinations necessary to make this "intrigue" intelligible as something other than a convergence of stories. This constellation is one composed of individuals who have circulated in, as well as at the outskirts of, the Fluxus collective and

its activities over the past forty years. It does not consider all or even most Fluxus artists, nor are all of those in this study individuals whom most Fluxus artists would consider to be part of their orbit. (This book is indebted to the already existing excellent studies of Fluxus artists.)[21] What it does seek to do is to theorize—that is, to script in such a way as to be the object of theoretical engagement—the peculiar confluence of ideas, agendas, works, concepts, and individuals that cohere around this strange event that took place between Beuys and the Dalai Lama over two decades ago. How to write a history that takes as its center of gravity a meeting in which nothing in particular seems to have happened, a meeting that went unrecorded and yet seems to have been the nexus of a set of historical forces that have yet to be catalogued?

Today discussions of contemporary artistic practice lavish much attention on the term *process:* the experience of making work, inhabiting the present moment of its creation, attending to the inherent qualities of the media and the way they do or do not respond, the internal dialogue that happens between oneself and one's work. Yet in critical debates, almost never is "process" discussed in language that dares to broach the subject of spirituality. If ever that word rears its head, we all usually feel free to enjoy a clinical wink and smirk at the naïf's expense, as things get rerouted back to the safety of the academic. And yet what is most interesting about the artists who compose this study—Joseph Beuys, John Cage, Ben d'Armagnac, Robert Filliou, Dick Higgins, Alison Knowles, Yoko Ono, and Louwrien Wijers, to name a few key figures—is that precisely this question of the relation to the spiritual is what haunts, drives, and nourishes their practice. So it is, too, that the peculiar form of collectivity that comes closest to capturing the dynamism of the passages of events and individuals traced by this book is the Buddhist *sangha.* This concept, in part because of its spiritual bearing, offers more theoretical mileage than many of the more familiar assemblages of civic and secular concerns that are used to conceptualize collectivities of art and artists in the moment of "de-ism-ization."[22]

This book offers a study of the "interhuman intrigue" that has taken the form of the constellation of individuals, ideas, and practices that are linked historically to the phenomenon of Fluxus and are bound by a set of artistic imperatives that circulate around the

question, posed by the educator Paulo Freire, of what it means for the human to pursue his or her ontological vocation, namely, *to become more fully human*.[23] This is the meaning of spirituality as it is used here; there is nothing New Age about it. What unfolds in this investigation is thus not a history of Fluxus but a circumambulation of it, one that is partial in both senses of the term, that can do some justice to its anarchic, ludic, and ongoing contributions to the history of the avant-garde, a history that Fluxus and its various offshoots continue to craft.

Gilles Deleuze wrote, "Creation is all about mediators. . . . I need my mediators to express myself, and they'd never express themselves without me: one is always working in a group, even when it doesn't appear to be the case. . . . Félix Guattari and I are one another's mediators."[24] The objective of this book is to explore a particular constellation of individual artists and thinkers and their shared entanglements—knots and interlocks of individuals, works, texts, ideas; cohesions of material worth making; intimate encounters worth recording, touching but, crucially, not always connecting, and indeed cohering even more powerfully because of these proximate nonconnections, these passages of life and work that graze and glance at one another, that are together without coming together. Ultimately this tangle constitutes a very particular and peculiar sort of love story, the historicity of which this book sets out to imagine.

# INTRIGUE
## Toward the Scripting of Intimate Space

A Play Called FALSE!

DISHONEST FAITHLESS!

DECEITFUL MENDACIOUS!

UNVERACIOUS!

TRUTHLESS! TROTHLESS! UNFAIR!

UNCANDID!

DISINGENUOUS SHADY SHIFTY

UNDERHAND UNDERHANDED!

HOLLOW HYPOCRITICAL INSINCERE

CANTING JESUITICAL

SANCTIMONIOUS PHARISAICAL!

TARTUFFIAN DOUBLE DOUBLE-

TONGUED DOUBLEFACED!

SMOOTHSPOKEN SMOOTHSPOKEN

PLAUSIBLE!

MEALYMOUTHED INSIDIOUSLY

DESIGNING DIPLOMATIC

MACHIAVELLIAN!

BROTHER!

—ROBERT FILLIOU, "A Play Called FALSE!"

In a recent survey, *Frieze* magazine asked thirty-three artists, critics, curators, and other art-world culture workers the question:"How has art changed ... over the last forty or so years?"Artist John Armleder's response finishes with the following reflections:

2

> I am personally quite grateful to have been around long
> enough to now experience eternity limited to a couple
> of weeks. The significant changes are: more people, more
> venues, more publications, more artists, more words—and
> less duration. If only—and sorry for being such a retarded
> hippy—we could stop war, disease, and poverty.[1]

How to write a history of cultural practice that engages with these
very same last four decades without taking seriously both Armleder's
wish and his apology for having it?

Has the contention that art ought to be concerned with these
grandiose objectives been subject to sophisticates' derision for long
enough that, now, nobody is laughing? Certainly the overall message
to be gleaned from the *Frieze* survey is that the art world, like the
world in which it is nestled, has gone to the dogs, that there is no
longer any scope for real criticality, no way around the capture by
market forces of any mode of artistic production of meaningful social
change. The final words of artist Andrea Fraser's *Frieze* statement put
a sharp point on this:

> The threat of instrumentalization by corporate interests has
> been met by a wholesale internalization of corporate values,
> methods and models, which can be seen everywhere from
> art schools to museums and galleries to the studios of artists
> who rely on big-money backers for large-scale—and often
> outsourced—production. We are living through an historical
> tragedy: the extinguishing of the field of art as a site of resis-
> tance to the logic, values and power of the market.[2]

But as Paul Mann argues in his *The Theory-Death of the Avant-Garde*,
from its very inception, the avant-garde, far from being genuinely
resistant to the market, has been completely bound up in it; there
has never been a decisive capture of art by the market—such that
we could now, as Fraser has it, find ourselves living through the final
victory of capital over the critical—but rather a mutual exploitation
of each by the other that is as old as the avant-garde itself.[3]

Electron microscope image of felt fibers interlocking.

In his response to *Frieze*'s survey, artist William Pope.L recasts Fraser's indictment, showing up the pitfall in imagining that market forces have really succeeded in co-opting resistance as such.

Something has shifted. No one can deny this. But what's more interesting is how capable the art world is of absorbing these shifts and, if not nullifying them, then ignoring or altering them such that their one time criticality and difference seems softened or disappeared. But perhaps this disappearing act is an ideological illusion. Perhaps the criticality of these shifts has changed something. Maybe these shifts have been veiled to appear as nothing and the changes they caused made to look insignificant. Isn't it easier to believe that it just doesn't fucking matter? Isn't it easier to believe that, if everything is fucked, then we don't have to give a fuck? Artists have always loved to think the worst of each other and their home called the art world. In a strange way, we like to soil our own nest. Maybe it's a defensive gesture.

4

We feel we'd better do it to ourselves before some non-artist does. Maybe we just like to wallow in filth and deny our hands are dirty. I think we artists are afraid that our work is worth nothing, that it's frivolous. I think the danger is not that the art is frivolous; I think the danger is that the people who make it might be so.[4]

## FRIVOLITY AND DANGER

In an early essay on aesthetics and criticism titled "Reality and Its Shadow," unusual among the writings of philosopher Emmanuel Levinas for its sustained consideration of aesthetic experience and artistic labor, he wrote that the characters that inhabit novels "are beings that are shut up, prisoners. Their history is never finished, it still goes on, but makes no headway. A novel shuts beings up in a fate despite their freedom. Life solicits the novelist when it seems to him as if it were already something out of a book."[5]

The variety of fiction that threads through Levinas's philosophy, by contrast to the novels he describes, unfolds into his work as a writing that finds itself utterly, and not just selectively, *solicited* by a life that would seem to exceed any art that would mediate it. This fiction is solicited by social life in its entirety, not just its aestheticized moments that appear to be refugees from a novel yet to be written but, all the same, more or less ready-made. There is an overlap here with the practice of writing about art and its histories, in that the art historian is similarly solicited in much the same way as Levinas's novelist, except in a kind of retro-garde current;[6] whereas Levinas's novelist is struck by life when it seems artful in relation to his life's exposures to various fictions of the everyday, the art historian is solicited by a version of the past that seems to cohere as a protofate for the art and artists that would be found to have been produced in and by such a past. A kind of idealism is always at work in this approach to art history. Its work can be described as the delivery of a historical moment's protofate into discourse in the form of a study of a past that could underwrite this moment's sense of its own future. Perhaps here, in the conviction that life will overflow the world that art

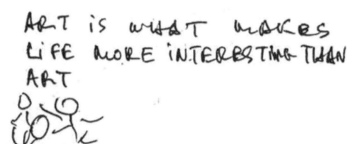

Robert Filliou, *ART IS WHAT MAKES LIFE MORE INTERESTING THAN ART*, postcard, not dated.
Reproduced by permission of Marianne Filliou.

invents for it, is where art history meets the provocation of Levinas's philosophy. As Pope.L asks, "If you can't be idealistic, then what can you be? . . . Idealism is what gets you out of bed. Once you're out of bed, you need to find something more than idealism. But you have to get out of bed."[7] How to imagine the writing of a history of art and the communities and social intrigues that cohere around it in a way that would honor both this idealism and the pragmatism embedded in this statement—a history of an art that, to follow Robert Filliou, "is what makes life more interesting than art"?[8]

In his *Fragments of Life, Metaphysics, and Art,* art historian Léo Bronstein wrote, through the voice of a fictional art historian writing a long letter in reply to his dearest former student, "*Space is the fragment in which the unseizable whole of life, material and moral, is transubstantiated or seized in the art of painting.*"[9] This is arguably at once the clearest and densest summation of the nature and possibilities of painting that exists in print—and, in Bronstein's invention of a fictional art historian who stages his book's histories of art, a provocative way of conceiving art history's ethos.

To enter his work through the practice of painting is a subversive way to characterize the writing of Levinas, a philosopher who argued in an early essay, "Reality and Its Shadow," that "art, essentially disengaged, constitutes, in a world of initiative and responsibility, a dimension of evasion" (12). Yet Levinas's approach to the craft of writing is a practice of soliciting passages of experience that permit one, in Bronstein's words, to seize the unseizable whole of life, material and moral; Levinas's writing can best be described as a painterly prose. And to think of his prose as painterly gives us a provocative way to examine his disparaging of aesthetic experience on the grounds of its fundamental irresponsibility: "To make or appreciate a novel and a picture is to no longer have to conceive, is to renounce the effort of science, philosophy, and action. Do not speak, do not reflect, admire in silence and in peace—such are the counsels of wisdom satisfied before the beautiful" (12). It is important to face up to this challenge in any art historical investigation, which should always, and rightfully, be expected to deal with the challenge to account for why one's work (yet another book) matters.

Levinas's scorn was directed only at an art that imagined itself to be separated from the criticism that integrates the inhuman work of the artist into the human world. "Criticism already detaches it from its irresponsibility by envisaging its technique. It treats the artist as a man at work. Already in inquiring after the influences he undergoes it links this disengaged and proud man to real history. Such criticism is still preliminary. It does not attack the artistic event as such, that obscuring of being in images, that stopping of being in the meanwhile" (12-13).

Levinas's insistence upon the mediating grace of criticality underscores his sense that art, left to itself, is at odds with responsibility. Put differently, today the poet cannot hold the philosopher culpable for his exclusion from the polis. The poet's own irresponsibility is to blame; he "exiles himself from the city. From this point of view, the value of the beautiful is relative. There is something wicked and egoist and cowardly in artistic enjoyment. There are times when one can be ashamed of it, as of feasting during a plague" (12).

Here it is instructive to consider Bronstein's own rejection of aestheticism, which offers the beginnings of a clarification of the retarded hippy's nostalgia for a project unafraid to deal squarely with its rela-

tionship to its own responsibility. Like Levinas, Bronstein had little patience for aestheticism. But he was capable of dismissing it without such poecidal pathos—by insisting on the ethical fundament of even the strictest formalism. "So I repeat: space in art is a *moral* space. So falls the ivory tower of the aestheticians. The 'pure visibility' worries of a painter are not aesthetic and conceptual worries only, they are human, moral worries" (*Fragments of Life,* 37). It is not, then, that art is always aesthetic and sometimes ethical; it is as ethics first and foremost that art is intelligible, and this is at the root of any aesthetics. Curiously, this position seems far more consistent with Levinas's emphasis upon the primacy of the ethical relation than does Levinas's own insistence upon the fundamental amorality of art and artists.

Pursuing this strand, we can find in Levinas's work a range of evidence to suggest that he would have had, at most, a tenuous attachment to his own assertion that to write or enjoy a novel entails a renunciation of responsibility. For instance, the problem of responsibility as it is taken up in *Totality and Infinity* (first published in 1961 and often considered to be Levinas's magnum opus, the first mature formulation of his philosophy, and arguably the most stylistically subtle of all his works) is very much an elaboration of a particular passage from Dostoyevsky's novel *The Brothers Karamazov,* for which Levinas had great affinity.

In an interview with Florian Rötzer given near the end of his life, Levinas borrowed that passage to articulate the central concern of his own ethical philosophy, saying, "We're all guilty of everything in relation to the other, and I more than all others. This ending, 'more than all others,' is what is most important here, although in a certain sense it means to be an idiot."[10]

This conjunction of the ethical and the idiotic in what Levinas would later call an "interhuman intrigue" might, in its playful seriousness, be the best way to conceptualize Armleder's challenge and its implications for art history.[11]

## ALTERITY'S CHARACTER

Emmanuel Levinas called upon philosophy to engage with its great "unthought" dimension: the "search for the human or interhuman

8

intrigue as the fabric of ultimate intelligibility."[12] In this provocation, the effort to recognize the transcendent, to render the transcendent intelligible, must also engage with "the human or interhuman intrigue which is the concreteness of its unthought"; this unthought, he warns emphatically, "is not purely negative!" That is to say, although critics have nevertheless cast his method as a complex orchestration of nega-tions,[13] Levinas's drama of ethical experience, a drama that unfolds as social existence (a "sociality which . . . is a *relation with the other as such* and not with the other as a pure part of the world"),[14] has a materiality, a palpable existence, and a presence with which think-ing must contend. That the human or interhuman intrigue remains unthought for philosophy does not for this reason make it a problem that is able to be framed only in the negative.

Although by this point in his career Levinas was taking pains to bind his theological concerns to his philosophical writings, and while he dared to follow his figuration of "the human or interhuman intrigue as the fabric of ultimate intelligibility" with the gnostic sug-gestion that such a renewed phenomenology might even be "the way for the wisdom of heaven to return to earth," the problem of the intrigue of ethical alterity nevertheless remains as much a secular as a theological concern.[15]

In Gillian Rose's philosophical memoir *Love's Work,* published shortly after her death in 1995, she captured what was at stake in this intrigue, which while it may be called spiritual is not necessarily religious: "I will stay in the fray, in the revel of ideas and risk; learning, failing, wooing, grieving, trusting, working, reposing—in this sin of language and lips."[16] Assuming that such an intrigue and its intelligi-bility are our concern or ought to be, what does it mean to speak of them, as Levinas does, as a "fabric"?

To suggest that this fabric would be metaphorical would not be troublesome within the terms of Levinas's thinking. For him meta-phor was part of "the marvel of language"; he argued that the possibil-ity of deconstructing a particular metaphor's "psychological, social, or philological history" in no way detracts from its marvelous capacities: "The *beyond* which metaphor produces has a sense that transcends its history; the power to conjure up illusions which language has must be recognized, but lucidity does not abolish the beyond of these illusions."[17] This *beyond* finds itself rendered within the etymology

of the term; *intrigue* derives from the Latin *intricare:* to entangle, perplex. Already at this "origin," we have the folding together of the tangling of an abstract materiality and the thickening, troubling, fulling, and complication of consciousness.

Gilles Deleuze, in his *Expressionism in Philosophy,* offers a way of beginning to approach the nature of the fabric that could be adequate to the task of rendering intelligible this interhuman intrigue: by using Spinoza's notion of *fabrica,* a term that captures both the structural and the operational dimensions of a body. Deleuze writes, "Spinoza can consider two fundamental questions as equivalent: *What is the structure* (fabrica) *of a body?* And: *What can a body do?* A body's structure is the composition of its relation. What a body can do corresponds to the nature and limits of its capacity to be affected." This capacity to be affected Deleuze defines "as the aptness of a body both for suffering and acting."[18]

The proximity of Deleuze's variation on Spinoza's *fabrica* to the fabric of Levinas's "interhuman intrigue" is uncanny and runs counter to the received sense of the irreconcilability of their work. Yet we even could perform a sleight of prose and say that the two notions, posed in a relation with one another, themselves constitute a *fabrica;* we could imagine an interhuman intrigue whose structure—a kind of sensate fabric—and whose capacity for suffering and acting would be equivalent. But to do so we would also have to consider this composite body not just to exist in spite of, but in fact to be constituted by, the tension between two opposing and perhaps irreconcilable orientations. That they are irreconcilable does not, however, mean that they are unable to operate as a body.

Spinoza's ethical philosophy poses a notion of an absolute and infinite substance that decenters the human subject from its place of privilege; as Andy Goffey puts it, whereas "Descartes can be seen as setting out from the intrinsically modest nature of the human subject which is, as finite being, unable to know anything of God, Spinoza . . . sets out, more or less, from infinity and affirms the integral knowability of God" as this infinite substance. This formulation of an absolute infinite substance entails a paradox, in that "one must maintain both that it is an entirely artificial construct, the product of an extreme formalism and that it is entirely unformed, natural."[19] This knowability of God could not be more abrasive to Levinas's philosophy, which uses

the figure of a fabric precisely in order to enable the opening to what is beyond it, beyond knowledge; for Levinas, infinity always overflows the very idea one can have of it.[20]

10

But if we refrain from forcibly weaving these two notions, *fabrica* and the fabric of interhuman intrigue, together into a synthesized figure that would mean violence and, worse, dilution for both, how then do we imagine the form that would sustain their relation? Another way to put this is to ask: Given the differing ethical obligations of these two notions, what are the ethics of crafting, through the act of writing, the body they would have to share? Perhaps, to follow Irigaray, this body sharing is every bit as carnal as it sounds;[21] perhaps the task then would be to articulate this body's aptness both for suffering and acting, this fabric's ability to be made, unmade, remade in and through sociality.

There is no clearer foregrounding of what is at stake in these questions than this first sentence from Levinas's *Totality and Infinity:* "Everyone will readily agree that it is of the highest importance to know whether we are not duped by morality" (21). This text has become a crucial source for engagements with ethical alterity and its implications across a range of disciplines, from literary criticism to art history. Its availability has had the effect of producing a variety of cursory—and more often than not "sentimental"[22]—readings that have rarely done justice to its volatility.

Primary among its complexities is the current in Levinas's thought that opens into a tolerance for and a sanctioning of violence. *Totality and Infinity* begins its effort to think through a notion of peace that might be something other than simply the absence of or pause between wars by asking, in the book's second sentence: "Does not lucidity, the mind's openness upon the true, consist in catching sight of the permanent possibility of war?" (21). If we are necessarily duped by morality, then there is no option for peace but to operate in this economy of war and its precipitation, preemption, or postponement. And indeed, as Howard Caygill has argued, Levinas would find himself ultimately unable to craft a philosophical fiction that would extricate his own thought from the possibility of war.

One of our historical moment's key studies of social and political life begins by tackling this very question of the possibility of peace. At the outset of their book *Multitude,* Michael Hardt and Antonio

Negri describe their project as an inversion of Thomas Hobbes's *Leviathan;* whereas Hobbes began his analysis with an investigation of a newly emergent social class and proceeded to theorize the form of sovereignty imbricated with it, theirs moves from the theory of postmodern sovereignty, developed in their previous book *Empire,* toward a consideration of the emergence of a "new global class" they call "multitude."[23] And whereas Hobbes's conception of the interhuman intrigue of sociality was framed by a vision of war that "consisteth not in actuall fighting; but in the known disposition thereto, during all the time there is no assurance to the contrary,"[24] Hardt and Negri's multitude emerges from the condition of "a *general global state of war* that erodes the distinction between war and peace such that we can no longer imagine or even hope for a real peace."[25]

Levinas's consideration of the need to attend to the permanent possibility of war is posed in order to open the possibility of an eventual overcoming of the thinking that remains bound to war. He proceeds to argue that this "lucidity, the mind's openness upon the true," is confined to a thinking of totality that does not permit an opening to alterity, an opening to the infinity that consists in the ethical encounter and the philosophy that would elucidate it and underwrite the form of sociality proper to it. Whether this is, in Levinas's words, a "sociality which . . . is a *relation with the other as such,*" or whether it is instead a sociality formulated in Spinozist terms that considers "the other as a pure part of the world," is perhaps an undecidable choice. But it is one whose inherent and constitutive tension the interhuman intrigue is perfectly capable of sustaining. Precisely this aptitude for sustaining such intractable contradiction is what makes possible the production of (the body of) an intrigue.

In 1982 Levinas was a participant in a radio broadcast with Philippe Nemo that followed that year's execution of refugees in the Lebanese camps of Sabra and Shatila by Phalangist militias. Caygill has noted how Levinas, in his on-air comments, mobilized his philosophy in order to avoid a condemnation of the actions of the Israeli state, demonstrating a "coolness of political judgement that verged on the chilling, an unsentimental understanding of violence and power almost worthy of Machiavelli."[26] He suggests that Levinas's response to the Sabra and Shatila war crimes (which met with outrage by many Israelis and Jews in the diaspora and provoked an official inquiry that resulted in the

11

dismissal of then-defense minister Ariel Sharon)[27] has to be seen as "a touchstone for his ethical and political principles as well as his views on Israel and the State of Israel." In conversation with Nemo, Levinas found himself face to face with the following question: "Emmanuel Levinas, you are the philosopher of the 'other.' Isn't history, isn't politics the very site of the encounter with the 'other,' and for the Israeli, isn't the 'other' above all the Palestinian?" Levinas's evasive answer, for Caygill, "opens a wound in his whole oeuvre":

> My definition of the other is completely different. The other is the neighbour, who is not necessarily kin, but who can be. And in that sense, if you're for the other, you're for the neighbour. But if your neighbour attacks another neighbour or treats him unjustly, what can you do? Then alterity takes on another character, in alterity we can find an enemy, or at least then we are faced with the problem of knowing who is right and who is wrong, who is just and who is unjust. There are people who are wrong.[28]

Rather than judge this as a one-time wavering from an otherwise wholly consistent and stable philosophy of ethical alterity—a commitment to thinking and performing the responsibility for and the welcoming of the other that would seem, on the face of it, to have obliged Levinas to at least gesture at a condemnation—Caygill argues that Levinas's response is in fact "rigorously consistent with his philosophy, which we have argued recognises the inevitability of war. To describe the other as enemy at this point is thus entirely consistent with such a reading of Levinas's ethics."[29]

Caygill's study demonstrates that the openness to violence is a central current in Levinas's work. This gives it a volatility, a "not-niceness," that many have sought not to notice. But far from enabling the simplistic argument that this in some way compromises Levinas's thought, the ability to see Levinas's language of responsibility and obligation through the optic of the political permits us to experience his philosophy as something other than an impregnably moralizing discourse. It is in just this troubled dimension, in its embodiment of the interhuman intrigue in tandem with its philosophical exploration of it, that Levinas's work, at its most visceral level, finally does suc-

ceed in its wish to open to the unthought beyond totality, which is precisely where he finds himself facing, indeed condoning, unthinkable violence and thus inescapably becoming part of the interhuman intrigue his work sought to understand.

## THE LOOK OF ETHICS

To imagine that the concept of the text captures all that is or may be written is to deaden writing. Writing can be produced as text but need not be. Thinking and writing stutter into and past one another; writing is always at once one or more steps behind thinking's pace and possibly obliquely ahead of it whenever thought repositions its relation to itself, because even the most linear thinking operates in relations, displacements, and intensities and thus does not so much change direction as unfold in a changing constellation. This folding and fulling movement and the space it produces, despite the habit of calling its product a "text," is not often translatable into the terms of the textilic.

If we are to think of the interhuman intrigue as a fabric, we are better served by figuring it as a nonwoven and aleatory form rather than a woven and regularized one. The material felt provides a wholly different set of limits and aptitudes for the figure of a fabric that might permit us to model with greater clarity the inescapably intimate cohesion that binds us in the interhuman intrigue. To think in terms of a materiality of the nonwoven as the fabric of intersubjective experience, instead of in the stabilizing terms offered by the textual–textilic, permits a subject who is effectively lost in this space where she must continually craft a connection with it.

This entails a practice of the art that Filliou described when he wrote of "losing oneself without getting lost" (*Teaching and Learning,* 24), an art of navigating a constantly shifting and buckling intersubjective space; it is, to use Filliou's words again, an "art of peace," the peace that Levinas described "as awakeness to the precariousness of the other."[30]

There are many ways in which *Totality and Infinity* and Léo Bronstein's little-known book *Fragments of Life, Metaphysics and Art* appear to have been written for one another. Ultimately, the most

important convergence is the authors' shared concern: to explore what it would mean to render intelligible a sociality predicated upon the notion of peace—that other great unthought. It is striking to read, alongside the first lines of Levinas's preface ("Does not lucidity, the mind's openness upon the true, consist in catching sight of the permanent possibility of war?"), the concluding line of Bronstein's own: "For conceived in war, this book is of peace" (*Fragments of Life*, xx).

Bronstein's book consists entirely of letters written between fictitious characters. They are, however, anything but "beings that are shut up" in a fate. For them fiction, far from leading them to their imprisonment, seems utterly liberatory; it seems, that is, to free them into the bondage of their responsibility to one another and to us who read their words, or rather Bronstein's. One particular passage from that book is especially pertinent here. It comes from the letter mentioned above, by the art historian Philippe, written to his student Robert. Its elaboration of the relation of the ethical and the aesthetic—unfolding as judgment and participation, each embodied, respectively, by the figures of face and profile and operationalized in the corresponding play of convex and concave forms of spatiality—makes it worth quoting at length:

What I intend to say or to suggest here is this:

*Space is the fragment in which the unseizable whole of life, material and moral, is transubstantiated or seized in the art of painting.* Because space is the most material concrete element of our visual consciousness.

I mean the material space we see, not any abstract "meaningful" derivative space; I mean simply the banal yet astonishing phenomenon of extension, of distance, of three-dimensional visibility.

The individual space structure with which, like the snail within its shell, an artist surrounds himself is his whole unbroken reality and truth, his triple level: lyrical—the hidden truth of his inspiration or his personality; epical—the hidden impact of his precise historical momentum; cosmic—his calculable and incalculable breaking through the stellar flow. Space in art is a choice, therefore a judgment.

That is why I say *space in art is a moral space.*

Those are big words, perhaps repugnant to the cultured up-to-date man, strictly and proudly confined to the words-must-make-sense frontier. But perhaps the words are not big enough, perhaps there should be no measure of words at all for such things: only contemplation, exalted [*sic!*] in "silence and secrecy."

. . .

And human, moral also are the opening of the *face* and the opening of the *profile* into space awareness, the opening in front of things visible, the opening among things visible. I call the first space structure *space-image,* the second *space-ornament.* Image is what is given *to* the human eye *by* visible nature; ornament, what is given *by* the human eye *to* visible nature. Image is the law of human judgment imposed upon nature; ornament is the mimic of human participation in nature. The space-image is space which comes by itself toward us, in front of whose narrated and cognitive contents we stand in stillness and judgment. It is symbolically, remember, morally speaking, as it were, a *convex* space whose limit of successive advance or self-projection toward us would be the shortest possible interval or the extreme nearness between our eye and the salient center of that convexity. The space-image is the transubstantiated human being; ultimately it is the revelation in art of humanity *per se:* of man without his beyond, without landscape. . . . Now then, space-ornament is space toward which we go by ourselves, into which we penetrate, in participation with its to-be-constructed content. Symbolically, and so morally, it would be a *concave* space uniformly surrounding our coming into it, therefore offering its center all over its concavity: an expression of simultaneity and not succession, the continuity of man and his beyond. Space-ornament is thus the transubstantiation of nature in man; is landscape. (*Fragments of Life,* 35–40)

Bronstein's *Fragments of Life* invents a set of tools for calibrating the aesthetic and the ethical in the art historical endeavor. This meshes strikingly with Levinas's wish for a philosophy that would recognize "the power to conjure up illusions which language has" but whose

15

"lucidity" would nevertheless "not abolish the beyond of these illusions." The terms of Bronstein's passage return us to the question raised above, namely, how to imagine the structure and the nature of the body that would sustain the nonsynthetic relation between Spinoza's *fabrica* and Levinas's fabric of interhuman intrigue? Here we recall the corollary of this question: Given the differing ethical obligations of these two notions, what are the ethics of crafting, through the act of writing, the body that they would have to share?

A first step in responding to this would be to displace text itself as the metaphorical underpinning of a writing that would explore the space that these notions share in their embodiment; an interhuman fabric would necessarily be a nonwoven one. This shift permits Levinas's fabric to open to the beyond, even at the level of its operative metaphor. No longer bound by the warp and woof of the weave, both his writing and the interhuman fabric that it seeks to address and also to constitute reveal themselves to be at once the producers and the products of an aleatory and ultimately unknowable but enactable, graspable intrigue. This poses a point of connection—a kind of sinew—between Levinas and the Spinoza whom he imagined to oppose his philosophy that would, at least under the rubric of a "human or interhuman intrigue as the fabric of ultimate intelligibility," permit their ethics to converge in and as a nonwoven fabric. An intimate cohesion without the necessity of "connection."

Goffey notes, "Levinas has argued that nothing could be further from his own efforts to reverse the metaphysical—and ethical—prioritisation of the Same over the Other, as Spinozism." He adds that, despite Levinas's sense of his distance from Spinoza, "it is not clear how the transcendence of the Other, described by Levinas in terms of its incarnation in the face, could distinguish an other from Other, most particularly because it is so easy to extract a few sensible resemblances from a face, thus crushing its alterity under a wave of sameness."[31]

But this characterization forgets the entangled space in language—which as in painting is always, following Bronstein, a *moral space*—which Levinas employed when he mobilized several variable terms for alterity whose confluence and associative ambiguity can be seen as integral properties in his work. As Adriaan T. Peperzak notes, this variability is a "particular difficulty" for any translator who wishes

to solve the rendering of *Autre, autre, Autrui,* and *autrui,*
Levinas's use of which is not always consistent. Among Levi-
nas scholars it has become a convention to reserve "the
Other" with a capital for all places where Levinas means
the human other, whether he uses *Autrui, autrui, autre,* or
*Autre.* This convention has many inconveniences, however.
For example, it cannot show the difference between *Autre,*
when it is used to refer to God and when it refers to the
human other.[32]

The objective here is not on some simple level to reconcile Spinoza
and Levinas but to suggest that something is to be gained from imagin-
ing, across the imperatives that separate them, a capacity for intrigue
that their convergence makes possible.

"But," asks Goffey, "can we say that Spinozist nature marks the
death of others?" For him the answer is affirmative only to the extent
that "we forget that Spinozist substance doesn't ground [a subject],"
that its "substance is quantity, and as it is not quantity in the sense of
the extensive magnitudes dealt with by geometry, it must be an inten-
sive quantity—a continuum of intensities. *This* experience forces
thought by virtue of its unannullable intensity."[33] We might open a
field of possibility by imagining this unannullable intensity together
with Levinas's existence that "can go beyond being" (*Totality and
Infinity,* 301). Notwithstanding Levinas's objections to the "Spinoz-
ist tradition" (301–2), its status as intrigue is itself an intensive prop-
erty of sociality.[34] And, conversely, perhaps any thought forced by the
experience of an unannullable intensity must be embedded in a con-
vex (judgmental) or a concave (participatory) spatiality—modes of
the spatialized ethics of the interhuman intrigue.

At the close of *Totality and Infinity,* Levinas deploys precisely
these terms, *convex* and *concave,* to reflect upon the mechanics
by which the I identifies itself as the "same," on the basis of which
the encounter with alterity becomes possible. This unfolds as the I
beholds the "logical sphere" that is exposed to its gaze and, by means
of this gaze, organizes this sphere into a totality. There is then, accord-
ing to Levinas, a movement of reversion—a "reversion, so to speak,
of convexity into concavity"—a kind of buckling in the "curvature

of [intersubjective] space," by means of which this logical sphere is inflected. This inflection produces the singularity of the I, its "ipseity" (289, 291).[35]

What seems like an odd and abrupt move into this quasi-geometric discourse at the conclusion of *Totality and Infinity* accomplishes an important metaphorical illustration of a central dynamic in Levinas's philosophy. By means of the convex–concave reversion, he demonstrates that ipseity "does not consist in [the identity of the individual] being like to itself, and in letting itself be identified *from the outside* by the finger that points to it; it consists in being the *same*—in being oneself, identifying oneself from within" (289).

This buckling is crucial, as it both crafts the interiority, without which the encounter with exteriority means nothing, and also elucidates the materiality of intersubjective space—that continuum in which the I is able to recognize itself as the other's other and thus able to inaugurate a properly ethical sociality: "The social relation, the idea of infinity, the presence in a container of a content exceeding its capacity, was described in this book as the logical plot of being." Levinas goes so far as to suggest that "the entire analysis of interiority pursued in this work describes the conditions of this reversion" (289).

His designation of the intersubjective space as curvature suggests that, rather than imagine sight to be fundamental to the intersubjective encounter, we see that the encounter with alterity itself is in fact what frames and substantiates the phenomenon of sight and the acts of looking and seeing:

> That the Other is placed higher than me would be a pure and simple error if the welcome I make him consisted in "perceiving" a nature. Sociology, psychology, physiology are thus deaf to exteriority. Man as Other comes to us from the outside, a separated—or holy—face. His exteriority, that is, his appeal to me, is his truth. . . . This surplus of truth over being and over its idea, which we suggest by the metaphor of the "curvature of intersubjective space" is, perhaps, the very presence of God. (291)

Here again we find Levinas thinking sociality in prophetic terms, making "way for the wisdom of heaven to return to earth." To ask Iriga-

18

ray's question above in different terms, we might wonder whether—if Levinas can suggest, "The face to face is a final and irreducible relation which no concept could cover without the thinker who thinks that concept finding himself forthwith before a new interlocutor; it makes possible the pluralism of society" (291)—there is ultimately any need for a God in the interhuman intrigue. Or to put it differently, perhaps the essential variability of Levinas's *Autre* and *autre*, *Autrui* and *autrui*, permits us to consider his writing, much like painting, as a *moral* space where God is sought but not always found and where, even within the terms of Levinas's philosophy, it would matter little if he were.

In his *Existence and Existents*, Levinas suggests that the work of art can also serve as a site of alterity; it can derail intentionality, cause it to get "lost in sensation itself, and it is this wandering about in sensation . . . that produces the aesthetic effect." The work of art lends "the character of *alterity* to the objects represented which are nonetheless part of our world."[36]

What would it mean to literalize this expression, "the character of *alterity*," to treat alterity as though it could perform the role of a dispersonified character in a fiction—not unlike the "Mysterious Companion" that Bronstein's Philippe meets in the thrall of the aesthetic: "Whenever I am in the presence of a great—I mean, real or moving—painting, I am also in the presence of another presence in me and in the painting. I call this presence the 'Mysterious Companion'" (*Fragments of Life*, 18)?

In book V of Bronstein's *Fragments of Life*, we find ourselves faced with an incarnation of the Mysterious Companion, but this time not in the realm of the work of art. Yet this companion gives the character of alterity an intonation of precisely the "inhuman and monstrous" dimension that Levinas discovered in aesthetic experience. The companion appears, is exposed, in a short letter addressed to a Mrs. Paul Berg. It reads, "The Secretary of the Army deeply regrets to inform you of the death of your husband on September 24, near Bologna. Further details will follow" (75).

This is the only section of Bronstein's book that has the audacity to be no more than one page long. These two numbing sentences constitute a doubled death sentence for Berg's widow. The first makes her husband's death official, thus officially kills him with the banal-

ity of military efficiency: an interminable intelligibility. The second sentence puts to death that part of her that was his—to the extent that she shared it with him—implicitly registering its death. "Further details will follow": Which ones? What good could they serve now? But of course for this reason she needs them all the more; "near Bologna": How near? In a town that has a name, a place that she might visit, refuse ever to visit, whose name she might curse? In a nameless zone between fronts? Is it conceivable that the military would not have known the precise location of his death when it sent this first letter? How could they know enough to say "near Bologna" and not enough to say just where, precisely? And if they knew too little to say just where, with certainty, then why bother with the effort at specificity in the first place? Why not simply inform her of the death of her husband? She cannot do other than wander in this fog, produced by the conjunction of the inhuman and the all-too-human, an affective and intellectual atopia that hovers between the cold facts stated in the letter and their promise of greater certainty to come. What more consequential certainty is there than the one already delivered?

This soldier's widow does not exist as a character in Bronstein's book except as the imagined interiority that remains in the wake of the letter's delivery of its two-sentence death sentence. It is not enough to say that the reader (at turns we and Mrs. Berg) or the author (again, at turns, the military clerk and Bronstein) imagines this interiority and makes it present by means of writing or reading. Mrs. Berg is posed by the writing's encounter with her. This writing poses her, conjures her in all of her realness, as an interlocutor. It does this just as the letter itself would do in the world outside the book—a world that, if this character is real enough to exist as the imagined and traumatized reader that she must be in order for Bronstein's letter to do its work, is and must be inseparable from the book.[37] The delivery of this letter to the home of a woman whom it will have just made a widow also exposes her in a way that is at once faceless—sender and recipient will never meet each other—and utterly intimate. What could be more intimate than to share with her, to force upon her in a way that cannot do anything but affirm her desire at once to know more and not to know at all, the secret of her loved one's death?

Who has not reread a thousand times the letter that delivers horrifying news in the hope that we may have read it wrong or indeed

that, even though we know we have read it correctly, we might nevertheless find something in the space between the words that will permit a different reading, a different conclusion, a seam or a break in the "inhuman interval"?

Space (the space in art that is a *moral* space) operates as *"the fragment in which the unseizable whole of life, material and moral, is transubstantiated or seized."* The interval, on the other hand (that "eternal duration of the interval in which a statue is immobilized . . . is the meanwhile, never finished, still enduring—something inhuman and monstrous") does not permit us to seize or transubstantiate the whole of life but rather *faces us with it,* makes it intelligible, even in its inhuman presence, as part of the interhuman intrigue. It is vast, whole, and convex with respect to us. We stand as an empty interior, exposed, evacuated, eviscerated by it: "The Secretary of the Army deeply regrets to inform you of the death of your husband on September 24, near Bologna. Further details will follow."

---

In a sense that is what I wish for us in Visual Culture, that we become a field of complex and growing entanglements that can never be translated back to originary or constitutive components. That we produce new subjects in the world out of that entanglement and that we have the wisdom and courage to argue for their legitimacy while avoiding the temptation to translate them, or apply them or separate them.

—IRIT ROGOFF, "What Is a Theorist?"

---

Hardt and Negri describe the multitude as "composed potentially of all the diverse figures of social production," including "the production of material goods [as well as] the production of communications, relationships, and forms of life." They argue that the Internet is a useful model for describing the dynamism of this assemblage:

> Once again, a distributed network such as the Internet is a
> good initial image or model for the multitude because, first,
> the various nodes remain different but are all connected in
> the Web, and, second, the external boundaries of the net-

work are open such that new nodes and new relationships can always be added.[38]

But what if the global networks that are commonly invoked to speak about flows of people, ideas, capital, and commodities were thought as a mass whose organization is not reducible to the regularity of the grid or the mesh, and has properties such that, like felt, the more it is pulled, tweaked, torn, and agitated, the more structural integrity it would have? What if, in the materiality of felt, we could find an important provocation: the possibility that, just as all spiral strands in a swath of felt cohere without necessarily connecting, even the most ostensibly connective meshworks might well have nodes that will never touch, that will maintain a tense and tensile proximity without ever connecting? Even the most sophisticated analyses of the dynamics of networks and the cultures sustained by them maintain a belief in the prospect of all touching all, each potentially connecting with any; would the materiality of felt permit us to probe with greater clarity the inescapably intimate cohesion that binds us if it could help us to see the possibility of sharing intimate space without this effecting or entailing any connection among the diverse figures whose interaction produces that space?[39]

The words *text* and *textile* share the same etymological root, the Latin verb *texere,* meaning "to weave." Felt has a different composition altogether. It is a nonwoven fabric, a body without axes, created through the multiple, random interlockings of spiral strands. The material owes its structural integrity to the chance bindings among its irregular spiral fibers. Felt is arrived at through the leaving-to-chance—even if it is a methodical and meticulous leaving-to-chance—of the combination of the spiral fibers, textures, and interstices of wool.

Rereading *Multitude*'s opening with this in mind, we find that Hardt and Negri's discussion of the production of a new common depends upon a play of forces that are not likened to the lines of the web or the strands of the net but to the spirals that constitute felt:

Our communication, collaboration, and cooperation are not only based on the common, but they in turn produce the common in an *expanding spiral relationship*. This produc-

tion of the common tends today to be central to every form of social production, no matter how locally circumscribed, and it is, in fact, the primary characteristic of the new dominant forms of labor today.[40]

Could felt's materiality provide the tools for staging a dialogue between, on the one hand, the political stakes raised by *Empire* and *Multitude* and, on the other, what Emmanuel Levinas speaks of as the great "unthought" dimension of Western philosophy, namely, the "search for the human or interhuman intrigue as the *fabric* of ultimate intelligibility"?[41]

Hayden White has argued, "All systems of knowledge begin . . . in a *metaphorical* characterization of something presumed to be unknown in terms of something presumed to be known, or at least familiar."[42] We regularly find fabrics enlisted as metaphors for processes of integration, organization, cohesion—on a micro- and a macroscale. The weave operates as the default formation for any fabric enlisted as a trope for organizing discourse; does the figure of a nonwoven material like felt displace the grammar of our terminologies enough to open up new territories for thinking a multitude formally, to render it as the fabric of an interhuman intrigue?

In his discussion of the pitfalls of the concept of positionality that came to be so central to the thinking of identity in late twentieth-century cultural theory, Brian Massumi notes, "The positional grid was abstract, despite the fact that it was meant to bring cultural theory back down to the local level, since it involved an overarching definitional grid whose determinations preexisted the bodies they constructed or to which they applied."[43] What is true for the positional body in Massumi's investigation is of course also true with respect to the textile: the same abstract grid underwrites any and all of their particular material emplacements or manifestations. There is, by contrast, no overarching definitional structure for felt, at least not in the sense that one can predict the particular configuration that a bit of felt will take on, not in the sense that one can forecast where certain strands will connect, or fail to connect, with others. Felt comes into existence, comes to matter, as a result of an unpredictable interaction of tendencies (of the fibers, of the manner and the conditions in which they are worked).

## GROPING IN THE DARK

"It is conceded as an axiom that theory and practice, in the pursuit of any object, are in their natures essentially different and distinct. But at the same time they long for a mutual understanding each to conform to the assertions of the other, the consummation of all practical results being the mutual embrace and perfect reconciliation of these two attributes."[44] So begins the 1868 *A Treastise on Hat-Making and Felting, Including a Full Exposition of the Singular Properties of Fur, Wool and Hair,* written anonymously by someone referring to himself or herself simply as "A Practical Hatter." It begins with a series of ruminations that speculate on the relationships between theory and practice in ways that are strangely familiar to us. The Practical Hatter's objective in writing this treatise was "to describe intelligibly his [any felter's] calling, dispensing with all technical terms," which she (assuming the author was a woman) imagined would draw flak from his fellow felters because of their "prejudices engendered by the many would-be secrets that pertain to the different workshops, together with their various modes and methods of working, all of which most generally are but trifles merely to gain a name."[45]

She went on to insist, "Theory without practice, or practice without theory, is like groping in the dark, and perfection in no trade can be attained till every effect can be traced to its cause, and *vice versa.*"[46] She operationalized this coupling in an attempt to save the felting process "from its misty obscurity by a faithful expose of the whole system: well knowing that an increase of business, like free trade, [would] be the result of a right understanding of a formerly supposed mystery, [i.e.,] the True cause of Felting." Whether or not this anonymity was a conceit designed to effect even more publicity, it underlines the fact that, as late as the end of the nineteenth century, feltmaking was considered an insider's art, enough of a trade secret that the insider who shared that secret would place herself at some professional risk.

It was not until the turn of the twentieth century that the process by which wool becomes felt was fully understood. Only a few years ahead of the 1868 *Treatise on Hat-Making and Felting,* Tomlinson's 1854 *Encyclopedia of Useful Arts and Manufactures* noted that pressed felt is one of the oldest forms of nonwoven fabric and

that, while the woolen fibers "become stably intermeshed by a combination of mechanical work, chemical action, moisture and heat," the actual reason why felting occurs was unknown: the *Encyclopedia* speculated that it has to do with existing tension in the wool or with the unique jagged shape of its surfaces.

It was the French scientist and mathematician Gaspard Monge (1746–1818) who first described the ability of wool fibers, grouped in a mass, to felt—an ability attributed to the way in which the scales that make up their surface creep in a tip-to-root direction when pressure is exerted on them. The scales "overlap from the root of the sheep's wool fibre up to the tip," and when you introduce moisture into the mix, "the scales open up. Then when you rub it, roll it, pound it or tread it, the scales interlock and close up tighter than ever."[47] Combining the rigidity of the fiber's scales, its elasticity, and the differences in its natural curling depending upon the breed, age, and diet of the shorn animal, each strand is a mixture of two different tensile and textural properties. Composed mainly of the protein keratin, a strand is made up of two longitudinal bundles. One is hard and stiff, the other soft and supple, and because each bundle twists on its own axis inside the fiber, the hair is not simply curled but slightly spiraled as well, which gives the strand its distinctive crimp.[48] Microscopic investigations have revealed that the keratin molecules themselves spiral on their own axes as well as with one another, which means that a strand of wool consists of several tiers of coiled helices. Cross-links between these molecules keep them folded and intact when they are pulled and stretched. The repeated exertions of firm pressure, heat, and moisture during the preparation process make the grouping of strands more and more tangled, and the eventual result is a layer of felt.[49]

The process by which wool felts is still sometimes cast as a mystery. In historian Suzanne Pufpaff's twentieth-century update to the volume that includes the Practical Hatter's 1868 treatise, she writes, "No one completely understands why animal fibres make felt even in this age of modern research and technology." According to her, the only consensus is: "Animal fibres felt and plant fibres do not. . . . The fibres must be agitated in some manner. . . . [And ] some moisture is required to make the process work. Beyond those three statements, our knowledge of what makes felt has not changed much in the last one hundred years."[50]

Commercial production of felt made strictly from wool, a process that was first effectively mechanized during the Industrial Revolution, began to decline around the mid-twentieth century. In our own time, the manufacture of felt is a growth industry; manufacturers today have developed a vast product line, and the section of the "textile" industry that deals in nonwovens is now a multi-billion-dollar industry.[51] A variety of animal fibers can be used in making felt, but sheep's wool is the most common choice because of its superior felting properties. Industrial felts often combine nonfelting fibers with animal fibers to produce felt hybrids; these constitute the majority of felts produced today.[52]

We find references to the usage of wool in the Old Testament, in Herodotus and Homer, and in Greek vase painting. Historian Agnes Geijer suggests, "The oldest civilizations of the ancient world may be termed 'woolen' cultures."[53] Humans are presumed to have learned felting well before the appearance of spinning, weaving, or knitting (during the Bronze Age), and after dogs, sheep were likely the second species of domesticated animal—able to provide meat, milk, and fleece.[54] Historian J. Kay Donald suggests, "Feltmaking could go back almost to the dawn of consciousness, and would be part of man's earliest technology."[55] She refers to one account of felt's origins that "attributes its discovery to the early practice of wearing animal skins with the wool or fur closest to the body for warmth. Continual warmth, sweat and wear would have caused the inner layer eventually to felt." In the King James Version of the Old Testament, in Genesis 3:21, we find that God clothes Adam and Eve in animal hides as they leave Eden: "Unto Adam and to his wife did the LORD God make coats of skins, and clothed them."[56]

Donald notes that Joseph's "coat of many colours" was perhaps made of felt, and then she refers to another felt legend: "Noah laid down fleece to make a soft resting place for the animals in the ark. Warmth, trampling and urine would certainly have done the rest, and the story claims that by the journey's end the floor covering had become the world's first felt rug."[57] The menu of felt's biblical originary myths continues with a story of Abel, the son of Adam and first shepherd, who was supposed to have had the idea that the fleece from his sheep would make a similarly fine coat for humans if he could devise a way to make the wool stick together. "He cut some

and tried various ways without success. Finally he grew angry and jumped up and down on the offending fleece, thus achieving his objective." All of the narratives of the origins of felt "attribute [its] origin . . . to happy accident rather than conscious intent."[58] From France comes the story of St. Feutre of Caen, patron saint of feltmakers, said to have discovered felt as a result of wearing fleece as padding in his sandals; many European countries tell tales of saints or wandering ascetics who "discovered" felt in a similar manner. Early Christian accounts put two different saints, St. Clement, the patron saint of hatters, and St. Christopher, the patron saint of travelers, both on the run from various oppressors at different times. The saints paused in their flight to grab bits of fleece that had got hung up on the hedges and used them to line their sandals and soothe their aching feet. The heat and sweat of their feet, coupled with the consistent pressure and agitation, conspired to produce a pair of felt socks by the end of their journey.[59]

McGavock and Lewis note, "The spiral, the main single motif employed in felt decorations, is in fact so closely related to the actual scientific process through which each single hair passes in becoming, along with the other hairs, felt."[60] Textile historian M. E. Burkett explains:

In almost every prehistoric culture the spiral as a single structure appeared as a decorative motif. Its frequent occurrence on stone images, rocks, pottery and even upon the body extended from certain tribes of Australian aborigines, to Central America, the steppe lands of Central Asia and to the British Isles. Double spirals were carved by Megalithic man. This latter is the most familiar as the Yin Yang of the Far East. That man was at an early stage preoccupied with the spiral order and his own spiral development is obvious from the labyrinth of the nineteenth century BCE in Egypt, Minoan Crete and Paleolithic rock engraving.[61]

The spiral, seen in all manner of seashells, plants, and other natural formations and in the "spiral processes of wind, water, cloud and many other natural forces," has for tens of thousands of years "ordered man's wanderings both before and after death in time and space."[62]

Throughout felt's history is an intriguing inability to separate the ornamentation of the material from its structure; ornament, "especially when the pattern covered the entirety of the fabric, actually helped to hold the felt together. This was particularly important when more hairy and less easily feltable wool was the only kind available." These patterns were frequently derived from curved shapes and spirals. "Simple animal forms, mythical beasts, and signs to ward off evil were common, and also used curved forms. Curves of stitchery or quilting on the finished piece strengthened it, where straight lines might have caused the felt to split."[63]

Felt makes a quick appearance in Gilles Deleuze and Félix Guattari's *A Thousand Plateaus,* in the chapter "[1440] The Smooth and the Striated," where it exemplifies "smooth space," in contrast to the "striated space" exemplified by woven fabric. The smooth space of felt is the "anti-fabric," and

> implies no separation of threads, no intertwining, only an entanglement of fibers obtained by fulling. . . . An aggregation of this kind is in no way *homogeneous:* it is nevertheless smooth, and contrasts point by point with the space of fabric (it is in principle infinite, open, and unlimited in every direction; it has neither top nor bottom nor center; it does not assign fixed and mobile elements but rather distributes a continuous variation).[64]

Interestingly, in chapter "1227: The War Machine: A Treatise on Nomadology" of *A Thousand Plateaus,* though Deleuze and Guattari engage with the figure of Gaspard Monge, they do not mention that it was he who discovered precisely why and how felting happens—a wonderfully accidental anti-connection. Monge serves, in much the same way as do the thirteenth-century Mongols in their essay, as a segment of historical material reactivated and mobilized as powerful historical fiction;[65] he exemplifies the figure of the scientist caught in the interplay that Deleuze and Guattari stage between nomad science and its capture and appropriation by the state. It is this shifting opposition that they are concerned to engage: "This tension-limit between two kinds of science—nomad, war machine science and royal, State science—reappears at different moments, on different levels" (*A

*Thousand Plateaus,* 363). A history of experimental inquiry and its capture. Moments such as the event of Monge's thought take shape as decisive pressure points between the opposing tendencies: "Most significant are perhaps borderline phenomena in which nomad science exerts pressure on State science, and, conversely, State science appropriates and transforms the elements of nomad science. This is true . . . of descriptive and projective geometry, which royal science would like to turn into a mere practical dependency of analytic, or so-called higher, geometry (thus the ambiguous situation of Monge and Poncelet as 'savants')" (362–63).

Monge's storied career began with his teaching physics at Collège de la Trinité, in Lyons, at the age of seventeen and moved through a range of scientific and administrative pursuits and political affiliations. During the French Revolution the faithful Republican became minister of the navy. Later, as a friend of Napoleon, he accompanied the emperor's expedition to Egypt, where he was named president of Cairo's new Institut d'Égypte in August 1798 and where he completed his *application de l'analyse à la géométrie.*[66] After Napoleon's return from Elba to Paris, Monge carried on visiting him, but after Napoleon was shipped off to St. Helena, Monge came to fear for his life and fled Paris in October 1815. He came back in March 1816, in poor health and as a political pariah. He was booted from the Institut de France two days after his return. Jorland writes, "If Napoleon actually said that Monge loved him like a mistress, it proves that the utmost mathematical clarity can go hand in hand with political blindness."[67] "With Monge," Deleuze and Guattari write, "the limits of sensible, or even spatial, representation (striated space) are indeed surpassed, but less in the direction of a symbolic power (*puissance*) of abstraction than toward a transspatial imagination, or a transintuition (continuity)" (*A Thousand Plateaus,* 554 n. 23).[68]

Monge regarded reality as a "moving geometrical spectacle." For him, analysis was something other than a specialized language for describing that spectacle; analysis was, instead, its "script." Scripted analysis is also inescapably poetic, in that it creates or catalyzes the enactment of the forces and forms it describes, but as script, it builds into itself the possibility that the action it designates, "the moving geometrical spectacle that constitutes reality," can become improvisatory in its movements. Whereas the diagram's success is predicated

30

on the expectation that the phenomena it diagrams will act in accordance with it, the script has instead to work more dramaturgically with phenomena. The script may expect the geometrical spectacle that constitutes the real to depart from it, and yet it will nevertheless embed the script-in-progress within itself as it moves. This notion is written into Deleuze and Guattari's conception of the equation, a formulation specific to nomad science, a generative and not simply representative or de-scriptive: "One does not represent, one engenders and traverses. This science is characterized less by the absence of equations than by the very different role they play: instead of being good forms absolutely that organize matter, they are 'generated' as 'forces of thrust' (poussées) by the material" (364).

Felt is a material that takes its especial cohesion from its chaotic constitution, and perhaps more important it is a material enactment and embodiment of elements, tendencies, and forces that cohere most effectively because of, and not despite, the fact that not all strands have the capacity to connect with any or all others. Cohesion occurs without the necessity of ubiquitous connection, because, unlike the network, each strand cannot, even in principle, connect with all others. There is intimate space without each connecting with all, intimacy that exists because of, and not despite, the inability of each genuinely to connect with every other. In this very basic sense, the "feltwork" provides a much more effective and accurate scripting of the event of the interhuman intrigue—itself a moving spectacle that constitutes the production of social space.

"Of course," Deleuze and Guattari argue, "smooth spaces are not in themselves liberatory. But the struggle is changed or displaced in them, and life reconstitutes its stakes, confronts new obstacles, invents new paces, switches adversaries. Never believe that a smooth space will suffice to save us" (A Thousand Plateaus, 500). Our access to felt as a metaphor, one that helps both to theorize and to engender the sorts of "entanglement" that Irit Rogoff describes as constitutive of the space of contemporary cultural encounters, will not conjure away the difficulties inherent in living through the interhuman intrigue that this metaphor may help to model, the complexities and impossibilities that are a part of a world that is composed of such intrigues and their outcomes.

## HAPTIC OR NOT

Deleuze and Guattari do begin to touch in a quasi-ethnographic manner upon the central role that felt played in the Mongol "war machine," but the significance of felt for the Mongols themselves is not explored in any depth in *A Thousand Plateaus,* which is both packed full of historical references and utterly unconcerned with the niceties of "state" historiography. Many, including anthropologist James Clifford, have found this ahistoricizing style to be especially problematic when it comes to Deleuze and Guattari's discussions of the Mongols. He has wondered aloud whether the nomadology that became so popular in the wake of their work might be "a form of postmodern primitivism?"[69]

For all the Central Asian (Turko-)Mongolian tribes that Chingis Khan unified, he gave the collective name "the generations that live in felt tents," and for centuries the Chinese had identified the Mongols with this material. One such identification from the fourth century BCE described the expanse of territory in which the Asiatic nomads made their homes as "the land of felt." Pursuing this connection between felt and nomadology a bit further, we might note the closeness between the word *nomad* and the Hungarian, Iranian, Georgian, and Khotanese words for felt: *nemez, nemed, nabadi,* and *namadi,* respectively.

In his introduction to *A Thousand Years of Nonlinear History,* Manuel DeLanda characterizes the "nomads of the Steppes (Huns, Mongols)" as instantiations of elemental forces, "almost as if they had condensed not into a pool of liquid but into a moving, at times turbulent (like the sacking of Kiev, perhaps), fluid." DeLanda's requirement that human history be able to be rendered in the language of nonlinearity leads to some theatrical visions of this history; these are perplexing not so much because they confound or reject "proper" historiography but because they skirt the theoretical significance of the actual historical practices and processes that his staging disregards. Of the rise of the Mongol Empire, for instance, he writes: "When these nomads did acquire a solid state (during the reign of Genghis Khan, for instance), the resulting structure was more like glass than crystal, more amorphous and less centralized."[70]

And yet it was the Mongols' profoundly centralized, structured, "crystalline" command and governance apparatus that saved Europe from being the westernmost territory under the "Mongol yoke." The Thirteenth Ecumenical Council was convened by Pope Innocent IV in June 1245. Rome had been surrounded by soldiers of the Holy Roman Empire and Innocent had fled with his court to Lyons under the protective aegis of King Louis. Among the most urgent points on Innocent's agenda was "to seek a remedy against the Tartars."[71] The Mongols had sacked Moscow in 1238, and Kiev, the headquarters of the Orthodox Church, in 1240. In April 1241 a combined army of Poles and Germans were wiped out by the Mongols in Silesia. By December of that year, having reduced Pest to rubble and decimated the last army capable of posing any threat to them as far as England, they had pushed to just a few miles shy of Vienna.[72] The previous pope, Gregory IX—who had long ignored pleas for help from eastern Europe, believing that the invasions were the work of divine grace sent to punish the Eastern churches so that they would realize their errors and return to the Catholic flock—and other European rulers knew it was only a matter of time before they would be attacked.

What saved them was neither ingenious strategy nor brilliant tactics but that inversion of divine intervention known as dumb luck. The death of the Great Khan Ögödei required the leaders of the army to make the months-long trip back to the Mongol capital, Karakorum, for the succession of power.[73] The Mongol army postponed their reconnaissance mission (exploratory invasion) of Europe, and never again did they push farther west than Russia's Golden Horde under Batu Khan. But in their absence, their unexpected arrival and its horrific heraldings left their mark upon the feuding Christian rulers of Europe. The newly elected pope Innocent IV called upon the Italian Franciscan friar John of Plano Carpini to undertake the papacy's first ambassadorship, to travel into the unknown, across the steppes to the Mongol court. On Easter Sunday in 1245 Friar John left Lyons, along with Friar Stephen of Bohemia (who did not complete the grueling trip), and was later joined by another Franciscan, Benedict the Pole of Silesia, for what would be a year's journey to Karakorum. They were armed with letters from the pope intended for the newly enthroned Güyük Khan, which explained the finer points of the Christian faith and enjoined the khan to embrace them and the

true Church. These were an important component but only a corollary of the mission's actual aims, which were to "discover the extent of the Mongols' power, to observe the methods of their army" (*The Devil's Horsemen,* 116).

In addition to being the first of several of European emissaries, it was Carpini who became the first European ethnographer of Mongol culture. He noted that they used felt to make idols in the image of humans and put them at either side of the door of their tent. Above this, they placed felt in the shape of teats, which they believed to guard their flocks and to ensure the provision of milk and colts. "Whenever they began to eat or drink they first offer these idols a portion of their food or drink."[74] The ethnographic tradition was duly carried on by a later Christian emissary, William of Rubruck, who devoted much space in his accounts of his eight months in Karakorum to detailing Mongol culture. In chapter 25 of *Papal Envoys to the Great Khans,* titled "Of Their Temples and Idols and How They Comport Themselves in the Worship of Their Gods," he explained, "Mongols or Tartars belong to [the Uigur priests'] sect as far as their believing in only one God is concerned. . . . They do, nevertheless, make out of felt images of their dead and they clothe these in the most precious materials and place them in one or two carts; these carts nobody dares touch and they are in charge of their diviners who are their priests."[75] The Mongols used black felt inside tents to ward off evil, and they seated brides (and also sacrificed animals) on white felt. Red and blue felts were used as well, for funerals and mourning. Felt coats were a mark of status and were given as gifts on state occasions.[76] William of Rubruck described the use of felt figures to create protector doubles for the man and woman of the house and described the practice of making well-dressed images of the dead out of felt and putting them in the death carts.[77] Further, Carpini wrote, when one of the Mongols became severely ill, a spear was placed outside his or her tent and wrapped with black felt, and no strangers could come into the dwelling.[78]

However much thirteenth-century Europe was shaken by "the disastrous menace of Genghis Khan and his Mongolian hordes," the effects of the reorganization of trade that it permitted more than compensated for putting the holy fear back in Christendom. Italian merchants now controlled the Levantine trade, for which the Mongols had

been directly responsible. The Mongol expansion catalyzed a flood of products and materials (particularly textiles and spices), technologies (from eyeglasses to gunpowder), and art from throughout Asia. "This is reflected by the many silk fabrics of East Asian origin mentioned in the written sources (church inventories) though less frequently preserved, and above all by the new style, inspired by Chinese motifs, which came to revolutionize the Italian silk industry during the fourteenth century."[79] When Chingis Khan's generals Subedei and Jochi, the khan's son, were leading the Mongols' first European reconnaissance, they met their first western Europeans, who happened to be Venetian merchants. The Mongols and the Venetians became fast friends, immediately aware of the future value of their partnership. From then on, in exchange for the Venetians supplying concise and detailed reports of the economic and military strength of all of the countries that the merchants visited and spreading whatever propaganda the Mongols required in those countries, the Mongols agreed that wherever the wind took them they would destroy all trading stations they encountered except for those of the Venetians, enabling them to have a series of lucrative monopolies. Their first act of goodwill was to destroy a Genovese station on the Crimea. Those "lucky" enough to escape fled to Italy and gave to Europe its first report of these "merciless horsemen" (*The Devil's Horsemen*, 24–25).

Eurasian trade routes that had long been closed were reopened by the Mongols. Geijer notes, "The papal inventory of 1295 tells us that large quantities of 'Tartar' fabrics, meaning Iranian as well as Chinese products, were accumulated in the papal stores." Another result of actions taken by the Mongol Empire, "which still included southern Russia in the early fifteenth century, was the transfer of Chinese craftsmen to its western territories. Silk manufacturing enterprises were developed in which Chinese motifs and techniques mingled with alien themes, especially Mohammedan characters, such as fabrics with colourful stripes embellished with Cufic letters." Although it seems that the European importation of Chinese silks all but ceased after the middle of the fourteenth century, the century or so of westerly flow of Chinese textile designs and techniques, facilitated by the Mongol Empire, makes it difficult even now "to determine in particular cases whether a fabric was made in China or further west."[80]

During Chingis Khan's reign, his defeat of the Chinese to Tibet's northeast persuaded the Tibetans to submit to him and pay tribute. After his death in 1227, the payments stopped. In 1240, his grandson Godan mobilized thirty thousand soldiers and invaded Tibet. Four years later he made the Tibetan lama Sakya Pandita an offer he couldn't refuse, inviting him to come and act as his people's moral and spiritual leader in Godan's court. Sakya Pandita, along with his nephew Phagpa, set out for the court, arriving in 1247. So impressed was Godan with Sakya Pandita that the khan gave him

temporal authority over the whole of Central Tibet. As Godan modified some of his more ruthless policies in accord with the precepts of Buddhism, so Sakya Pandita instructed his fellow countrymen not to resist the Mongols but to pay them regular tributes. This was the first time in the history of Buddhism that a monk was conferred with political power, and the beginning of the Buddhocratic government of Tibet, which was to last, with interruptions, until 1959.[81]

## WAR MACHINES

Even though his armies were almost without exception outnumbered by the foes they faced, "Chingis Khan knew how to gain his objectives with the minimum amount of force. Relying on a vigilant intelligence network, he advanced his armies on a wide front, controlling them with a highly developed system of communication and using their supreme mobility to concentrate them at the decisive points" (*The Devil's Horsemen*, 43).

In the modern era strategists differed on war's fundamentals; Jomini believed that dominating the geography of the enemy was paramount, and Clausewitz, his theoretical adversary, believed that crushing the troops themselves was of primary importance. This differentiation quite ingeniously did not register for the Mongols, for whom these concerns were inseparable. Their success had to do with evolving a sophisticated operational practice long before it was conceived as such; their coordination "was faultless, but the timing of

the decisive engagements was astonishing. It can not be dismissed as coincidence, and since the uncertainty of the enemy positions would have made pre-planning impossible, the only explanation seems to be the speed of the Mongol messengers and in particular the efficiency of their signalling system" (*The Devil's Horsemen*, 101).

The "nomad war machine" figures prominently in Manuel DeLanda's categorization of war in human history into a schematic diagram separating two distinct modes of waging war and their respective logistical procedures for organizing forces. The first, for him, is the war machine assembled by the nomads of the steppes, by which he means the armies of Chingis Khan, which invaded Europe in the thirteenth century. The second is the war-making machinery of sedentary people (Assyrians, Greeks, Romans), from which modern armies evolved. He characterizes the tactics of nomads as consisting of the combination of psychological shock and physical speed. "They were the first to integrate the swift and sudden movements of loose cavalry formations with the deadly effects of intense missile power. The nomads combined the skills of highly mobile archers and horsemen with a flexible tactical doctrine that utilized every feature of the battleground for ambush and surprise."[82]

But speed and mobility offer little advantage to an army without the means to coordinate them. In this respect DeLanda skips over what is perhaps the most important factor in the Mongol army's blistering successes against the foes they encountered, namely, its sophisticated—and, by comparison to its enemies' operational practices, imperceptible and instantaneous—communication system for coordinating its activities. Using different kinds of arrows, banners, and messenger relays, it could maintain a front of hundreds of miles and concentrate its power at the right points at the right times to deadly effect. The Mongol's methods demonstrated an ability to virtually eliminate the uncertainties that constitute what modern military brass refers to as "the fog of war."

In *The Framework of Operational Warfare*, Clayton R. Newell discusses the emergence of the term *operational art* in American military discourse. The revised edition of "Field Manual (FM) 100-5," published in 1986, introduced the term, defining it as "the employment of military forces to attain strategic goals in a theater of war or

theater of operations through the design, organization, and conduct of campaigns and major operations." While the terms *strategy* and *tactics* are often taken outside the military to encapsulate the entirety of war's conduct, as Newell explains, "they alone are not adequate to explain many of war's activities." And "while [the term] operational art may be new to many students of war, the concept of operational art is not."[83]

Newell quotes Sun Tzu's claim that to subdue the enemy without fighting is the acme of skill (92). Military deception takes the form first of a kind of posturing: it must be apparent to both sides that both forces are actually willing to engage in combat. A product of the language of deterrence, Newell's treatise is concerned with the plausibility of the *threat* of strike, counterstrike, or that most perverse and ingenious invention, the preemptive counterstrike. A product also of the age of deterrence, the operational sphere is a necessary response to the logistical complexities faced by the modern military. The operational is concerned with the *mediation* between strategic objectives and their tactical application, both of which demand imagination as well as calculation; operations must be at once art and science (28). As Newell explains, both are necessary in the actuality of war. Even if there were not an enemy to contend with,

> the employment of a modern military force with its vast array of complex weapons and equipment is difficult at best. The addition of an enemy who wants to disrupt that already complex employment of military forces makes the difficult become next to impossible without detailed plans to provide at least a starting point for tactical commanders, since virtually no plan survives its first contact with the enemy in the chaos of war. (93)

The Five-Paragraph Format, a standardized method for communicating strategic objectives to tactical commanders and reporting tactical results to strategists, provides such an example of a contribution made by the domain of the "operational arts." Another is the campaign plan, a kind of logistical road map developed from the operational perspective that outlines how forces may achieve neces-

sary tactical objectives that would lead to the fulfillment of a larger strategic objective. As Newell notes, such technologies are invaluable to military commanders in helping them to

> deal with the fog of war. Although the planning process is important, it is the fog of war, featuring incomplete intelligence on the enemy and imperfect information on friendly forces, which dictates that commanders have the flexibility and capability to change plans even in the midst of the chaos of war. . . . In fact, good military planning from any of the three perspectives of war must include plans to change plans. . . . [Leaders] must also constantly evaluate whether the desired ends must change as the available means fluctuate according to the course of the conduct of war. Military leaders and commanders must provide clear guidance in the concept of the operation so that subordinates will be able to carry on in the fog of war. (93–94)

Voicing the need to endure chaos without succumbing to it, Newell's study repackages one of the fundamental concerns of Sun Tzu, for whom this clarity amid chaos is the key to victory and for whom exhaustive knowledge—and, critically, the imagination necessary to operationalize it as inspired military leadership in the face of the unique demands of each particular battlefield situation—is central.

In his consideration of postmodern warfare in *War in the Age of Intelligent Machines,* Manuel DeLanda reiterates this point, locating Sun Tzu as its origin:

> The activity of gathering military intelligence about an enemy's geographical location, hostile intentions and destructive potential has always been an essential component of warfare. And so have been the activities involved in preventing an enemy from obtaining knowledge about one's own forces, as well as those involved in misleading him by supplying deliberately false information. The oldest known treatise on the art of war, written by the Chinese strategist Sun Tzu (ca. 400 B.C.), locates the essence of combat not in the exercise of violence, but in foreknowledge and deception: that

is, the foreknowledge needed to make strategic estimates for a campaign, as well as the deceptive means to conceal from a potential enemy one's true dispositions and ultimate intentions. . . . With the advent of motorized armies, foreknowledge and deception, the essential elements of warfare according to Sun Tzu, returned to the battlefield. (179, 182)

However, there is a deeper current in Sun Tzu, one that is lost on some postmodern military minds: namely, the only general who attains excellence is the one who strives at all costs *not* to fight. Once engagement becomes absolutely necessary, the highest and best practice is to capture victory without taking or losing a life. A general who does not at all costs seek to avert violence is "utterly inhumane."[84]

> Taking a state whole is superior.
> Destroying it is inferior to this.
> Taking an army whole is superior.
> Destroying it is inferior to this.
> . . .
> Therefore, one hundred victories in one hundred battles is
>    not skillful.
> Subduing the other's military without battle is skillful.[85]

Victory over an enemy can and must, for the humane general, be only a moment in the struggle to achieve victory over war. In pursuit of this greater victory, Sun Tzu commands the general to be:

> Subtle! Subtle!
> To the point of formlessness.
> Spirit like! Spirit like!
> To the point of soundlessness.
> Thus one can be the enemy's fate star.[86]

The Five-Paragraph Format deals with the fog of war by providing a formal structure in whose rigor and reliability—in whose *architecture,* regardless of the content it houses and supports—combatants and commanders can put their faith, and thus it permits the management of the formless in the midst of battle.

40

In addition to their various battlefield communication techniques, the Mongols extended their operational system to include forms of intimacy, an interpersonal fabric of oaths and bonds. An example of this was the importance placed upon the ability of the leader to uphold his commitment to arrive with his troops at a prearranged location on time. This is treated in a verse from *The Secret History of the Mongols:*

> Temüjin, To'oril Qan, and Jaqa Gambu having likewise made ready their troops, coming unto one another and, moreover, recognizing one another, when Jamuγa spake, he said, "Said we not unto one another, 'Let us not be late
> > at the appointed place of meeting,
> > even though in a snowstorm?
> > At the assembly,
> > Even though there be rain?'
> Are not the Mongol ones which have an oath [pronounced only with the word] 'yea'? We said unto one another,
> > 'Let us expel out of [our] ranks
> > The one which shall be fallen behind from [his]
> > > 'yea.'"[87]

It is precisely here, at the moment of the articulation of a responsibility that is itself what constitutes "the Mongol," that the material felt is invoked. Subedei was, until his death, one of Chingis Khan's most trusted generals. It was he who was chosen to plan and to lead the invasion of Khwarizm, which was to be the first step in the Mongols' westward sweep. Called before the Great Khan, Subedei, who "as a strategist had no equal" (indeed, as Chambers notes, Rommel and Patton were both attentive students of Subedei),[88] swore to the khan the following oath: "As felt protects from the wind . . . so will I ward off thine enemies" (*The Devil's Horsemen*, 67–68).

A passage from the *Secret History of the Mongols,* in which Temüjin is made Chingis Khan, documents the way in which those closest to the newly appointed Great Khan pledged their word and swore their oath to him. Subedei said:

Becoming a rat
I shall gather with [others].
Becoming a black crow
I shall assemble with [others]
Those which are outside.

Becoming the felt which covereth [a horse]
I shall assay with [others] to cover [thee].
Becoming the felt which restraineth the wind
Toward [thy] tent
I shall assay with [others] to serve as shelter.[89]

In *A Thousand Plateaus*, the chapter "1227: The War Machine: A Treatise on Nomadology" begins with the Hindu god Indra, a key figure in Hindu nomadology because "he unties the bond and betrays the pact" (352). However, it was not a pact-betraying practice but rather a richly wrought condition of being bound by pacts that permitted the mobilization of what would become the Mongol Empire. When Temüjin assumed the title of Chingis Khan in 1206 he was made to sit upon a mat of felt; he was told to look upon it and to behold. If he would govern well, he was told, his rule would be glorious and the world would obey him. If he did otherwise, he would become "so indigent" that he would "not even have a piece of felt on which to sit."[90] In preparing to become Chingis Khan, Temüjin renewed his bond with his *anda* Jamuɣa: "Declaring themselves *anda*, loving each other, banqueting and feasting, they rejoiced and, at night, in their covering they passed the night together alone."[91]

In the introduction to his translation of *The History and Life of Chinggis Khan*, Urgunge Onon has pointed out, "Chinggis Qahan established his empire and held it together on three vital ties, expressed in the words quda, anda and nökör. These were familiar concepts to the nomad tribes, but he used them with enormous skill and foresight as the means of uniting a sprawling and shifting population and making them into a superb fighting machine."[92]

The first of these, *quda*, "was the tie of marriage. Chinggis Qahan made many skillful marriage alliances, as for instance when he gave

one of his daughters to [one khan because that khan] had submitted to him without a fight. A potential enemy was now a son-in-law." The second word, *anda*, "was the tie of sworn brotherhood, ratified by a valuable gift. . . . In this case too, an unbreakable bond was created that only death could sever" but that sons often renewed in honor of their fathers. Finally, *nökör* "was the tie of friendship that held Chinggis's followers to him in a relationship rather like that of medieval lord and liegeman. With these three ties he created a vast network of loyalty, and had the confidence of knowing that he could rely on many far flung tribesmen when he needed their support, held as they all were in the strong web he had woven so skilfully"[93]—or, we might suggest, that he had fulled.

Such oaths were often sworn by evoking one's liver, heart, and other viscera. After Temüjin's bride Börte had been kidnapped by the Merkids, Temüjin said to his ally the Ong Qan:

As to my breast,
I have been rent in twain.
Are we not kindred of liver?[94]
How shall we requite
Our requital?

The Ong Qan vowed to help go after her:

I shall set forth from hence, twenty thousand [in number], becoming the right hand. Let Younger Brother Jamuγa, being twenty thousand [in number], set forth, becoming the left hand. Let our appointed time be [decided] from [the part of] Jamuγa.[95]

These systems that he nourished with information flowed through five different channels: spies, Mongolian caravans, prisoners of war, those who voluntarily surrendered, and "subjugated natives of countries or tribes who were neighbours of those about to be attacked."[96]

Before embarking on any campaign, Chingis Khan would deploy spies to find out as much as they could about conditions (social, political, logistical, cultural, economic) of the area he intended to invade. "When he learned of the religious conflict between Buddhists

and Muslims in the Qara Kitad region, for example, he instructed his commander-in-chief . . . to proclaim complete religious freedom in 1218."[97]

Though this point is not made explicit in *A Thousand Plateaus*— Deleuze and Guattari never make clear their reasons for assigning particular dates to their various chapters—1227 was the year that Chingis Khan died. Not from an arrow that pierced his thick felt armor while in pursuit of his enemies, not from being cut down while embodying "the nomad war machine . . . for a moment in its pure form on the vacant smooth spaces of the steppes of Inner Asia."[98] This exemplary horseman died on August 18, 1227, after sustaining a fatal injury in an accidental fall from his mount.

Brian Massumi argues that the important question to ask of *A Thousand Plateaus* "is not: is it true? But: does it work? What new thoughts does it make possible to think? What new emotions does it make possible to feel? What new sensations and perceptions does it open to the body?"[99] In this sense it becomes crucial to underscore the ways in which the construction of a free-floating, quasi-historical, loosely ethnographic Mongo–Turco–nomad war machine waters down what was the most distinctive and efficacious element of that machine; in gussying up the centrality of the "undoing of pacts" and the "betraying of bonds" to that nomad war machine of the steppes, Deleuze and Guattari's wild and wonderful fabrication loses some of its power, because the Mongol war machine's forms of bondage, so intricately calibrated and yet flexible and plastic, are precisely what made it so effective. Its bonds, pacts, oaths, allegiances— various modes of scripting, punctuating, organizing the interhuman intrigue—are what, in historical hindsight, allow it to appear to have described such a "smooth" space.

## TO LOVE TO HAPPEN

Felt's haptic nature is what attracted Deleuze and Guattari. They approached felt through the act of ornamentation, the nomad art par excellence, an art of the haptic. "'Haptic' is a better word than 'tactile' since it does not establish an opposition between two sense organs but rather invites the assumption that the eye itself may fulfill this

nonoptical function" (*A Thousand Plateaus,* 492–93).[100] It is curi-
ous, however, that what captured Joseph Beuys's interest in felt and
inspired his commitment to that material was "not its haptic nature as
has often been thought, but insulation."[101] Insulation played an inte-
gral role in Beuys's thinking, as a mode in which the material and the
spiritual are visibly and palpably intermeshed:[102]

44

> Felt as used in all the categories of warmth sculpture . . .
> does have a bearing on the character of warmth. Ultimately
> the concept of warmth goes even further. Not even physical
> warmth is meant. If I had meant physical warmth, I could
> just as well have used an infrared light in my performance.
> Actually I mean a completely different kind of warmth,
> namely spiritual or evolutionary warmth or the beginning
> of an evolution.[103]

Beuys thought of this evolution in social and political terms as
well. In an interview with Beuys, Achille Bonito Oliva likened Beuys's
notion of "Social Sculpture" to a practice of "peaceful coexistence."
Beuys adamantly refused this connection:

> No, I don't mean that. Peaceful coexistence accepts every-
> thing that one's opponents bring out and tries to solve it
> politically. Peaceful coexistence means that I want to repress
> difficulties. A political system is worked out, planned in such
> a way as to prevent problems from rising to the surface.
> Hence I consider peaceful coexistence to be the biggest lie
> ever told. Coexistence doesn't exist, only cooperation exists.
> These are the exact concepts, the concepts of the past,
> which must emerge again: democracy, socialism, the con-
> cept of socialism as a Christian concept, love thy neighbor.
> This concept has to be developed further, and that is some-
> thing which only the individual can do. *All in all, socialism
> is love.*[104]

Strange though they appear, Beuys's final words serve as the script,
an open-ended set of prompts and cues, according to which, follow-

ing his amorous tone, the aleatory self-production of the social fabric *loves to happen.* Can we read the following passage from *Empire* in similar terms? Its confluence of Marx and Deleuze and Guattari in the event of the multitude's becoming-snake suggests that there is some scope for moving beyond the formal terms of the network that *Empire*'s argument appears to rely upon:

Marx tried to understand the continuity of the cycle of pro-
letarian struggles that were emerging in nineteenth-century
Europe in terms of a mole and its subterranean tunnels. . . .
Well, we suspect that Marx's old mole has finally died. It seems
to us, in fact, that in the contemporary passage to Empire, *the
structured tunnels of the mole have been replaced by the
infinite undulations of the snake.* The depths of the modern
world and its subterranean passageways have in postmoder-
nity all become superficial. *Today's struggles slither silently
across these superficial, imperial landscapes.* Perhaps the
incommunicability of struggles, the lack of well-structured,
communicating tunnels, is in fact a strength rather than
a weakness—a strength because all of the movements are
immediately subversive in themselves and do not wait on any
sort of external aid or extension to guarantee their effective-
ness. Perhaps the more capital extends its global networks
of production and control, the more powerful any singular
point of revolt can be. *Simply by focusing their own pow-
ers, concentrating their energies in a tense and compact
coil, these serpentine struggles strike directly at the high-
est articulations of the imperial order.* Empire presents a
superficial world, the virtual center of which can be accessed
immediately from any point across the surface. If these points
were to constitute something like a new cycle of struggles, it
would be a cycle defined not by the communicative exten-
sion of the struggles but rather by their singular emergence,
by the intensity that characterizes them one by one. *In short,
this new phase is defined by the fact that these struggles do
not link horizontally, but each one leaps vertically, directly
to the virtual center of Empire.*[105]

46

In this passage Hardt and Negri's mass of serpentine struggles and their concentration in a tense and compact coil parallel the structure of felt itself: each enacts a cohesion of coiled energies. Hardt and Negri's scripting of the serpentine space exercises a charge on the imagination and directs it into an enactable form without which there is no orchestration by the multitude of its own efforts. The more the bonds between these coils are disrupted, the tighter they become. When the enfelted coil, caught in and among a fabric of others at once like it and unlike it, makes its leap to strike directly at the highest articulations of the imperial order, it is, we might imagine, structurally impossible to keep it from pulling the rest of the fabric along with it.

And yet, in all this, it is possible to imagine such forces cohering without connecting, living pleasurably and painfully proximate and exposed to one another—without being in any sense networked, without linking, socketing up, plugging in. Amorous, engaged without connection, across a distance that networks are designed to overcome but without which intimacy does not exist.

## INTERFERING SPIRALS

In his book *The Theory-Death of the Avant-Garde,* Paul Mann suggests that the avant-garde has always been the vehicle for the production of discourse, one that habitually takes the form of theories that pronounce its death and thereby nourish the avant-garde and the discourse machine alike. In characterizing this pattern that constitutes the life and death of the avant-garde, Mann traces three overlapping stages that extend from 1945 to the present. The first consists in what he calls the "consolidation and recuperation of the mode of anti-art": this is the moment when attacks on the institution of art become institutionalized and legitimated. The second stage he calls "super-saturation": the moment when it becomes clear that any avant-garde gesture can and inevitably will be recuperated. Last is the period of "atomization and reorganization." Of this moment he writes,

> The visible surface ... of this stage is called postmodernism and defined as pluralist, decentered, eclectic, deconstructive, self-consciously ideological, non- or hypersubjective

(the same thing), and largely indifferent to charges that it has abandoned the tasks historically assigned to the avant-garde. Around this postmodernism [is] an economy frantically struggling to retool discursive technology in order to recuperate it.[106]

These three stages—the period of recuperation, of supersaturation, and of atomization and reorganization—in Mann's view "are not fixed spans of time but simultaneous, overlapping features of the post-1945 period, localizable to some extent but more fundamentally describing *expanding, recurring, and interfering spirals.* These curves converge in and spin out from every inscription of the death of the avant-garde."[107]

That is to say, every time we hear about the death of the avant-garde, these three forces commingle to make that death possible, and when the critic or theorist or artist pronounces the avant-garde dead, the "frantic economy" recharges and releases them yet again. Mann argues that it is in the rhetoric of the new above all that we can see most clearly the way "art binds itself to a discourse that both sustains and cancels it in a continuous cycle of reflections."[108]

But Mann's words also touch upon an architecture, one that is made of expanding, recurring, and interfering spirals. In their book *What Is Philosophy?* Deleuze and Guattari offer up a rationale for art that echoes the dynamism of this form, speaking to the intrigue of sociality, the making-felt that underwrites and makes possible the production of affect that art undertakes—and thus that becomes the mechanism for reaching back into, agitating, and enlivening the anarchic ordering of that space of intrigue: "Life alone creates such zones where living beings whirl around, and only art can reach and penetrate them in its enterprise of co-creation."[109]

This adventure of sociality, with its difficult forms of intimacy, its ambiguities, and its moments of dissolution of the certainty of one's work and its purpose, is the interzone of cocreation that is ground zero for beginning the work of imagining what peace might look like, a peace that takes shape as the amorous socialism that Beuys sought, with great difficulty, to concretize in his practice and that Wijers saw as the kernel of Beuys's project: "Well, if you want only one word [to define Beuys's work], I would say that word is *love.*"[110]

# 1. INTERHUMAN INTERMEDIA

We're all *against* war. But what are we *for*? Peace, we say. What is peace? Nobody quite knows. It's an art, likely, not an abstraction. An elusive art: "Peace is not of this world," we say. Not of this space either, by the way. Space is fast becoming militarized. As there is suddenly no alternative to peace, unless we change worlds suddenly we're doomed. Can we achieve peace before achieving peace? Or is high-tech gloom our only prospect?

—ROBERT FILLIOU, invitation to the 1985–86 Art-of-Peace Biennale

In 1929 Constantin Brancusi created a spiral portrait of James Joyce, a likeness at once of the writer, his ear, and the labyrinth that has been so central to his and his protagonists' itinerant paths. The current version of Richard Ellmann's biography *James Joyce* includes it as a frontispiece. Apparently Joyce, writes Guy Davenport, "kept it pinned to his wall, and told people that it was a symbol opposite to that of 'la pyramide fatale,' by which he meant the idea of fitful material progress."[1]

This image of the spare spiral describes the journey constituting what Joyce called the "sedentary trade" of working one's life into one's work. It symbolizes the purposive wandering that is itself the origin of theoretical inquiry. In recent years we have heard from various quarters that theory as we know it has come to the end of its course. Perhaps this has less to do with an event that we might call the "death of theory" (as though it were now, after several decades in the driver's seat, suddenly theory's time to die, as painting has had to do so many times over that this has become a crucial part of its pulse) than with the death of the ways in which we have known

49

Constantin Brancusi, *Symbol of Joyce,* 1929. Copyright 2011 Artists Rights Society (ARS), New York/ADAGP, Paris.

theory. Indeed, if there is a way out of or around the corporatizing of academia and of education (i.e., if there is an alternative to the drive toward specialization, the production of reliably demonstrable skill sets and knowledge outcomes, and the killing of thinking), then perhaps it begins quite simply with an unlearning of the ways in

which we know theory and have been forced to know it in order to participate in its production.

"From the Greek words referring to sight or seeing," writes Donald Preziosi, "the 'theory' of anything may be understood to be a particular view that unifies in some fundamental sense a wide variety of disparate phenomena."[2] The term *theory* connotes a tradition of careful observation and engagement and, crucially, a viewing, an imaging, of phenomena in a manner that permits the construction of a new constellation of their relationships. This provisional model guides an engagement with the world in a way that affords possibilities for the production of knowledge, forms of practice, ways of being in the world that were not imagined in advance of the outset of a particular theoretical endeavor.

The term *theory* derives from the ancient Greek *theoria*, a pilgrimage undertaken to a foreign place to see a religious festival or to consult an oracle, in which the *theoros* is the individual who makes such a journey on his or her community's behalf.[3] Plato's *Republic* begins with an account of such an undertaking:

> SOCRATES. I walked down to the Piraeus yesterday with Glaucon, the son of Ariston, to make my prayers to the goddess. As this was the first celebration of her festival, I wished also to see how the ceremony would be conducted. The Thracians, I thought, made as fine a show in the procession as our own people, though they did well enough. The prayers and the spectacle were over, and we were leaving to go back to the city, when from some way off Polemarchus, the son of Cephalus, caught sight of us.[4]

The theoretic voyage was thus one that was an enactment of solidarity, though at the same time it demanded physical and psychological discipline and endurance from the *theoros* and entailed periods of solitude:

> The early Greek *theoria* was not a private matter, an individual intellectual or professional path leading away from home and tradition. It was, instead, a circular journey, beginning and ending in a rootedness and commitment to one's

native place, family and community, and supported by them every step of the way. Theory, the journey to new and more comprehensive insight, and practice, the living of daily life, were not divorced. Theorizing did not lead only outward and forward, in the linear style of modern thought, but back to the hearth and the *polis*.[5]

Plato's *Republic* thus begins with precisely such a scene: Socrates has been at the Piraeus, the port of Athens—about six miles from Athens proper, connected to Athens by the Long Walls, two parallel walls six hundred feet apart—where he has witnessed the first festival held in honor of the Thracian goddess Bendis and been struck by the impressiveness of the foreigners' prayer and procession. As he returns home with Glaucon, Polemarchus approaches them and initiates the dialogue without which the history of Western thought is unthinkable. And here, at the outset of the *Republic,* we find the "interhuman intrigue" that has, perhaps since this very moment when it emerges out of the interruption of Socrates' theoretic voyage, been Western thought's "unthought."

## RESPONSIBLE IDIOCY

Sometime in the late 1960s, Filliou had a conversation with his friend Billy Klüver, then a research scientist at Bell Laboratories, in which Klüver explained that the reason scientists are able to make greater strides in their fields than artists do in theirs is that scientists "don't know what science is." The quote comes from Filliou's 1970 book *Teaching and Learning as Performing Arts* (87). It is unique among publications in welcoming its readers to consider themselves its coauthors, an invitation Filliou upholds as more than just an egalitarian gesture by leaving space throughout the entire book for readers to write down their own thoughts and by inviting them to send these back to him in order to stimulate further, yet-unimagined collaborative projects. Apart from the sections containing Filliou's interviews with artist friends such as John Cage, Dieter Roth, Dorothy Iannone, Benjamin Patterson, Joseph Beuys, and Allan Kaprow, the format of

each of the book's pages is one-third Filliou's text in German, one-third in English, and one-third empty space reserved for the reader. The book is in many ways Filliou's answer to Klüver's provocation. "It is true," Filliou says, "that artists spend a powerful lot of time and energy trying to convince each other about what is art and what is not. They do not know that they don't know" (87). For Filliou this idea was more than something to muse about over drinks with his friends. Indeed, for him there was something very serious at stake in his playful nonknowledge. "Every generation of young people has to fight fascism," he explained. "For mine, it was the overt fascism of the Nazis and their allies. For theirs, in relative peace time, it is the covert fascism of the square world. Usually this fight is lost, because young people fail to root out the seeds of fascism within themselves" (87).

Clearly today, an artist's or critic's exhibition of traces of nostalgia for any historical moment is at best uncool and at worst a symptom of affliction by the more acute form of longing that Susan Stewart has characterized as a "social disease."[6] Accordingly many works from the 1960s and 1970s—like Filliou's book, like Yoko Ono and John Lennon's famous hotel room occupations enjoining the world to give peace a chance, and indeed even the utterance today of the word *peace*—tend to be met with responses ranging from a condescending smile to clinical annoyance. But the question that many of the artists of that historical moment were, and indeed still are, trying not simply to pose but actively to perform was and is how peace might be thought of not simply as the absence of war or a pause, even indefinitely protracted, between wars, but as something other than that, something dynamic that has necessarily to be continually reinvented, though also, crucially, as something with a horizon of possibility.[7]

In 1968, Yoko Ono released *Film No. 5 (Smile)*. A year earlier she had spoken of her desire to make a film that could include "a smiling face snap of every single human being in the world."[8] Much of the recent interest in the works of artists involved with Fluxus, both its central and its more orbital participants, is marked by a tendency to delight in the light-hearted playfulness of these works. This is an important element of what can count as Fluxus, but it is not divorceable from the difficult politics that, despite differences among their agendas and ways of working, can be found throughout Fluxus in

varying degrees of intensity at different points in its history over the past four decades.[9] Indeed, as Ono's statement about *Film No. 5* continued, it revealed a more trenchant dimension. She suggested, "We can arrange it with a television network so that whenever you want to see the faces of a particular location in the world, all you have to do is press a button and there it is. This way, if [Lyndon] Johnson wants to see what sort of people he killed in Vietnam that day, he only has to turn the channel."

Emmanuel Levinas's *Totality and Infinity* was first published in 1961, incidentally the year that Fluxus got its name from Lithuanian-born artist, designer, and provocateur George Maciunas. From the time of this book's publication to the end of his life, Levinas was consumed with the question of whether the "egalitarian and just" European state was to be produced through Hobbes's "war of all against all—or from the irreducible responsibility of the one for the other" (169). It is this question that is raised in Ono's work by the flashing shift from the world's billions of smiling faces to close-up views of their strategically indiscriminant murder. And it is in this balance that peace, whatever it might yet be, must always hang.

Both Filliou and Levinas were consumed with the question of peace. Or perhaps it is more accurate to say that they both consumed this question, were nourished by it and by always remaining committed to asking it. We recall from his conversation with Klüver the importance Filliou placed upon nonknowledge in practicing the art of peace. In this as in so many other respects, he virtually shares the same breath as Levinas, who wrote, years later, "It is in the knowledge of the other (*autrui*) as a simple individual—individual of a genus, a class, or a race—that peace with the other (*autrui*) turns into hatred; it is the approach of the other as 'such and such a type'" ("Peace and Proximity," 166). Their mutual concern with peace was shaped not just by having lived through war but by having actively participated in it. Both served in the French military during the Second World War, Filliou as a fighter in the French communist underground Resistance and Levinas as an officer and interpreter of German and Russian.[10]

Despite the numerous connections between their lives' work, the war seems to be the only point at which their biographies could have

come into contact. Levinas was born in Kovno, Lithuania, in 1906. By 1923 he was studying philosophy in Strasbourg and in the late 1920s went to Freiburg to work with Martin Heidegger. In 1930 he published his dissertation on Husserl, became a French citizen, did his military service, was married, and took a teaching job at the Alliance Israélite Universelle, in Paris.[11] He translated Husserl's book *Cartesian Meditations* into French and began a book on Heidegger, which he later stopped working on when he became aware of Heidegger's involvement with the Nazi Party. In 1939 he was drafted into the French army and was taken as a prisoner of war in 1940. Though Levinas was a Jew, his status as a French officer saw him interned in a military prison camp rather than a concentration camp, though he lost nearly all of his family in Lithuania to this fate, except his wife and daughter, who survived the war in a Christian monastery.[12]

Filliou was born in La Sauve, in the south of France, in 1926. After the war he left for California to find the father he never knew, worked in a Coca-Cola plant for two years, and then, after studying economics at the University of California at Los Angeles, he was sent as part of a United Nations research mission to Korea and Japan. He spent years traveling thereafter, living in Egypt, Spain, and Denmark, and returned to France in 1959. In 1960 he met the Romanian artist Daniel Spoerri and later, through him, came into contact with a number of the Fluxus artists with whom he was to have lifelong partnerships.

In 1973, with Wolfgang Becker, Filliou realized a project he called *commemor,* in which he tried to persuade the European cities of Lüttich, Maastricht, and Aachen to exchange their war memorials with one another. The project proposed creating "a mixed 'committee for the exchange of war memorials' . . . the work of which will be accompanied without any doubt by rational consciousness and high pleasure." The committee would attempt

> to achieve the reconciliation of the nations by one effective action only . . . to give an example which other continents might follow one day . . . to honor the victims of twentieth century's worldwars in a truthfull way . . . to make the future generations aware of the absurd and murderous obscenity of all nationalisms . . . to carry out the final fraternization

of the towns and villages of Europe ... [and] to change the pompous and revengeful style of history-writing into a new, generous expression of our destiny.

To this end, COMMEMOR issued the following request: "COUNTRIES WHICH NOWADAYS THINK OF WAR ARE SUMMONED TO EXCHANGE THEIR WAR MEMORIALS BEFORE AND INSTEAD OF MAKING A WAR." Filliou hoped by the end of the year to exhibit "the total of the activities of COMMEMOR and all of the works sent to us as a 'CONTRIBUTION FOR AN ART OF PEACE.'"[13]

The project is a preemptive countercommemoration, designed to disconnect the present from its seemingly inevitable immediate future (the particular war believed to lie over tomorrow's horizon) and to mesh it instead with the longer-term future when one might presume the antagonists will have already become reconciled. Since memorials are always built to commemorate those who died fighting a particular war, why not skip the war, go straight to the memorials, exchange them between conflicting groups, and thereby create a symbol of goodwill that would make going to war doubly perverse? "Filliou's project was branded blasphemous in Lüttich," recalls Becker, "practicable in Maastricht, and artistic in Aachen."[14]

## AWAKENESS

Filliou lovingly referred to his work as a kind of protopractice for what would become the art of the future, namely, "the art of losing oneself without getting lost." This was inseparable from his "art of peace," a practice that would, as Filliou came into contact with Tibetan Buddhism, come increasingly to mesh with Levinas's conception of peace "as awakeness to the precariousness of the other" ("Peace and Proximity," 167). Awakeness is the condition denoted by the Sanskrit term *buddha*. After his enlightenment, Siddhartha Gautama came to be called Buddha, "the one who is awakened." This state of being awake to the precariousness of the other, each and every sentient being, was what convinced the Buddha, after much deliberation, to set forth and share his realization with others; thus was born the practice that came to be called Buddhism, along with its various ethical traditions.

Levinas always maintained a lack of interest in Buddhism. According to Buddhist scholar Stephen Batchelor, Levinas "certainly had no interest in Buddhism and seemed slightly disdainful" of it.[15] In one interview, Levinas declared that his interests were purely in Western philosophy and in the Bible, saying flatly, "I don't have any nostalgia for the exotic. For me Europe is central."[16] His interviewer asked him whether by this he meant to say that "we, too, should remain in this tradition ... of thought?" To this he replied:

> Yes, that's what I mean. You can express everything in Greek. For example, you can say Buddhism in Greek. Europe will always remain a speaking-Greek—that's our language of the university. In saying this I'm thinking neither about the Greek roots of words nor about Greek grammar. The way of speaking in the university is Greek and global. In this sense, Greek is certainly spoken at the University of Tokyo. That's central, for not every language is Greek.[17]

The word *Buddhism* is itself of course a Western invention, one that appeared in European academic discourse in the first half of the nineteenth century.[18] In none of the Asian countries to which Buddhism has been indigenous has it been reducible to a single categorical term, least of all, it perhaps goes without saying, one that would translate seamlessly into English. So in this sense Levinas is correct to argue that "Buddhism" can be said in Greek, if it is true that Greek underwrites the grammar of Western scholarship, given that the concept of Buddhism is a product of Western academic knowledge. But the ability to invent the term *Buddhism* masks the impossibility of canning the plurality of philosophical, religious, psychological, meditative, artistic, and literary traditions and cultural histories, along with their complexities and contradictions, in a single word.

This condition—as is true of most any catchall category, in any discourse, which stands in for a complex admixture of concepts, practices, and histories—is one that Hannah Higgins has articulated carefully, in relation to the quasi-tradition summed up by the term *Fluxus*. She is an unusual example among art historians for her interest in playing up, rather than seeking to tame, the anarchy in Fluxus's past and present, showing an aversion to the production of crystal

clear periods and comprehensive taxonomies. "As long as the nature and history of Fluxus remain debatable, contested and unstable," she writes, "the spirit of flux in Fluxus remains alive, even when the debate takes place in academic venues." She anticipates

> a time when some well-meaning, academic type will come along and can Fluxus. In being canned, it will be preserved for all time but will lose much of its flavour. It may be that this process is inevitable if anything of Fluxus is to survive the life of the artists. The canning process is, however, unnecessary as long as the artists and those who know and love them are alive. This does not mean that rigorous histories of this or that Fluxus cannot be written. It merely means the history of all Fluxus cannot be.[19]

## BUDDHIST JUDAISM

In her book *Mourning Becomes the Law,* Gillian Rose takes issue with what she perceives to be a disavowal of politics in Levinas's work, taking his concern for the primacy of the ethical to imply a kind of political detachment, an ironic charge when we recall Levinas's early critique of aesthetics on much the same grounds.[20] This leads her to label his position a form of "Buddhist Judaism." The notion that Buddhism is entirely unconcerned with things political depends for its truth, like most things to do with Buddhism, upon which specific Buddhism one is talking about, where, and when. It would be impossible, for example, to consider apolitical either the Vietnamese Buddhist monks who were part of the resistance to the Vietnam War, or the Tibetan Buddhist monks who fought against Sir Francis Younghusband when he brought the British army into Tibet in 1904, or the Dalai Lama himself.[21] Levinas's Buddhist Judaism is of course inherently political; however, perhaps it is possible to suggest that its politics takes on a more anarchic complexion than other forms of Buddhism possess, a complexion in which a radical and absolute responsibility plays a central role. For Levinas, any politics "must be able in fact always to be checked and criticized starting from the ethical" (*Totality and Infinity,* 80). If, as he notes at the

outset of *Totality and Infinity,* peace has to be rethought against the grain of the rote tendency to think of it as the opposite of a war that, following Clausewitz, is politics pursued by other means, then Levinas's insistence on the fundamental inseparability of ethics from politics is crucial to his formulation of peace as awakeness to the precariousness of the other.

Fluxus artist and historian Ken Friedman writes, "Fluxus . . . proposes a world in which it is possible to create the greatest value for the greatest number of people," and he notes that this notion "finds its parallel in many of the central tenets of Buddhism."[22] Filliou, like many of his Fluxus friends, sampled and appropriated Buddhist ideas and practices to varying degrees and purposes for his work. But unlike most of those artist friends, at least most of those who grew up in European and American cultures, both Robert and his wife, Marianne Filliou, actually took the vows of refuge that make one officially "Buddhist."[23] He studied with Tibetan Nyingma master His Holiness Dudjom Rinpoche and with other important teachers, such as Lama Sogyal Rinpoche and Gendun Rinpoche. When Filliou died, in 1987, it was in the midst of a three-year meditation retreat.

## PERMANENT CREATION

In the first of his appendixes to *Teaching and Learning as Performing Arts,* Filliou shared the secret of what he called "Relative Permanent Creation." This is a variation on what he had elsewhere called "La fête permanente"—the permanent party, a continuously playful anarchy in response to the "fascism of the square world." It is also the title of a poem that is a partner to an action poem Filliou presented in 1965 called "Le Filliou ideal," which in his book he describes as the "secret of Absolute Permanent Creation." The score of the poem "Relative Permanent Creation" reads:

not deciding
not choosing
not wanting
not owning
aware of self

wide awake

SITTING QUIETLY

DOING NOTHING[24]

After speaking these words to the audience, Filliou sat for a while in meditation, "motionless and silent" (*Teaching and Learning*, 95). "Le Filliou ideal" is in fact the second part of a larger action poem published in 1967. Titled "Yes—an Action Poem," the larger poem is an unadulterated affirmation of difference that begins where "Relative Permanent Creation" ends, with Filliou seated in meditation, and expresses a more lyrical meditation than the earlier poem, also on his own body. Now the poet, Filliou, sits on a chair, and a "lecturer introduces him soberly to the audience, and reads as follows":

Part One—The Adult Male Poet

The Legs: All poets present the characteristics which we have just described [the limbs, etc.], but the diverse agglomeration of poets show, among themselves, some differences that suggest distinguishing among them.
> —thus the yellow poet has yellowish skin, prominent cheekbones, thick hair, slanted eyes, a large nose and thick lips.
> —the black poet has a colored skin, varying from golden brown to deep black, kinky hair, a flat nose, thick lips, and very strong, powerful jaws.
> —the white poet has pinkish skin, an oval-shaped face, straight hair, eyes slit horizontally, a straight nose and thin lips.
> —the red poet has a copper skin, unruly hair, prominent cheekbones, a hooked nose, and thin lips.[25]

The poem begins by exploring the exterior differences among a range of various possible poets. In the next section, titled "Of the Necessity of Alimentation," the pinkish male poet takes the reader on a tour of his innards. While Filliou finds pronounced differences when looking at the poets from the outside, their interiors, he notes,

are virtually identical: all have the same cycles of consumption, diges-
tion, and excretion, whose workings he details. His careful attention
to poets' excretory faculties prompts him to consider the differences
between the male and the female poet, again from the point of view
of the pinkish male.

> In the case of the female poet, the urethra opens to the out-
> side of her body, between her legs. Just behind her urine-
> opening is the vagina of the female poet, which, in the case
> of the adult virgin female poet is closed by a thin membrane
> known as the "hymen." Around these two openings are folds
> or lips of flesh, which form what is called the "vulva" of the
> female poet. But of course she is praised also for her poems,
> which are just as beautiful.
>
> In the case of the male poet, the urethra passes through
> a fleshy tube called the penis of the poet, which hangs
> between his legs.
>
> Excretion is of such vital importance to the good func-
> tioning of the poet that the departed savant, Leonardo da
> Vinci, insisted that "the poet is a wonderful mechanism
> transforming good wine into urine."[26]

In "Reproduction and Senses of the Adult Male Poet," the sixth
subsection of the fifth section, "Brain of the Poet," Filliou goes on to
consider that reproduction and those senses, which predictably are
tied closely together. In section seven, "Conclusions," he considers the
process by which the poet notices a woman passing by him and the
range of factors that arise for him to sort through as he wonders what
he should do about it.

> And even before deciding, perhaps it is boring to decide.
> Better, he thinks, to accept all possibilities in advance. Better
> to accept all the possibilities in advance, and accepting them
> always, to remain beyond that region where everything is
> parcelled out, and everybody is owned by what he owns.
> This at least is his ideal. And he expresses this ideal in a
> poem, because he is a poet.[27]

In *Teaching and Learning as Performing Arts,* Filliou mentions two discussions on the subject of Permanent Creation, one with mathematician Warren Hirsh and the other with John Cage in the car ride to Hirsh's home.

Permanent creation is a collective achievement. It cannot be perfect in any one of its components, but only as a whole, as more and more persons come to practise it. In February 1967, I went to dinner at [the home of] my friend the mathematician Warren Hirsh, who teaches and does research at New York University. John Cage drove Marianne and me to his place. It is during this ride that John told me we should, in social matters, achieve the equivalent of getting rid of harmony and counterpoint in music. It is by this, you remember, that I began my taped conversation with him. That evening I asked Warren what he was presently working on. He answered that it had to do with some complex mathematical problems exploring the possibility "of building perfect wholes out of imperfect parts." It concerned circuits, of course. As I understood what he said, if [in] a circuit composed of many components, one of them breaks down, the whole circuit stops. But if each component itself reproduces the whole circuit, with all its components, and each of these in turn reproduce the whole circuit, and so on and so on, we may arrive at a total circuit that will never break down, no matter if any or some of its components do. It made me think of the human brain, of memory, for instance. You may try to remember somebody's name by calling to mind his face. If it does not work, recall of making his acquaintance may bring up his name. Or odd association of ideas, having to do with sounds, smells, objects, etc. . . . In most cases, some components of the brain fail, and yet the answer will come out: the brain does his work. It also made me think of this study. I told Warren: "That's exactly what I try to discover in the fields of art, education and social matters." Yes it is. (177)[28]

Permanent Creation emerged again in different but related form later in 1967 in a series of discussions between Filliou and Allan

Kaprow. The State University of New York had been considering
opening an experimental university. Its administration began to con-
fer with a range of teachers, students, and interested nonacademics
about what the program might entail. One of these collaborators was
Kaprow, who invited his friend Filliou to sit in on two of the meet-
ings, and Filliou proposed establishing the Institute of Permanent
Creation. We can only speculate about how this might have shaped
American higher education; unfortunately the institute never made it
past the brainstorming stage (*Teaching and Learning,* 43). But Per-
manent Creation remained central to Filliou's vision of peace, and
if the finding of inner peace characterizes Absolute Permanent Cre-
ation, Filliou explained that the secret of Relative Permanent Creation
is something he called "autrisme."[29] He wrote:

> "Autre" means "other" or "else." I suppose that "autrisme"
> could be translated by "otherism" or "elsism"—such horrible
> words. I prefer to leave it in French. I wrote l'autrisme in 1962.
> Both the title and subtitle were chosen tongue-in-cheek. I
> hate -isms. I hate manifestoes. L'autrisme is an action-poem.
> It illustrates the possibility of making a performance out of
> one's ideas, instead of turning them, through the writing of
> manifestoes, into theories. Thus, as in any performance, pos-
> sibilities of spontaneous improvisations, even contradictions,
> remain. Clearly it is teaching and learning as performing arts.
> (*Teaching and Learning,* 90)

The score for "l'autrisme" consists of conversations among five
characters named "A," "B," "C," "D," and "E." These conversations
revolve around their either deciding for themselves or being directed
by another to do something other than what they are doing or to
be other than what they are. The action poem nears its end with
A, B, and C moving out into the audience. En route to the exit, they
question members of the audience at random: "What are you think-
ing about?" "What are you doing?" "Who are you?" "What are you?" No
matter what answer they are given, A, B, and C respond in these ways:
"Think of something else." "Do something else." "Be somebody else."
"Be something else." Filliou's stage direction reads: "And in the midst
of the general confusion thus created—spectators coming and going,

shouting, fighting, kissing, rising, laughing, protesting, etc. . . . A, B, and C leave the room" (*Teaching and Learning*, 91–92). Filliou ends the poem, not because some resulting dramatic action seems to demand it, but only in order that he as the author may himself be permitted to go forth and think, do, or be something else, to be other.

64

## FRAY

Levinas's "interhuman intrigue" is an ideal term for characterizing Gillian Rose's promise at the end of her memoir *Love's Work:* "Stay in the fray, in the revel of ideas and risk; learning, failing, wooing, grieving, trusting, working, reposing—in this sin of language and lips."[30]

That they stay in the fray was also precisely the advice given to Robert and Marianne Filliou in a discussion they were to have with His Holiness Lama Dudjom Rinpoche, years after writing *Teaching and Learning as Performing Arts.* Robert had told their teacher,

> I am fifty-four years old. . I am an artist. . I have written a few books. . I have worked for quite a while now in this field . . and I am invited at times to speak to people . . to work with them . . and artists of a younger generation have at times a way of looking upon me as some sort of teacher . . while I myself, I know that I have much to learn . . ! So, what do you think I should do . . ? Do you think I should stop for a while . . and really learn what I have to learn, before I speak to these young people and fulfil what they expect from me . . ? Or should I go on . . ?" Their teacher immediately answered: "As long as we haven't reached illumination . . we are all students. . [ . . . ] Meanwhile, [ . . . ] what we know we teach, and what we don't know we learn." Dudjom Rinpoche told him and Marianne: "Just go on with your work."[31]

In *Teaching and Learning as Performing Arts* Filliou lists the three principles that he felt could usher in an entirely new way of conceiving value. Filliou called the umbrella concept that captured these three principles Poetical Economy. The first principle entails "rehabilitating" what he calls the "café-genius." All of us who have spent

time as teachers and learners will readily agree that our most impor-
tant lessons have come not from being on the giving or receiving end
of formal instruction but from the hours sitting around and discuss-
ing ideas informally, moments far away from the one-way street that
leads from informer to informed. Filliou's café genius was an attempt
to encourage just this kind of laughter- and caffeine-enhanced brain-
storming, alone or with friends, the anarchic *autrisme* of Permanent
Creation.

The second principle of Poetical Economy is the "homage to fail-
ures." The failure is Filliou's nonhero, the person who influences no
one and thereby achieves the greatest success: helping to dismantle
"the idea of admiration" and "the deadweight of leadership" (*Teach-
ing and Learning,* 74). This idea was central to what could be called
Filliou's Fluxus pedagogy, which did in fact seek to treat teaching
and learning as performing arts.[32] Filliou stressed the interdependent,
nourishing relation between teaching and learning, one in which fail-
ure would be celebrated in advance for the fruit it could not help but
bear one day.

Filliou's third and final point, which is in many ways the linchpin
of the Poetical Economy and the key to Permanent Creation, is what
he calls the "celebration of the spirit of the staircase." We have all had
the experience of leaving a party and finding ourselves halfway down
the staircase when we are struck full force by what we should have
said but did not. This is the spirit of the staircase. Filliou wrote that he
was sure that once *Teaching and Learning as Performing Arts* was
published, what he had "left unsaid, or said but could have expressed
better," would be all too apparent to him. But rather than kick him-
self for not exploring all avenues, resolving all contradictions, bringing
things to closure and his critics to their knees with his acumen, Fil-
liou believed we should enjoy the anticipation of the revelation of the
spirit of the staircase. In fact, he proposed updating it by calling it the
"spirit of the elevator." This special kind of late-blooming "wit should
make us smile, or laugh. Feeling too strongly that what we should have
said is more important than what we actually did say, can only lead to
guilt, or impotence, or both" (*Teaching and Learning,* 74).

On one level, these points constitute an amusing art historical
footnote from an artist who, like many central and peripheral par-
ticipants in Fluxus, can always be counted on to provide us with a

laugh. But on another level, Filliou's work helps focus the pointedly ethical nature of the serious anarchic play that has long been at work in the divergent projects of so many of the artists working, talking, drinking, and laughing together in and around the Fluxus constellation. The focus that Filliou's pedagogy provides is one that, though it might delight in reminding these artists of their near equivalence when it comes to their innards, does not close down the differences among these individuals and their creative and critical practices. His approach to the performance of teaching and learning provides a useful orientation to the current flood of reappraisals of Fluxus, in that it provokes us not only to think about the place of the rise of interest in Fluxus in the current production of new forms of academic knowledge but also to ask once again about the ethics of such knowledge and whether the practice of peace might require the production of something like Filliou's nonknowledge.[33]

## WHY NOT?

In 1966 Fluxus artist Dick Higgins (also a poet, writer, typographer, publisher, critic, and mycologist, among other vocations) proposed the term *intermedia* as a way of articulating the nature of much of Fluxus's experiments. "Much of the best work being produced today," he began that essay (with a confident stance that would sound Greenbergian only until the next part of the sentence), "seems to fall between media."[34] His discussion of the art form known as the Happening characterizes it

> as an intermedium, an uncharted land that lies between collage, music and theater. It is not governed by rules; each work determines its own medium and form according to its needs. The concept itself is better understood by what it is not, rather than by what it is. Approaching it, we are pioneers again, and shall continue to be so [as] long as there's plenty of elbow room and no neighbors around for a few miles.[35]

Higgins's essay concludes with an instructive distinction between two modes of criticality, one of which takes a concept like "interme-

dia" and wishes to use it to look back on the twentieth century to find itself preiterated in various movements, and the other of which treats it as an invention of a very particular and peculiar cultural moment, something new, the inauguration of a future form of practice:

> Is it possible to speak of the use of intermedia as a huge and inclusive movement of which Dada, Futurism and Surrealism are early phases preceding the huge ground-swell that is taking place now? Or is it more reasonable to regard the use of intermedia instead of traditional compartments as an inevitable and irreversible historical innovation, more comparable, for example, to the development of instrumental music than, for example, to the development of Romanticism?[36]

Just as Higgins's notion of intermedia is an essential tool for understanding the kinds of formal and situational experiments undertaken by Fluxus artists and their contemporaries with similar sensibilities, so have these loose-knit cohesions of individuals continued to exemplify what could be called an "interhuman intermedia": a social fabric produced by the entanglements of individuals continuing to find and invent new ways to live and work together for over four decades and counting, despite personal or political or artistic differences.

The accompanying figure is a dog-eaten slide of Dick Higgins's famous *Intermedia Diagram,* which charts possible overlaps and confluences among a range of contemporary media. Before the transparency, dangerously loosened by the teeth of a colleague's puppy, fell out of the plastic frame and became lost to history, careful inspection would have revealed a small, transparent convex area, a zone without name or discernable boundary, which overlapped with the Concrete Poetry sector.

The dog's addition to Higgins's diagram raises a profound question, something like a Zen koan: What would the overlap between a dog bite and concrete poetry be? How would we define the boundary between the two? A sound bite? As Fluxus artist Larry Miller once suggested, in reference to Alison Knowles's *Identical Lunch,*[37] the way to understand Fluxus is to sink your teeth into it.[38]

I showed this dog-eaten slide in 2003 as part of a talk at the opening of "Intermedia: The Dick Higgins Collection," in a symposium that

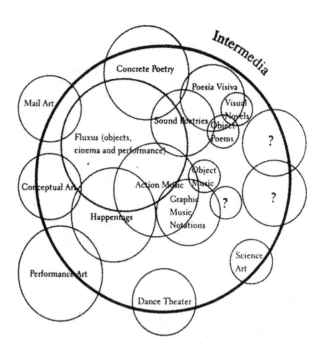

(top) Dick Higgins, *Intermedia Diagram*, 1995. Reproduced by permission of Hannah Higgins and the Dick Higgins Estate.

(bottom) Slide of Dick Higgins, *Intermedia Diagram,* partly chewed by dog in 2003.

included Hannah Higgins, Alison Knowles, Kathy O'Dell, and Owen Smith.[39] The last time I had seen Professor Smith had been several months before, in the spring of that year, when he came to the Maine College of Art, where I teach, to talk about Fluxus and the work of Yoko Ono, in preparation for her upcoming commencement address at the college. Not a great many art historians study Fluxus. Two of us happen to teach at what may be the only two colleges in Maine that would consider giving full-time jobs to art historians who do so.

One would think that we planned it, this "it" that loves to happen. Somewhere on the two-hour drive between Orono and Portland, Maine, and a mere hour before his talk was to begin, in true Fluxus fashion Owen called to say that he had just realized he had forgotten all of the slides he had put together for his talk. He asked if I had a few slides on hand that he could use. I got a few sleeves of them together, but he ended up doing something else—performing a few Fluxus events for the students, giving them a thumbnail sketch of Fluxus's history and its origins, all with such aplomb that one would never have known he had to wing it. My unnecessary slides ended up sitting in their folder, untouched, for three months, until another colleague, George Smith (no relation to Owen Smith), asked if I could loan him some Fluxus slides for a lecture. This was August 2003. As I started to prepare for the Intermedia symposium talk in Maryland later that year, I called George and asked if I could get the slides back. It took him a few days to e-mail a sorrowful apology, saying that his puppy had chewed on the slide sheets. I told him not to worry, that the dog at least had good taste, and that I bet the ones she mangled were probably only the irreplaceable ones. This *Diagram* was the only slide that I knew I absolutely needed to use in the Baltimore Intermedia talk, and I hoped and prayed that at least *it* would have been spared those sharp puppy teeth. No luck.

In the winter of 2002, when the exhibition Betwixt and Between: The Life and Work of Fluxus Artist Dick Higgins came to the University of Maine, Orono (where Owen Smith teaches and where he invited me to take part in a panel with Alison Knowles and himself), I wrote a review of the show for the *Portland Phoenix* newspaper, a little alternative weekly in Portland, Maine. It was the second in a series of two articles on Fluxus, the first one a review of the Fluxus Constellation show at Villa Croce, in Genoa, Italy, which I had visited

when I was in that city for my Ph.D. final examination. Fluxus artist and historian Geoff Hendricks was also there, serving as one of my Ph.D. examiners, and so he had invited all of us to attend the opening of that exhibition. Here are a few lines from the review of the Dick Higgins show:

> Sometime during his long and fertile career as an artist, poet, writer, typographer, publisher, scholar, mycologist, father, and friend to many, Higgins had [said]: "Fluxus is not a moment in history, or an art movement. Fluxus is a way of doing things, a tradition, and a way of life and death."
>
> [He] characterized Fluxus as a path, a Tao of life and death. In his film *Ghost Dog: The Way of the Samurai,* which he referred to as an "Eastern–Western," director Jim Jarmusch explores precisely this path. Early in the film, [Forest Whitaker's] voice reads aloud a passage from the samurai treatise called the *Hagakure:* "Among the maxims on Lord Naoshige's wall there was this one: 'Matters of great concern should be treated lightly.' Master Ittei commented, 'Matters of small concern should be treated seriously.'"
>
> I know a guy who bought a book on Zen Buddhism that he fell in love with, and one day, just before he was able to finish it, his dog ate the last chapter. Maybe it was the chapter in which Ghost Dog and Dick Higgins met. They might have been great friends, or the bitterest of enemies, in that both followed a way of life and of death in a world in which adherence to a way of life and death has become an anathema.[40]

This practice of committing oneself to a tao of living and dying is integral to the notion of interhuman intermedia. Deciding at each moment whether the matter at hand is of great or small concern and acting accordingly are trickier than they sound: deciding that something is of small concern and treating it seriously risk turning it into a matter of great concern and having to treat it lightly. We can thus see how even the most seemingly mundane task—determining whether to have buttermilk or soup with one's tuna sandwich—can become a genuine conundrum.

Interhuman intermedia constitutes a practice in which the ethical and the spiritual are inextricable from one another and are perfectly consistent with a political practice in the sense that Levinas intends when he argues that any politics "must be able in fact always to be checked and criticized starting from the ethical" (*Totality and Infinity*, 80). As Hannah Higgins suggests in her recent book, Fluxus derives its peculiar social cohesion from its status as a changing community based upon shared experience,[41] from a dynamism that is cohesive but at the same time is not unified by singular interpretations of the experiences that are shared or by programmatic political or aesthetic perspectives. To sustain such a practice over forty years despite the absence of such unifying ideologies is itself a radical political act, one that continues to unfold because of the rigor of an ethical–spiritual intermix with decidedly pragmatic objectives. These are traced by Alison Knowles when she explains what is crucial to Fluxus; it is what she calls

this point of *necessity*. There's a lot of things you can do in this world—you need not feel like you're frittering your time away. Maybe you need to walk around New York City all day, being a flaneur. Being a human being, having a human birth, is something that I feel is in the necessity of Fluxus. You're not dallying. You don't have to leave this world spiritually empty-handed. I very much like and am interested in this sensibility about how things mix. In terms of the interest in spirituality, that for me has come in since I've been an adult. When I was first with Fluxus, I didn't see all of that. I think that Fluxus, these event scores, they have so much *fun* with a kind of spirituality. This is in part because they're not proving any point. They have this open frame, the way Buddhism does. Buddhism accepts Christians! Buddhism entails working on yourself while you're in this life.[42]

As Western culture has ingested Buddhism in its various forms, translating it into forms that can operate meaningfully in American life, it has had little trouble with finding ways to package two of the jewels, the Buddha and the dharma, for its own, often instant, con-

sumption. But the third jewel, the *sangha,* has proved a bit more difficult for Westerners to assimilate. In order to accomplish this, one has both to sustain a practice and to do so as part of a collective— to learn to be, in the words of Buddhist scholar Stephen Batchelor, alone with others.[43] And yet Knowles speaks of Fluxus as precisely this kind of community.

> For me, they are absolutely the people I'm closest to on the earth, apart from my own family. Just look how long it's been! I talked with students at NYU recently about why this Fluxus material doesn't seem to disappear. It continues to circulate, and not so much because of promotion, but perhaps because of this *sangha* idea. Somehow it's needed in the world; it has some edge of necessity.[44]

Hannah Higgins suggests, "In offering opportunities to gain knowledge by multisensory, and performative means, Fluxus has political implications in the unfixed, unassigned, perhaps anarchic sense."[45] She speaks of this "compression of shared experience, form, and content," the stuff of anarchy, as "mattering," using this term as less a verb than a condition.

When Dick Higgins deployed the notion of intermedia, he noted his indebtedness to Samuel Taylor Coleridge for his first coinage of the word. In his obituary of Dick Higgins, Ken Friedman differentiates between Coleridge's word *intermedium* and Higgins's word *intermedia,* noting,

> Coleridge used the term "intermedium" once (and apparently once only) in referring to a specific issue in the work of Edmund Spenser [in his] Lecture Three: "On Spenser" [in which] Coleridge's use was different [from Higgins's] and distinct in meaning and form. Coleridge referred to a specific point lodged between two kinds of meaning in an art medium. Coleridge's "intermedium" was a singular term, used almost as an adjectival noun. Higgins's "intermedia" referred to a tendency in the arts that became both a range of art forms and a way of approaching the arts.[46]

Though Friedman takes pains to distance Coleridge's use of the term in order, rightly, to stress the important innovation offered by Higgins's term *intermedia,* might Coleridge's notion of singularity actually be an interesting one to try to recuperate in the context of Fluxus? This notion of a "lodgedness" of meaning seems to be a useful one in elaborating upon what Owen Smith calls a "density of experience"; we might even imagine this lodgedness to be the tensile force, nested in and among different forms of meaning, around which the stuff of experience would cohere, in increasing degrees of density and intensity, as a Fluxus event unfolds—as the last drop of soup washes over the lingering taste of tuna and the waiter appears with the check. We might imagine this lodgedness, this absolutely irreducible but always transforming point that is receptive to and productive of the interhuman encounter, as the *materia prima* from which the fabric of ultimate intelligibility is crafted, the fabric that is produced in and as the "interhuman intrigue," the *stuff* of an intimacy without which the social never coheres.

## EXERCISES

In 1994, a group of art historians and theorists gathered to discuss the reception of Duchamp in relation to Conceptual Art. A few artists who have been linked with Fluxus were named. One of the participants, Benjamin Buchloh, noted that of all of the conceptual artists he had spoken to, "all, without exception—Weiner, Kosuth, Barry, Graham—disavowed any relation with Fluxus whatsoever. In fact, just the opposite. So why," he asked, "is Fluxus so discredited?"[47]

Alexander Alberro responded by suggesting that Fluxus intended "to expand the concept of art to the universal," whereas "all of the models of Conceptual art do the opposite; that is, they are not really about the expansion of art to the universal, but rather the withdrawal of the experience of aesthetic pleasure from art."[48]

By way of retort to this strikingly neat opposition in which Fluxus expands and Conceptual Art withdraws, Thierry de Duve pointed to George Brecht's proposal pieces as examples that can be seen either to fit squarely into both categories or at the same time to refuse

both of them. The difference for de Duve is that anyone can perform Brecht's work.

In his score titled *Exercise,* Brecht provided direction to potential participants: "Determine the centre of an object or event. Determine the centre more accurately. Repeat, until further inaccuracy is impossible."[49] Luckily for us, further inaccuracy is always possible.

In continuing the now well-rehearsed debate about the ability of art and life to blur, de Duve flirts with Beuys, criticizing the circularity inherent in the following logic: "If this is art because an artist proclaims it to be, then anyone who proclaims something to be art is thereby an artist." He also takes issue with the "ethical problem related to the utopia of everyone an artist, which also fuels other people's practices, not only that of Conceptual art. Beuys, for example. Beuys is the last great proponent of that utopian brand of modernism, as it becomes a sort of caricature of itself."[50]

Interestingly, "Everyone is an artist," that statement that has marked Beuys, that thing that we insist upon being irreducibly his, is arguably not his at all but rather Filliou's. Louwrien Wijers has noted that while Beuys became famous for the statement "Everyone is an artist," it may actually have been Robert Filliou himself who first came up with this notion, although he expressed it in somewhat different terms, saying, "The artist is everybody."[51]

Here we might recall George Maciunas's simple formulation: the "art attitude," which held:

> There was no need for art. We had merely to learn to take an "art attitude" toward any phenomenon we encountered. Making artworks, he believed then, was essentially a useless occupation. If people could learn to take an "art attitude" toward all everyday phenomena, artists could stop making artworks and become economically "productive" workers.[52]

This unpredictable confluence of the comic and the political, personal and collective, ethical and existential, is the zone seized upon and experimented with by the activities of those involved in Fluxus. Even in the moments of Beuys's or Maciunas's rhetorical zeal, Fluxus nevertheless succeeded in prising open this zone with an elegance

and playfulness that has only begun to be understood. George Brecht called these low-key Fluxus epiphanies "little enlightenments" that he wanted to share with his "friends who would know what to do with them."[53] If it is true that the private and the personal are always already political, then by the same token we could say that Fluxus events permit the most seemingly mundane actions and irrelevant moments to become sites for ethical and political engagement.

"As long as the nature and history of Fluxus remain debatable, contested and unstable, the spirit of flux in Fluxus remains alive," writes Hannah Higgins.[54] Truly, once art becomes art historical, we tend to feel easily embarrassed about posing the kinds of simple questions about artworks that often were an integral part of their conception, construction, and reception in the first place and that keep any history contested and unstable. The dynamic dialogical relationship between slapstick simplicity and experiential complexity that has always been crucial to Fluxus works is easily elided in art historical writing. The only good questions, it comes to seem, are the ones that advertise their sophistication with an imposing learned ring that either shows that you are in the know or avoids betraying you in your attempts to try to be.

But what about the stupid questions? It sounds like this is itself a stupid question, but it is the right one to ask if the encounter with a Fluxus work like Robert Filliou's 1965 *Ample Food for Stupid Thought* is to be something other than an intellectual exercise or a knowing flip through an art historical relic. ("Good! Now there's another important Fluxus work I can check off the to-see list!") A few years after the publication of *Ample Food,* which is a collection of ninety-six postcards, each one bearing a stupid question,[55] Filliou offered his poignant and hilarious challenge to ethnography: "Hey, instead of studying us, why not come over here and have a drink with us?" (*Teaching and Learning,* 74).

A kind of reply to this question is served up with loving care in *Ample Food,* a work that stages a variation on the lampoon genre, in which the smarty-pants always misses all the fun. If we remove the connotations of malice and attack that are typically part of the lampoon but keep the intimacy that is assumed between the writer and those he or she seeks to provoke, we have *Ample Food.* It is the kind of lampoon bespoken by the word's French origin, *lampon,* meaning

"let's drink," a regular refrain in seventeenth-century satirical drinking songs; hence, "come have a drink with us."

In *Ample Food*'s amalgamation of introductory passages,[56] Filliou's friend Jackson Mac Low asks him, "Why 'for *stupid* thought'?" He replies, "Because . . . whenever I ask questions—no matter how serious—I usually get stupid answers. It's like hitting my head against a stone wall."[57] Mac Low was one of the contributors to the collection, and even he didn't know the point of it all until he asked.

Mac Low's introductory question is auspicious, because it reminds us: (1) that it's perfectly fine, indeed, sometimes it's essential *and* consistent with the spirit of the work, to ask a question that might sound stupid; (2) that a question qualifies as stupid or not depending on who is asking and who is answering, on what kind of answer is given, and on what that answer's results are. Does it kill the discussion and send everyone home angry? Does it lead to better questions, or a few more stupid questions, maybe over drinks, in a spirit of teaching and learning? (3) that—speaking art historically now—this Fluxus business, at its best, is not about who is in and who is out.

## ABSENCE

On June 30, 1952, before the Situationist theorist Guy Debord was a Situationist, his film *Hurlements en faveur de Sade* was first screened at Paris's Musée de l'Homme. Only twenty minutes into it, someone yanked the plug. Even some of his fellow Lettrists considered it an atrocity, and several of them left the group in protest. Five years later, in 1957, *Hurlements* was shown in London for the first time. The Institute of Contemporary Arts warned visitors that the Paris screening of the film had sparked riots, and even though the ICA was going to show the film and let its members come to their own conclusions, the institute would not be held responsible for the outrage the film might cause. In his book *Lipstick Traces,* Greil Marcus notes that, with a warning like that, it would have been impossible to sell "more tickets with a sex film starring Princess Margaret."[58]

Even three years later, at the film's 1960 screening, the ICA could count upon *Hurlements* to push the institute's members into a state of pandemonium. Art critic Guy Atkins wrote the following description of the event:

Those who had just seen the film came out of the auditorium and tried to persuade their friends on the stairs to go home, instead of wasting their time and money. But the atmosphere was so charged with excitement that this well-intentioned advice had the opposite effect. The newcomers were all the more anxious to see the film, since nobody imagined that the show would be a complete blank! Afterwards one realized that Debord's use of emptiness and silence had played on the nerves of the spectators, finally causing them to let out "howls in favor of de Sade."[59]

Earlier, before he had completed the script to *Hurlements,* Debord had written a preface to it called "Ion," which paid backhanded tribute to Immanuel Kant in its subtitle, "Prolegomena to Any Future Cinema." In this preface Debord lamented that he "lacked the leisure to create a work that would be less than eternal"; his aspiration was to make a work that would be absolutely ephemeral, that would last only as long as the immediate realization of the intention behind it. Although *Society of the Spectacle* would later develop this point into a full-length study, here in his preface to *Hurlements* Debord put the problem in the simplest of terms: to make a moment, to really *make* a moment, no more and no less, is the most difficult thing to do.[60]

Sarat Maharaj has likened this moment making to an openness to silence, to a silence that is spoken by the body, a silence that is not about opposing words but about a process of teasing words' own wordlessness out of them. He calls this kind of silence, so much like Debord's, the "silence of the untranslatable . . . a moment *beyond* language, not before it," and notes that this moment beyond language has always been one of Western thought's other great unthought territories.[61]

The year that Debord's *Hurlements* was screened, 1952, was also the year that Cage performed his *Silent Piece, 4' 33".* It is indeed an extraordinary coincidence that these two works, both of which attended to what happens when nothing happens, happened in the same year. Had Cage's *I Ching* dictated that his *Silent Piece* be two hours long, perhaps someone would have pulled the plug on him as well.

Musician and Cage biographer Sam Richards notes that, after Zen, Cage's encounter with the *I Ching* was the "decisive catalyst" for his

work. "This ancient Chinese oracle of divination operated by what Cage usually referred to as chance, though synchronicity would be a better term." Cage appropriated the *I Ching*'s navigation "by apparently random means" of "horizontal" and "vertical" time (i.e., the sequential experience of linear time as well as the simultaneity of the synchronistic alignment of events) and used it as a mechanism for composition. His infamous *4' 33"*, wherein no sounds are made intentionally, is "a reference to the time length determined by the *I Ching*."[62]

While Cage did indeed draw much from his studies of Zen Buddhism with D. T. Suzuki,[63] his journey into the world of Zen was not his first or arguably his most important encounter with Asian thought. "Aspects of Indian philosophy had already begun to exert an influence in the percussion and prepared piano pieces of the 1940s, signalling his intention to proceed musically without reference to Europe," notes Richards.[64] And his musical pieces between 1948 and 1951 were influenced by his readings in the Christian mysticism of Meister Eckhart, as well as by his studies with Suzuki and by various pan-Asian philosophical conceptions of nature that Cage had digested in his encounter with the writings of Ananda Coomaraswamy, for whom, as Richards puts it, "the function of art was to 'imitate Nature in her manner of operation.' . . . Her manner of operation, as Cage interpreted it, was non-intention, uncluttered by humanly made notions of aesthetics and value."[65]

Despite Zen's important contribution to his thinking, however, Cage was not himself a "Buddhist."[66] Nor should Cage's experiments with chance or synchronicity be conflated with Zen; as Sam Richards points out, "There is nothing in Zen Buddhism about art created by chance. Chance procedures in composition remove the unique gesture. Zen art, calligraphy being the most obvious, is the art of the unique gesture *par excellence*."[67] In an interview with *Vrij Nederland* from October 17, 1964, twelve years after he had performed *4' 33"*, Cage took pains to articulate this nonexpressive nonuniqueness, his excision of "deliberate attempts at the expression of anything unique to himself."[68] His interviewer asked Cage whether he felt it would be important for students of music "to express themselves." Cage answered, "scornfully," as noted in the transcript, and went on to clarify what was important: "No. To open their ears. To learn to enjoy it. We don't have anything to express, but we must notice a lot

of things." To which the interviewer replied, "And what if you belong to the kind who have to express themselves?" Here Cage opened his mouth and laughed "for a few seconds without any sound or movement" and then replied, "When you catch a cold you have to sneeze, but it's much better not to catch a cold. It is better to get rid of the non-art of expression."[69]

In his interview with Larry Miller just before his death, Maciunas credited Cage with inventing the practice of concretism that enabled what Maciunas referred to as Fluxus's "monomorphism." Maciunas explained, "That means one form. Now, the reason for that is that, you see, a lot of Fluxus is gag-like. That's part of the humor, it's like a gag. In fact, I wouldn't put it in any higher class than a gag, maybe a good gag."[70] Yoko Ono perhaps put this network of ideas most succinctly when she told her own interviewer, "The essence of Zen that connected with Cage and all of us was a sense of laughter. . . . Laughter is God's language."[71] Said Cage, "The prepared piano, impressions I had from the work of artist friends, studies of Zen Buddhism, ramblings in the fields and forests looking for mushrooms, all led me to the enjoyment of things as they come, as they happen, rather than as they are forced to be. . . . Beauty is now underfoot wherever we take the trouble to look."[72]

In one of the charts and diagrams for which he was famous, George Maciunas (again in 1964) listed Fluxus's ancestry:

*derived from*
*Vaudeville*
*Gags*
*Dada*
*Duchamp*
*some Cage*
*Japanese Haiku*
*" Zen*
*much Spike Jones.*[73]

Dick Higgins has suggested that Cage and Duchamp are more appropriately considered "uncles of Fluxus rather than direct progenitors or father figures" and that, while Fluxus relates to Cage and Duchamp, this relation is closer to affinity or confluence rather than direct causal

influence. Indeed, Higgins notes that the more familiar we become with Fluxus events, the less resemblance they bear to the works of Cage and Duchamp.[74]

Ken Friedman has made this point from a different direction, arguing that while it is in one respect accurate to consider "individual artists such as Marcel Duchamp and John Cage ... as ancestors of Fluxus," it is more accurate to say that ideas, not individuals, "played a larger role."[75] Friedman's point thus moves us away from privileging singular figures as the motors of Fluxus history and provokes a follow-up question: Where does one draw the boundaries between ideas and individuals?

Chieko (later Mieko) Shiomi's *Shadow Piece II,* first performed in 1964, invited readers to perform the following action, using as a tool the piece of paper on which her instructions were written:

Shadow Piece II
1
Project a shadow over the other
side of this page.
2
Observe the boundary line between
the shadow and the lighted part.
3
Become the boundary line.
1964[76]

This score provides a point of entry into a reading of the relationship between Duchamp and Cage; Sylvère Lotringer has noted the ways in which Cage's increasingly intimate friendship with Duchamp in the last decade of Duchamp's life became inseparable from Cage's own ways of thinking. Lotringer argues:

Cage had to see things for himself in such a way that Duchamp's work would be kept alive through his own. The only way to celebrate Duchamp was to "recerebrate" him—a Duchampian pun Cage invented—which meant to plug Duchamp's mind into one's own, the way the chessboard had been plugged [in]to the sound system [in their 1968

Toronto musical chess match]. And the music would be both [of] theirs.[77]

This was the inaudible music of intimate immersion in each other's company, mediated through the game of chess, which Duchamp had described as "a school of silence."[78]

Cage once said, "The effect for me of Duchamp's work was to so change my way of seeing that I became in a way a Duchamp unto myself." Cage, through his "recerebrations," did not become "like" Duchamp but in a more complex sense became Duchampian in order to become more fully Cage. So what we might wish to focus upon is not the influence of individuals or ideas as such in an art historical sense but rather the performative practice—within the space of the interhuman encounter—of this kind of interpersonal intermedia.

A notion of interpersonal intermedia brings us close to what anthropologist Michael Taussig refers to as the mimetic faculty, whose practice takes "us bodily into alterity." In its enactment, he says,

> it is the artful combination, the playing with perplexity, that is necessary; a magnificent excessiveness over and beyond the fact that mimesis implies alterity as its flip-side. The full effect occurs when the necessary impossibility is attained, when mimesis becomes alterity. Then and only then can spirit and matter, history and nature, flow into each other's otherness.[79]

For Taussig, mimesis operates as a moment of knowing that, "in steeping itself in its object," is thus overflowed by it; this flow of oneself into the alterity of another is framed by George Brecht's oft-cited 1961 piece *Two Exercises:*

> Consider an object. Call what is not the object "other."
> EXERCISE: Add to the object, from the "other," another
>          object, to form a new object and a new "other."
>          Repeat until there is no more "other."
> EXERCISE: Take a part from the object and add it to the
>          "other," to form a new object and a new "other."
>          Repeat until there is no more object.[80]

## FLUXUS GLOBAL

Geoff Hendricks has said, "Fluxus is about internationalism, the idea that in a certain way we're nomads. We travel and we connect up with people of similar minds and then things grow out from there."[81] Owen Smith has referred to this pragmatic experimentalism as a "small-scale opportunism" that has catalyzed as well as orchestrated the logistics for Fluxus's avowedly interdisciplinary activities;[82] the internationalist dimension of Fluxus's history and present is addressed by Hannah Higgins, who notes that what has enabled the success of the nomadism named by Hendricks has been Fluxus's inclusionary ethos, which she believes can teach us something "about an expanded sense of humanism." She speculates, "Fluxus is the first or maybe even the only major movement to have members who are black, white, Asian, Hispanic, male gay and straight, female gay and straight. It was truly open in a time before identity politics would again make that impossible."[83]

Coupled with and perhaps inseparable from the growing interest in Fluxus on the part of historians and curators is the tendency to forget that it still exists and continues to be active. "Collections make the mistake of terminating their collecting policy with the year Maciunas dies [1978], which is absurd, because these people [involved with Fluxus] are still active. It's been twenty-five years since Maciunas died, and they still collaborate. It's not like they just get together for museum shows."[84]

This blend of pragmatism and idealism permits a conception of political practice whose charge comes not from a unified political platform but from the ability to continue to produce an inclusionary Fluxus despite tensions among the political perspectives of the participants. It could be argued that this ethos more than anything else, along with Beuys's affinity for those individuals who enacted it, is what excited Beuys and what he felt must be defended against the threat of a Duchampian silence that, paradoxically, had in fact played a nourishing role for Cage and indeed for many Fluxus artists. Beuys declared Duchamp's silence as overrated, and insofar as this was a tailor-made response to the aims of Duchamp's withdrawal from art,

Beuys's declaration led him to perform a ready-made event despite himself.

Larry Miller's "Maybe Fluxus (a Para-Interrogative Guide for the Neoteric Transmuter, Tinder, Tinker and Totalist)" asks no fewer than twenty-three tough questions, one fewer than the number of hours in a day or the number of stations in Beuys's Guggenheim show. If you can answer all of them, you can consider yourself a Fluxus expert. I tried to answer them all, because what can we do but try to be experts, but I got stuck on this one: "Maybe you just want to have some fun and need some other playmates—will Fluxus love you?"[85]

# 2. RATE OF SILENCE

JOYCE: A Romanian rhymer I met
used a system he based on roulette.
His reliance on chance
was a def'nite advance
and yet . . . and yet . . . and yet . . .

—TOM STOPPARD, *Travesties*

## STATIONS

In 1979, Jacques Derrida visited Joseph Beuys's retrospective exhibition at the Guggenheim Museum in New York. Rather than take the elevator to the top and walk down the museum's cascading spiral ramps, he began at the bottom and saw the show the hard way. Beuys had referred to the sections of his exhibition as "stations." Later, reflecting upon his experience, Derrida told his son Jean, "The exhibit experience replicated nicely the 'Stations of the Cross.'"[1] Perhaps having deliberately viewed the exhibition against the grain of its curatorial and architectural logic enabled Derrida in his nonchalance to make the connection that Beuys might have hoped for.

The exhibition comprised twenty-four stations, one for each hour of the day and ten more than the medieval devotion consisted of. At Station 10, a winded Derrida would have seen a large black-and-white photograph showing Beuys standing in his art uniform, jeans, vest, and felt hat, holding a paintbrush and a jar full of his *"Braunkreuz"*—paint mixed with chocolate. At his feet was a large placard on which he had just finished painting, in German: "The silence of Marcel Duchamp is overrated."

85

We might imagine a Duchamp more amused even than Derrida to see the lengths to which Beuys was prepared to go in order to shout out his silence. Beuys's action had begun by building a fat corner into a construction meant to call to mind a wooden gate. Next he made a sound piece out of several bells, which he placed on the floor in front of the fat corner. Then he went to work on the poster. All of this was recorded, live, for West German television's channel 2, on December 11, 1964, as Wolf Vostell, Bazon Brock, and Tomas Schmit performed other actions simultaneously in other parts of the room.[2]

Still four years before Duchamp's death and the revelation of his swan song, *Étant donnés,* Beuys's action was a protest, extraordinary for its coupling of the literalness of its motivations and the opacity of the action's formal components, against what he considered to be Duchamp's self-imposed exile from art making: his withdrawal into the silent world of the chessboard. It was a gesture proclaiming his distress at Duchamp's refusal to engage with the political and social concerns that Beuys felt should be the artist's arena and his frustration at all the attention that Duchamp had been paid for what, in Beuys's view, amounted to his having simply shirked the provocative questions that his oeuvre had raised.

As Antje von Graevenitz argues in her seminal study of Beuys's relationship with Duchamp, "Breaking the Silence: Joseph Beuys on His 'Challenger,' Marcel Duchamp," Beuys's engagement with Duchamp's legacy cannot be seen to have been "merely motivated by competition or small-mindedness. Duchamp," she concludes, "mattered much more to him than that."[3]

Beuys's concern with the implications of Duchamp for modern art in general and, more particularly, for his understanding of Duchamp's place in it was central to his thinking as a mature artist; he obsessed over Duchamp's provocations from the early 1960s to the end of his life. When Beuys was in London in 1985,[4] installing both *Lightning (Blitzschlag)* at the Royal Academy of Arts for the exhibition German Art in the Twentieth Century and his work *Plight* in the Anthony d'Offay Gallery,[5] he spoke with William Furlong about Duchamp's significance. Over the twenty years since his *Silence of Marcel Duchamp Is Overrated,* Beuys's basic criticism—that Duchamp's ready-made had posed fundamental questions for the role of art and artists in society, which he then skirted—had not changed,

although he had modulated that criticism relative to his own increasingly sophisticated positioning of himself as the advocate of "an era of anthropological art." Beuys told Furlong that the crux of Duchamp's importance was to have raised, only to dodge, the possibility of a new conception of human labor:

> This would have been of great importance, because since then it could have already become a kind of discussion about existing ideology in society, the capitalistic system and the communistic system: the germ in the right directions practiced by Marcel Duchamp. But then he distanced himself from further reflection. So he did not understand his own work completely.[6]

This is the clearest formulation of Beuys's goal: to remake the figure of Duchamp by suffusing his work into the panorama of Beuys's Social Sculpture, to make him a kind of anticipation of the Beuysian system, treating him as a pivotal and even a prophetic figure who was nevertheless not able to fathom the depth of his contribution to modern art. And, indeed, Beuys would suggest that, but for a few of his contemporaries, the version of modern art that unfolded in Duchamp's wake also bought into or was duped by the same kind of failure to engage with art's "anthropological" potential: "[Duchamp] wanted to become a hero-in-silence. . . . So I principally tried to push this beyond the threshold of modern art into an era of anthropological art, as a beginning in all fields of discussion . . . not only of minor problems."[7]

If, for Beuys, Duchamp could not understand his own work, then Beuys's task would be to understand it, make it intelligible, and offer Duchamp a kind of retroactive redemption in the context of Social Sculpture and its formulation of an anthropological art. Von Graevenitz offers a generous reading of this goal: for Beuys, Duchamp's silence "should not only be broken; rather, his thread should be recovered and introduced into completely different areas of life." This emphasis on Beuys's desire to link viewers' profound emotional and intellectual experience of his works with the cultivation of a desire on their part "to work towards social change" makes Beuys, in von

88

Graevenitz's view, an artist who "stood in the Romantic tradition of avant-garde artists who—especially in the Fluxus movement—felt obliged to carry out social duties. In response to the question of what a viewer of his work *Plight* might perceive . . ., Beuys answered, 'He leaves as a changed being.'"[8]

Ultimately, as von Graevenitz notes, despite Beuys's desire to imagine Duchamp's commitment to total withdrawal from the social implications of art in general and of his work in particular, there is evidence in Duchamp's own statements of his interest in such a goal of engaged citizenship: "Artists," Duchamp explained to art critic Dore Ashton,

> are the only people in the world who have a chance to become citizens of the world, to make a good world to live in. They are disengaged and ready for freedom. . . . In a way the artist is no longer an artist. He is some sort of missionary. . . . Art is the only thing left for people who don't give science the last word. I didn't want to be called an artist, you know. I wanted to use my possibility to be an individual.[9]

It is at this point—the imagining of a way in which those whom we call artists have the capacity and potential (in Duchamp's case) and, further (in Beuys's case), the responsibility to produce a kind of global citizenship—that we might understand Beuys's affinity with Duchamp most productively and that we might also move toward an understanding of Beuys's relationship with his Fluxus contemporaries.

Beuys was once asked, "Which of your works contributes most of all to the image of Christ?" His reply: "The expanded concept of art."[10] He discussed this notion at length in his lectures, interviews, and writings, but the most concise formulation of it came in a written work from 1979, the year of his Guggenheim exhibition, in which he theorized the relationship among a variety of formalisms (formalism of objects, of thought, of speech, and of collective action), which find their culmination in a kind of evolutionary register: the enactment of the Social Sculpture.

> My objects are to be seen as stimulants for the transformation of the idea of sculpture . . . or of art in general. They

should provoke thoughts about what sculpture can be and how the concept of sculpting can be extended to the invisible materials used by everyone.

THINKING FORMS—how we mold our thoughts or
SPOKEN FORMS—how we shape our thoughts into words or
SOCIAL SCULPTURE—how we mold and shape the world in which we live:
sculpture as an evolutionary process; everyone an artist.

That is why the nature of my sculpture is not fixed and finished. Processes continue in most of them: chemical reactions, fermentations, color changes, decay, drying up. Everything is in a STATE OF CHANGE.[11]

In his dialogue with Friedhelm Mennekes in the book *Beuys zu Christus* (Beuys on Christ), Beuys offers an explanation of his famous notion that everyone is an artist, in which he makes the subtle but integral point that this refers to a potentiality inherent within everyone. Beuys's statement is thus a kind of eschatological claim rather than simply a didactic one, and this distinction is crucial given the frequency with which the "potentiality" of the human being embedded in the phrase is overlooked by critics and commentators. Also important, it is within the context of a wide-ranging but ultimately theological conversation with Mennekes that Beuys gave this statement what is arguably its clearest formulation.

Mennekes asked Beuys, "Without these thoughts as to increasing and mobilizing creativity, humanity and the world don't have a good future. In your view, who would be the carrier of such creativity?" Beuys answered, "Every person in the same manner. Thus the formula: each person is an artist by potential. The possibility exists."[12]

Mennekes replied that while this indeed sounds like a fine proposal, "most people live in a kind of embarrassment and in a spiritual powerlessness," while artists have the privilege of "harbor[ing] a liberated creativity. Would you say that generally speaking the artist participates in this liberated creativity or is part of it?"

BEUYS: The artist has become completely suspect for me, above all because he feels reduced to and, so to speak, part of the old systems: the artist must be a painter or a sculptor

or a dancer or a poet or anything that people call "cultural." I really don't mean that at all. Rather, each person is an artist who demands much more from humanity than what artists are able to attain if they paint wonderful pictures. O.K. that has a certain value. But for the future of humanity that is not crucial.

What is crucial, shall we say, is relating the concept "artist" to every person and simply to his own work. . . . The extended concept of art stating "Each person is an artist" is not easy, although it is very necessary for art. A trash collector can accomplish this in the sense of an anthropological art sooner than a painter, but that remains open. We cannot say who accomplishes this in his line of work. For the time being, it looks as if the artists wanted that least.[13]

Beuys's reply is crucial to understanding both his sense of the scope of meaning of "everyone is an artist" and his argument against Duchamp's silence, which Beuys could not help himself from understanding as a refusal to bear the responsibilities that Duchamp's work ought, in Beuys's view, to have entailed. Indeed, Beuys's indictment of Duchamp sets into clear relief his own inability ever to remain silent: he waxed prolific on every existing subject and even invented subjects in order to keep up with his discursive drives. The problem lay in maintaining the consistency among symbolizing social change, producing works of art and action that can function either as symbolic provocations of change or a need for it, and actually enacting or catalyzing social change as such. Unlike Cage or Duchamp, whose forms of choosing silence reflected operational objectives, Beuys felt it impossible, unconscionable, to stay silent.

Artist Merilyn Smith wrote of Beuys, "Succumbing to verbal explanations was . . . the weakening of Beuys' position. He seemed to listen to his own rationalising and to like what he heard." Against Beuys's wish for a seamlessness among the various modes of his formalism (of objects, of thought, of speech, and of collective action), his investment in their transparent correspondence with one another, Smith contends, "The potency of his 'actions' and objects was in a different language and of another order, and—significantly—was dependent on his remaining mute."[14]

Two implications of Smith's critique are worth addressing here. The first is her contention that two, or more, languages are at work within Beuys's work and that, despite his desire to make them seamlessly transferable and translatable, this is not and cannot be the case; further, she claims, the performative pedagogical "language" that Beuys spoke can and does interfere with, obfuscate, deaden, and introduce an extralinguistic static into the encounter with the actions and objects themselves. The second important point of Smith's account is that it traces the way Beuys depended upon his interlocutor's attention to help him bridge the gaps and create linkages among the various formal languages he sought to suffuse in his single and ostensibly total Expanded Concept of Art. This is to say that this "interlocutorial other" was, for Beuys, the mechanism by which the various modes of his work could cohere. But of course, as Smith shows us, this condition produced complexity, interhuman intrigue, moments when the formal language of the objects infected the speech of their maker and when the words of Beuys could stand at odds with the material dynamics of the works he had produced. The point worth holding on to here is the fundamental—and, with respect to his work, compositional—nature of Beuys's dependence upon his "others."

The theatricality of his engagements with these others, however, could, when they left the symbolic level, become painfully out of joint with the difficult politics he sought to address. In one encounter during his visit to Northern Ireland in 1974, with his entourage and cameraman in tow, Beuys was interrogated by an old Protestant woman in Belfast. "From Germany?" she asked quizzically and then continued. "They're all here—Japs, Germans—all pickin' Ulster's bones, pickin' the carcass. God help this country." Beuys protested amiably, "We could all help." The woman replied, "Help? You don't understand the situation at all." [15]

## THINKING BODY

Despite Beuys's wish to integrate speaking forms and material forms in a totalizing strategy aimed at producing the condition of Social Sculpture, the contrast between the forms of affect produced by the work and the impact of his public interventions is stark. Beuys

wished that his sculptures "should provoke thoughts about what sculpture can be and how the concept of sculpting can be extended to the invisible materials used by everyone."[16] His sculptures can and do provoke such thoughts; they do make one wonder what sculpture could be, and how, as a concept, it can be extended to the invisible materials used by everyone. His sculptures do achieve this state in which intense and extraordinary passages of experience are created, passages that also precipitate questions about the capacities and limits of sculpture and, as with a warm cheek melting a block of tallow, register the possibility of imagining the sculptural process to be a model for the sorts of immaterial labors that constitute an interhuman intrigue. But it does not follow—certainly not to the degree that Beuys's words suggest it does or, more to the point, to the degree that he wished it would—that his sculptures' palpable success as forms, even as "thinking forms," were met by Beuys's own ability truly to demonstrate how a sculptural insight could actually be extended to the invisible materials used by everyone. For the formal sophistication of his sculptures and installations was never truly part of a continuum of activity that would permit a linkage between them and his projection of his public persona; these were entangled endeavors, insights from one able to seep into the other, motivate the other, clarify or complicate the other, but not phases in a continuum leading from sculpture as such to Social Sculpture writ large. On the contrary, the "Beuys effect" is marked by frequent clashes between Beuys's claims for his work and his own inability to instrumentalize formal dynamics and insights at the interhuman or collective level, by a desire but not necessarily a capacity to fully operationalize the goals of a grandly conceived "anthropological art" as politics.

For Irit Rogoff, Beuys's 1955 contribution to a contest soliciting submissions for the design of an Auschwitz memorial (his entry was not selected) demonstrates the way in which the essentially fragmentary nature of the work anchors it in "an alternative form of historical narrative," which, in contrast to most commemorative projects, "is not heroic, monumental, present or possessed of a coherent narrative; rather it is a testament to absence, being small, fragmented, humble and requiring a prolonged process of reading and reconstituting."[17] The elements of the piece, which formed one of the stations in the Guggenheim show and which are now on display in a vitrine at the

Hessiches Landesmuseum, in Darmstadt, consist of "blocks of tallow on a rusted electric plate,[18] forms alluding to chimney stacks, electrodes and wires, maps of railroad tracks leading into the death camp, drawings of emaciated young women, rows of sausage-shaped matter alluding to waste and organic debris, repeated references to his declared desire to 'show your wound.'"[19] These elements operate together by offering assorted points of entry, facilitating an engagement with historical trauma without placing a viewer in a particular subject position (a kind of set of thoughts without a particular thinker), a mode of dealing obliquely with what could not be squared up against and with what would of course have included Beuys's own participation in the Nazi war machine as a radio operator and Luftwaffe pilot. For a system meant to function as a seamless totality predicated on movement across the continuum of sculptural processes—thinking forms, spoken forms, and Social Sculpture—an important irony of the Beuys effect is that it was structured upon Beuys's silence with respect to his own wartime exploits. This silence was constitutive: it underlay his most effortfully disinterested expositions of his work's objectives, statements, and exhortations, which were often belied by the experience of the work itself, which deals so fully and so viscerally, albeit not directly, with the difficult and compromising subjects in Beuys's past and present.

In Caroline Tisdall's catalogue for Beuys's Guggenheim show, a book that has become a Beuys Bible of sorts, Beuys explains: "I do not feel that these works [in the Auschwitz vitrine] were made to represent catastrophe, although the experience of catastrophe has contributed to my awareness. But my interest was not in illustrating it." His interest lay in describing not the unfolding of this particular catastrophe but "the content and meaning of catastrophe" as such. Here, as his sentence comes to an end in his own ears, he shifts gears from an ethical orientation—in which his concern is to articulate verbally that his work is focused on its intersubjective possibilities, not on a specific event—to an epistemological one, which, as his words spiral forth into the ether, already begins a diversion into a firm moral stance that becomes intensely illustrative in its criticism of his unnamed contemporaries: "The human condition is Auschwitz and the principle of Auschwitz finds its perpetuation in our understanding of science and of political systems, in the delegation of

responsibility to groups of specialists and in the silence of intellectuals and artists."[20] And here we have it: Duchamp's silence rendered as an extension of the "Auschwitz Principle."

For Beuys the human condition seemed to demand his active therapeutic engagement, and the last years of his life saw him moving with increasing intensity in the direction of this healer–teacher hybrid. In Beuys's 1986 interview with Achille Bonito Oliva, he moved from a discussion of the role of the metaphorical concept of heat in his work to the use of heat as a metaphor for spiritual warmth. This quality led Bonito Oliva to make the connection with the notion of Eros. Beuys was prepared to accept this provisionally but quickly moved to check the associations with Freud that this called forth. He said:

> On the other hand, I am in no means satisfied with Freud, or let us say that I don't believe one can stop at Freud: one has to go beyond him. With Freud we are faced with a historical phenomenon similar to that seen in the case of Marx. There is no mention of some of the most important categories which—in my opinion—still require study. To this extent my actions can even be seen as a criticism with regard to Freud.[21]

Having raised this criticism, he then made a detour away from this line of argument in order to talk about the role of the body as a communicative device, but moments later he returned to it:

> I agree with Freud's diagnosis, according to which man lives to a considerable extent on his unconscious forces: however, in my opinion, Freud failed to work out a therapy or to state how such a therapy could be developed. The whole business remains confused. . . . I didn't say I was an enemy of Freud, what I said was that something in Freud leaves me dissatisfied because it fails to provide a therapy.[22]

However inept this might be as a critique of psychoanalysis, it raises several interesting questions: Did going beyond Duchamp entail for Beuys the same thing as going beyond Freud? Could the same therapy heal the condition that he felt had been brought on by both of these

two figures, Freud and Duchamp? For Beuys, both Freud and Du-
champ had gone far but not far enough; they had provided therapeu-
tic concepts, but in not pursuing them far enough they had turned
from cure to poison.

Over the space of the next two pages of transcription, he and
Bonito Oliva wandered through Nietzsche, Schiller, and Marx in order
to arrive at a discussion of the relation between Beuys's Social Sculp-
ture and the notion of "peaceful coexistence," to which Bonito Oliva
compared Beuys's concept. But, as noted in the Introduction to this
book, Beuys rejected this connection:

> Coexistence doesn't exist, only cooperation exists. These are
> the exact concepts, the concepts of the past, which must
> emerge again: democracy, socialism, the concept of socialism
> as a Christian concept, love thy neighbor. This concept has
> to be developed further, and that is something which only
> the individual can do. All in all, socialism is love.[23]

It was at precisely this point, at the statement "socialism is love," that
Bonito Oliva brought up the subject of Marcel Duchamp. One won-
ders whether he felt a direct intuitive link between Duchamp and
the notion of an amorous socialism, or whether he had simply been
waiting to ask Beuys about Duchamp all along, and the declaration
"socialism is love" was sufficiently impenetrable to justify the non
sequitur.

Bonito Oliva asked, "You have said that the silence of Marcel
Duchamp is overrated. Could you say something about the relation-
ship between your work and that of Duchamp?" And Beuys replied:

> In discussing his work it is necessary to avoid overrating his
> silence. I hold him in very high esteem, but I have to reject
> his silence. Duchamp was simply finished. He had run out of
> ideas; he was unable to come up with anything important.
> As I said, I have a great deal of respect for Duchamp as an
> individual, but not for his silence, or at least I don't consider
> it as important as other people do.
>
> All our discussions are excluded by the idea of silence.
> So far we have said that Marcel Duchamp's silence is over-

estimated. I would say that even the bourgeois tendencies in Duchamp's work—i.e., a form of provocative, bohemian behavior intended to *épater le bourgeois*—follow the same path. Duchamp started out from here and wanted to shock the bourgeoisie, and because of this he destroyed his creative powers, which really did atrophy. Here, as far as I am concerned, the silence of Marcel Duchamp starts to become a tremendous problem. Moreover, everyone knows that Duchamp was in the habit of reproaching young people by saying, "We have already done this, we have already done everything: actions, happenings . . . it's all old." How come everybody is so interested in Marcel Duchamp?[24]

When Beuys criticized the silence of Marcel Duchamp less than a year after his Fluxus debut, he considered himself to be acting in support of Fluxus. Beuys argued that Duchamp's silence could be reduced to the surrealist "aim of leaving the subconscious passive, of developing it," instead of focusing on developing consciousness.[25] Beuys explained that the Surrealists thought themselves able to live with their subconscious and thought they were, in his words, "way above reality, but instead they were beneath it."[26]

In 1986, when this interview was conducted, Beuys, too, was beneath a reality with respect to his criticism of Duchamp. This was the reality of *Étant donnés,* Duchamp's posthumous punchline, of which Beuys had in 1964 been unaware. Now he could no longer characterize Duchamp as merely silent; the silence needed to be rerated:

> The fact that Duchamp was not interested in consciousness, in methodology, in serious historical discussion and analysis, makes me think that he was working in the opposite direction: i.e., he had reached the point where he was no longer working. He merely repressed his ideas. Duchamp's "silence" should be replaced by the concept of an "absolute absence of language."[27]

Bonita Oliva asked Beuys, "What about the time before [Duchamp's] 'silence'?" Beuys replied:

Before that he had a language. He questioned a particular work. He should have joined in that discussion instead of withdrawing and thinking that he had made his contribution. Duchamp failed to solve or achieve anything. Had he come out into the open and discussed things, especially with young people, his work would have been productive, it would really have led somewhere, to concepts which would have been useful today. But—politically and aesthetically— Duchamp got nowhere. He refused to participate. Why? It seems to me that we must return to the concept of "absence of language." How could it be that he had nothing left to say? That he was without language, i.e., unable to communicate? That is the question. I only want to present him as a figure with a general significance, standing for a lot of other things. Looked at in this way, he offers useful negative information. But of course Marcel Duchamp is free to remain silent. I respect that. I hope that is clear.

Bonito Oliva: "In your opinion, did he carry out the first phase of this process of communication correctly?"

Beuys conceded that Duchamp's *Fountain* "was a genuine revelation" in its time, but he insisted that Duchamp "could have used it as a subject for discussion during the period of his silence." He then took a curious and telling turn in his discussion:

> Several people have told me, although I'm not sure whether it's true, that Duchamp once said: "Somebody in Germany has been talking about my silence, saying that it is overrated. What does that mean?" I am convinced that he knew very well what it meant. If he was unsure about it, he could have written me a letter and asked me what I meant. Why not?

This sounds far more like longing than critique. And while in 1964 Beuys's action may have been a defense of Fluxus and his involvement in it, by 1986 the action seems to have become a lament as well. " In 1964 [he] could have written: 'I read that my silence is overrated. Could you explain what that means?' That would have been better."

But by now Beuys's wounds had healed and he had moved on. "For some time now," he told Bonito Oliva in a curious aside, "I have been working on a new idea: that Ingmar Bergman's *The Silence* is not overrated. I have a copy of the entire film. I had it mailed to me. I don't know if I should have done that. The silence of Ingmar Bergman is not overrated."[28]

It is puzzling that Beuys described his engagement with Bergman as "a new idea," given that he had produced a multiple called *The Silence (Das Schweigen)* consisting of five galvanized film reels of Bergman's film thirteen years earlier, in 1973. Beuys gave each reel its own cryptic title. These were, in order: COUGHING FIT—GLACIER +; DWARVES—ANIMALIZATION; PAS—VEGETABILIZATION; TANKS—MECHANIZATION; *we are free* GEYSER +.[29]

One critic has noted that these bear an uncanny resemblance to Duchamp's own *Green Box*.[30] It seems that Beuys's engagement with Duchamp's silence did not take the form of a few outbursts at all but may have consisted in a much more prolonged and protracted archival game, and that even in the last year of his life Beuys was, much like Duchamp, combing over his earlier works, reshuffling and reindexing them.[31]

Ultimately, while the silence of Ingmar Bergman, and indeed Beuys's entire critical fiction, may not bear at all upon what Duchamp actually did or intended to do, Beuys's explicit differentiation between silence and the absolute absence of language is decisive, both in the genealogy of Beuys's relationship with Duchamp and as a way of approaching Fluxus today in terms of the amorous socialism that Beuys tried to articulate. This differentiation between silence and the absolute absence of language is something like the distinction Beuys drew between cooperation and coexistence, which is something like the difference between peace and the absolute absence of war. Again:

> Peaceful coexistence accepts everything that one's opponents bring out and tries to solve it politically. Peaceful coexistence means that I want to repress difficulties. A political system is worked out, planned in such a way as to prevent problems from rising to the surface. Hence I consider peaceful coexistence to be the biggest lie ever told. Coexistence

doesn't exist, only cooperation exists. These are the exact concepts, the concepts of the past, which must emerge again: democracy, socialism, the concept of socialism as a Christian concept, love thy neighbor. This concept has to be developed further, and that is something which only the individual can do. All in all, socialism is love.[32]

Beuys's amorous socialism gets us back to the problem posed by Levinas's philosophy: to think of peace not merely as the absence of war but as something defined positively, in a yet-unwrought language, as a dynamic engagement with others—Levinas's interhuman intrigue rendered in the textures of the Beuysian tongue.

In his early writings, Duchamp hinted at a parallel problem in saying that when it came to theological inquiry, to him there was "more than just *yes, no,* and *indifferent.* There is also the absence of such investigations."[33] This quote helps to mark the difference between the declaration of, or a commitment to, the absence of such metaphysical investigations and the declaration of, or commitment to, the presence of an investigation that knows that "yes, no, and indifferent" are insufficient and yet insists on actively proceeding in those investigations, actively producing their presence by enacting them. This was Beuys's approach, a decidedly faith-based investment in the world; this is, ultimately, another way of saying "yes" (as opposed to "no" or "indifferent") but to another and more personal sort of question. In his book *After Christianity,* philosopher Gianni Vattimo poses the paradox faced and felt by many modern and postmodern Christians, Beuys included, a paradox in which one cannot say with certainty that one believes, although one can be certain that one *believes* that he or she believes. Recounting a conversation with an old professor and mentor, "who was also a fervent believer," Vattimo writes:

I had not seen him for a long time, and he asked me whether I still believed in God. I answered, "Well, I believe that I believe." This is still my attitude today. Upon reflecting on that spontaneous response I came to understand, or I believe to have understood, that this unclear meaning of faith is entirely bound up with my experience as a scholar of

philosophy, and perhaps as an intellectual belonging to this epoch, too.[34]

Art historian and critic Christopher Phillips has underscored the theological and spiritual bearings of all of Beuys's work, arguing that all his art objects, his performances, and his public persona have always been concerned with questions of faith and mortality, impermanence; they "dramatize the search for fleeting signs of transcendence amid the terrifying succession of accidents, the flux-toward-death, that defines human life." Beuys, as Phillips notes, was shaped by his immersion in what one of his earliest critics described as "postwar Christian existentialism,"[35] a milieu that shaped a generation of Christian artists and intellectuals in Europe after the Second World War. We find the shared concerns of many "Catholic youth" articulated in Vattimo's short autobiographical sketch at the beginning of *After Christianity*:

> After World War II, when I was about ten years old, I used to go to the parish church, where I developed my basic attitudes toward the world and others, including my social, political, and religious interests. Indeed, it was to live up to this blend of interests that I decided to study philosophy at the university: I wanted to contribute to the formation of a new Christian humanism, which would be free from liberal individualism and from collective and deterministic Marxism.[36]

Without a conception of the centrality of Beuys's faith to his practice—to the works he made, the initiatives he planned, the selves he styled—we can at best only partly understand the prophetic bearing he sought to give his work and, indeed, the prophetic bearing he sought to *have* by means of his work and its reception. It almost goes without saying that this dimension of his practice would come to render his work all but unintelligible and certainly uninteresting to the generations of Anglo-American critics who have sought to understand it in the context of early postmodernism, of the legacies of American formalism and minimalism, or—in the case of his most caustic critics—of a secular literary romanticism.

In a discussion from 1979, Louwrien Wijers asked Beuys how he felt about the word *mysticism* as it applied to his work, a word that, as she noted, had been tossed around quite frequently in American reviews of Beuys's retrospective at the Guggenheim Museum in New York that year (most notably Benjamin Buchloh's famous article "Twilight of the Idols," which would be published the following year).[37] Wijers asked, "Reviews on your show . . . say that people over there [in America] are especially attracted by the mysticism in your work. In the 'Soho News' art-critic John Perrault writes that you bring a totally new feeling to America with this mysticism that your work has. How do you look at mysticism yourself?"

Beuys answered curtly, "There is no mysticism. The first distortion of the idea [of the work] is that it deals with mysticism. Perhaps there are some mystics in it, but not mysticism. And there is a difference between mystics and mysticism." Continuing in his consideration of the response of his American audience, he said, "I don't know what they call mysticism, it is in truth perhaps the interest of the spirit; that the work expresses the spirit, and not the formal aspect."

In the context of American art, Beuys felt, "a lot of art production runs along the line of formalist art; what one could call Post-Modernism, a kind of formalist intention like Don Judd, Carl Andre, Robert Morris," whereas his work, in his estimation, gave viewers the feeling that he had "a real other intention to go on with art, an intention which is related to the problems of the world and related to the questions existing on [the issue of] ecology and on powers, you know. My work is mostly related to creative powers."[38]

He suspected that the reason for the imprecise choice of the word *mystical* on the part of many critics owed to their sense that he was conducting experiments that, although they operated formally, were nevertheless not motivated by what an American audience would conceive of as formal concerns. How else to describe something that was neither Pop nor High Modernist, neither kitsch nor avant-garde, or at least not avant-garde in any of the right ways, but to make recourse to the nameable ineffable evoked by the word *mysticism*? Beuys went on to impute a readiness on the part of his American audience for "a real other context," one that he felt was "variated to all directions, to the existing problems of humankind; nature, society, psychology, creativity. The existing questions have to bring up the consciousness

and then the consciousness has to be researched again and has to be brought up to a real other, higher level of understanding of what culture means." The people could feel this new context, he thought, even if they lacked a vocabulary to articulate it. And it was "variated" in such a way that it demanded respondents who themselves wanted something more, something that would be receptive and responsive to their creativity. A collective test-drive of everyday life. It lay outside of language, but it was on the cusp of it: "That they feel. And I think they quote it sometimes with the word mysticism. But there is perhaps not a clear idea about the differences of mysticism and mystics and spirit and consciousness. I think that's perhaps the excuse for the application of the word mysticism in the intentions of the writers." He added, "So I refuse ever to be interested in mysticism."[39]

In one of our discussions, Wijers told me, "You shouldn't put words on things too easily, because you may rob it [of its] content. Especially *mysticism,* because as soon as you call something 'mysticism,' the mysticism of it is gone."[40] In their 1979 interview, Beuys was very clear on this point. Asked whether, despite the problems of naming such things, he could say a bit more about what "mystic" meant to him, he replied squarely, "Yes, mystic means the undeclared secrets of life. But I do not call it mystics, I call it the unsolved questions in the whole culture."[41]

Philosopher Arthur Danto's neat sum-up of Beuys's impact is quite close to Beuys's own self-assessment above, his sense that his work was concerned with existential issues and spiritual problems that captured the interests of his viewers and interlocutors. "Beuys' greatness as an artist," writes Danto in his foreword to a new critical anthology on Beuys and his legacy, "perhaps consists in convincing us that there is a riddle for which his works serve as partial solutions."[42] A riddle: What does it mean to be in this body, in this world, with these others, at this time? How do I, in this body, with these others, invent a world in which my work can matter?

We must count Beuys among the contemporaries that Vattimo mentions when he suggests, "For those like me who have any familiarity with contemporary philosophy, but above all with postmodern life, religious belief can only have this meaning characterized by a deep uncertainty of opinion."[43] Beuys considered that contemporary

life masked, but had not eliminated, possibilities for a cooperative and prophetic amorous socialism, a strange and—even for him, only half-cooked—cohabitation and collaboration among individuals, species, and their respective realities, real and imagined. Amorous socialism was at once grand and expansive in its perception of possible modes of interdependence and fraught with political problems, intensely speculative and inventive, but also often didactic and egomaniacal, in its way of giving form to these instantiations of interpersonal, inter-species, international, and "supersensible" confluence.[44]

In 1973 Beuys released the photograph of his 1967 *Eurasian-stab* action as an edition of 180 prints. The multiple itself, entitled *From Eurasianstaff: Action with Fat on the Body,* shows Beuys with a lump of fat being squished inside the crease of his bending knee.

In the original 1967 action, a work that was meant to encourage cooperation between a generalized people of the East and people of the West and also between the spirituality and the science that these two geographies symbolized for him, Beuys arranged shoe soles in the form of a cross. Antje von Graevenitz recalls that Beuys attached

a lump of fat in the upper corner of the room and in the opposite bottom corner, [implying] that the room itself required a deposit of warmth for the traveler. Fat in the form of a triangle or a pyramid was synonymous for Beuys with thought, production, and the creative act. Fat and its form were thus synonyms for energy and thought.[45]

Andrea Duncan has written, "Beuys has an approach to the body which is physiologically untenable: he is using the body to think. . . . This is a departure from the history of Western dualism, opening up a discourse with the body in which thinking is also a process of descent—it moves from head, to chest, to pelvis through knee to foot. We are reminded that Beuys said that he 'thought with his knees.'"[46] For Duncan, Beuys's work and its calls for bearing and sharing wounds perpetually had to walk a line between a radical openness to the multiplicity of the discursive body and what she calls "the associated fear of the moist, for there is no wounding without moisture's escape: dissolution and loss of objectboundaryhood." Duncan's coin-

age of this term, *objectboundaryhood*—the edging contouredness that lets things sustain themselves as things in our engagement with them—is an important theoretical concept for dealing with Beuys's work; for Duncan it is in this state of an always morphable object-boundaryhood where Beuys's work does its *work*. This propensity to call the body's boundaries into question, to see them as trajectories of becoming something other, or even, more disturbingly perhaps, becoming similar,[47] is the quality of Beuys's work—over and above any verbal statements and rationales—that lets it "remain open to discourse, to risk," and stages its commitment "not to foreclose on the subject *in process*."[48]

Beuys's inscription on a 1954 piece, *Double Fond,* two stacks of layered felt, each topped by a copper plate, reads: "The iron lumps are so heavy in order to prevent me escaping lightly from this hell."[49] In this wonderfully theological self-referential moment, we find that felt is taken to embody the "Beuys" that is prevented from escaping the hell in which he finds himself. This line tempts us to imagine that, much as he could liken himself to a hare, or to Chingis Khan, or to Anacharsis Cloots, the self that Beuys understood himself to be was intelligible to him in terms of the feel, form, function, capacities, and material histories of felt. This felt, again, is a different one from the haptic body so fascinating to Deleuze and Guattari; it is a thermal, breathing, insulating, moist, soundproof body, at once an acting body and a functioning buffer. And it is here that we have to be most careful; it is here that the pull of metaphor becomes tricky and dangerous: it is crucial not to let this deft formalism, one that operates so elegantly precisely because it can move across and between modes of "object-boundaryhood," facilitate a more simplistic metaphorization in which felt becomes (for us, in our reading of his work) somehow "equivalent" to Beuys, his surrogate, a trace that conjures him wherever we find it, a surrogate self that incarnates itself, and reemphasizes Beuys and his mythos, wherever it crops up. The more interesting way to grapple with Beuys's use of felt is to see it as an instantiation of his willingness to take the risk of losing his objectboundaryhood, pushing for that openness and intimacy with a world inhabited by others, however much his own more public presentations of self may have delimited the possibility for such genuinely risky and entangled encounters.

## BELIEVERS

In Caroline Tisdall's catalogue, in the entry accompanying Beuys's action against Duchamp's silence, she notes, "Such a direct criticism of something within the canon of modern art is unique in Beuys' work and was provoked by the nihilist Duchamp cult of those years, when it was still believed that the master had given up art for chess."[50] Here we might jump back a bit to look at the events that led up to this dramatic attempt to root out these dangerous nihilists and their arch Anti-Artist.

The resurgence of interest in Duchamp in Europe had been rekindled only a few years before, in 1960, when he had his first major exhibition in Europe at the Kunstgewerbemuseum, in Zurich, one year after the 1959 publication of the German edition of Robert Lebel's monograph on him.[51] It seems that when all is said and done, history was the medium that Duchamp was able to wield most successfully. In 1965, a year after Beuys made his action, as Eugen Blume notes, "history answered this gauntlet thrown down by Beuys with a strange coincidence": Duchamp's first show in Germany was held in Krefeld, Beuys's birthplace. The exhibition would have been in the making in 1964, when Beuys performed *The Silence of Marcel Duchamp,* and Beuys was no doubt anticipating it when he and his activist brand of Fluxus went live on West German TV.

The following quote from Duchamp appears on the cover of the catalogue for the 1965 show in Krefeld:

I believe art is the only form of activity through which human beings can manifest themselves as true individuals. It is through art alone that human beings can go beyond the animal stage, for it is an escape into realms where neither space nor time apply. Living means believing, at least that's what I believe.[52]

It is important to spend a moment trying to decipher what is meant here by "believing," with the caveat that a successful deciphering of Duchamp's message, far from understanding him better, would most likely entail *not* understanding him more interestingly. To revisit

something that we've already seen of Duchamp's early writing, before his "retirement" from art making:

> In terms of popular metaphysics I'm not prepared to discuss the existence of God. Therefore the term *atheist,* as opposed to *believer,* does not interest me. Nor does the word *believer* and the opposition of these words. To me there's more than just *yes, no,* and *indifferent.* There is also the absence of such investigations.[53]

In a 1963 interview in which this writing was read back to him, Duchamp gave it a lukewarm affirmation:

> I don't regret writing that. To me it's relevant even today. I'm still convinced that the positive, the negative and the indifferent do not offer satisfactory explanations. . . . You'll ask me what I have achieved . . . I wouldn't know. The future will judge. It really doesn't matter to me. I've lived what I wanted and how I wanted. Many say, "If only I had a country house . . ." But that's pointless.[54]

In response to Duchamp's Krefeld exhibition, Beuys made a note that read, "On 12.5.1963 Marcel Duchamp falls on his sword." May 12 was Beuys's birthday, and the year 1963 was significant in that on February 2 and 3, Beuys had performed in and helped George Maciunas to organize the Fluxus performance festival at the Düsseldorf Art Academy.

Beuys dated his involvement with Fluxus to 1962, when he first met Nam June Paik and Maciunas and discussed with them "the whole problem of art and anti-art, all those ideas."[55] He explained:

> We three worked together to organize something in various places at such Fluxus Festivals. While Maciunas and Paik concentrated on the Wiesbaden Action, which took place in 1962 and in which I, although I was on the list of participants, for some reason could not take part, prepared the Düsseldorf Festival Festival [*sic*] for the following year at the Academy. In 1962 I myself did not take part in any actions.[56]

Perhaps he was waiting to see how the first one turned out in order to gauge his level of commitment. In any event, Beuys later said that if he had been a participant in Wiesbaden, "he would have done something with the Earth Piano," an idea for an action combining piano and earth, which, since Beuys deemed that it "was much better as a concept," he never actually produced. Beuys said that this first almost-Fluxus action was nevertheless not his first Fluxus action but an idea that he and Paik had discussed.[57]

His first Fluxus action was *32nd Sequence from the Siberian Symphony,* which he described in an interview with Robert Hamilton as one of his most important actions and also "a key point in [his] further development of demonstration in FLUXUS."[58] Beuys characterizes himself as a provocateur with respect to the early aims of Fluxus. He explained:

I was directly involved in the ideas of Maciunas to realise examples of a new attitude and of a new shape or feature. But at the same time I felt that this understanding of these new attitudes as a neo-Dada attitude for me was too much only a repetition from an older state in the development and therefore in my first action I did it directly opposite. Inside the FLUXUS movement I did my first action directly opposite to the understanding of FLUXUS. For instance for Maciunas or the American artists I saw that they could not really understand the connection, but they were a bit against my first action. My first action was an action with a hare too. . . . I had a big black piano on the right side and a blackboard and on the blackboard I wrote diagrams. The idea was to communicate with other spectators than only human beings, therefore the hare. And I made the connecting line from the blackboard, from the dead hare who hung on the blackboard over these diagrams. And there was a connecting line divided in proportioned sections and it hangs over small sticks, stuck in balls of clay. And this line goes over the whole piano and then I played piano. I produced special sounds, and made this action with the dead hare. I made it open, took the heart out and placed the hare away and the last feature-evasion. In

this piece was only the small heart on the blackboard. Yes only the small heart connected with the whole line to the piano and the sticks and balls of clay. It looked very empty, very real like a Siberian landscape. That was the shape. From this time I used the word action more than happenings, anti-art, FLUXUS, Art Totale and all these declarations.[59]

As Owen Smith has suggested, the Düsseldorf event itself, like many of Fluxus's activities, was less a partnership among individuals with a cohesive aesthetic and political agenda than it was a kind of "small-scale opportunism";[60] despite frequently complex organizational efforts, Fluxus events were often produced in and by means of a constantly changing web of friendships, friend-of-a-friendships, connections, and loose-knit groupings that arguably had as much to do with happenstance as they did with strategizing. But Beuys's action had literally nothing to do with Fluxus as it is commonly understood today; it participated in the same kind of small-scale (but increasingly growing) opportunism.

Wolf Vostell had also been a participant in the Düsseldorf Fluxus event, and he along with Beuys and Schmit had taken responsibility for orchestrating further Fluxus events in Germany after George Maciunas, Dick Higgins, and Alison Knowles left Europe in late 1963.[61] In 1965, at the opening of yet another Duchamp exhibition in Germany, this time in Hanover, Vostell, perhaps opting for understatement in contrast to Beuys's dramatic prophecies and television appearances, went on a Fluxus defensive–offensive by presenting Mr. Silence with the gift of a toothbrush.[62]

Of course Beuys's statement is polemical and had more to do with coloring Duchamp as a curmudgeon who had little time for things new and revolutionary than with any real desire to understand the fullness of his relationship to the artists directly and indirectly involved with Fluxus. In fact Duchamp thought highly of a number of Fluxus artists and participated in projects with them as well as contributing to publications by Higgins's Something Else Press.[63]

In the notes to her *Coeurs volants (Flying Hearts)* project, undertaken with Duchamp in 1967, Alison Knowles recalled:

Through Daniel Spoerri, the Something Else Press arranged to meet Marcel Duchamp. This screen print was preceded

Alison Knowles with Marcel Duchamp at his apartment in New York, selecting colors for their *Coeurs volants* collaboration, 1967. Reproduced by permission of Alison Knowles. Photograph by Bill Wilson.

by a four by five color swatch showing two circles, one red, one blue. He selected this color swatch one day while we were having tea at his tenth street apartment in New York. There were eleven color swatches, each showing blue and red circles but in different intensities. He selected one and left it out on table saying "Oh, that's it." I put the others in my brief case and we kept talking. Teeny Duchamp walked

by the table, saw the color swatch and said "MARCEL, when did you do this?" He asked for a pencil, smiled and signed the color swatch. This color swatch was quickly framed and the rumor quickly spread through New York that we had Duchamp's last readymade! I kept this little swatch for about a year and then sold it to a collector in Remsheid. Richard Hamilton, to whom I gave a copy of a final print, called this work a piece of memorabilia, not a readymade. Duchamp died the following year but I am sure he would have agreed. I like the story very much because it describes the process as important as the product according to a master.[64]

Emmett Williams elaborated on this account:

Hansjorg Meyer, way back when, did the first version of *Sweethearts*.... I went over to Nantes, to work with Daniel Spoerri on translating the book he had done in Greece [*Mythological Travels*]. And while there, Dick [Higgins] said, "Ah! This is so wonderful, everyone is raving about this! Let's have an edition of *Sweethearts*." So I said okay. He said, "Could you think of a cover?" Hansjorg's edition was beautiful—black and white and so on. I said to Daniel, "Frankly, when I think of sweethearts, the only thing I'd like to see on the cover is Marcel Duchamp's *Coeurs volants*." He said, "Why don't you ask him?" I said, "I'm going to ask Duchamp if I can use this famous work?" He said, "Well, if you haven't the nerve, I'll ask him!" So Daniel wrote to New York, and said, "Look, Emmett Williams here." And Duchamp wrote back: "For God's sake! I know the book very well. I have two copies. Richard Hamilton sent me one and Jasper Johns sent me the other. As soon as he's back in New York ..." So that's the second time I met Duchamp. The first time we didn't really embrace or anything like that.... The Something Else Press did a print, you know, on the occasion that ... they didn't give me any credit for it, mind you. The whole idea that I'm there, signing this and that, and Duchamp said, "Don't we have a print for Emmett?" Alison [Knowles] found an old rejected print or something like that. He said, "Oh, that's very good!" So

he wipes off the print, you know. "A special dedication for Emmett," you know, zero, zero, a broken heart for Emmett.[65]

Beuys's take on Duchamp's opinion of Fluxus is thus best understood as a fabrication devised in order at once to position himself alongside Fluxus and its activities and to mark Duchamp as a kind of reactionary worth scolding for his offhand rejection of them and their work. This must also be squared with Beuys's notion of Social Sculpture, an idea that could take on a certain cohesion by being pitted against the example of Duchamp's ostensible withdrawal from art, one whose insistence upon active and politically engaged creative practice was decidedly at odds with what artist Elaine Sturtevant described as Duchamp's deliberate relinquishment of creativity: "What Duchamp did not do, not what he did, which is what he did, locates the dynamics of his work. . . . The grand contradiction is that giving up creativity made him a great creator."[66]

This was the issue that, for Beuys, would never compute. In the midst of the swell of interest in Duchamp toward the end of his life, Beuys wondered aloud why everyone was so taken with him; in a 1969 interview with Willoughby Sharp, he asked polemically why people were not instead spending more time "thinking about Schiller or Nietzsche" rather than Duchamp?[67]

We can perhaps leave this as a lingering rhetorical question or, even better, write it up as a Fluxus event score:

*Stop or Spend*
    1. Stop thinking about Duchamp
    2. Spend time thinking about Schiller
    or
    3. Spend time thinking about Nietzsche

1969/2008

In that 1969 interview, Willoughby Sharp asked Beuys when he had first become aware of Duchamp's work. Beuys was uncharacteristically inaccurate; he said, "In 1955, I think." His choice of this date is an interesting one, in that 1955 was also the first year of Beuys's "phase of depressive exhaustion," which lasted until 1957.[68]

In Martha Buskirk's essay on Duchamp's extensive artistic and archival labors during the years of his putative withdrawal from art making, she notes that Duchamp's rising fame in the mid-1950s was also a source of considerable "irritation" for no less a master than Picasso.[69] Maybe the paradox of Duchamp's rising fame despite his orchestrated rejection of art making was what sent Beuys past the edge and what compelled him later, literally, to become the boundary line between Duchamp and Fluxus, the figure that would fight an increasingly absurd battle to keep Duchamp quiet in his self-imposed silence and to keep Fluxus alive and aloud in support of Beuys's own political and personal agendas. In their 1986 interview, Sharp asked, "I feel the presence of Duchamp in one of your earliest pieces of sculpture, 'Untitled,' of 1954. Do you see any influence?" Flatly, Beuys answered, "No, I don't think Duchamp influenced it at all. It was influenced by life."[70]

Beuys continued to describe his Expanded Concept of Art, one whose expansion was tied intimately to his engagement with Fluxus. This prompted Sharp to ask him which artists he felt closest to. Without hesitation, he answered, "John Cage. These concepts are not alien to him."[71] Sharp then asked, "What about the new Italian sculptors like Mario Merz or American sculptors like Richard Serra?" Beuys replied, "Yes, I feel close to them, because they are contemporaries. But not that close because I have a feeling that these things already have been done. Perhaps the reason I love Cage and Nam June Paik more is because they are at the point of origin. Things have a certain reach. Beyond that everything is derivative."[72]

It is important to note again that this interview happened in 1969, during which time Beuys's friend Robert Filliou was completing his book *Teaching and Learning as Performing Arts*. The book contained interviews with a number of Filliou's artist friends, and Beuys and Cage were among them, which is perhaps what had put Cage in the forefront of Beuys's mind. Cage had come to Cologne in 1960 and had performed in the Contre-Festival, which was organized by Mary Bauermeister, wife of Karlheinz Stockhausen, and in which many of those who would later become involved with Fluxus—George Brecht, La Monte Young, Benjamin Patterson, and Nam June Paik— also took part.[73]

Though Beuys disavowed it, his relationship to Duchamp was nevertheless just as recerebratory as Cage's to Duchamp and just as

intimate, albeit far less comfortably so. *Recerebration,* a term all the more Duchampian for having been coined by Cage,[74] is the perfect concept with which to approach Beuys's rating of Duchamp's brand of silence. Beuys's rejection of Duchamp's silence was the mechanism for his recerebration of Duchamp; in his outright refusal, Beuys had none of Cage's success in recerebrating his way through the anxiety of influence. (Indeed Cage, who seemed to think of his engagement with Duchamp not as influence as such but rather as a kind of confluence, taking the form of an intimate, however distanced, friendship, appeared to draw great pleasure from their arrangement.) Beuys's refusal only bound him more tightly and confusedly to Duchamp and his labyrinthine legacy. The irony is that Beuys's affinity for Cage and Cage's notion of silence, which for Cage was a recerebration of Duchamp, was what inflected Beuys's explicit rejection of Duchamp himself.

## A TORRENT OF JOYCEAN ERUDITION

Like Duchamp but with an autobiographical zeal closer to James Joyce, Joseph Beuys helped himself to episodes of his own life for aesthetic material.[75] As art historian Pamela Kort has argued, through his autobiographical work, Beuys

> found a means to come to terms with his past by reshaping the very experiences that had at times cruelly shaped him. For both [Beuys and Joyce], autobiography meant focusing upon the thoughts of their lives rather than its fortuities of act or occasion. By turning fact into fiction and fiction into fact, they reordered their lives and universes to fit the purposes of their production of art.[76]

The routes Beuys provided for those seeking to analyze his oeuvre are entangled ones. The one strand that has seemed at once most promising and perplexing is a text to which Beuys gave the title *Lebenslauf/Werklauf (Life Course/Work Course).* He began working on this cross between "curriculum vitae [and] quasi-fictional narrative" in 1964 and tended to it himself until 1970, when, according to his wife, Eva Beuys, Beuys's friend and collector Heiner Bastian

"decided to supplement the *Lifecourse* between 1970 and 1973."[77] A subsequent version was released in 1984 for the catalogue of the Joseph Beuys–Ölfarben exhibition (in Tübingen, September 8–October 28, 1984). Whether Beuys sanctioned this expanded version or not is unclear but likely. Art historian Pamela Kort has argued that what was at stake in it

> was more than a matter of syntactic order: at stake was the ordering of Beuys's life, and the fixing of his self. This is the hidden agenda of Beuys's *Life Course;* it is implicit in its construction and suggested by his continuous adjustments to it between 1964 and 1970. That Beuys considered it a manifesto is indicated by the fact that he authored no other document to which he accorded such importance: it was included in almost every book and catalogue published about him over which he had some form of control.[78]

And yet the final version—which ends with the following entry for 1973: "Joseph Beuys born in Brixton"[79]—was thus arguably not authored by him.[80] Nevertheless, even if Beuys did not conceive of this strangely Joycean move of ending his narrative with his own rebirth in Brixton, it seems unlikely that it could have been published in the 1979 catalogue or elsewhere without his blessing. Also unlikely is the notion that Beuys would have become less interested in it just under a decade. Instead we might wonder if he had become intrigued by the possibility that others might contribute to the grain of his own authorial voice, that the more it became *not* his, the more ownership he would have over it.

Two explicit references to Joyce occur in the *Life Course*. The first is one of the entries for the year 1950: "Beuys reads 'Finnegans Wake' in 'Haus Wylermeer'"; the next is one among several entries for the year 1961: "Beuys adds two chapters to 'Ulysses' at James Joyce's request."[81] Whether or not we take Beuys at the word of his *Life Course,* the emergence of Joyce in his work can be traced to at least 1958. It was then that he began what would later compose six books of drawings that were the basis for his extension of *Ulysses.* Kort suggests that this two-chapter addition was an allusion to two new "chapters" in his own life, the first opened by the birth of his son,

Boien Wenzel Beuys, in 1961, and the second by his appointment as a professor at the Düsseldorf Academy of Art. "From this perspective," Kort suggests, "the seeming disparity between Beuys's description of the sketchbooks as '2 additional chapters' and their enclosure in six folios may be resolved."[82]

We might imagine Beuys relishing the difficulties he was cooking up for the historians and critics investing their energies in exegesis of his obliquely autobiographical stylings, loving the notion that this opacity would be a genuine gift to more than one generation of art historical detectives. We might also imagine the relish with which he made his way through Richard Ellmann's masterful biography of Joyce, with whom he had imagined a kinship, perhaps looking to it for suggestions as he brainstormed his own strategies for self-presentations and the acts of preemptive historical scramblings with which he would pepper them.

Beuys got hold of Ellmann's biography in 1971.[83] According to Kort, although his copies of *Ulysses* (he had two, the original and the German translation) and *Finnegans Wake* were kept clear of markings,[84] Beuys "marked thirteen passages in Ellmann's book with pencilled triangles," the following two of which he had indexed by page number inside the book's cover:

> But Stephen's esthetic notions are not renunciant; he becomes an artist because art opens to him "the fair courts of Life" which priest and king were trying to keep locked.

and

> In later life Joyce, in trying to explain to his friend Louis Gillet the special difficulties of the autobiographical novelist, said, "When your work and life make one, when they are interwoven in the same fabric . . ." and then hesitated as if overcome by the hardship of his "sedentary trade."[85]

It is difficult to say with certainty what Beuys read, how much of it he read, in what order, and in what language. Obviously he could not have acquired the 1972 English version of *Ulysses* that he kept in his library until a year after he had acquired Ellmann's book (1971). So, if

116

Kort is correct in suggesting that Beuys "read the book soon after buying it, given his long-standing interest in the author and considering the presence of the Joyce photograph in [his quasi-autobiographical installation] *Arena,* exhibited just a year later,"[86] possibly it was his reading of Ellmann's book itself, with its intricate tracking of Joyce's life and its transfiguration in his writing, that truly captivated Beuys and prompted him to tackle the English version of *Ulysses.*

Beuys actively pursued his studies of Joyce while he worked on his *Arena* project.[87] This work saw several incarnations, evolving ultimately into his 1979 retrospective at the Guggenheim Museum in New York, and was exhibited most recently in 1992–93 at Dia Center for the Arts, in New York.[88] The first version was shown at the exhibition Strategy: Get Arts in Edinburgh in 1970, as part of the Edinburgh International Festival. An untitled collection of 160 photographs of Beuys's work, this exhibition provided a kind of "visual analogue to the *Life Course/Work Course,* which, after 1970, Beuys left others to append";[89] he presented it along with a new action, *Celtic (Kinloch Rannoch) Scottish Symphony,* performed with composer Henning Christiansen at the Edinburgh College of Art,[90] as well as his recent sculpture *The Pack* (1969). Two years later in 1972, when the *Arena* project was first shown at Lucio Amelio's Modern Art Agency in Naples, it had undergone significant changes. For instance, it was renamed *Arena—Dove sarei arrivato se fossi stato intelligente! (Arena—Where Would I Have Got If I Had Been Intelligent!).* And where the images had at first been presented in unassuming photographic mounts, now they were "sequestered, portentously entombed, in specially designed, heavy aluminum frames."[91] In the next year and a half, *Arena* saw three more showings in Italy: at Galleria l'Attico in Rome (1972); at Studio Marconi in Milan (1973); and in a large parking facility underneath the Villa Borghese in Rome, as part of the large international exhibition Contemporanea (1973).

In 1972, during a visit Beuys paid him in London, Richard Hamilton recalled their lengthy discussion about Joyce and his work, sparked by Beuys cooking sheep's kidneys:

> Being in London somehow reminded him that Leopold Bloom fried kidneys in *Ulysses.* My comment that Bloom

had eaten pig's kidneys provoked a torrent of Joycean erudition. Though Beuys's fluency in English, at that time, was not great, his knowledge of a masterpiece of English literature was intense and deep.[92]

With this Joycean dialogue reaching its pitch, in 1974 Beuys, with the help of Caroline Tisdall, staged a show of his drawings, *The Secret Block for a Secret Person in Ireland,* which would introduce Ireland, north and south, to his work.[93] The trip had also served "as a vehicle for a lecture tour around Britain and Ireland in search of support for the FIU"—the Free International University, an experimental educational institution that Beuys, together with novelist Heinrich Böll and others, attempted to cofound.[94]

Beuys said of the enigmatic *Secret Block,* composed of drawings made between 1936 and 1972: "These are the drawings that I have put aside over the years . . . my selection of thinking forms in evolution over a period of time."[95] Kort has pointed to the interconnectedness of the *Life Course, Arena,* and *The Secret Block,*[96] autobiographical artworks whose relations to one another consumed Beuys throughout the 1970s, "a singular and unprecedented moment in Beuys's career as he consolidated his work into major holdings for posterity: these 'blocks' established significant presentations of his art in perpetuity."[97]

Spurred by the suggestively oblique reference to Joyce in *The Secret Block*'s title, we might wonder whether Beuys's reading of a particular passage in Ellmann's biography of Joyce played a role in his decision to make his block "secret." In his discussion of Joyce's days at University College, Ellmann explores several of the young artist's friendships, among which his relationship with John Francis Byrne appears singularly close. According to Ellmann, Byrne's

> power over Joyce came from his habit of refraining from comment: Joyce's admissions about his feelings towards family, friends, and church, about his overweening ambitions, struck like waves against Byrne's cryptic taciturnity. Byrne listened to Joyce's confidences without offering any of his own, and, as Joyce noted, without conferring absolution.[98]

Byrne's ever-ready ear as a silent secret-keeper, a confidant who could be counted on not only never to spill the beans but also, perhaps more important, never to offer a word of condolence or forgiveness, made him someone whom Joyce depended upon. "The friendship was of such importance to Joyce that when it dwindled," writes Ellmann, "he felt less at home in Ireland."[99] And in a footnote to the passage quoted above, we are told,

> Byrne kept this [cryptic and taciturn] manner in later life, when he concocted an allegedly unbreakable code without divulging its key; he wrote a memoir, largely about Joyce, in which he made clear he was withholding more information than he was furnishing, added a coded appendix to it, and gave the whole the appropriate title of *Silent Years* (1953). It is one of the most crotchety and interesting of the many books by Joyce's friends.[100]

Would Beuys have unearthed in Byrne's example a kind of confirmation of his own earlier addition–edition of six cryptic notebooks of drawings (i.e., the two further "chapters") that he had appended to *Ulysses* "at James Joyce's request"? Perhaps the reference to an entire appendix packed with Joyce's choicest long-buried revelations, riotous anecdotes, stories that could be known by only Joyce, Byrne, and whoever else could crack the "allegedly unbreakable code"—stories that were present but unintelligible and therefore pregnant in their silence—was altogether too alluring for Beuys to leave alone. Drafting from both the spirit of Byrne's book and his character as Beuys imagined them through Ellmann, Beuys's conception of *The Secret Block*, positioned as a supplement to the autobiographical fiction he had composed through his *Arena* photographs, could then be read as a kind of intervention directed toward activating an intimacy with Joyce. But it had to remain sufficiently opaque in order to keep the reference to Byrne from becoming literal and thereby crossing the line into the sort of trespass that Byrne had avoided by keeping quiet. Thus could Beuys resuscitate the figure of Byrne and incarnate himself into a twice-removed closeness with Joyce, skirting Byrne's name in order to slip into the skin of his deceptively generous silence, keeping Byrne's tactic of depending upon the power of secrecy to evoke

the noble aura of one who knows much more than he is willing or able to let on, yet who *must* speak and must therefore do so in code on behalf of the secret person in Ireland, even though his secret block be exhibited for all to see.

## ACTION FRAGMENTS

In a 1979 discussion with Martin Kunz, Beuys called *Arena* "practically my totally typical work, with its entire theory, the action fragments."[101] This statement poses an interesting challenge to critical engagement with Beuys's work: to somehow reconcile the notion that his work would have an "entire theory," a cohesive one that *Arena* might embody so aptly that he could call it "practically my totally typical work," with the notion that this cohesiveness would at the same time consist in a state of fragmentation.

In his 1967 action *Eurasian Staff*, performed with composer Henning Christiansen in Vienna and in Antwerp, Beuys cast himself in the role of an "East-West nomad." He positioned shoe soles in the form of a cross, upon which this nomad identified the four cardinal directions. "These," as Antje von Graevenitz explains, "were meant not only as geographic pointers but also as directions of mind." Von Graevenitz describes Beuys's performance:

> *Eurasian Staff* was a kind of staged story that had nothing in common with the reality of the room in the gallery. It was a story told in fragments that included healing materials, fragments of movement, sacred objects, and written words.[102]

According to Richard Ellmann, the artist's life "differs from the lives of other persons in that its events are becoming artistic sources even as they command his present attention. Instead of allowing each day, pushed back by the next, to lapse into imprecise memory, he shapes again the experiences which have shaped him."[103] Beuys's theory of the action fragment—and his fashioning of his autobiographical fictions operate in these terms—was thus theoretical in the strict sense of the word: it was a device for bringing a kind of cohesion and intelligibility, idiosyncratic but ultimately not inscrutable, to phe-

nomena that would otherwise be disparate. Beuys's action fragments, like John Cage's mesostic poems, are also a form of (to borrow Cage's parlance) "writing through"[104] experience. They provisionally frame episodes of his own life and the lives of others with whom he identifies, congealing them, but only in order that they might be rearranged, added to, expanded, and elaborated in accordance with the unfolding geometric spectacle of the interhuman intrigue.

It is interesting to note that, while Cage connected Satie with Thoreau and paired Joyce and Duchamp as modernism's two who stood alone, Beuys connected Joyce with Satie, his favorite composer.[105] When asked about the relationship of Satie to his action *Celtic,* Beuys said, "In the world of sound, Satie assumed a significance similar to Joyce's poetic or literary feats. Both attempted to construct a mythos that made reference to the ordinary man."[106] Elaborating upon the place of Joyce in *Celtic* and in Beuys's understanding of the voice, Henning Christiansen pointed out, "The manner of speaking, the tongue, palate, teeth, how one speaks purely technically, how one articulates, these are thoughts that Beuys understood through Joyce."[107] Beuys considered that the formation of speech was a sculptural act that "materializes thought, namely, it is already materialized in speech. Here the larynx is already vibrating, material already participates" (*Teaching and Learning,* 171).

In 1984 Beuys transcribed by hand part of a discussion with Heiner Bastian and Jeannot Simmen from 1979 and released it as an edition. The fragment he selected was one in which he had addressed the impact of Joyce's ideas upon himself.

I referred to Joyce because I felt that these things that change the universe belong to our consciousness, that you should give them prominence, for nothing less will do. But if you want to do something of this kind, then of course you have to make sure that these things live and that they really do radiate something. You must take no notice whatsoever of formal and stylistic criteria, but only concern yourself with the life principle of the thing as living matter. If you are not concerned with living matter then the thing will destroy itself. Nothing else can ever be central. All I want to say by this is that the principle of changing the world as an ingredi-

ent, as matter, you could even say as dynamic medicine—has
been crucial to me.[108]

Here we return to the theme of risk, the exposure to that which
exceeds one's objectboundaryhood; the determination to be at risk
in such a way was central to Beuys's faith and the variety of artistic
practice that he modeled from it.

Referring to an instance of *Finnegans Wake*'s scrambling of En-
glish and German and the conflict it poses between certain words
that cannot be "heard" but can nevertheless be read, Derrida has sug-
gested that Joyce's polylinguistic and synesthetic prose has the effect
of "placing the tongue at risk."[109] Referring to the following sentence
from the *Wake,* "And he war,"[110] Derrida insists,

> The Babelian confusion between the English *war* and the
> German *war* cannot fail to disappear—in becoming deter-
> mined—when listened to. It is erased when pronounced.
> One is constrained to *say* it either in English *or else* in Ger-
> man, it cannot therefore be received as such by the ear. But
> it can be read.[111]

We might approach a Cage composition in much the same way; his
attempt to foster "flexibility of mind" by sonic means makes listening
a profoundly destabilizing activity.[112]

Asked if he considered his *Writing through Finnegans Wake*—a
mesostic indexing of Joyce's magnum opus—to be a transgression of
Joyce, like Duchamp's mustachioed Mona Lisa, Cage answered that
the writing through "has nothing to do with him. It's something else.
He would have enjoyed it, and there are some Joyce scholars who
think that Pound would have enjoyed my *writing through* the *Can-
tos.* Certainly there are more Joyce scholars who enjoy my writings
through *Finnegans Wake* than Pound scholars who enjoy my writ-
ings through the *Cantos.*"[113]

This is the strange sort of gift that Deleuze and Guattari aimed
to give Kafka in their *Kafka: Toward a Minor Literature,* whose aim
was to craft a "writing through" Kafka's work that could give him
"a little of this joy, this amorous political life that he knew how to
offer, how to invent. So many dead writers must have wept over what

was written about them. I hope that Kafka enjoyed the book that we wrote about him."[114]

Beuys's version of experimentalism—"I felt that art was at its richest," he said, "when the laboratory spirit of research, scientific results, and a clear theoretical structure were there to extend it to a wider understanding"[115]—had much in common with Cage's own, even though Cage portrayed his experiments as efforts to elude imprisonment in the relational regimes of any particular theoretical structure. Both generated processes that depended upon a radical openness to the complexities and singularities of the materials with which they worked. But their views of formal and conceptual experimentation do diverge, and this has much to do with their political leanings; where Beuys embraced a democratic socialism whose enactment would be dynamic and chaotic, Cage was committed to the condition of anarchy as such.

In this respect, Cage's aversion to systems of conceptuality thus strikes a chord with Deleuze and Guattari's characterization of minor literature as a writing that "begins by expressing itself and doesn't conceptualize it until afterward";[116] Cage said in one interview:

> While our way of thinking is so simple, our experience is always, and in each instant, extreme and complex. When we think, we continually return to the paired opposites, sound and silence, Being and Nothing. This is precisely in order to simplify experience, which is beyond simplification and never reducible to the number two.[117]

## FIELD CHARACTER

In an essay on Joseph Beuys's drawings, Ann Temkin makes reference to the impact that Cage's innovations in musical notation had for Beuys, enabling him to make the link between his sculpture and what she calls Cage's "sculptural approach to sound." This shift in thinking and the new visual possibilities for producing sound that went hand-in-hand with it, she argues, "licensed the great variety of unconventional pages that would serve as 'scores' to Beuys's actions," although

she notes the important differences between Beuys's drawing-scores and Fluxus artists' scores. "While the latter primarily were written as prescriptive recipes that anyone could enact at any time," she writes, "Beuys's drawings do not begin to offer such opportunity. They remain distinctly tied to unique events, wholly dependent on Beuys's own persona and the setting, sound, timing, and mood that he created."[118]

However, much as Cage's work with *Finnegans Wake* gave rise to the amorous readerly by-products that are at once integral to and distinct from his writings through it, the resemblance of his musical scores to drawings was also similarly supplementary. Their closeness to pictures, he said,

> arose as a by-product. The intention was to make a notation that would recognize that sounds did truly exist in a field; that our previous notation had not permitted our recogniz-ing this fact or even acting on this fact; that we needed other notation in order to let sound be at any pitch, rather than at prescribed pitches. In order to do that, it had to become graphic; and in becoming graphic, it could accomplish this musical purpose.[119]

Its becoming graphic permitted musical notation to picture sound, enabling one to "recognize that sounds did truly exist in a field [as Cage insisted], rather than in the abstract context of an intellectual system."[120] This use of the pictorial techniques to develop a score adequate to the existence of sounds in a field was intimately con-nected to both the process and the goal of Cage's writings through:

> I can go through the book and find out where I *hear* some-thing, for instance: if the writer says someone laughed or a dog barked I can jot that down and I can identify that by page and line and I can then *insert* a barking dog or a cry-ing child at the point that it belongs in relation to the ruler that I've already written. And if places are mentioned in the book, I can go to those places and make recordings and put them where they belong in relation to the ruler, and eventu-ally I have a piece of music.[121]

It was precisely this metaphor of the field that Beuys would employ, both in the organization of his ideas and in the very title of his 1973 statement "I am searching for field character," that text in which he outlined his notion of the Social Sculpture, predicated upon his conviction that "EVERY HUMAN BEING IS AN ARTIST."[122]

Beuys had been introduced to Cage's work largely through Cage's brief involvement with Fluxus in the early 1960s. Here we recall that in Willoughby Sharp's 1969 interview of Beuys, Sharp asked Beuys which artists he felt closest to. Beuys answered without hesitation: "John Cage. These concepts are not alien to him."[123]

He and Cage continued their friendship until Beuys's death in 1986. In 1982 Beuys dedicated his screenprint titled *Quanten* to Cage.[124] Under the title *Orwell-Blatt,* Nam June Paik published two drawings from Beuys's series *Words Which Can Hear* (1981),[125] together with a drawn score by Cage from the series *Where R = Ryoanji* (1983), printed in an edition of five hundred that was released by Schellmann/Klüser in 1984.[126]

In May 1986, four months after Beuys's death, Cage returned the dedication, composing a mesostic for Beuys for Klaus Staeck's homage collection, *Ohne die Rose tun wir's nicht: Für Joseph Beuys.*[127] Cage treats water and its elemental force as the organizing theme for the homage.[128] But it is a "detourned" and backhanded homage: it permits the mesostic to pose a cohesive association between the combined qualities of the relentless and the mercurial and Beuys's own tendency to embody these characteristics simultaneously in his management of his ever-proliferating courses of life and work. Indeed, by making use of an arguably deliberate play between two possible readings of the final line ("aS tool" could be reread as "a Stool"), Cage's mesostic gives rise to the possibility that the

> The interrelationShip
> of procEsses

to which Beuys's work refers, both in its content and in its materiality, include the bodily processes of ingestion and excretion; if acting in accord with this interdependence is

> more than Just a
> persOnal thing

124

```
        more than Just a
              persOnal thing
  the interrelation$hip
        of procEsses
    not the sPlitting of life into separate compartments
          wHoleness

          Bathtub
      the strEss is on the meaning
          to Use my life
      from earlY on
          aS tool
```

Thoroughness like water

it is because, precisely in the form of these practices, ingesting and excreting, the "persOnal" enacts its connection to the "wHoleness" of interconnected flows of change and transformation, "not the sPlitting of life into separate compartments." As Beuys said in an interview with Robert Filliou, "Most people ignore the fact that their own bodies also belong to the environment. They think only what which [*sic*] surrounds them is their environments" (*Teaching and Learning*, 171). Here we might recall Filliou's reflections on excretion in his "Yes—an Action Poem" from 1967, in which he suggests that urination has as much poetic potential as any other form of contributing something of oneself to the world: "Excretion is of such vital importance to the good functioning of the poet that the departed savant, Leonardo da Vinci, insisted that 'the poet is a wonderful mechanism transforming good wine into urine.'"[129]

In their book *Formless: A User's Guide*, Yve-Alain Bois and Rosalind Krauss note, "Laughing about the pun it incarnated, since German for chair (*Stuhl*) is also the polite term for shit (stool), Beuys was happy to give an excremental spin to his celebrated sculpture *Fat Chair* (1964)."[130] And Joyce himself, as Sarat Maharaj has noted, treated his writing practice as something that drew in equal portions from the heavens and from the bowels.

> The heavenly aura of writing, as the trace of the intellect's sublime processes, he set off against its lowly materials and mechanics. He saw it as earthly business closely tied in with the corporeal, to body functions and fluids, to creating from body-waste products. For his grubby scribblings, Shem, the penman, notoriously concocted a fecal ink from the "secretions of his foodstuffs"—a recipe so foul that Joyce rendered it in Latin to parody obscurantism and the time-honored convention of occluding the "unmentionable."[131]

## INTERIOR TUBLOID

Cage's mesostic for Beuys went through some suggestive draft stages. In Staeck's collection, two versions of it are published, one a sketchlike handwritten draft in red, blue, and black ink with crossings-out

and insertions, the other a neatly typed-out final draft. In his handwritten version, Cage presents us with several moments in the mesostic's development, leaving the scatterings of his experimentation with different possibilities for the central letters: for the *O* in "JOSEPH" he had begun to write what looks as if it would have been "sculptOr" but was left at "sculpt" and then crossed out, as was "One among," finally settling upon "sOcial." Oddly, with a caret he has indicated that this would be inserted into the line above ("not Just artist"), to make it "not Just sOcial artist," which would have taken the mesostic into new territory by disrupting the separation of the lines, scrambling the one below into the one above.

The most editorial activity flurries around the letter *E* in "JOSEPH." He has crossed the beginnings of a word ("urgen") only to have it reappear below as one of two final possibilities—he keeps the words "urgEncy" as one option and "Everyone an artist" as the other—which seem to have been arrived at after he had tried on for size the words "rEvolution" and the *Wake*-inspired "hEre comes everybody."

The entirety of this first draft was later scrapped, but Cage left his earlier scrawl on view on the same page as his new draft for "JOSEPH BEUYS," which was to remain virtually unchanged in the final typed version except for the removal of a few words here and there. (For example, "of all procEsses" was to become "of procEsses," "a wHoleness" was to become just "wHoleness," and so on, following Cage's semiconsistent practice of opting for omission in his mesostics.) Perhaps he had identified the passages for *P* and *H*

the Place we are
tHis moment

as the most fertile of the first draft and had maintained this emphasis upon attunement to the present moment as the effect he most dearly wished to achieve in his revision. Certainly this attention to the richness of the present remains in the final draft's embrace of "wHoleness" rather than ". . . the sPlitting of life into separate compartments"—twin phrases that are both captured by Beuys's notion of the action fragment.

In the handwritten draft, we find Cage's most suggestive act of editing. In his final treatment of the *B* in "BEUYS," he had decided after

much deliberation to opt for the word "Bathtub." The word refers to Beuys's sculpture from 1960, which is sometimes treated as a work without a title—as in the case of the recent catalogue *The Essential Joseph Beuys,* which labels it *no title [bathtub]*[132]—and is sometimes titled *Bathtub (Show Your Wound).*[133]

Beuys explained, "If we show our wounds to others, we can be healed. These wounds can be anything—desires, the unspeakable."[134] As Rogoff argues, Beuys's work sparked in postwar Germany "a notion of involuntary collective memory and led it in the direction of language, thereby facilitating some entry, however inadequate, into the hitherto taboo notion of narratives of the past."[135] But in the very passage in Caroline Tisdall's 1979 Guggenheim catalogue from which Cage drew his mesostic source material, Beuys insisted, "It would be wrong to interpret the *Bathtub* as a kind of self-reflection. Nor does it have anything to do with the concept of the readymade: quite the opposite, since here the stress is on the meaning of the object."[136]

In writing through this passage, Cage again ignored his own rules for mesostic composition. If he had settled on the word "Bathtub" as his first *B* in Beuys's text, then he deliberately skipped several eligible words (beginning with **"self-reflection"**), dodging them in order to get to the one he wanted to use: "the stress is on the meaning of the object." And in fact the word "Bathtub" had not been Cage's first choice. He settled on it only after first considering and ultimately crossing out the word "Biography."

Perhaps for Cage the relationship between biography and the bathtub had yet another layer of possibilities. We ought not forget that he published his draft of "Thoroughness like Water" complete with all its editings, knowing that his revisions and changes of mind were there for all to see. Conceivably Cage's inclusion of both a handwritten and a typed version of the mesostic, complete with editorial markings and crossings-out, was a kind of quotation of the overall graphic look and demeanor of Duchamp's notes for *The Large Glass* and Richard Hamilton's typotranslations of them.[137] As a text crafted at the intersection of Beuys and Joyce, visual, verbal, and sonic, the two-page spread of "Thoroughness like Water" becomes a living "crossmess parzel," to borrow a Joycean term, equal parts puzzle and gift—an artifact of interhuman intrigue.

In "Joyce, Mallarmé, and the Press," Marshall McLuhan, who had first suggested that Cage use the *Wake*'s Ten Thunderclap history of technology as the basis for a musical score, also mines the *Wake* in making his case that it is the condition of alphabet-based literacy,

> the problem of translation of the auditory into the visual and back again, which is the process of writing and reading, that brings the interior monologue into existence. . . . This intro-version with its consequent weakening of sense perception also creates inattention to the speech of others and sets up mechanisms which interfere with verbal recall.[138]

For McLuhan it was Joyce who captured this dynamism with his *Wake* word *abcedmindedness;* he claims that nearly all of the difficulties of reading *Finnegans Wake* start to dissolve when the reader sees that Joyce is using the media themselves as art forms in a "phantom city phaked of philm pholk," introducing another Joycean word, *tubloid,* to chart this dissolution: "Throughout the *Wake* this interior 'tubloid' or tale of a tub is linked both to the cabbalistic significance of the letters of the alphabet and to the psychological effect of literacy in creating a general 'abcedmindedness' in human society."[139]

We might wonder then if Cage's selection of "Bathtub" over the still-visible "Biography" was made merely to add metonymic charge to the mesostic. It was the artful way that Beuys navigated this whirl-pool territory between biography and life on the one hand and art on the other that Beuys-ed Cage. And the artistic problem that arose out of this interest was similar to the one Cage faced with Joyce: how to make a work that says this without saying it? The replacement of "Biography" with "Bathtub" accomplished all of this with the elegant economy of the action fragment. It let the Beuysian biographical fic-tion come straight from a particular work itself, with its complex constellation of biographical associations, instead of from the rather more limited terrain offered up by the word "Biography"; if we bear in mind McLuhan's Joycean notion of the interior tubloid or tale of the tub, then we recognize that drawing from the bathtub in *Show Your Wound* taps into Beuys's very first entry in his *Life Course/ Work Course*. This is Beuys's birth in 1921, which he had transformed into "Kleve Exhibition of a wound drawn together with plaster."[140]

## A WAY A LONE A LAST

On a cold day during his visit to Dublin in 1974, a photograph was taken of Joseph Beuys wearing a thick fur-collared overcoat and his felt hat, standing pillar-still in the pocket of an abandoned concrete fortification looking out at the Irish Sea. The photographer was his friend Caroline Tisdall. Of this photograph, she would later write, "Contemplating James Joyce's 'Snot green sea. The scrotum tightening sea.'"[141]

But given the spot in which he had chosen to stand and behold, we might wonder whether he was contemplating a different passage in Joyce:

> Soft morning, city! Lsp! I am leafy speafing. Lpf! Folty and folty all the night have falled on to long my hair. Not a sound, falling. Lispn! No wind or word. Only a leaf, just a leaf and then leaves. The woods are fond always. As were we their babes in. And robins in crews also. It is for me goolden wending. Unless? Away! Rise up, man of the hooths, you have slept so long! Or is it only so mesleems?[142]

This is the final monologue, an "elegy of River Liffey as she passes, old, tired, soiled with the filth of the city, through Dublin and back to the sea."[143] The music of her voice recalls Romeo and Juliet's first lover's quarrel, over which birds sing outside the marriage chamber, over which the notes announce of the night's watches, whether they can stay in each other's arms for just a moment longer. Now too, in the world of the *Wake*, a new day is approaching. Beuys wants to be right there with it. He meets Anna Livia Plurabelle, "the carrier of the Eternal Yes . . . the secret of the continuation of the jollification."[144] Standing still and watching the water move, he hears the mix of English and German bubbling up to re-create for himself the staggering beauty of her final affirmation, the River Liffey's voice animating Joyce's own words through to their symphonic finale, a shared interior tubloid, ending in order to start again. So it is that, as the dream fades and the *Wake*'s first iteration ends, Anna Livia Plurabelle's voice brings us "back to join immediately with the first. But in that suspended tick of time which intervenes between her dissolu-

Joseph Beuys at Sandycove, Dublin, Ireland, 1974.

tion into the vast ocean and her reappearance as 'riverrun,' a brave renewal has taken place."[145]

It would be this renewal that Cage would try to give Beuys, too, after his own death, in "Thoroughness like Water." He would scrap his first plan to anchor Beuys's first name, "JOSEPH," in Beuysian terms (such as Social Sculpture and so forth) and would rewrite the first stanza, reconfigure the name, so that it refers to exactly this sense of completion, the river returning to the sea not so much to start the cycle over again as to keep the infinite and anarchic spiral going.

"Finn, again!" sings Anna Livia Plurabelle as the waters rush, birds chirp, *Wake* ends, and day breaks;[146] in Cage's enactment of Joyce's endless beginning, we recall Nietzsche's Zarathustra and his embrace of affirmation, his will to reincarnation, committing to live life such that he would gladly live it again and again, an embrace of carnality and its carnival: Was that life? Well, then . . . again! "This is *my* morning, *my* day begins: *rise up now, rise up, great noontide!*"[147] In *Beyond Good and Evil,* Nietzsche, railing against "world-denying . . . ways of thinking," proclaims "the ideal of the most high-spirited, alive, and world-affirming human being who has not only come to terms

and learned to get along with whatever was and is, but who wants to have *what was and is* repeated into all eternity, shouting insatiably *da capo*"; this term, *da capo,* is of course a musical direction: "from the beginning,"[148] the conductor's call to delight in sound and sense that Cage hoped his silence would make possible, that Beuys sought through his Joycean "dynamic medicine."

Beuys and Tisdall had hoped to stage an exhibition of Beuys's six-sketchbook addition of two chapters to *Ulysses* at the Joyce Tower in Sandycove, together with Richard Hamilton's own *Ulysses* drawings as well as Joyce's original manuscripts that are housed there. "But the owner demurred."[149]

In their *Skeleton Key to Finnegans Wake,* Joseph Campbell and Henry Morton Robinson write, "The dream and the strange black book that celebrates it will have more to say the second time."[150]

In 1977, Beuys gave Tisdall a copy of this "little black book with this inscription on the front page: 'only to start me off,' and, in German, 'and now six more chapters are needed.'"[151]

# ENTANGLEMENT

Felt as used in all the categories of warmth sculpture . . . does have a bearing on the character of warmth. Ultimately the concept of warmth goes even further. Not even physical warmth is meant. If I had meant physical warmth, I could just as well have used an infrared light in my performance. Actually I mean a completely different kind of warmth, namely spiritual or evolutionary warmth or the beginning of an evolution.

—JOSEPH BEUYS, in "Statements from Joseph Beuys"

People never think far enough ahead to say well, if he's working with felt, perhaps he means to evoke a colorful world inside us? . . . Nobody bothers to ask whether I might not be more interested in evoking a very colorful work as an anti-image inside people with the help of this element, felt.

—JOSEPH BEUYS, in Charles Wright, ed., *Joseph Beuys*

## RAINBOW'S GRAVITY

In his book *The Tibetan Book of Living and Dying*, Lama Sogyal Rinpoche notes, "The ancient Tantras of Dzogchen, and the writings of the great masters, distinguish different categories of [an] amazing otherworldly phenomenon, for at one time, if at least not normal, it was reasonably frequent."[1] Lama Sogyal relates a famous instance of this phenomenon in eastern Tibet, an instance that, we are told, had

many witnesses. It happened with the death of Sonam Namgyal, the father of Sogyal's tutor.

134

> He was a very simple, humble person, who made his way as an itinerant stone carver, carving mantras and sacred texts. Some say he had been a hunter in his youth, and had received teachings from a great master. No one really knew he was a practitioner; he was truly what is called "a hidden yogin." . . . When [his] illness got worse, his family called in masters and doctors. His son told him he should remember all the teachings he had heard, and he smiled and said, "I've forgotten them all and anyway, there's nothing to remember. Everything is illusion, but I am confident that all is well." [After he died, the family] placed his body in a small room in the house, and they could not help noticing that although he had been a tall person, they had no trouble getting it in, as if he were becoming smaller. At the same time, an extraordinary display of rainbow-colored light was seen all around the house. When they looked into the room on the sixth day, they saw that the body was getting smaller and smaller. On the eighth day after his death . . . the undertakers arrived to collect his body. When they undid its coverings, they found nothing inside but his nails and hair. My master Jamyang Khyentse asked for these to be brought to him, and verified that this was a case of the rainbow body.[2]

When the enlightened being dies, the consciousness exits the body instantly through the crown of the head, often with such force as to leave a tiny hole, like a trephination, in the skull. Now, as the body dissolves and is "reabsorbed back into the light essence of the elements that created it,"[3] a rainbow is produced simultaneously in the sky above. The only remains of the realized being, apart from the brilliant and ephemeral rainbow body, are the hair, fingernails, and toenails.

In Tibet, in the case that a death does not produce a rainbow, the body of the deceased may be given a sky burial. Taken to a place outside town, a place reserved especially for this rite, the body will be cut up and offered, by those who do this work at their karmic expense, to the gathering vultures. The bones will be hammered to

pieces and ground to a powder and mixed with grain to feed the crows that arrive for the burial's second round.

At the Hessiches Landesmuseum, in Darmstadt, Germany, Joseph Beuys installed his permanent collection *Block Beuys.* Room 5 (of seven in total) houses a series of vitrines filled with various sculptural objects and relics. Perhaps the most well-known of these is Vitrine 4, *Auschwitz Demonstration, 1956–64,* which contains elements of Beuys's contribution to a 1955 contest soliciting designs for an Auschwitz memorial, as discussed in chapter 2. Adjacent to this, in Vitrine 7 and dated 1954–67, is a lesser-known assortment of artifacts; though its contents are listed in the catalogue, they (along with those in Vitrine 2) were not selected for reproduction in the 1997 guide *Block Beuys,* while Vitrine 4 figures prominently in the guide.[4] Its contents include: *Astronautin* (1961): a figure dismembered by cuts at each of its joints; *Haare (Atom-Modell) und Zehennägel Aus >>Vehicle Art<<* (1963): tangled clusters of hair together with clippings of fingernails—all that the rainbow body would leave behind. The title *Vehicle Art,* as Alain Borer has noted in relation to another of Beuys's works,[5] has Buddhist connotations (the Sanskrit suffix *yana* is translated as "vehicle," as in "Hinayana," "Mahayana," "Vajrayana"). The 1985 work *Palazzo Regale* was the last major installation Beuys produced before his death, following his *Plight* project at the Anthony d'Offay Gallery, in London; he completed it just four weeks before he died, for a show at the Museo di Capodimonte, in Naples, Italy. It consists of two vitrines made from brass and glass and filled with various objects (relics from previous works, others encased especially for the occasion of this work) and seven brass plates, varnished and surfaced with gold dust, hung on the walls surrounding the vitrines.

In the central vitrine we find the remnants of a body: iron head (recycled from Beuys's earlier work *Tramstop*) atop fur coat, flesh and bone dematerialized. Together with these relics of the earthly form are a conch shell and a pair of cymbals.[6] Beuys imagined the palace referred to in the work's title to be the mind itself; as he said, the palace "that we should first conquer and then inhabit in a fitting manner . . . is the human mind, our own mind."[7] This practice is of course central to Tibetan Buddhism. If Beuys's assertion is read in the context of his last major work, the elements of which speak directly to the phenomenon of dying, only a little leap is necessary to con-

nect it to the work of the deceased after the moment of death. With his consciousness now free from a body and even more susceptible to peaceful as well as wrathful illusions that converge upon him, the deceased, unless he is a skilled practitioner, will need rigorous guidance in order to attain enlightenment and not be caught up in the movement through the *bardos* and back into the cycle of birth and rebirth.

The conch shell plays an important role in Tibetan ritual practice; outfitted with a mouthpiece at its tip and with a metal casing for its mouth, the shell becomes a musical instrument with tremendous sonorous force.

The conch shell is one of Buddhism's Eight Auspicious Symbols. Much Buddhist art depicts the Buddha with three conchlike lines traced on his neck, meant to symbolize the resonance of his voice, which brought forth the teachings of the dharma. So the conch shell itself is associated with that voice and the truths it embodied, particularly those conchs whose spirals unfurl in a rightward direction. These "are very rare and considered especially sacred, the right spiral mirroring the motion of the sun, moon, planets and stars across the sky. Also, the hair whorls on Buddha's head spiral to the right, as do his fine bodily hairs, the long white curl between his eyebrows and the conch like swirl of his navel."[8]

## REFRAIN

Beuys's frequent references to Eurasia are often traced to his infamous tale of his plane crash in the Crimean during the Second World War, from which he was rescued, so he maintained, by "Tartar" nomads. He was covered in animal fat and wrapped in felt in order to stay warm as he underwent his healing process and was ultimately accepted as one of them:

> I remember voices saying "Voda" ("water"), then the felt of their tents and the dense pungent smell of cheese, fat and milk. They covered my body in fat to help it regenerate warmth, and wrapped it in felt as an insulator to keep the warmth in. . . . "Du nix njemcky [you are not German]," they

would say, "du Tatar," and try to persuade me to join their clan.[9]

The veracity of this story has been debated elsewhere.[10] The tale is most productively read as a fabrication, the debate over whose truth-value has become an integral part of the power held by this auto-biographical invention. But what seems to have been missed by all accounts and accountings is the implication of Beuys's choice of set-tings for his founding fiction, whether or not he chose it knowingly: the area between the Crimean and the Black seas placed him amid "Tartar nomads" who would have been Tibetan Buddhists. This land is home to the Kalmyks, Tibetan Buddhist Mongols who settled there in the seventeenth century in the wake of the gradual Mongol with-drawal from their conquest of eastern Europe.[11] As Donald S. Lopez Jr. notes, because the Kalmyks had suffered under Soviet oppression, they backed the Germans during the Second World War; when the Germans withdrew from the Soviet Union, a large group of Kalmyks followed them in their retreat to Austria.[12]

So, whether by choice or happenstance, in Beuys's tale it was Tibetan Buddhists, ones who were particularly sympathetic to Ger-mans in general and to the German military in particular, who saved his life.

# 3. WHAT HAPPENS WHEN NOTHING HAPPENS

What is really at stake is one's image of oneself.

—JEAN-LUC GODARD, epigraph to Walter Abish, How German Is It?

This something has no name. It is beyond love and hate, beyond feelings, a savage joy, mixed with shame, the joy of submitting to and withstanding the blow, of belonging to someone, and feeling oneself freed from liberty.

—JEAN-FRANÇOIS LYOTARD, *Libidinal Economy*

## DHARAMSALA, INDIA, APRIL 12, 1982

His Holiness the XIV Dalai Lama of Tibet sat in a slip-covered chair in a reception room at Thekchen Choeling, his official residence, and slowly flipped through Caroline Tisdall's catalogue for Joseph Beuys's 1979 retrospective at the Guggenheim Museum in New York.[1] Louwrien Wijers sat next to him, together with Ngari Rinpoche, His Holiness's younger brother and special secretary, and the renowned Indo-Tibetan studies scholar Jeffrey Hopkins, who had been enlisted by His Holiness to help translate possibly obscure phrases during his discussion with Wijers. Convinced of the urgency of establishing a dialogue between Beuys and the Dalai Lama and charged by Beuys with making it happen, she had arranged this second visit to speak with the Dalai Lama about Beuys's work in particular and modern art in general, along with modern art's relationship to a number of

issues that she and Beuys considered consequential for contemporary society.

Wijers had submitted a list of questions in advance of her and Hopkins's audience. Moments before, one of these had been read aloud to His Holiness: "Could Your Holiness suggest how artists can successfully help to overcome present-day materialist greed?" He had replied with a question: "Is the planting of the 7,000 oaks an example of something that artists are doing to stop greed?"[2] Wijers: "Yes it is." Here Hopkins's voice slipped in: "And you're wondering what other examples His Holiness might think of?" Wijers was looking not for help in compiling a curatorial checklist but for a more substantive sort of guidance: "Or . . not examples, but how our attitude could be towards the problem, how we can make ourselves look at it in a right way . . and then maybe do something about it in the right way."[3]

At this point, as her words had trailed off and as Ngari Rinpoche had begun to speak to His Holiness in Tibetan to try to help reroute things, the Dalai Lama quietly picked up the Beuys catalogue and began to browse. After a time, his eyes still trained on the reproductions of Beuys's work, he said:

> There are many pictures of wastelands and destruction in here. . In our mandalas there are parts that depict cemeteries to remind us of impermanence, death and so forth. . And the same is true when one sees these pictures of wastelands . . and of broken things and so forth. . You realise that, no matter what articles, or whatever impermanent thing it is, eventually it comes to a state like this. . And it serves as a reminder.[4]

Continuing slowly to turn the pages, he came to the photograph of Beuys's infamous 1974 action *I Like America and America Likes Me,* his performative cohabitation with a "wild" coyote at the Rene Block Gallery in New York.[5] Here the Dalai Lama stopped looking at the images, closed the book, and spoke in Tibetan, with Hopkins providing translation:

> In terms of techniques for causing people who do not have satisfaction, to generate the essence of satisfaction . . this

can be done from the positive side and from the negative side.. From the negative side is to consider the deterioration that happens to everything in time.. And on the positive side, to consider just what kind of things are finally achieved through proceeding only in a materialistic way .. what is the fruit, what is the essence .. what can be achieved.. In other words, to see the limit of what can be achieved.[6]

Many years later, Wijers recalled this moment in their audience and the subtle but significant shift in her understanding of Beuys's work it had provoked:

There was nothing on the market at that time in English, except for the Caroline Tisdall book [the 1979 Guggenheim exhibition catalogue]. . . . So this big, expensive book I thought I should bring for the Dalai Lama. And, so, after first having read every sentence, and word, memorized it more or less, the whole book, I thought, "Whatever question he's going to ask me, I have to be able to answer it!" Well, the Dalai Lama takes the big book on his lap, looks at it; he doesn't go page by page, but he goes, you know, a few pages by a few pages, and he says, "Aha, this artist is working on the same thing as we are: impermanence." I was amazed, because I had never thought about his work, Beuys, as working on impermanence; although he had so often said the word, I had never thought to put it in that context, [that] big context.[7]

It excited her to consider that the Dalai Lama had made a connection between Beuys's work and his own, and even eighteen years later, this excitement had not diminished from her assessment of their audience together. She paraphrased the Dalai Lama's words: "'That's what we are working on too,' you know!" and then mimed his soft chuckle: "'Ha ha! It's the same thing,' you know, 'I can relish this!' So he closes the book, puts it on the table; he knows what we are talking about," Wijers added with a laugh.[8]

Wijers's memory of the Dalai Lama's exact words and comportment is of course an elaboration on what, according to her own book,

he actually said after having encountered Beuys's work through the images of it in Tisdall's catalogue. This ought to come as little surprise, given that much of Wijers's work from 1982 to the present has been propelled both by the conviction that compelling points of convergence exist between the philosophical positions of Beuys and of the Dalai Lama and by the desire to allow the promise of their encounter to come to some form of fruition in the context of the initiatives she has undertaken over the past two and a half decades. To risk a reductive generality but at the same time to try to do justice to the clarity with which Wijers herself understands the relation between Beuys's and the Dalai Lama's thinking, it is fair to say she believes that despite the differences between them and the traditions they emerge from, both Beuys and the Dalai Lama hold the notions of impermanence and compassion to be central to their practice.

## KASSEL, WEST GERMANY, JUNE 30, 1982

Carrying his loot in two plastic bags bearing the lime and melon logo of the Holiday Inn hotel chain,[9] Joseph Beuys arrived early at the site where he would soon perform a particular cross between action and street theater that came to be referred to as *Tsarenkrown*. More than just giving a nod to the Holiday Inn for its sponsorship of his *7000 Oaks* project, Beuys chose these particular bags for the way their cheap inconspicuousness masked the preciousness of the cargo they contained: a solid gold replica of the crown of Ivan the Terrible, together with the slew of goldsmith's tools he would soon put to use on it. The *Tsarenkrown* action involved prying the jewels and removable ornaments off the crown, melting it down, and casting the molten gold in molds he had brought with him, one of the *Peace Hare* and the other of a golden spheroid known as *Sun Ball*—all to a frenzy of encouragement from his placard-waving students and supporters, whose actions mixed to great effect with angry protests from those opposed to him, his work, and his decision to ruin this much-loved piece of kitsch from a local nightclub.[10]

Beuys performed *Tsarenkrown* in anticipation of his upcoming meeting with His Holiness the XIV Dalai Lama of Tibet, the organization of which had been undertaken primarily by Wijers. The *Tsaren-*

*krown* action dovetailed with Beuys's participation in that year's Documenta VII; Beuys and Wijers alike had hoped that the meeting with the Dalai Lama could be incorporated into Beuys's summer programming as well. As his contribution to Documenta, Beuys had conceived his *7000 Oaks* project (to raise money for the planting of seven thousand oak trees in Kassel, each of which would be paired with a rough-hewn basalt column) and had begun in earnest to promote the Free International University (FIU), which he had recently worked toward cofounding with novelist Heinrich Böll, among others. In 1973, as Böll's *The Lost Honor of Katarina Blum* was going to print, he and Beuys cowrote the FIU's manifesto, into which Beuys injected his slogan "everyone is an artist" as the possible basis for the reimagining of a socially engaged pedagogy. The FIU set itself an ambitious task: "Each one of us has a creative potential which is hidden by competitiveness and success-aggression. To recognize, explore and develop this potential is the task of the school."[11]

In terms of the broad scope of Beuys's vision, these initiatives, *7000 Oaks* and the FIU, were to function as enactments of the "spiritualized economy" that he had elaborated in his statement for Documenta VII, titled "An Appeal for an Alternative." This statement included the provocation with which he was to frame his impending meeting with the Dalai Lama, in both of which, statement and meeting, Beuys cast himself in the role of analyst, political strategist, and healer:

> Let us examine our concepts according to which we have shaped the conditions in the East and West. Let us reflect whether these concepts have benefitted our social organism and its interactions with the natural order, whether they have led to the appearance of a healthy existence or whether they have made humanity sick, inflicted wounds on it, brought disaster over it, and are putting today its survival in jeopardy.[12]

The meeting between Beuys and the Dalai Lama took place in Bonn on October 27, 1982. In Wijers's account of the meeting in her book *Writing as Sculpture, 1978–1987,* she wove Beuys's terms together to outline her view of the significance of the meeting, casting it as a kind of first step in the direction of Beuys's

vision of the new human individual that can easily overcome unemployment, economical crises and ecological misconduct by dealing with MONEY in a truly DEMOCRATIC way; by incorporating our natural SPIRITUALITY into all production methods and ECONOMY so that EVERYBODY BECOMES AN ARTIST; by transferring all institutes for education into places where POSITIVE CREATIVITY is taught, making everyone aware of their own ultimate abilities; and by eradicating the false power that politicians seem to think they have he promises to CHANGE POLITICS INTO ART thus realising the "wider understanding of art" that Professor Joseph Beuys has stood up for ever since the early sixties.[13]

In April 1980 Wijers published a collection of interviews with Beuys in which the two of them had discussed these themes at length;[14] around the same time, she had also been "reading the heartbreaking autobiography of the Fourteenth Dalai Lama of Tibet," *My Land and My People*.[15] It seemed to her that "it would be most important to explain the principles of the 'Social Sculpture' to His Holiness the Dalai Lama and beg his advice on the different points."[16] In April 1981, she visited him at his home in exile in Dharamsala, India, and had two discussions with him, the first an hour-long audience on Wednesday, April 15, and the second, at his request, an hour-and-a-half audience the following Saturday, April 18. In *Writing as Sculpture,* she recalls:

The profound and very practical answers of the Dalai Lama to questions on the UNIFICATION OF OUR WORLD, on DEMOCRACY, on MONEY, on EDUCATION, on ART and the task of the artist in our modern society, and on ways to achieve a UNIVERSAL SPIRITUALITY were so similar to the solutions Joseph Beuys had proposed, that immediately after having left the Dalai Lama's palace I wrote a letter from the high Himalayas to Joseph Beuys in Düsseldorf to inform him. As soon as I had returned to Europe the spontaneous proposal of Joseph Beuys was that a permanent co-operation with the Dalai Lama should be arranged and Joseph Beuys suggested inviting His Holiness to the opening of the Documenta Art Exhibition at Kas-

sel in June 1982. . . . The schedule of the Dalai Lama did
not allow him to come to Kassel, but for the purpose of a
permanent co-operation Joseph Beuys did want to meet the
Dalai Lama personally and charged me with the realization
of an audience.[17]

Wijers and Beuys's intention had been to convene the meeting with
the Dalai Lama during and as part of Documenta VII. Wijers discussed
their disappointment:

We were a little bit sad at the Documenta. Also Beuys was
sad that the Dalai Lama wasn't there. Everybody, even the
Buddhist community—the word was out that the Dalai Lama
would go and meet Beuys at the Documenta, you know. So I
couldn't realize that. Instead we had the *Tsarenkrown* and
a lot of attention on the *Oaks* of course, and the FIU [Free
International University] itself was there, which brought
many people together. And I kept working on the meeting,
and then finally when the Dalai Lama came [to Europe], it
was easy to make this meeting in October 1982. But what
happened from the meeting, this "Permanent Cooperation
with the Dalai Lama"—we none of us had an idea *how* this
would go, how this would work. Just Beuys had this idea
that, you know, *it would work*. And I just put my trust in him,
and he put his trust in me, you know. And then, you know
that the first part of the interview I wasn't there, because
[Tsering] Dorje didn't want me to enter the room. And then
the second part, I was *there,* and I wasn't allowed to tape it,
and the photographs that were made in the second part of
the session never turned up.[18]

Wijers was in the audience that had gathered in Kassel to watch
*Tsarenkrown,* to see Beuys play the part of the public alchemist, enact-
ing the role of catalyst for change by symbolically liquefying rigidity,
turning an emblem of authority upheld by violence into twin figures
of regeneration and peace. Holding the *Peace Hare* in his hand and
the *Sun Globe* with goldsmith's pliers, Beuys called out to her, over
the crowd: "Louwrien! With the Dalai Lama we will realize Eurasia!"[19]

## BONN, WEST GERMANY, OCTOBER 27, 1982

The prospect of the Dalai Lama's visit to Documenta VII had sown the seeds of excitement, however uncertain, and possibility, however vague, in the minds of many. As Beuys and Wijers made their way to His Holiness's suite in Bonn's Hotel Königshof just before 9:00 A.M. on the morning of October 27, 1982, a large crowd of artists, activists, students, writers, and other interested folks, some of them members of the European Buddhist community, some well-known and some not, had already begun to gather in the hotel's waiting area in anticipation of the group meeting with the Dalai Lama that someone (but no one knew whom) had promised would follow the meeting with Beuys.

Upon their arrival at His Holiness's suite, Beuys and Wijers were greeted by the Dalai Lama's staff, his guards and secretaries. For reasons that will perhaps forever remain shrouded in the vagaries of bureaucratic whim, Wijers was denied entrance to the first half of this meeting, which she had worked for almost two years to bring into being. Like any bureaucratic utterance, this one was at once arbitrary and irrefutable. Beuys shrugged, said, "Okay then, let's have it that way," and sauntered into the suite without a protest and without Wijers, who stood for some time trying to talk the Dalai Lama's secretary into letting her in. Finally he agreed that she could wait outside for half an hour, and then she could sit in on the meeting's second half.[20]

## ARNHEM, HOLLAND, SEPTEMBER 30, 1978

"Perhaps the best thing is that you put some questions."[21] Thus begins the first interview included in Wijers's *Writing as Sculpture, 1978–1987,* the book that chronicles the interviews and encounters that led to the conception and the realization of the 1982 Beuys–Dalai Lama meeting in Bonn. After the initial interview in 1979, Wijers held two others with Beuys in relatively close succession, on November 22, 1979, and June 3, 1980, both in Düsseldorf.[22] At the 1980 interview, having spoken at length about the notion of Social Sculpture, Beuys "suggested that his investigations should be presented to his friend Andy Warhol too, who in his famous studio The Factory in New

York was with his many co-workers realizing the enlarged concept of art in a different way, but with the same motivation."[23]

Wijers met with Warhol in Geneva five days later, on June 8, 1980;[24] because Beuys could not go to meet Warhol as he had hoped, he sent Wijers in his stead. Warhol—whose *Interview* magazine had recently published the first interview with the Dalai Lama in September 1978, effectively the beginning of the Dalai Lama's rise to notoriety as a secular celebrity in Western popular culture—suggested to Wijers that she pose the same questions to the Dalai Lama as she had posed both to Warhol himself and to Beuys. She returned to speak again with Beuys in Düsseldorf on June 24, 1980, when she asked him the same list of questions she had asked Warhol.[25]

Wijers then went to Dharamsala, India, for her first audiences with the Dalai Lama, on April 15 and 18, 1981.

> Directly after the interviews His Holiness the Fourteenth Dalai Lama of Tibet had given me in Dharamsala, I enthusiastically informed Joseph Beuys how struck I was by the similarity in the viewpoint of His Holiness the Dalai Lama and the ideas that he himself had been working towards in his "Social Sculpture" for the last fifteen years. I was able to come to this conclusion because my questions in the first interview with His Holiness had for a large part been inspired by the subjects Joseph Beuys had put to discussion first through his "Organisation for a Direct Democracy," and then through his "Free International University," the ecological "Green Movement" and the political party "The Greens." The immediate reply from Joseph Beuys to my remark was that "he would very much want to set up a permanent cooperation with His Holiness the Dalai Lama."[26]

She first succeeded in gaining the agreement of the Office of His Holiness the Dalai Lama to hold the meeting with Beuys. Then, in order "to prepare the ground thoroughly for a fruitful audience with His Holiness the Dalai Lama,"[27] she arranged for Beuys to meet Lama Sogyal Rinpoche in Paris on January 29, 1982. This Paris meeting had itself been suggested by French Fluxus artist and practicing Tibetan

Buddhist Robert Filliou, a close friend of both Wijers and Beuys, with whom she had spoken at her home in Amsterdam on October 11, 1981.[28] Thereafter, Wijers returned to Dharamsala on April 12, 1982, with Tisdall's catalogue in hand, for the audience discussed at the beginning of this chapter, and two weeks later, on April 28, Lama Sogyal Rinpoche visited Beuys's atelier at the Düsseldorf Art Academy.[29]

As for the Beuys–Dalai Lama meeting itself, *Writing as Sculpture* includes only a general report on what transpired in the Dalai Lama's suite, and this is followed by a partial transcript of the subsequent group discussions in the hotel café.[30] Then, on November 15, 1982, Wijers interviewed Beuys again in order to push forward with the consideration of precisely how Beuys and his energies could be of direct help to the Tibetans.[31] But following this, the book ceases to present a cohesive narrative; though it continues to proceed chronologically, it becomes a collage of discussions and quotations that cohere around what were then, at the time of *Writing as Sculpture*'s first publication (in German), the still-developing possibilities of the Art-of-Peace Biennale. This project had been conceived by Robert Filliou, who had suggested the idea to Beuys (with little initial response) in their talks in the hotel café following the Beuys–Dalai Lama meeting in October 1982. It was eventually to take place in 1985–86 in Hamburg, West Germany, followed by the Art Meets Science and Spirituality in a Changing Economy (AmSSE) conferences in 1990 (Amsterdam) and 1996 (Copenhagen).[32]

## BONN, WEST GERMANY, OCTOBER 27, 1982 (9:30 A.M.)

When Wijers joined Beuys and the Dalai Lama in His Holiness's hotel suite, her entrance halfway through the talk enhanced what was already a slightly awkward, however amicable, mood. She pulled out her tape recorder and prepared to set it on the table but was told by His Holiness's deputy secretary, Tempa Tsering, that recording was not permitted.[33] She requested permission to take photographs but was told that the official photographs that had been taken before she had entered the room would be made available at a later date.

Twenty years later and after waves of inquiries, neither photographs nor reliable information about who took them are anywhere

to be found. Numerous requests for information or records kept by the Tibetan Government in Exile about this meeting have met with replies of varying verbosity that no such records exist. The response from Tsering Dorje, His Holiness's secretary at the time of the Bonn meeting, was as follows: "With regard to the audience granted to Joseph Beuys in Bonn on 27th October 1982, I do not recollect any particular subject discussed at length. Neither did we record any."[34]

Although Dorje's letter tells nothing of the content of their discussion, its reference to the meeting not as a "meeting," as if between peers, but as an "audience" is worth noting. It would, however, be hasty to suggest that his secretary's statement and its dismissiveness voice the Dalai Lama's own response to his encounter with Beuys. Given the Dalai Lama's participation, at Wijers's invitation, in both the 1990 and 1996 AmSSE conferences, it is fair to conclude that he was, and has remained, interested in the dialogue that had been opened up by Wijers and Beuys.[35]

Wijers can recall only passages of the second half of the meeting.[36] (Since it was not recorded on tape, no actual records exist except for those that can be created from the memories of the people present.) She remembers that Beuys and the Dalai Lama discussed two overlapping topics. The first was the issue of the Chinese occupation of Tibet. In the early 1980s the Tibetan Government in Exile, as well as the diasporic Tibetan community, was publicly committed to a fervent anti-Chinese position and argued that the Chinese should be pressured to leave the country. Beuys told the Dalai Lama that he felt that this position was not a viable one; according to Wijers, Beuys said, "The work of building a good society can be done equally well with the Chinese in Tibet." The notion that Beuys would presume himself a capable political adviser to the Dalai Lama regarding the public policy of the Tibetan Government in Exile seems as audacious as his prescription for peaceful coexistence between the Tibetans and Chinese. In *Writing as Sculpture,* the introduction to Wijers's paraphrased report on the meeting gives the impression that this proposition was the subject, and its consideration the purpose, of the entire meeting:

> At that occasion Joseph Beuys made the proposal to the exiled Dalai Lama to free the area of Tibet, that has been

occupied by the Chinese communists since 1950, by making Tibet into an example of a human community which practices the "Spiritual Economy" that Joseph Beuys propagates in order to change society into the "Social Sculpture" which he considers his most important work of art to accomplish.[37]

This proposition, then, seems to have constituted the first topic of discussion; the means by which it might be pursued, the second. Here Beuys suggested the possibility of staging a Social Sculptural experiment-cum-political performance in Beijing—a half-baked but ambitious attempt to invent an autonomous Tibetan region that could be the testing ground for Beuys's fledgling economic model in which creativity would function as capital (a model that was of course never fully fleshed out). Remarkably, the Dalai Lama—according to Wijers—expressed interest in the possibility (though most likely he understood this not in its full Beuysian splendor but as a somewhat more limited political intervention involving this eccentric German artist) and asked whether Beuys had any thoughts about how to go about it and, more to the point, whether he had any friends in China. Beuys, by this time head over heels into the construction of his political persona, having staged the *100 Days for Democracy* at that summer's Documenta, got the *7000 Oaks* project (which the Dalai Lama was later to support publicly) under way,[38] and made trips throughout Eastern and Western Europe in support of the Free International University, was undaunted by his lack of a network of players who could supply the gravitas to make such a dream come to fruition. "We will make friends in Beijing!" he said.

At this, says Wijers, the Dalai Lama's face sank a bit, and shortly after, the meeting came to a nebulous but pleasant end. Beuys made a diplomatic faux pas when he tried to press a few thousand Deutschemarks into the Dalai Lama's palm; it is customary to offer donations to Tibetan lamas to help further their dharma work, but these always go through subordinates. The Dalai Lama recoiled and exclaimed, "Please give it to them. I can't touch money! They will do something good with it!" Beuys, Wijers, and His Holiness had a good laugh over it, but every Tibetan in the room was mortified, especially given the way it compounded what they had considered the disrespectful first impression Beuys had made by failing to remove his trademark felt hat in His Holiness's presence.

Lobby, Hotel Königshof, Bonn, Germany, October 27, 1982. *Above:* Beuys, at left, listens as Robert Filliou, at right, speaks to him. *Below:* Beuys responds as Filliou and Jacinto Molina, seated at Filliou's right side, listen. Louwrien Wijers is seated in the foreground, to the right of Beuys. Photograph by Cathrien van Ommen. Reproduced by permission of Cathrien van Ommen.

Interestingly, though on the one hand Beuys's proposed Beijing action was doomed from the start, on the other hand, by 1987 the Tibetan Government in Exile had in fact officially altered its policy and its public rhetoric from its explicit Tibet-for-Tibetans position to one that advocated a kind of Chinese protectorate and limited Tibetan autonomy.[39] Wijers says that she has always wondered whether Beuys's intervention had even a tiny influence on this shift. As with all of the tangible results that were to be borne of that morning's meeting, this one—if it is one—came long after the day of October 27, 1982, had run its course.

## BONN, WEST GERMANY, OCTOBER 27, 1982 (10:00 A.M.)

Once the meeting was over, Wijers and Beuys left His Holiness's suite to find that the group in the lobby had grown to around sixty people.[40] A blend of excitement at the prospect of dialogue and exchange and uncertainty about how precisely these would take shape and proceed had drummed the crowd into a chaotic state. A tangle of agendas, aims, and aspirations that under the circumstances could not be stitched together, the crowd was to find that the "promised group-meeting [that they had anticipated with the Dalai Lama] was not organized."[41] After a few minutes the Dalai Lama descended from his suite, and as the gathering of artists, writers, activists, and others watched, chatted, and waited, he and his entourage left the hotel. Those assembled managed only to catch a glimpse of him as he made his way to his next engagement at the University of Bonn. Any possible chance of that "group-meeting" with His Holiness had just vanished into the autumn sunshine.

What now? According to Wijers, Beuys had always been a "Toulouse-Lautrec": he felt that "he could do his work better in café's than anywhere else."[42] Here we might recall the passages in *Teaching and Learning as Performing Arts,* in which Robert Filliou, who was in attendance that day in Bonn with his wife, Marianne, argues for the "*réhabilitation des génies de café*" as the third part of his Poetical Economy:

People used to make fun of wild, picturesque, tortured artists sounding off in drinking places, and leaving their work

unattended. Some still do. They don't know yet that all of us now are sorts of café-geniuses. Not only do we have more ideas than possibilities of realizing them. . . . But many of us don't even try any more. . . . So it is high time to rehabilitate the Génies de Café, precursors of the whole beat, hippy and other movements. (73)[43]

The combined effect of these two café geniuses, Beuys and Filliou, together with the presence of so many people who had come all that way and with such high hopes, made it perhaps inevitable that the group should find its way to the hotel's café.

Recently the curator Hans Ulrich Obrist, feeling that the most interesting ideas at any conference are born not in its keynotes or seminar sessions but in the chats that take place during the coffee breaks in between them, organized an entire conference as a single large coffee break.[44] This instance of interdisciplinary brainstorming is actually a useful way of thinking about the events of October 27, 1982, whose intrigue of agendas and historical forces could perhaps best be read as psycho-meteorology; indeed, it was Robert Filliou who, unknowingly and in a lightning bolt of café ingenuity, provided the insight that would, months later, come to take shape as the result of this stormy day.

For over a year he had been working on something he called Artists-in-Space/Art-of-Peace, a project aiming to create discursive or performative environments in which artists, always a loosely defined title for Filliou, could explore the question of how to reimagine peace as something dynamic and inventive, not simply the absence of or pause between wars. His idea was a remarkably holistic one that included a dimension that would be focused upon the role of food and nutrition in these considerations.[45] That day, sitting around the café table, he proposed his plan to Beuys:

> On the same basis as Kassel, why couldn't there be a show, like a biennale or a triennale or a quartrennale, of work by artists that deals with the specific problem of making the world a world with peace and harmony. Suppose there was such a thing, you see. . It might be very, very interesting as a kind of focus once in a while of plans and projects which are at times not known. Maybe we could give some thought

to this and perhaps organize such a thing or propose the creation of it. And in my mind it could become almost the equivalent of the "Peace Prize for Artists." The artist who came up with the best readily realizable project might be honored.[46]

Beuys nodded in approval, and said, "Sure," but his mind was elsewhere, halfway between the formlessness of the meeting with the Dalai Lama that had just adjourned and the possibility of meeting with him again later that evening.

But Filliou continued: "Perhaps little by little it could become like a meeting place, where every four years for instance people would meet. You can imagine what a different catalogue it would make than the one of a Kassel Documenta."[47]

This was to be the "spirit of the staircase," whose appearance, months later, would enable this day to become something other than the mockingly spastic end of the romantic dream of Eurasian east-west synthesis. Indeed, the Art-of-Peace Biennale was to be a successful and fertile project, one that paved the way for and articulated many of the themes with which Wijers's 1990 and 1996 AmSSE conferences would engage.

But for the rest of that day in Bonn, attentions remained focused on Beuys, and his attentions remained focused on his missed opportunity, one that he could perhaps still make good on if he played his cards properly.

Wijers brought out the tape recorder that had been barred from the semihermetic meeting upstairs and placed it on the corner of the table at which she was sitting with Beuys, the German artist Ute Klophaus, the Filipino artist Jacinto Molina, Robert and Marianne Filliou, and others. Wijers described what followed as "enthusiastic conversations."[48] After the talks in the hotel café, which went on for some time, the group moved to another space in the Hotel König-shof in order to meet Carolyn Tawangyowma, the oldest living Hopi Indian, and her associate Joan Price. At Wijers's invitation, the two had come from the Bookfair in Frankfurt, Germany, where some days before Tawangyowma had met with the Dalai Lama, and they were now eager to meet with everyone there in Bonn.[49]

During the first part of the discussions following Beuys's meeting with the Dalai Lama, before the group had moved out of the hotel café, Jacinto Molina asked Beuys specifically about his work on the notion of Eurasia: "In your work, you have mentioned a lot about the Eurasian aspect, or concept; the unity of Eurasia. Do you have any programme, or plans, on how to unite these two areas, how to make the East and the West blend together? Which you said is the most important thing in your work."[50] Beuys began by agreeing and rehearsing his thesis on the idea of the implementation of "a spiritualized economy," which he had been discussing for some time in varying degrees of depth, and then continued his reply:

> The Eastern world has to take the spiritual capacity of all the Eastern traditions, concentrate them and metamorphosize their ideas into the most practical and useful means to serve the people of the world, to solve problems. I think, only the integration of the idea of economy with the spiritual idea can solve problems. The economy is now highly developed in the West, the spiritual idea is highly developed in the East, now they have to integrate.[51]

But here, perhaps wary of the echoes between Beuys's catch-all Eurasia and earlier twentieth-century Nazi dreams of a Eurasian synthesis and suspicious of endorsing such a program without evidence of clearly articulated methods and goals,[52] Molina pushed him:

> In what way do we try to blend these two concepts or goals together? Do you have any models? Do we do it through economics, through mass-communication . . . in what manner are we going to escalate this Eastern philosophy, or spirituality, to blend it with the materialism and advanced technology of the West? Is there any structure you are proposing so that these two can come together and blend into a system?[53]

This kind of pressure for specific plans about how these grand ideas might be undertaken, which was of course, crucially, also a variation on the point put to Beuys by the Dalai Lama, produced a strange

response from him. It began with a tactful escape from the directness of Molina's examination, followed by a reconfiguration of the formula that had, up to today, rarely been called into question:

> For that, we have a lot of proposals to make, we have to make proposals, we are not dictators—we have only to speak and report about our research and show the people what our proposal is—so, we are asking the people if our proposal might be a solution for the problem and whether it serves their means. So, we are not saying this is a solution. We are asking if our findings can serve the needs.[54]

Interestingly, even as Beuys changed gears in order to present his process as a path of proposals and thereby defuse his critic, so too did he turn to an elaboration of the relatively simplistic assessment of the relationship between East and West that he had employed only moments before. Rather than reiterate his detached formulation— "the economy is now highly developed in the West, the spiritual idea is highly developed in the East, now they have to integrate"—he now provided himself with a fascinating detour, evoking a firsthand experience of the emergent landscape of global capitalism and the way it might be seen to have disrupted the oppositions he himself had used as the supports for his notion of Eurasia. He said:

> If one characterizes the situation in the world, the East is spiritual and the West is materialistic. This is not really true. . If you go to the East. I was in Kuala Lumpur recently, it's full of Western businessmen. The whole world is determined by the idea of the Western world's economy, capitalist or communist. So, that is the situation. And now we come with a real idea of how to overcome such systems. The materialism of the West, the oppression of the people and the exploitation of the country's reserves, is already completely covering all the working places in the Eastern world.[55]

Here Filliou came to the rescue: "I think, Joseph, what I find hopeful and optimistic is that no society until now has solved this problem."

Beuys, relieved: "No, that's right."
Filliou continues excitedly:

> So it's a fantastic challenge. It's a fantastic opportunity. We
> are bound to succeed because we cannot fail, if you see
> what I mean. There's no room for failure. No society has ever
> made it and because of this—listening to Jacinto, at the same
> time—I think that the artistic model, which is a sort of way
> without imposing oneself, to go up even when you appear
> to go down. The artistic model is something that can give a
> solution.

Of course. Beuys responds, "That's what I think and that is what
I told His Holiness the Dalai Lama too this morning. That is the idea
of the spirit. It cannot be dealt with by way of politics, it cannot be
dealt with by way of religion, it can only be dealt with by art. Art is
the solution of the problem. But then also the traditional art has to
change radically."

Filliou laughs in agreement. They are old friends, and their inti-
macy allows Beuys to trade a stock reply: "There is a traditional so-
called modernism, but that cannot solve the problem. Modernism
cannot solve the problem."[56]

This statement, "Modernism cannot solve the problem," might
well have been printed on T-shirts worn by everyone present in the
hotel café.

After the discussion presented above had gone on for some time,
Tempa Tsering entered the room with two representatives of the
Tibetan community in Germany, T. T. Thingo and N. G. Rongé. Tser-
ing carried with him "a statue of the Buddha almost completely cov-
ered in a white silk shawl," which had "been especially blessed by His
Holiness the Dalai Lama." He presented this to Beuys and shook his
hand "warmly." Beuys placed "the heavy antique Tibetan sculpture in
front of him on the table around which a large group of people [was]
seated."[57] Just after this consecration of their discussions, Wijers's cas-
sette tape ground to its end, with the result that the third phase, the
remainder of the afternoon, went unrecorded.

What is not explained in Wijers's book is that Beuys had in fact
been all but strong-armed, unbeknownst to the Dalai Lama, by one

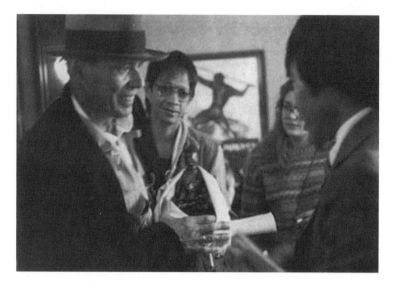

Tempa Tsering presents Beuys with the Buddha statue, with Jacinto Molina looking on. Photograph by Cathrien van Ommen. Reproduced by permission of Cathrien van Ommen.

of his Tibetan representatives to purchase this expensive sculpture some time in advance of their meeting, a point that was a bit of a disappointment to Beuys.[58] Upon presenting Beuys with the statue, Tsering invited him to attend a reception for the Dalai Lama that evening between 5:00 and 6:00 P.M.

## BONN, WEST GERMANY, OCTOBER 27, 1982 (3:00 P.M.)

In Jean-Paul Sartre's *Nausea*, at 3:00 P.M. one bleak January day, narrator Antoine Roquentin notes, "Three o'clock is always too late or too early for anything you want to do. An odd moment in the afternoon. Today," he laments, "it is intolerable."[59]

It must have been nearly three o'clock when Beuys was given the statue. Someone, but not he, requested permission for the entire group of artists and friends that had gathered to come to the reception as well. So with the prospect of a collective meeting with the Dalai Lama still dangling, the afternoon continued, and the oddness of the three o'clock moment became protracted as the time crept up to four and then five o'clock. Even then it still seemed early enough to salvage Eurasia.

Statue of the Buddha presented to Beuys. Photograph by Cathrien van Ommen. Reproduced by permission of Cathrien van Ommen.

The request for the whole group to come to the evening reception was at "first gladly accepted, but later on almost all [were] denied entry" and went home.[60] Even those who were permitted to enter, including of course Beuys and Wijers, were kept at some distance from the Dalai Lama by his attendants; according to Wijers, "Beuys was not allowed to be in the neighborhood of the Dalai Lama."[61]

## BONN, WEST GERMANY, OCTOBER 27, 1982 (6:00 P.M.)

Wijers has said, "The actual day in Bonn, I was happy that I had put the tape on the table [in the café and later in the restaurant], because this way something of the day came out, but actually when the day was over we had nothing in our hands. We just had a vague smile to Beuys at the end."[62] The mix of uncertainty and determination that jockeyed with one another as the day unfolded, Wijers says, was nauseating. "It was the worst feeling that you could ever have, you know, it was terrible. It was like . . . it was . . . ," she groped for a comparison,[63] but as she recalled the reception of the evening of October 27, 1982, she found that it was not quite like anything. Perhaps, then as now, that might be all that could be said with certainty: that it *was*. It was as if Beuys's own Eurasian backlog caught up with and overflowed itself. It was as if the East–West synthesis that had been fated to happen all along somehow lost track of itself. Nothing happened, and kept happening, it seemed, all throughout the day. It was as if the modernist Eurasian rhetoric was called up short by the actuality of the Eurasian encounter, one that had to happen in real time, in the language and the temporality of the everyday, with real participants, in order to have a shot at yoking the idea of East–West synthesis— a synthesis that, as his dialogue with Molina suggests, Beuys hoped would produce a global spirituality able to provide a resistance to global materialism—to real time and space, to give it thereby a foothold in history, so that Eurasia as geography and Eurasia as epistemology could become seamless.

In this respect Walter Benjamin's reflections regarding the undermining of the "authority of the object" by modern techniques of reproduction provide a useful way to read the function of the meeting as a historical moment. "The presence of the original is the prerequisite to the concept of authenticity" in the case of a mechanically reproduced image;[64] conversely, the meeting is made to operate as a temporal object with the capacity to confer retrospective originality upon the intentions of its organizers and legitimacy upon the aims of its participants. Its manufacture serves as an irrefutable present that permits the past to proceed to enact its futurity.[65]

As a meeting between two such legendary figures, two famous men whose every word and gesture have been habitually recorded by

their respective entourages, this meeting, one would expect, would have seen significant treatment, at least in an art historical journal article or two. In fact it has gone all but unnoticed by academic as well as popular history.[66] In large part, of course, these absences from the historical record stem from the difficulty in speaking simultaneously to the histories and modes of analysis of Western art and visual culture and of Tibetan Buddhist philosophy and spiritual practice, despite the unavoidable role that Tibetan Buddhism itself, in addition to other Buddhist traditions, has played in the lives and works of a number of twentieth- and twenty-first-century artists.[67]

Six o'clock—the reception was over, the possibility of leaving the Hotel Königshof with a clear plan of action for Beuys's "permanent co-operation" with the Dalai Lama had dissolved into the grain of a few unofficial photographs, and it was now officially too late. The Beuys–Dalai Lama meeting happened, of that there can be no doubt. But what happens when nothing happens? The meeting would be far more thinkable, far more intelligible, had it *not* happened. It could then have retained the clarity that is peculiar to those ideas that fuel aspirations; instead, having happened, and having happened in a manner that bore little resemblance to any of the ideas that motivated its occurrence, the meeting directly resulted in an opaque emptiness, entangled, anarchic, uncertain.

## DÜSSELDORF, WEST GERMANY, NOVEMBER 15, 1982

Early in his diary, Sartre's protagonist writes, "This is what I must avoid, I must not put in strangeness where there is none. I think that is the big danger in keeping a diary: you exaggerate everything. You continually force the truth because you're always looking for something."[68]

Beuys and Wijers met again on November 15 in Düsseldorf, less than a month after the nebulous day of October 27. Wijers asked him about his response to the meeting. Beuys began:

> For me the meeting with His Holiness the Dalai Lama was very interesting, but I am not really clear what in reality could come out, you know—what real procedures there

could be to solve firstly the existing spiritual problem, the embracing of the two worlds Asia and Europe, and how this spiritual programme then will become completely clear with His Holiness—since we are thinking from this point of view in almost the same manner, I am not really clear how this could lead to practical doings. There is from this point of view no difference, almost no difference. Then His Holiness was telling about his interest in solving the problem of his people in Tibet. Surely, he can try to do it alone, he does not need my help for instance, but I made the proposal to him that it would perhaps be a great interest for the Chinese to have his coming back integrated with an economical programme, with a new economical programme, which would also be interesting for the Chinese government. Because I know that the Chinese at the moment are very curious to make equations and different views of the future, and on the development of economical forms for organisations.[69]

The two of them went on to speak about the possible points of contact between Beuys's notion of the expanded concept of art and the notion of global responsibility and cooperation. Wijers asked him, "Did you exchange views on this point with His Holiness the Dalai Lama?" Beuys said:

Yes, there was a kind of exchange, but I think in this meeting I was more active than the Dalai Lama. I made the proposal, and I described the proposal in similar terms like I do now. The Dalai Lama was always very thankful and accepting— accepting the direction of speech, and *I think I sensed that he felt* that there was a very important thing going on. But maybe I felt at the same time a kind of attitude that for him it was in a way a new methodology toward new things—so His Holiness was mostly listening. He was mostly observing and trying to understand this kind of methodology, maybe this was a very new thing for him. And also with the problem that the available time was relatively short, there could not develop an interchaining discussion on all the different points. I had enough work to bring a convincing shape of

the complex problems to him and show him my readiness to help the Tibetan people, or help on this line. If His Holiness wants to help, then this was a proposal from my side. It was a proposal. Now we must see if they think in the same direction. It is not aloof from the reality to return to Tibet to serve all the people there and to develop an economical order, thereby caring for an autonomous entity under the roof of the Chinese system.[70]

At this point in their interview, Beuys began to retreat into the complexity of this proposal that had been too vague for Molina and that indeed must have seemed foggily perplexing, however interesting, to the Dalai Lama:

It was a complex proposal, very complex. It was founded from the philosophical point of view and it was founded from a point of view of the necessities created by the present economical situations in our world in general, and also it was founded on the special need of the Tibetan people. So, I couldn't do more in this short, time. Anyway, one cannot do more than this. The next step must be a real step. All other long and broad discussions on this philosophy will not lead to results. Now, I think, we have to do something. We must do real steps, otherwise it goes again back to those very old fashioned kinds of religious attitudes. With respect for Buddhist traditions, for the Tibetan traditions including all Tantric traditions,[71] for Zen Buddhism and for Hinduism and Christianity, and even for pre-Christian Druid philosophy, all these interests are spread out very intensively already over the world. Of this we have enough stock, but now we have to do something. We have to transform the systems, and we have to find real means for better production to regulate the structure.[72]

Translation: His proposal was too complex for one hour; it was an intricate philosophical argument, with multiple economic variables and implications; it was laid out with the specific needs of the Tibetan people in mind; it was the best he could do; it's up to the Dalai Lama

now—the real step has yet to be taken; but it cannot be *too* philosophical—now is a time for action; though we must move beyond the sectarian concerns of the various world faiths, the proposal for action still cannot be too broad; it is a question of systems, transforming systems, of better production. What were we producing again?

Despite the uncertainty about what had been produced by the meeting with the Dalai Lama, Wijers believed they were on the right track and pressed Beuys to develop a concrete next step: "What should the first action in respect of the Tibetan problem be?" Beuys hedged:

> I cannot say. I cannot say what they need and what they want . . at least, I think, there must be appearing a kind of will, there must appear a kind of signal to go on with this and the will of the Tibetan people and His Holiness to return to Tibet. And in case I might not get that signal I will stay completely modestly in the background. I will not press. I have as it is enough to do here in this direction. So, I can give my part of co-operation to this problem here and this will change the world, I am clearly convinced of it. If one tries to change the world every idea which works on this line has to co-operate and has to be done on the spot in public. It cannot be a hidden thing. It has to be done in public actions.[73]

Translation: He will wait and see. The next step depends upon the will of the Tibetans. If they don't give him the signal that they really want to return to Tibet, then what can he do? He will remain a supporter, but without a clear indication that they are ready for his help, it makes more sense to focus upon his other, more immediate, local projects. In any case what he is doing is engaging locally with global issues—and furthermore he is doing so actively, not working through secret meetings and backroom deals; he is working openly, in public. At the end of this thread, Wijers, who was trying to get him to outline what specifically he would be willing to commit to doing to further what progress had been made there that day in Bonn, says, "The moment is there—we should do this now." Beuys, never one to back down from direct action, agrees. And the intensity of his agreement makes way for a slippery withdrawal: "Yes, sure. . In a way it is already done. Everything is already there. We have only to execute it.

Therefore I insist in DOING it. I am not so much interested in making too many conferences with only speaking, speaking, speaking . . talking, talking, talking. . I am no longer interested to talk only."[74]

Wijers is in agreement: "I know, so, what can I propose to the Tibetans?" But having insisted on doing more than merely speaking, what does he offer?

> *The content of this speech.* I can only help if they really want me to do something. If they are just interested in making education centres in France, in Spain, in Italy, in the Netherlands, here in Germany, and everywhere, groups with venerable persons who are surely very important, then let them do that, but I am not interested in this.[75] We also have our schools of education, and our schools of spiritual teachings and all that. We could do this also here, but it will not solve the problems existing so, I am in this way really in the field of economy. And I think, here again the Dalai Lama and I are thinking along the same lines. It is the statement of the Dalai Lama that he is not interested in speaking on religion[,] that he is not interested in the old-fashioned discussion on politics, but that he is interested in a recreation of the world, and in economical doings. So, from the side of verbalization the thing is clear. Now we will see if it can also become clear from the point of view of performing and executing these ideas into the physical life conditions. That's all. Every other statement would be a repetition.[76]

## AMSTERDAM, HOLLAND, JANUARY 29, 1983

On January 29, 1983, Wijers appended the text of the November 15 interview with Beuys. The appendix explains that she had prepared a copy of the transcript of that discussion and sent it to the Office of His Holiness the Dalai Lama in Dharamsala. His deputy secretary had written back to tell her and Beuys that "the relevant content of the received writing had been brought to His Holiness' kind notice," going on to say:

> We all greatly appreciate the concern of Professor Joseph
> Beuys towards the sad plight of the Tibetan people. Unfortu-
> nately, as you would have noticed, during the past few months
> China seems to have hardened their attitude towards the
> issue of Tibet. Therefore, in the near future, the suggestion
> of a meeting between the representatives of Tibetan people
> and Red China and Professor Beuys seems infeasible.[77]

The work of Beuys and the Dalai Lama was seemingly very compatible
in many ways, but in real time their encounter became almost bewil-
deringly uneventful. And yet from the low-key chaos that the meeting
produced, an entirely different set of routes gradually became appar-
ent for effectuating what was in some ways the original hope of all
the participants in the meeting. But the collective aim demanded the
absence of the determining uncertainty of Beuys's Eurasia in order to
begin to take shape. *Nothing* had to happen in order for the objec-
tive to have the chance to be realized. This meant, most practically,
that the terms of this encounter had to eclipse the Beuysian refrain
and the Beuysian ego. Both the refrain and the ego, indeed, played a
major role in effectuating this encounter, which was ultimately highly
productive in the long term. Though the objective was not possible
within the fraught space of a single day to do so, nor, arguably, was
Beuys himself the person to achieve it, his refrain at least marshaled
the individuals and events into position to produce something other
than what he alone could accomplish.

Although the West knows the Dalai Lama as a Nobel laureate, an
eloquent writer, speaker, and activist on the subject of contemporary
ethics, in short, as a multifaceted part of the West's own pop-culture
pantheon, he is something more than this. He is the political leader
of the Government in Exile of Tibet, which includes those Tibetans
living in Chinese-occupied Tibet, as well as members of the Tibetan
diasporic communities in India and worldwide. Although the Tibetan
Kashag is now in exile, it represents one of the oldest continuous
governments on the planet, and the Dalai Lama is its patriarch. He is
also the head of the Gelugpa sect of Tibetan Buddhism, the largest
and most powerful of its four major sects, and as Dalai Lama he is the
senior leader of the adherents of all of them. Beyond that, although
all of the various traditions of Buddhism do not have an official leader,

he is arguably Buddhism's unofficial figurehead. To think of the two of them as roughly equivalent political and cultural figures, one representing the West and the other the East, would be misleading.[78]

Caroline Tisdall's *We Go This Way*—a quasi-catalogue that organizes Beuys's oeuvre geographically, looking at voyages to specific places (America, Italy, Ireland, Japan) and melanging his words, written and spoken, with Tisdall's summaries and images of works, actions, and informal photos of him in action and repose—contains a section that documents Beuys's visit to Northern Ireland in 1974. In the introduction to that section the following quote is given as if to explain his reason for traveling there: "We have reached a crisis of materialism in the Western world. We have to break through the wall of analysis. It's like Brecht's poetry, we are still isolated, we are still sitting in the garbage can. This is one of the problems of Christianity. It's easier with Buddhism. I am who I am. Investigation of the mind."[79]

The notion that this would say anything of substance about Northern Ireland is a stretch, and it takes away from the important current in the statement itself, which demonstrates, with more precision than is often available in Beuys's recorded words, the way in which he connected the crisis of Western materialism to what he felt represented its remedies: here Brechtian existentialism and Buddhist meditation. Here we also see how his "Eurasia" could represent a recovery of the split between Eastern and Western Germany, Eastern and Western Europe, Eastern and Western spirituality, Eastern spirituality and Western materialism, depending upon the context in which he might feel called upon to offer up a diagnosis.[80]

For Beuys, the run-up to the meeting with the Dalai Lama, from *Tsarenkrown* and his visits with Lama Sogyal to the Bonn meeting, forced the quick crystallization of Eurasia as a concept, gave it an urgency in relation to the prospect that Beuys might extend his practice to include crafting a kind of Tibetan economic experiment dedicated to putting into practice an as-yet-undefined social and economic model whose crux was a contention ("creativity = capital"). This Eurasia was the only thing that could happen, the only way in which what happened could happen. It was at the same time left wide open, without certain parameters, but perfect in its limiting effect, such that the Tibetans' eventual failure to "bite" on Beuys's "offer to help" meant the dissolution of his endeavor. This is why

picking up on the relevance of Filliou's Art-of-Peace proposition took several months and another listener, Wijers. Indeed, only when the distressingly unthinkable happened—that is to say, when nothing happened, when Eurasia lost itself in the real world and chased itself back into the imaginary steppes peopled by Beuysian visions and Deleuze and Guattari's Mongols—could this project begin to take shape.

Months after that October day, Wijers, having gotten over her own disappointments about what had seemed to her, too, to have been a failed event, was then faced with the news of her mother's terminal illness. She had to give up her work to return home in order to attend to her mother. She brought along her tape player and tapes from October 27, thinking that she could at least transcribe them while she cared for her mother.

As she sat alone and listened to the taped recordings of the meandering discussions that took place over those hours at the hotel's café tables, she heard Filliou's comment about the Art-of-Peace project replayed and caught a glimpse of how it might bear the fruit whose seeds had been planted in Eurasia's ruins. She describes her epiphany:

> Because we couldn't get this practical work with Tibet going, which Joseph Beuys had been thinking about, I thought, through that way [i.e., through Filliou's Art-of-Peace Biennale] maybe we could reach there finally. So I suggested to Beuys to use this idea of Filliou and invite the Dalai Lama to meet artists, more artists, and get to that, to a working relationship. So, I used Beuys and Filliou and suggested to do that. So both Beuys and Filliou thought this could be done. And that's how it started. It was actually because Filliou said that to Beuys during that meeting. It had very little to do with the actual meeting with the Dalai Lama, but he said it on that day, informed Beuys on what he would like to see happen, you know. So, and then I used that; I thought "Aha!"[81]

## HAMBURG, WEST GERMANY,
## DECEMBER 1, 1985—JANUARY 12, 1986

In Hamburg, West Germany, at the Kunstverein and the Kunsthaus from December 1, 1985, to January 12, 1986, just a few years after the Beuys–Dalai Lama meeting, Filliou's Art-of-Peace Biennale, in association with the Week of Visual Arts, became a reality involving hundreds of collaborators. The idea had emerged through Filliou's own work with the students in his Artists-in-Space/Art-of-Peace Biennale Study Group at the Hochschule für Bildende Künste, in Hamburg, where he was artist-in-residence from 1982 to 1984. For Filliou, Art-of-Peace and Artists-in-Space were inextricable from each other, but at the same time, this initiative was sufficiently broad, flexible, and playful that Wijers's AmSSE conference in Amsterdam in 1990—even though it was not to include specific elements of either Artists-in-Space or Art-of-Peace as such—could nevertheless consider the Art-of-Peace project to be its direct progenitor. And Filliou could consider both projects, Artists-in-Space and Art-of-Peace, to be part of the same larger aim. In a 1987 invitation for AmSSE that he composed at Wijers's request,[82] Filliou wrote:

We are all against war and yearn for peace. But mere absence of war, however much we welcome it, is not truly peace. Peace is presence. It is not an abstraction, but an art. (Here, art = artists are. Peace = the peaceful are—it could mean all people on earth, if we but dared.) Peace is an art and, like all arts, an adventure, possibly the last one left to us, and certainly the greatest. In Amsterdam, Art meets Science and Spirituality precisely to probe what forms this art of peace may take and what new vistas its adventure may unfold.

This much we know: if we want peace, we must prepare for peace—and not "for war," as the unrealistic saying goes. Then one day for sure, the radiance of peaceful minds—yours, theirs, ours—will set off the gentle chain reaction Bernard Benson calls "the peace bomb,"[83] and all will be well. The source of Art, Science and Spirituality is Intuitive Wisdom, akin to space, ever new. Masters of Wisdom are masters of peace, and catalysts. In Amsterdam, they may well infuse

our open minds with the energy to walk the sky of Intuitive Wisdom together—all the way to just here, where peace *is* already, just now, we're told.

ALL ARTISTS ARE INVITED TO JOIN THE ADVENTURE

Thank you, and good wishes.[84]

This drew directly from the invitation he had drafted for the 1985–86 Art-of-Peace Biennale, which we've already seen without its attendant notes at the start of chapter 1:

We're all *against* war. But what are we *for*? Peace, we say. What is peace? Nobody quite knows. It's an art, likely, not an abstraction.[85] An elusive art: "Peace is not of this world," we say. Not of this space either, by the way. Space is fast becoming militarized. As there is suddenly no alternative to peace, unless we change worlds suddenly we're doomed. Can we achieve peace before achieving peace?[86] Or is high-tech gloom our only prospect?[87]

In preparation for preparing for peace, as part of the Artists-in-Space and Art-of-Peace-Biennale projects, in November 1983 Filliou wrote a poem titled "FROM LASCAUX INTO SPACE: An Instant Trip":

1) being in a cave
   being like being in a cave
   being in the Lascaux cave
   being like being in the Lascaux cave
   when hungry for food
   recording the magic in our cave
   the miracle of feeding/being fed
   recording in our cave
   when hungry for food
   creating Lascaux in our cave.

2) when hungry for light in our cave
   when hungry for light in the
   darkness of our cave

our minds being split
by our own arrows our minds being
split
wanting to heal the mind
being hungry for light
making stars to go to

3) seeing stars on all sides
being sky to go to

4) coming back to this place now
coming back to this town
coming back to this school
coming back to this room
smiling the peace smile[88]

On February 15, 1983, Filliou wrote a letter to the European Space Agency, telling them of his work with his eleven students in the Artists-in-Space project, which he had "initiated a while ago for the urgent fun of it." At the end of this sentence, Filliou inserted the letter's only footnote:

see PILOT PROPOSALS, Assembling Press, New York, 1982. A similar proposal is made in the same book by Roger Eri[c]kson, who suggests "a collaboration with NASA: orbit a team of artists as a study in effect of what to do during leisure time on long space trips" as "if anyone knows how to make the most of [a] bad situation artists do." Roger and I, unawares, are each secounding [*sic*] the other's motion, as it were.

Both Filliou and Erickson were among dozens of contributors to Richard Kostelanetz and David Cole's *Eleventh Assembling: Pilot Proposals,* which collected proposals submitted in response to their question: "If you could apply for a grant of $500,000, what precisely would you propose to do?"[89] The accompanying figure depicts Filliou's contribution, published a year before his residency in Hamburg; interestingly, at this early date his proposal targeted NASA.

Richard Kostelanetz and David Cole (1939–2000), cover of *Eleventh Assembling: Pilot Proposals,* 1981. Reproduced by permission of Susan A. Cole.

spring 81.

I propose myself[*] to

write NASA

" all governments

" all artists :

- suggesting the presence of artists in space ( to NASA )

  artists-in-space project

  ( from homo sapiens to homo non-sapiens (?) )

- advocating ( to artists ) developing training programs of their own .

- carrying on " a training-for-space project " of my own within the framework of

  FROM MADNESS TO NOMAD-NESS

  ~~txt~~ ( a 5-billion-year ~~project~~ long )

  an illustration of which it will be ( performances, video, eventually

  pour de vrai ) in terms of attitudes for the future ( forgetting the self

  and ~~towards~~ the past ( ~~Principles~~ Outline of Poetical Economy ).

  It's another aspect of the Eternal Network, thru' the stars.

p.s. to and for Assembling:

artists-in-space project

could sure use

$ 500,000

to propulse itself into orbit

D .F:.11:._

Robert Filliou, contribution to *Pilot Proposals*, 1981. Reproduced by permission of Marianne Filliou and Richard Kostelanetz.

In that retooled proposal for the European Space Agency, which now enfolded the Art-of-Peace project, Filliou explained:

> We do not feel that artists should be expected to remain mere spectators of humanity's investigation of space. As we know from past human performance, such as the conquest of the New World, this venture carries with it staggeringly negative as well as positive potential.
>
> I am suggesting that artists participate in the space program of their various countries if the conquest of space is to be tolerably light and graceful. Of course, only genuine spiritual masters know by what precise alchemy homo sapiens might grow wings. Meanwhile, you know, we are threatened with all-out atomic war, and yearly millions of people are dying of hunger, and we know all these problems to be related. So what can we do?
>
> Well, for instance, as the other side of the ARTISTS-IN-SPACE coin, an ART-OF-PEACE BIENNALE wherein artists from all arts would present their visual and verbal intuitions regarding space, regarding peace, regarding space for peace and peace for space. . . . The names of the artists participating in the Peace Biennales might be given to stars in our galaxy (or even to nameless galaxies). The collaboration of the scientific community would be necessary. This is one way to start working together. This is one way to send artists into space, pending the real thing.
>
> Please let us know when we could visit your organization and begin informal talks touching th[e]se lively matters,
>
> Sincerely Yours,
>
> R. Filliou[90]

Perhaps unsurprising, Filliou had not yet been able, in his COMMEMOR war-monument swap, to convince the governments of Europe to consider alternatives to war. What is surprising is the success he had in getting the Artists-in-Space project taken at least somewhat seriously. Six months before he wrote "FROM LASCAUX INTO SPACE," Filliou and some of his students at the Hochschule für Bildende Künste actu-

ally visited the European Space Operation Center in Darmstadt at the invitation of its director.[91]

Much as Filliou's engagement with the possibility of sending artists into space shaped his approach to the interdisciplinary Art-of-Peace project, Wijers's own attendance of the Other Realities conference in Alpbach in September 1983 led her to a complementary conception of what the future might look like for her interdisciplinarity initiative Art Meets Science and Spirituality in a Changing Economy.[92] At one of the meals during the 1983 conference, she had mentioned Beuys's "enlarged concepts of art and science," and an interested Fritjof Capra said to her, "Bring us together with the artists of our time. We have no idea about their way of thinking."[93]

So from 1983 onward, this staging of a discussion among artists, scientists, and spiritual practitioners became Wijers's aim for the Art-of-Peace Biennale. She, Filliou, and the organizational committee had first planned to hold a "preview" of the 1985 Art-of-Peace Biennale in Amsterdam in 1984.[94] But Wijers soon got word that, because funding had suddenly become available to hold the project in Hamburg, the Amsterdam preview would have to be postponed. This meant that the Art Meets Science and Spirituality component (the notion of a dialogue with economists had not yet entered into the project) would have to wait until AmSSE in 1990. She recalled her attempt in 1984 to secure funding for the Amsterdam preview:

> I had put out the first application for money—here, in Amsterdam. And I think I would have gotten it, [if I hadn't had] the message from Robert, that the first Art-of-Peace Biennale would be organized by René Block, and René Block already had money in Hamburg [from Deutscher akademischer austausch Dienst, or DAAD]. And we couldn't do a *biennale* in Amsterdam and Hamburg at the same time, so Amsterdam was going to be postponed; first Hamburg was going to happen. And that was December '85, and my part, Art Meets Science and Spirituality, would just be in the catalogue. I felt, "This can't be." I felt so bad. Even the writers for the [*Zugehend auf eine Biennale des Friedens*] catalogue I wasn't allowed to choose. So they were choosing one person for

"Art," one person for "Science," one person for "Spirituality" in this catalogue. So I really dismissed the whole thing. And I came for the opening, but it was as if I couldn't be there, you know. I left early, and I felt bad, because it was another exhibition, four hundred participants,[95] and everyone there, hanging up a little thing [on the walls]—I couldn't believe it. I mean, I didn't want to be negative, because it was a good thing, all together, and I didn't want to disappoint Robert, because Robert had thought of it differently too, and Robert was already in retreat, by that time. I just wanted to keep . . . Anyway, René Block said, "You'll do the thing in the right way in Amsterdam." That was his washing off of it. So, that was the real false start. I was very disappointed. And it meant that I was waiting for two years to realize the first meeting. And so in '86 after Beuys died, I started again. The year before, '85, Beuys was very sick. Johannes Stüttgen [a former student and assistant], whenever you called, he said [voice raised, scold-ingly]: "*Don't* go and see Beuys; he's *too tired*!" So I kept quiet, you know. I felt I couldn't go. I think the year '85 I had seen him hardly, maybe once. So therefore also I was a little bit off. I couldn't do much in the year '85. And '85 was the opening of the *biennale* in Hamburg, and indeed Beuys sounded on the phone—because he couldn't come, he was too sick to come, he made his beautiful oxygen piece[96]—it was quite clear that indeed Beuys was ill, and . . . still it was very sudden that he died, you know, in January '86. It was very sudden. I had felt it, but I didn't want to think it, you know.[97]

On one hand, for Wijers the Art-of-Peace Biennale fell short when seen in relation to her desire for a project that would bring artists, scientists, and spiritual leaders together for dialogue. But on the other hand, as a collaborative artistic engagement with the notion and nature of a practice of peace, the *biennale* emerged as a forum for experimental inquiry that must be seen as an important contributing partner both to AmSSE as an actual event and to the ethos of commit-ted, collective, interdisciplinary dialogue that both events shared.

The Art-of-Peace committee's first newsletter, titled *Towards an ART-OF-PEACE Biennale* and written in early 1984 or perhaps slightly

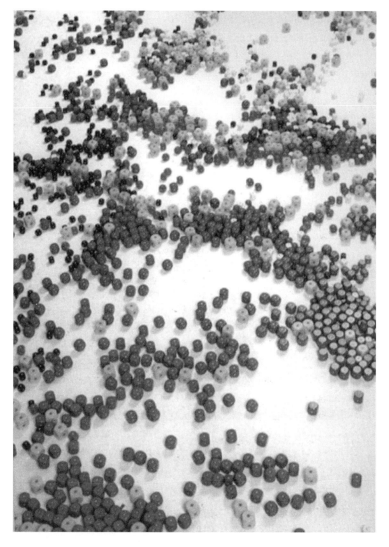

Robert Filliou, *Eins. Un. One.* Reproduced by permission of Marianne Filliou.

earlier, mentions that the *biennale* was to be held in Hamburg, West Germany, in the autumn of 1984 and the spring of 1985. On Wijers's copy of this newsletter, which contains both Filliou's and her annotations and which had initially been mistakenly attributed to "the Artists-in-Space/Art-of-Peace-Biennale coordinating committee," the words "the Artists-in-Space" have been crossed out. A footnote is also

included, explaining that the committee members were, "to date, Ann Berning, K. P. Brehmaer, Robert Filliou, Georg Jappe, [and] Louwrien Wijers." This draft of the newsletter, a shortened version of an earlier draft (see n. 95), was sent as an invitation to any artists who wished to take part:

[The committee] requests your participation in the Art-of-Peace Biennale Preview to be held in Hamburg, West Germany, in autumn 84 and spring 85. As a start, your advice and comments are welcome.

At the Art School in Hamburg we initiated the Artists-in-Space/Art-of-Peace-Biennale study group. These projects are the two sides of the same creative coin:

Artists-in-Space suggests that artists participate as such in the space programs of their various countries, so that the non-utilitarian, playfully creative, PEACEFUL aspect of the conquest of space is not lost sight of.

Art-of-Peace-Biennale proposes international gatherings wherein artists from all countries and all the arts could present hunches and intuitions regarding space, regarding peace, regarding space (inner and outer) for peace and peace for space. . . . Meeting with scientists (i.e. Rupert Sheldrake, David Bohm, Fritjof Capra, Francisco Varela) and accomplished tradition[98] masters (i.e. the Dalai Lama, Lama Sogyal, Michio Kushi)[99] could be organized, contributing to the weaving back together of the three threads of art, science and wisdom[100] into a new Tradition, a "nouvel art authentique," let's say.

So!

Over the past two years, at the Hochschule für Bildende Künste Hamburg, down-to-earth contributions to the art of peace have been experimented [*sic*] (i.e. the PEACE SMILE), and promising contacts established with the staff of the Dalai Lama and the scientific community (the European Space Agency, the Danish Space Research Center), the Kunstverein in Hamburg, the Biennale de Paris delegation, and the Fodor Museum, Amsterdam, have offered to host Art-of-Peace Biennale previews[101] in 1985 and 1986 respectively.

At this point, DAAD Berlin lended its logistical support, and delegated René Block to organize the first manifestations on our calendar: a symposium between artists, scientists and tradition masters and an exhibition in May/June 85, at the Hamburg Kunstverein.

As we see it now, the symposium week-end will include:

—an international discussion between some ten (in all) invited artists, scientists and tradition masters (names and dates will be announced in due time by René Block).[102]

—*a public debate* during which all the proposals made by artists (yours) will be aired. By the way we intend to publish a catalogue. It will list all your proposals. Depending on our budget, the coordinator will have recourse to summaries or groupings when and if the weight and length of the responses make it necessary.

—*actions by artists*. For instance the HFBK (Hamburg Art School) Study Group plans to enlist the support of scientists working at the Planetarium and for one night at least give the name of each participating artist (yours, unless you choose otherwise) to a star in our galaxy.[103]

In May/June 1985, there will be an exhibition at the Kunstverein under the provisional title of *WHAT SHAPES PEACE?* It should include samples of contributions to the art of peace made in the recent past by contemporary artists, and some new contributions drawn from your proposals.

During the 1985 Paris Biennale, plans at this time are to carry out some actions from an information booth manned by members of the HFBK and Danish Study Groups and French overseas guests, where films and books will be shown and information on the Art-of-Peace will be given. The 1986 Fodor Museum Amsterdam Preview[104] will take into account and build upon the results obtained in Hamburg and Paris.

That's all for today, except for 4 questions:

—do you think it advisable to set-up an Art-of-Peace Biennale?

—if you don't, would you care to say why?

—if you do, how should we go about organizing it? will you participate in the Hamburg Preview?

—if you will, what's your proposal?

Please send all answers[105] to:

René Block/ART-OF-PEACE-BIENNALE PREVIEW

DAAD

Steinplatz 2, 1 Berlin, West Germany[106]

## DÜSSELDORF, WEST GERMANY, SEPTEMBER 28, 1984

Filliou's final appearance in public, at least as far as the art world was concerned, was on September 28, 1984, in Düsseldorf, at the opening of the *von hier aus* exhibition. Here, Filliou had presented his *Eins. Un. One.,* which Wijers characterizes as a "mandala, nine meters across, in which over 5,000 different coloured dice were thrown" such that only the number one appeared on all of them. In addition to operating collectively as a chance-arranged mandala, the dice also functioned as more or less traditional Fluxus multiples. As Filliou suggested, "You hand out the 5,000 dice to people who then carry together the exhibition 'Oneness' around in their pockets."[107] Wijers wrote, "After the exhibition with this last statement, Robert Filliou entered a three year retreat, together with his Danish wife Marianne, and died towards the end, in 1987."[108]

In Filliou's absence, his friend Emmett Williams delivered the inaugural address for the Art-of-Peace Biennale, aptly titled "Welcome, in the Name of . . . . . ." Mentioning Robert and Marianne Filliou's retreat, he touched upon their hope that the encounter with Tibetan Buddhism might serve as the catalyst for the reimagining of an art of peace.

As many of you know, Robert and his wife Marianne have withdrawn to a center of meditation in the Dordogne for three years and three months and three days, to a monastery close to the caves of Lascaux, near the spot where the remains of Cro-Magnon man were found. They are both joyfully confident that the coming of Tibetan Buddhism to the West will help shape the future of humanity in the direction of peace.[109]

Williams underscored the experimental nature of Art-of-Peace's collective inquiry, returning to Filliou's insistence that working for peace would entail something radically different from fighting against war:

> There are Peace marches East, Peace marches West. And Peace protests and sit-ins and strikes. Some pray for it, some fast for it, some sing and dance for it, some fight for it. And some even kill for it. Is being *against* war the same thing as being *for* Peace? Filliou reminds us that, sure, we don't want war and injustice, but to fight war and injustice does not automatically create Peace and justice.[110]

The most powerful legacy both of Filliou's work and of the *biennale* he conceived is this notion that working for peace is something radically other than working against war and that such a positively defined practice—working not in negation of or in opposition to war but for peace—is characterized by a unique set of challenges as well as pleasures. Speaking about these in relation to Fluxus in general and Filliou's work in particular, Henry Martin writes of what he calls "the principle of libidinal research":

> I am . . . trying to say that Joe Jones truly enjoys the sounds of his music machines, and that learning to enjoy these sounds—as well as the questions that enjoying them raises—is what his work is all about. Or that Alison Knowles has discovered the bean to offer a first-class spiritual adventure that takes her into terrain that she couldn't explore in any other way. Or that Robert Filliou's "Genial Republic" was a place that he truly tried to inhabit, and that his "principle of equivalence"—the equivalence of well made, badly made, and not made—was a part of a mode of thought that he actually attempted to practice.[111]

Art as libidinal research

> sometimes shares its problems with other fields of inquiry— as Surrealism, for example, shared the problems of depth psychology—but it seems to achieve its status as art by

accepting no obligation to share the solutions that other such fields of enquiry espouse. . . . To look to any particular discipline for a key to any art is to court a kind of blindness. Art is a way of creating and testing experience, a way of following intuitions for only as far as in fact they will take us, whereas codified systems of thought are the things to which we turn when we feel the need to fill up the gaps in the body of intuitions that we can say we have culled on our own. And precisely where our do-it-yourself investigations will finally lead us is something of course that we cannot know. I remember an interview in which Louwrien Wijers questioned Robert Filliou about his involvement with Tibetan Buddhism. She asked him if he felt that he had been able to incorporate the Dharma into his work as an artist, and he replied, "I would feel incredibly lucky, as an individual, if I were able to combine the Dharma and my art." I think that "lucky" is the word that most needs to be stressed. Filliou had earlier remarked that art is not worth doing if the artist isn't totally committed to art, and he recognized that any such commitment is also a danger. He described it as the danger of becoming a "Master of Crazy Wisdom," and thus of creating one's own particular hell. That's the risk one has to take.[112]

This experimental practice of creating and testing experience was what Emmett Williams found most compelling about the Art-of-Peace Biennale:

> By and large, the exhibition does not look or feel like a demonstration. It is positive, exploratory, and forward-looking, with only a few attempts to recount the horrors of war past and present. As René Block, the organizer of the exhibition, predicted, contributors concerned themselves with peacefulness, beauty and the future; happiness, laughter and sadness; music, art and faith; about justice, wisdom, time, tradition and space; your problems, my problems and theirs, and an as yet undefinable something spelled p-e-a-c-e.[113]

Still in the midst of his retreat, Filliou's health was ailing. On November 5, 1986, he wrote what was to be his last letter to Wijers. He told her that as a result of an earlier operation he had undergone to remove his cancer, he had developed a secondary cancer, of the liver. "Western medicine," he wrote, "gives me a few months to live. Spiritually, Marianne and I are very well." He told her of his plans to remain on retreat until Christmas, when they would go home to see their family and to contact close friends by phone. Until that time, he said, she was welcome to write him. He ended his letter:

> The thought of all of you working so hard on making the Art-of-Peace-Biennial no. II a reality is always present with me.
>
> Don't let the news of my illness discourage you. TOUT VA *BIEN*,
>
> really—
>
> Robert

## AMSTERDAM, HOLLAND, SEPTEMBER 10, 1990

Though neither Beuys, nor Filliou, nor Warhol would live to see the first AmSSE conference, Wijers was able to bring it into being in Amsterdam in 1990. She had conceived a full-scale dialogical environment that included everything from macrobiotic cuisine for the participants to a custom-built structure to house the conference. This structure, which was based upon the chocolate grinder from Marcel Duchamp's *Large Glass,* was to be called the Adobe Pavilion and was to be constructed out of traditional adobe materials. Amen or alas, the version of AmSSE that actually took place—ham and cheese sandwiches in the Stedelijk Museum—had to be scaled down significantly to avoid exceeding the available funding. But by all accounts the project was a success, and precious few were cognizant of the stellar cuisine and delectable ambience they almost enjoyed.

In the first panel, held on September 10, 1990, at the Stedelijk Museum in Amsterdam, Robert Rauschenberg, the Dalai Lama, physicist David Bohm, and economist Stanislav Menshikov spoke together under the session title "From Fragmentation to Wholeness."[114] The

Canadian artist collective General Idea contributed a project in which they had several bright yellow Amsterdam trams painted with AIDS awareness posters, which after much protest their operators agreed to drive throughout the city. René Block suggested one of the other elements of the art initiatives that accompanied the dialogues themselves: a fax project by means of which artists from around the world could contribute to AmSSE. These faxed contributions were hung like posters at the tramstops throughout Amsterdam for the two weeks coinciding with the conference.[115] For Wijers, the unfolding of this project was in every sense a continuation of what she saw to be the spirit of the Beuys–Dalai Lama meeting,[116] though it took eight years for these initiatives to begin to catch up with the possibilities that the meeting's promise had set forth.

## BEFORE AFTERWORD

Speaking of her ongoing work in the wake of AmSSE, Wijers says:

> I would so much enjoy if [AmSSE] can travel to all the places in the world, if it gets into a way of being, of existing, where it can be welcome in any part of the world, and still has Western ideas and combines [these] with other ideas. So, the format of the talks in New Zealand I am hoping to get from the Maoris.[117] So maybe we will change the format completely, so that maybe it becomes a different format. And I think that is what Art Meets Science needs at the moment. It has worked, but it should grow, it should grow into something that can live in the twenty-first century almost by itself.

If it was unable to develop this inclusivity, it would be just another conference. After a pause, she said, "It's easy to get empty things. You can buy them everywhere."[118] Given this language of organic growth and change, we are tempted to think of this project, one that can transform as necessary in response to the challenges and demands of encounters with cultural difference, in terms of a notion of freedom—of action, travel, thought. But for Wijers, the attachment to free-

dom offers little. Though most of her male artist friends sought after it tirelessly, she never quite knew what to make of it; for them,

> everything was about freedom, how to free yourself, your inner self. And, you know, Filliou, Beuys, it's all about freedom. And then you come to the Dalai Lama and he says, "Freedom? What do you mean? Nobody is free from money."[119] So you know, when I explained to the Dalai Lama the Free International University, he said: "Free, what do you mean? Nobody is free for instance from money." So you know, for me that was good, because I could never catch the image of freedom, throughout all those years, even with the existentialists, they were always talking about freedom. I could never understand what they were talking about. It was so vague. Your own freedom shouldn't count. It is the other one's freedom. It is all about: how can I protect you, so that you can be free from sorrow and blockages, and wounds that you have? So, we're always freeing each other.[120]

## AFTERWORD

Wijers's current project, one that unfolded from the AmSSE initiative, is called Compassionate Economy—a collaborative and transdisciplinary inquiry into a problem posed by the Dalai Lama to economist Stanislav Menshikov during the 1990 conference. Writes Wijers:

> German artist Joseph Beuys, my most important teacher in art, told me: "You can do anything in art, science or spirituality, but if you can't make your suggestion effective in economics you have not changed a thing." So I had to confront economics. It is why I initiated "Art meets Science and Spirituality in a changing Economy," where artists, scientists, spiritual leaders and economists talked together. On the first of five days of dialogue in Amsterdam, in 1990, panelists were artist Robert Rauschenberg, scientist David Bohm, spiritual leader His Holiness the Dalai Lama and economist Stanis-

lav Menshikov. That day the Dalai Lama asked, bending over to Professor Menshikov, "Can you write a book or design a model for a Compassionate Economy?" It was the first time I heard the term Compassionate Economy. The Dalai Lama had coined it. Professor Menshikov answered: yes, he could define Compassionate Economy.[121]

In the excerpted dialogue that follows, Menshikov and Wijers discuss the nature of Compassionate Economy:

PROFESSOR STANISLAV MENSHIKOV: Dr. Naushad Ali Azad. He said, "Have compassion for the people who cannot participate in the market system." Exactly! Of course, but not because they don't want to participate. The market system itself throws them out. Louwrien Wijers is sitting here, from the Netherlands. She knows a lot of people in the Netherlands, who are creative artists, who are not accepted by the market system. Creative people can't sell whatever they produce to make a living. They have to be supported by somebody, because the society loses their talents and the results of their work.

Remember how less than a hundred years ago the famous Modigliani died from hunger and poverty in Paris? That is what she is talking about. How many current Modiglianis, and other artists, potential invaluable resources of mankind are being lost, just because they are not accepted by the market economy today. We don't know what would develop from such an artist, if he or she would have the resources. Because Modigliani, in spite of whatever, he still was painting where others would start drinking, and others would start using drugs. And what is the name of this other painter, who painted, but he was sick? A French painter?

LOUWRIEN WIJERS: Henri de Toulouse-Lautrec.

PROFESSOR STANISLAV MENSHIKOV: Yes, Toulouse-Lautrec. If somebody had not taken care of him, his mother I think took care of him. And before her a dance girl did. But she was a private person taking care of him. Normally some instance has to take care of him in a Compassionate Society. If nobody had taken care, we would lose Toulouse-Lautrec and he would

never have been known to anybody. This would be just a waste of resources.

The market economy cannot adequately give a value to that output. Eventually after they die of course their price is high, just because the rich want to buy those paintings. But at the time, no. So this is another example of inefficiency. Maybe it is just for the minority of the talented people, but still it is important. Because what they produce is for the spiritual richness of the whole humanity.[122]

Recently Wijers and I spoke about the relation of Compassionate Economy to Adam Smith's work; as noted by Raimon Panikkar in the 1990 AmSSE conference, Smith's modeling of capitalism, as is often forgotten, entails the idea that consumer and seller meet in the market with equal power and with equal information. Wijers said:

We abuse Adam Smith very much. It's terrible how we have misused his ideas. In this Compassionate Economy project that we brought together in India in 2002, we talked a lot about Adam Smith, because he introduced a moral system too. He said that the market cannot go without the moral. So he actually says that there are people who cannot function in the market economy. Like artists. So you have to divert money that is in the stream to those who are not taking part in the market economy. Whereas now we are trying to make everybody part of the market economy, Adam Smith never thought of it that way. He was thinking that, yes, there is a consumer society, market economy, but there are people who don't fit in that because they don't have a product. Like artists don't really have a marketable product. We can try to do it, and that is what we are doing, we're trying to make the artist's work *work* in the market, but it doesn't. It's the wrong approach. And that is why we are losing art these days. And we are fighting hard to bring it back. But it is because we misunderstand Adam Smith. So we should go back to the works of Adam Smith, to the full range of words and rules that he has put forward, and we are just not doing it. So, we are just as bad as anyone, you know!

I replied, "Gandhi was once asked what he thought about Western civilization and said that he thought maybe it would be a good idea. Noam Chomsky says the same thing about capitalism: maybe it would be a good idea, but we've never seen it, so we don't know."

Wijers:

> Absolutely. In the moment of introduction you get the wrong interpretation. And actually a whole lifetime spent on thinking a good thing goes to waste. And we're doing it over and over again. Whoever puts a new example, model, or idea that could work out well, we just take a part, and we don't apply the whole thing. So we have to talk again and again to each other. And the simple thing, the real wisdom that is behind these ideas, we never get to it. Why is that?

## GETTING TO IT

The Dalai Lama's advocacy of the notion of universal human rights, most specifically as put forward by the United Nations in its Universal Declaration of Human Rights on December 10, 1948, has been attacked on the grounds that it represents cultural imperialism. The official position of the People's Republic of China toward the notion of universal human rights is that it is "a Western creation that is inapplicable in an Asian context and that is rejected by Asian peoples."[123] Indeed, the Dalai Lama's presentation of the notion of compassion, his championing of universal human rights, and his calls for "Universal Responsibility" have been crafted pointedly in response to the language of the Western liberal democracies that he most often addresses.[124] But this does not necessarily mean that this position is in any way inconsistent with the vast philosophical, philological, psychological, religious, political, and cultural practices that are collectively called Buddhism. Indeed, experts Buddhist and non-Buddhist are at odds about what exactly can be said to constitute the Buddhist ethical and moral traditions and how it might or might not accord with the similarly heterogeneous Western liberal, humanist, democratic tradition. John Powers points out:

If the Dalai Lama is correct in his assertions that Buddhism is also concordant with human rights thinking and that Buddhist notions of karma and interdependence inevitably lead to conclusions congruent with those found in the Universal Declaration and similar documents, this would indicate that although the history of human rights thought is strongly linked with Western thinkers and nations it is also compatible with at least two important Asian traditions [namely, Buddhism and Confucianism] that have profoundly influenced Asian thought and society.[125]

Further, regarding the intersection of the Buddhist and the Western liberal democratic traditions in the Dalai Lama's public performances, Jay Garfield notes that the Dalai Lama's "view that moral life is grounded in the cultivation and exercise of compassion" is itself "grounded in ... the tradition of Buddhist moral theory rooted in the teachings of the Buddha." Garfield also notes that the Dalai Lama has been consistent with these teachings when he has "urged in many public religious teachings, addresses, and in numerous writings that the most important moral quality to cultivate is compassion, and that compassion, skill in its exercise, and insight into the nature of reality are jointly necessary and sufficient for human moral perfection."[126]

In response to a question from a London audience in 1981 about the conundrum of practicing compassion for those defined as "enemies of humanity," the Dalai Lama responded:

Compassion, or tolerance does not mean that you accept your defeat . . or you let the wrong-doing triumph. . It does not mean that you may not take a strong reaction . . or a strong counter measure . . in order to stop that which is wrong. . Meanwhile though, deep down, you should not lose your compassion. . That is the way of practice. . For example a good parent is sometimes furious, very angry, towards a naughty child, but deep down one does not lose one's compassion. . With that compassion you have to take strong measures . . in order to stop that naughty child's action. . Similarly, without losing any deep compassion towards any-

body, particularly the enemy . . with that strong motivation . . with that strong compassion . . not due to anger, but due to compassion . . you sympathetically try to stop the bad behaviour. . That is the way.[127]

Sociologist Barrington Moore Jr. has suggested, "A general opposition to human suffering constitutes a standpoint that both transcends and unites different cultures and historical epochs."[128] He argues that by means of active inquiry into the causes and the necessity of suffering, "it becomes possible to escape from the trap of accepting each culture's self-justification at its face value while retaining a capacity for sympathetic insight into its torments and perplexities."[129] What is at stake here is the development of an exploratory ethics sufficiently elastic to be adequate to the complexity of the interhuman intrigue and to accommodating our desire for and attachment to it. In this regard, when the notion of Universal Responsibility is read not as exhortation so much as exploration—when it is seen less as a categorical imperative than as a device for articulating, for example, the Dalai Lama's own enactment of daily ethical practice—what is easily perceived as a simple and ostensibly moralizing position becomes something far more sophisticated, provocative, and difficult to achieve.

Irit Rogoff has argued for the urgency of a "shift from a moralizing discourse of geography and location, in which we are told what ought to be, who has the right to be where and how it ought to be so, to a contingent ethics of geographical emplacement in which we might jointly puzzle out the perils of the phantasms of belonging as well as the tragedies of not belonging."[130] The practice of compassion would be central to such an exploratory approach to ethics, to the experience in which one understands oneself to be the other's other; beyond and before the making of knowledge, compassion is the way in which the ethical encounter must unfold if it is to produce *ahimsa*, as a nonviolence that consistently finds the fortitude to pick itself up, brush itself off, and continue. Gandhi famously wrote, "Who that has prided himself on his spiritual strength has not seen it humbled to the dust? A knowledge of religion, as distinguished from experience, seems but chaff in such moments of trial."[131] Such humility produced the possibility of the insight that could itself produce the understanding that a religious act is inevitably also a political act:

"I can say without the slightest hesitation, and yet in all humility, that those who say that religion has nothing to do with politics do not know what religion means."[132]

Here we must mark the difference between a piety, religious or agnostic, that presumes to dictate its ethics to its others and a politics that refuses to remain silent in the face of what it perceives as unethical actions undertaken by others. As Garfield explains, "To demand of a society that it respect some fundamental set of such rights is not an instance of illegitimate cultural imperialism but an instance of mandatory moral criticism, even if it is not so experienced by those to whom such an effort is directed at the time."[133]

In his *Ethics for the New Millennium*, the Dalai Lama suggests that religion is ultimately far less important than spirituality:

> We humans can live quite well without recourse to religious faith. These may seem unusual statements, coming as they do from a religious figure. I am, however, Tibetan before I am Dalai Lama, and I am human before I am Tibetan. So while as the Dalai Lama I have a special responsibility to Tibetans, and as a monk I have a special responsibility toward furthering interreligious harmony, as a human being I have a much larger responsibility toward the whole human family—which indeed we all have. And since the majority does not practice religion, I am concerned to try to find a way to serve all humanity without appealing to religious faith.[134]

He characterizes religion as that which is "concerned with faith in the claims to salvation of one faith tradition or another, an aspect of which is acceptance of some form of metaphysical or supernatural reality, including perhaps an idea of heaven or *nirvana*." He conceives spirituality, on the other hand, as that which is "concerned with those qualities of the human spirit—such as love and compassion, patience, tolerance, forgiveness, contentment, a sense of responsibility, a sense of harmony—which brings happiness to both self and others."[135] He concedes the import of what are called "religious" elements, but only in a relative sense; this is not to say that they are superfluous in themselves, only that they are not essential to ethical practice:

> While ritual and prayer, along with the questions of *nirvana* and salvation, are directly connected to religious faith, these inner qualities need not be, however. There is thus no reason why the individual should not develop them, even to a high degree, without recourse to any religious or metaphysical belief system. This is why I sometimes say that religion is something we can perhaps do without. What we cannot do without are these basic spiritual qualities.[136]

The substrate of these basic spiritual qualities is the practice of compassion.

> In Tibetan, we speak of *shen pen kyi sem* meaning "the thought to be of help to others." And when we think about them, we see that each of the qualities noted is defined by an implicit concern for others' well-being. Moreover, the one who is compassionate, loving, patient, tolerant, forgiving, and so on to some extent recognizes the potential impact of their actions on others and orders their conduct accordingly. Thus spiritual practice according to this description involves, on the one hand, acting out of concern for others' well-being. On the other, it entails transforming ourselves so that we become more readily disposed to do so. To speak of spiritual practices in any terms other than these is meaningless.[137]

To speak of any sort of ethics without doing so in terms of the compassion without which ethical engagement means little is similarly meaningless. Compassion, a difficult and demanding practice, is the labor that consists in resisting the ability to find an enemy in alterity, a labor whose elusive goal is the overcoming of enmity. Jean-Luc Nancy has described what is at stake in this sort of compassion, which must be conceived not "as a pity that feels sorry for itself and feeds on itself" but as "the contagion, the contact of being with one another in this turmoil" of life in a world in which to be together means "being divided and entangled," a world "that is anything but a sharing of humanity. It is a world that does not even manage to constitute a world; it is a world lacking in world, and lacking in the meaning of world."[138]

# 4. OVERGAVE

I am, you might say, searching for an appropriate ending. In yester-day's paper there was mention of a young woman who jumped to her death from the fourteenth story of an office building only a few blocks from this hotel. Incidentally, someone on the seventh floor, or was it the eighth, sitting at his desk near the window, actually made eye contact with her. I mention this only because in life jumping out of a window is an end, whereas in a novel, where suicide appears all too frequently, it becomes an explanation.

—WALTER ABISH, *How German Is It?*

Two forces rule the universe: light and gravity. . . . What is the reason that as soon as one human being shows he needs another (no matter whether his need be slight or great) the latter draws back from him? Gravity.

—SIMONE WEIL, Gravity and Grace

## GIFT FROM BUCHENWALD

Louwrien Wijers was born in 1939 to parents who ran a small bak-ery in a village near Arnhem, Holland. She spent her childhood sur-rounded by people creating confections, baking breads, measuring and improvising with ingredients. One of her earliest and fondest memories is of watching her father practice the art of making marzi-pan, which requires pounding and kneading in equal measure to the finesse of its handling and shaping, giving it much in common, as she has noted, with the art of felt making. When later in her life she came

to work as a sculptor, she took pleasure in the realization that working with metal—at turns following and resisting the metal's properties, its tendencies to fold, bend, and break in certain ways—was not much different from working with marzipan.[1]

More generally she remembers a childhood surrounded by beauty, a memory enhanced rather than quashed by having grown up during the years of the Second World War and one that survived despite the wartime destruction of her family's home and bakery, flattened by the "friendly fire" of Allied bombers. The Wijers family had one of the few full deep basements in the town, so it would routinely fill up with their neighbors during air raids. On the day that the bomb hit the house, she happened to be upstairs instead of in the basement; the raid had come upon them quickly, and in the confusion she, only three years old, had not been located in time. She recalls a noise so loud and palpable that it struck awe in her rather than fear; a moment later she turned around to see daylight through the smoke where until then a wall had stood.

She remembers her uncle, R. H. Boer, taking her to see her first piece of modern sculpture, by British sculptor Henry Moore, at the Kröller–Müller Museum in Otterlo, Holland, the first of a flood of new works of modern art that came into Holland after the war. "It was a great feeling to see those things, because they were so different, such new shapes—those shapes I really appreciated. The whole time of the late '40s and early '50s was devoted to art and to dancing and music. Boogie-woogie was of course the music, and it was very important. We couldn't do without art." Her uncle nurtured her interest in this nascent postwar culture. She refers to him as "the Buchenwald uncle"; he was among approximately two thousand non-Jewish Dutch that the Nazis had gathered and sent to Buchenwald in the early days of their occupation of Holland. These inmates were artists, musicians, poets, and scholars, taken from throughout the country and held as something like cultural ransom: "They would be killed if anything went wrong in Holland." But their period of internment in the camp was one of relative comfort. As a collective insurance policy, they were neither sent nor worked to their death, but were allowed to continue their creative pursuits within the camp's confines, and could communicate with their families and friends. Wijers has fond memories of receiving parcels in the mail from a faraway place called

Buchenwald. They contained little things her uncle had made for her, mostly sketches and paintings and little figurines with which she covered the walls of her room—such as one little carved wooden piece, "a girl with an umbrella, nicely painted red, and a nice yellow coat." She speculates, "The beauty of those things made in wartime, in the most horrible circumstances, must have radiated something, because I didn't know about Buchenwald, and we—actually nobody knew, I think, at that time, they just knew they were in camps." The inmates were not permitted to tell their loved ones about what went on inside the camp. Wijers and her sisters knew it only as a place from whence nice things magically appeared, and so the name Buchenwald evoked wonder: "Aha! A new parcel!"

Where children today might collect pictures of fashion models, athletes, and movie stars, Wijers like many others in postwar Holland collected images of art. She and her sisters had stacks of postcards of art, clippings of writings about art, and arrays of small exhibition booklets. At an early age Wijers received a box of paints and a palette from her father. She began to use them in an earnestness that continued into her teenage years, when she earned perfect marks in her drawing classes. When the time came for those her age to commit to decisions about their further education, the art teacher at her school came to her house to speak with her father to attempt to convince him to send his daughter to art school. "My father said, 'She will go to art school if she feels like it.'" But for her, attending art school was out of the question. A few art schools were nearby, the closest in Arnhem, and she had older friends who had attended them. She was, she says, disappointed in the work they made there, feeling that the schools taught them the "craft, but not the art."

An epiphany in front of a transformative work of art was what convinced her that her path lay in the pursuit of further, more profound experiences of this kind. In the mid-1950s she saw one of Piet Mondrian's late paintings (she does not remember precisely which one), on display at the Kröller-Müller Museum. In our February 2000 conversation, she gave me a sense of the power this moment held for her by clasping her hands dramatically and performing the quietened thunderstruck state that had overtaken her when she met Mondrian's canvas for the first time. "When I saw that he cut it up into just little bits, I thought, 'Ah! Much more wise than I was doing!' I was amazed

Ontvangst in Buchenwald (pag. 13).

„Bettenbau" (pag. 17).    29

Es gibt einen Weg zur Freiheit. (pag. 56).    43

Wij gaan verhuizen (pag. 97).    67

Openluchtconcert (pag. 80).    79

Zolderfilm (pag. 121).

De Snoekkoning aan de Dommel (pag. 133).    127

Uur der bevrijding (pag. 146).    139

G. E. Matakupan, cover *(upper left)* and illustrations from R. H. Boer, *Van Buchenwald naar Vucht* (From Buchenwald to Vucht).

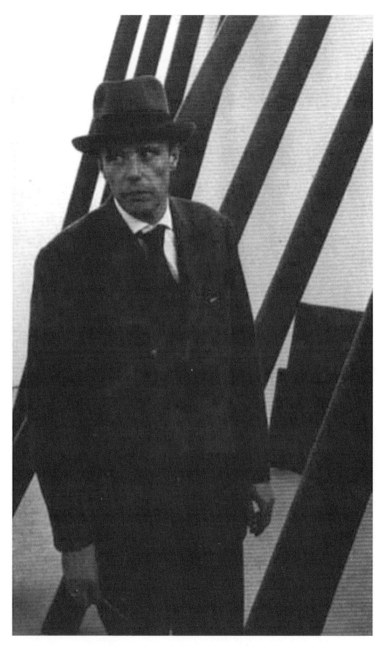

Joseph Beuys in front of *Raumplastik,* Documenta IV, Kassel, 1967. Photograph by Ad Petersen. Courtesy of Ad Petersen and Louwrien Wijers.

how somebody could get to that point. And still it is amazing to think how Mondrian was in 1917 actually showing quantum mechanics, or the reality of how things are." She patted the kitchen table where we sat and told me that while its wooden mass might seem solid, in fact it was not.[2] She had realized that the "Mondrian painting was saying exactly that: it looks solid but it isn't."[3]

But her perception of the closeness of Mondrian's formal experiments and those of the physicists of his generation came later for her, following an equally intense and intensely different experience in 1967, when she saw Joseph Beuys's *Raumplastik* installation at Documenta IV in Kassel, Germany (June 27–October 6).[4] This is the only other work apart from the unnamed Mondrian that has ever moved her to tears.

She saw the piece early on the day of her visit. She returned to look a second time in the evening, when the crowds had thinned. The gallery was empty except for a single figure leaning against the door jamb, looking at the work. Somehow, she felt certain that it was Beuys, whom she had never met before. They began to talk about the work; for her the room, with its symphonic stillness of felt-wrapped objects leaned against the gallery walls, conveyed the unstirred silence of the aftermath of large-scale violence. For her, Beuys's work tied a flashback to her family's house, gutted by Allied bombs, to images of disemboweled Eurasian cities from Dresden to Stalingrad. What was most powerful for her was not the representation of this destruction but rather the oblique "soft touch" that Beuys had devised, which would become a kind of trademark of his practice—one that today makes it possible, almost without exception, to differentiate between exhibitions of his work that he installed and those that have been staged since his death. Wijers saw, in this early work, a determinedly gentle "wound healing . . . how you put on a wound very softly"—and here she mimed for me the act of placing a bandage on a fresh cut—"a gaze. Oh, how do you call it, gaze or gauze or . . . ?" "Gauze."

# AGAZE

As a young woman in the late 1950s in Holland, Wijers found daunting the question of how to proceed with her work as an artist with an aversion to academic training. "I decided that I should not just go for the obvious," she recalls, "but I should go for a deeper insight into art. And of course it is confusing for yourself not to go and get an education. But this is what I specifically wanted not to do." She went instead to Groningen, where she got a job with a local newspaper in hopes that she would have the chance to write about art. It did not take her editors long to burst this bubble. They told her that she ought not occupy herself with things that she was not hired for in the first place.

She finally decided to enroll in the local art school; after attending six part-time classes she began to see the kind of drawing that she was required to do there as a waste of time, and she became equally convinced of her inability to continue painting. "I had a feeling that I had already gone into painting far enough, and knew what was happening there. I had no feeling for learning more about painting." Since she had begun in journalism, she was determined to return to it and to tackle it fully, wherever it took her.

"So I fought hard and I worked hard to remain myself, but felt very much ill in the years that I was in journalism, because I couldn't cope with the situation. It was too harsh on me. I lost all trust in people, really, at that time. And suddenly I saw how the world really was; it was very hard to keep up with, to keep the two things next to each other: your feeling for art, and [this other] reality. It was—maybe you know that feeling too? It was very hard to believe that the world was as it was."

Her job led her to London, then on to Paris, in 1964. There, she said, though still "just a little girl" of twenty-two, walking around the streets, for the first time she saw artists. She explains why the sight was striking: "I had never seen real artists; I had always seen people who were at art schools or trying to make art, but very provincial. [In Paris,] I got for the first time a glimpse of a very different kind of art, which I could carry home in me, because then I understood that you can do anything in art, that it could be done with any kind of material and also with ideas."

Wijers wrote the following account of her time in the Rue Mouffetard in Paris in 1964:

*Hotel de Carcassone, Rue Mouffetard 24, Paris*

Something definite happened to me in the Rue Mouffetard in Paris, in the spring of 1964. I had arrived by train with heavy luggage that I left at the Gare du Nord. The subway map gave one name I recognized: Saint Germain des Prés. I took the subway and came up in the bright light of the Boulevard St. Michel. I started walking. It was Sunday afternoon. Suddenly I was nailed to the ground for a while. I feel extremely good vibrations at the corner of Place de la Contrescarpe and the start of Rue Mouffetard. I stood right in front of Hotel de Carcassone.

In the hotel, from behind thick glasses the Parisienne in black dress, cardigan and apron said: "Complet." I took the nearest hotel in Rue Saint Jacques, but did not care to pick up my luggage from the Gare du Nord. Every day I went to Hotel de Carcassone and every time she said: "Complet." Finally, on the Friday she was friendly: "You have been coming here for the whole week, now I do have a room for you."

The floor was red brick, the window almost as wide as the room. The bed filled the room. There was a small table near the window and a tap. Behind a curtain one could hang clothes. When I started to meet others living there, they all happened to be artists. They had a room like mine, or slightly bigger. Big enough to hold except the bed an easel, canvasses, paints and brushes. Karel Appel lived by chance around the corner and kindly kept up my spirit in this new Parisian life style of the early sixties.

Through the Mexican painter José—we looked into each others rooms across the inner court yard—I met Swedish artist Erik Dietman, who introduced me to the friends he was involved with, like Fluxus artist Daniel Spoerri. He lived in our hotel too. I had landed in Fluxus. French Fluxus met daily at the sunny terrace of restaurant La Chope on Place de la Contrescarpe. They were light and happy people. They

changed my view on art. The impermanence of war found its place in art for me, thanks to them.[5]

When she returned to Holland, she moved to Amsterdam and into a house where Wim Beeren, who would later become the curator of the Stedelijk Museum,[6] also lived. His social circle became hers as well. This brought her into contact with the newspaper *Museumjournaal,* where the editors were impressed that she had spent time amid the Paris avant-garde art community and thus hired her. Then twenty-four years old, she found herself suddenly in "the best position to 'go to art school,' you could say. I see all those years that I was writing on art, as the real art school, because now I could talk to [artists like Robert] Rauschenberg and everyone." She began writing for *Museumjournaal* in 1962 and continued until 1970.

In 1968, the year after her encounter with Beuys, a friend returned from New York and told her that she must go there and see the work that New York's artists were making. For everyone in Amsterdam, she says, "New York was in the air, of course." Beeren armed her with a letter of introduction to the gallery owner Leo Castelli, asking him to see that Wijers was welcomed into the New York art world. "He made three appointments a day for me. Three or four. Yeah! I was running like crazy, I had even appointments [at] nine o'clock in the morning. I came to his office, he said, 'Okay, I'll give you two weeks in New York, completely full.'" She met with "everyone, everyone": Carl Andre and Donald Judd, Sol LeWitt and Dan Flavin, Andy Warhol and Robert Rauschenberg, Robert Smithson and Lawrence Weiner, among others. Drawing from these meetings, she wrote a series for *Museumjournaal* called "Avant-Garde New York."[7]

Despite, or perhaps in part because of, the exhilaration of being among the first writers to provide a Dutch audience with firsthand coverage of the developments in contemporary American art, Wijers found it difficult to square the kind of experiments happening in New York with those being undertaken by many of her contemporaries in Holland. Her two sets of inquiries ought to have connected, she felt; the investigations ought to have had the sense of a transatlantic network. But she could find evidence of none of this. What for some might seem like an encounter with contradictory critical and aesthetic imperatives was for Wijers something much deeper, a kind

Louwrien Wijers, "Avant-Garde New York," *Museumjournaal* 13 (1968).

of epistemological crisis. In the wake of that intense engagement with the New York avant-garde, she felt that the questions of what art ought to be, and what it meant to take it seriously as a vocation, and what it meant to invest oneself fully in what she—like many—saw as its radical promise, were all at stake.

The difficulty for Wijers was enhanced by her circle of friends and associates in Amsterdam; she found the nature of the kind of concep-

tualism they were invested in to be shallow and suspect, she recalls, and they actively discouraged her from having contact with artists like Rauschenberg or Beuys. These two artists represented modes of working and thinking that, according to Wijers, were at odds with the work of the Amsterdam artists. She believed that it was possible to trace connections between what was compelling and radically challenging about all of these works, no matter what side of the Atlantic they came from. But the reluctance of many of her Amsterdam contemporaries to accept her close relationships with these American artists, and the absence of a critical space or a discursive network that could help her to work through these conflicting practices, left her feeling unable to develop her intuitive sense of their interconnectedness into any kind of cohesive concepts. Because she saw so much importance in making sense of these practices and felt increasingly alienated from her social milieu the more she tried to do so, her inability to do so, even provisionally, led her to "a kind of nervous breakdown, or a crisis" in her life.

## ENFORCING THE THINKABLE

Tony Godfrey notes that around 1972 in Europe "the once radical galleries became more like businesses: those such as Konrad Fischer or Art & Project acquired bigger premises and took on extra staff. They tried to poach each other's artists. There were more collectors about, but they were less adventurous. To many it just was not exciting any more."[8]

That year, Wijers's friend Anny De Decker, who owned and ran the influential White Wide Space Gallery in Antwerp,[9] which had brought the first show of American Conceptual Art to Europe, complained about "seeing fewer and fewer artists and more and more dealers." She explains, "Artists were having more and more shows, and I was forever seeing the same things all over again. I couldn't stand it. I found it futile. I'd pretty much had enough of Conceptual Art. Because of the uselessness of those repetitive works. I was starting to find it all a bit dry, a bit boring." In 1975 she closed her gallery.[10]

Wijers characterizes this tendency toward sterilization as less a trend driven by commercialization—although it was, to be sure—

than a backlash against radically experimental work, where any practices that could be were "pulled back with very much strength into the thinkable." Since "the unthinkable couldn't be handled," many of the practices that resisted packaging and were concerned to explore realities other than those that were packageable were ignored.[11] She feels that this process of domestication, reterritorialization, and capture by the market was moving very fast. "A baby was growing here, you know; it was almost crushed under the feet of people who were thinking in political [and economic] terms; art was suddenly misused, and was put in a form, whereas it cannot have a form."[12]

She distinguishes the art that was in fashion at the moment, in the latter part of the 1960s, the "so-called Conceptual Art," from work that she believes was "actual conceptual art." In drawing this distinction, she points to David Bohm's linkage of art and fittingness (recall from the Preface, above):

> I think that fundamentally all activity is an art. Science is a particular kind of art, which emphasizes certain things. Then we have the visual artists, the musical artists and various kinds of other artists, who are specialized in different ways. But fundamentally art is present everywhere. The very word "art" in Latin means "to fit." The whole notion of the cosmos means "order" in Greek. It is an artistic concept really.[13]

Beuys, like Wijers, considered that whether or not this production of fittingness could be called art was superfluous and had no bearing on the quality of the action or the object's mode of engagement with the world. "I am no longer interested in the art world," he once said, "in this little pseudo-cultural ghetto. That's why I have no declarations to make about the creativity of artists and the modern art world but would like to make declarations about the creativity of human work in general."[14]

What Wijers calls "so-called Conceptual Art," the work and the attitude surrounding it that made Anny De Decker close up shop, is in her view simply a vocabulary for reproducing and further entrenching art and artists in their pseudocultural ghetto. On the other hand, what she speaks of as the "actual conceptual art" points to something else. This else is for Wijers that generation's great unthought, which she can

describe only as the beginning of a loosely communal experiment in what she calls, with deliberate connections to Buddhist philosophy, "nondual thinking." Wijers's use of this term comes into focus when considered in relation to the conceptual and performative vocabularies generated by Fluxus, whose work, from her first encounter with it in Paris in 1964, became a crucial inspiration to her own.[15]

The difficulty in making sense of nondual thinking in critical discourse has been readily apparent to nondual thinkers from the time of the Buddha to the present: How can concepts be used without our being imprisoned by an attachment to them, and, following from that, how can the pitfalls inherent in producing discourse about one's experiments in "nonduality" be avoided? Although we credit Duchamp with the first realization of the unassisted ready-made, the Buddha beat him to it by about twenty-five hundred years. In fact, the artist formerly known as Prince Siddhartha also gave us one of the ancient world's first examples of "actual conceptual art." Having reached enlightenment, after much deliberation about the wisdom in trying to share his experience with others, the Buddha decided to go forth and give it his best effort. One day in the deer park in Sarnath, India, in front of a small audience, he sat silently and held up a single flower. He uttered no words at all—and that was the lesson: How could words stand in for the intricacy, the mystery, and the beauty— or, to speak less romantically, the complexity—of that tiny blossom? The real challenge is knowing how to proceed in the wake of this realization, without making this demonstration a ready-made in itself, a perpetual one-liner about the inadequacy of words, when in fact the demonstration is a call for perpetual engagement in the specificity and unicity of each moment—including, perhaps, engagement by means of speaking or writing.

Much has been written about the relationship of the American avant-garde with Zen Buddhism from the 1950s onward, when it was brought into the purview of Western culture largely by the "proselytizing activities" of "native elites" such as D. T. Suzuki.[16] As Donald S. Lopez notes, other Buddhist traditions, by contrast, have tended to be "introduced to [Western] scholarship through the efforts of . . . Western historians and philologists who edited, translated, and interpreted Buddhist scriptures from classical languages." Lopez points to the way in which contemporary Western Buddhist studies tend to "replicate

the practices, tropes, and conceits located in Buddhist texts and institutions, where Buddhism is represented as a self-identical dharma that has moved from one Asian culture to another, unchanged through the vicissitudes of time. The share of complicity of Buddhists and Buddhologists in this universalist vision remains to be apportioned."[17] Interestingly, what Lopez describes is a variety of Buddhism that, despite or indeed because of the efforts of its various champions to claim for it the status of a robust and permanent object of knowledge, contradicts the fundamental Buddhist teaching of the impermanent and conditioned nature of all things; this is precisely what Marianne Filliou meant when she said, "The Buddha himself was not a Buddhist."

Considering himself "a philosopher above all," though he is often grouped with early Fluxus activities, artist Henry Flynt has said, "I never had any connection with Fluxus as an art movement. The connection was rather that Maciunas published important documents of mine in Fluxus publications at a time when nobody else would touch them."[18] Flynt is credited with coining the term *Concept Art* in contradistinction to *Conceptual Art,* a coinage he included in his 1960 essay "Concept Art." This essay appeared in the 1963 *An Anthology,* edited by Jackson Mac Low and La Monte Young and designed by Maciunas. In his essay Flynt wrote the now famous words: "Concept art is first of all an art of which the material is concepts, as the material of e.g. music is sound."[19]

Wijers brings her 1993 essay "Fluxus Yesterday and Tomorrow: An Artist's Impression" to a close by drawing a distinction between Flynt's Concept Art and Conceptual Art per se. "Roughly said, 'Conceptual Art' could be called idea art, whereas 'Concept Art' is based on direct visual perception. This direct perception is experienced mentally in a level of consciousness more subtle than language cognition."[20]

Wijers draws heavily upon Flynt's work in her own characterization of this "actual conceptual art"; despite the difference in terminology, this notion is virtually identical to Flynt's notion of concept art, although the way in which she has developed it vis-à-vis her practice has given it significant grounding in Tibetan Buddhist philosophy to a degree that one wonders whether Flynt would recognize himself in it. Describing the relation of direct perception to this creation of the nondual space, she says:

Also in tantra what I feel is, as soon as you leave your ego you have gotten rid of your thinking-in-language, and images. You have no way of connecting to language and images as soon as you get rid of your being as you are today in relative situations. So at that point is where I say art starts. There you are in an area that has no language, and no image. Actually it's very much like [the Buddhist notion of] emptiness. The whole emptiness thing is also another thing which we can look at in the terms of today, instead of saying it's something of another culture.

Reflecting upon the work of her closest colleagues, she says, "In my feeling we were there in '65, we were already at this area of non-dual thinking. And then the whole thing collapsed again. . . . Because nobody was ready for it."[21]

## MIDDLE PATH

For the Gelugpa tradition (the Tibetan Buddhist tradition in which Wijers received the majority of her teachings),[22] "direct perception" purports to know phenomena not in an absolutely unmediated and "unminded" way but by means of specific kinds of "sense data"; these data "are not related solely with objects but commingled with projections from the side of the subject."[23] The three higher systems of Buddhist thought with which the practiced Gelugpa student will be familiar—Sautrantika, Cittamatra, and Madhyamika—are agreed on the point that the phenomenal world of everyday experience "is a complex enmeshment of objective and subjective elements."[24] The Madhyamika prasangika, or "middle path," perspective, which was developed by the third-century Indian Buddhist sage Nagarjuna, considers that direct perception of both internal and external objects is possible; according to this perspective, perception for most "ordinary persons [is] so completely submerged in erroneous over-reification that phenomena are [nevertheless] not perceived as they actually exist."[25]

In his study of Nagarjuna's *Verses from the Center,* Stephen Batchelor explains that the verses' crucial insight is the "understanding of

emptiness as inseparable from the utter contingency of life itself." Nagarjuna argued that the experience of emptiness results from practicing a relaxation, in the direction of cessation, of one's "obsessive hold on a fixed self or things"; this was, in his view, the Buddha's "Middle Way," a space between the ideologies of materialism and idealism, of which Nagarjuna wrote:

> Contingency is emptiness
> Which, contingently configured
> Is the Middle Way.[26]

Emptiness itself is "inseparable from the world of contingencies, it too is 'contingently configured'"; in that it cannot be seen to be separate "from life itself, emptiness cannot be experienced apart from things."[27]

Anne Klein explains that for Tibetan Buddhist thought, just as for Western phenomenology, these principles "raise difficult questions about the status of 'real' things."[28] The difficulty is one of accounting for the obvious "functioning, and continuous" status of perceptible things and simultaneously analyzing the experience of the perception of these "real" things in a manner that can permit a critique of this experience itself and enable an understanding of "the causal conditions for and machinations of perceptions."[29] Yet Klein notes that the issue of paramount importance is not to arrive at an "uncontestable description of mundane reality" but rather "to articulate the limitations and depictions of ordinary cognition in order to depict a model of mental development that purportedly leads to liberation from precisely these errors."[30] What is at stake in the creation of this cognitive model is a "deep conviction in the alterability of the perceiving subject, and in the superior mode of behavior—ethical, serene, compassionate, and wise—that necessarily unfolds as the subject's misperceptions are dispelled."[31]

According to Nagarjuna, fixation upon emptiness itself is precisely one of these errors, perhaps the most insidious because of the centrality of the experience of interdependent origination and contingency to one's progress along the cognitive, ethical, and spiritual path that Buddhism presents. Thus the clinging to emptiness becomes the greatest trap of all, increasingly dangerous the more refined one's practice becomes.

Buddhas say emptiness
Is relinquishing opinions.
Believers in emptiness
Are incurable.[32]

Nagarjuna used the example of a venomous snake to elucidate the way in which emptiness is like "a dangerous but fascinating creature that elegantly negotiates the trickiest terrain. While a handler knows exactly how to pick it up, one who does not will be bitten and killed." Here the challenge doubles when the skilled practitioner moves to try to articulate her experience in language, where the risk is twofold: both that the fixative properties of language will trap one's thinking and that one's mode of expression will effectuate a form of entrapment for the reader. This demanded that Nagarjuna employ a style that was both "playful and provocative"; the verses manifest "the movement of a supple but disquieting intelligence, which constantly has to sidestep the logical traps of the language Nagarjuna cannot help but utter."[33]

Believers believe in buddhas
Who vanish in nirvana.
Don't imagine empty buddhas
Vanishing or not.[34]

"Direct perception," then, in the sense in which Wijers deploys it, entails not simply a cognitive and perceptual engagement but a more rigorous ethical and existential practice for which that perception is central. As Batchelor explains, while the investment in this contingency of all conditioned phenomena, including the constitution of the self, "may seem an intolerable affront to one's sense of identity and security, it may simultaneously be felt as an irresistible lure into a life that is awesome and mysterious."[35]

Glimpsing the extent to which "direct perception," central to an understanding of Wijers's life and work over the past four decades, is part of a spiritual practice is crucial. Without an acknowledgment of the richness and complexity of that term, *direct perception*, which might otherwise appear to signify a problematic and romantic hope of some form of unmediated experience of the world, and without some consideration of its Buddhist bearings, it becomes impossible

to take stock properly of the histories of artistic inquiry that mesh in this global concept art and its existential and ethical imperatives. So while *direct perception* is understandably unruly when approached via the lexicon of contemporary critical theory, we must bear in mind that its meaning for a practitioner of Tibetan Buddhism is substantively different from a naive notion of direct perception—a kind of unmediated engagement with the world—whose embrace of the "illusions of transparency and realism" Henri Lefebvre criticizes in *The Production of Space.*

For Lefebvre, no space, whether mathematical or mental, can be thought apart from social relations. All space is socially produced; it is the play between two mutually sustaining illusions, one of transparency and the other of opacity, or "realism," that keep the complex and conditioned nature of space concealed from our everyday view. It is the illusion of transparency that permits the assumption that "a rough coincidence [exists] between social space on the one hand and mental space—the (topological) space of thoughts and utterances—on the other."[36]

In Irit Rogoff's use of Lefebvre's work to help develop the critical framework to enable a "shift from a moralizing discourse of geography and location, in which we are told what ought to be, who has the right to be where and how it ought to be so, to a contingent ethics of geographical emplacement in which we might jointly puzzle out the perils of the phantasms of belonging as well as the tragedies of not belonging," she contends that this "illusion of transparency naturalizes knowledge and power relations between subjects."[37] Though Rogoff accords great importance to this first illusion and to a practice of wariness in relation to it, her analysis does not mention Lefebvre's second illusion: the illusion of opacity, or realism. For Lefebvre, this second illusion entails the "naïve attitude long ago rejected by philosophers and theorists of language" of the substantiality of things, "the mistaken belief that 'things' have more of an existence than the 'subject,' his thoughts and his desires." In rejecting this position, Lefebvre argues, philosophers embraced "an adherence to 'pure' thought, to Mind or Desire. Which amounts to abandoning the realistic illusion only to fall back into the embrace of the illusion of transparency."[38]

While Rogoff underscores the idea that "Lefebvre's negation of the illusion of transparency is of the utmost importance" in developing the means to deal critically with "positivistic thought and

with analyses which do not take on board issues of situatedness, of unmediated positionality, and which believe unselfconsciously both in exteriority and in the ability to define the realm of the known," and though she does so in the service of producing spatial analyses that would entail "a dialectical system in which opposing claims can be positioned in relation to one another which is not conflictual,"[39] the avoidance of the second side of Lefebvre's coin undercuts his explicit emphasis on the dynamism (itself nonconflictual and for this reason all the more powerful and seductive) between the two interdependent illusions. He writes, "The illusion of transparency has a kinship with philosophical idealism; the realistic illusion is closer to (naturalistic and mechanistic) materialism. Yet these two illusions do not enter into antagonism with each other after the fashion of philosophical systems, which armor themselves like battleships and seek to destroy one another. On the contrary, each illusion embodies and nourishes the other. The shifting back and forth between the two, and the flickering or oscillatory effect that it produces, are thus just as important as either of the illusions considered in isolation."[40]

Rogoff's insistence "on the multi-inhabitation of spaces through bodies, social relations and psychic dynamics" provides a suggestive mode of grappling with that unselfconscious belief in the ability to occupy a position of universality and unmediated perception of things that Donna Haraway has called "the god-trick";[41] indeed, without an understanding of its Buddhist dimension, one would be forgiven for criticizing direct perception on precisely these grounds. Yet in detouring away from the crux of Lefebvre's problematic, which targets the imperceptible shift from one illusion to the other in much the same way that Nagarjuna did in his verses, Rogoff's argument that the illusion of transparency itself—and not the synergistic bond between these two illusions and the third and most powerful illusion, namely, that of the independent existence of the space-producing subject—is what "naturalizes knowledge and power relations between subjects" serves to strip Lefebvre's formulation of the very insight that would help one remain vigilant against reifying this naturalization. Though Lefebvre might little approve of the connection, it is precisely this properly self-conscious attention that is meant by "direct perception," both as used by Wijers's description of her practice and as elaborated by Klein in her discussion of the Madhyamika prasangika, or "middle path." Significantly, the name Madhyamika prasangika itself owes to

Nagarjuna's attempt to chart a path between idealism and material-ism that avoids the pitfalls of both.[42]

Hannah Higgins makes reference to direct perception as well in her discussion of the peculiar materiality of Fluxus in her book *Fluxus Experience,* in which she argues:

> Fluxus materials are useful in . . . an emancipatory sense—
> not because they construct political ideologies but rather
> because they provide contexts (the Fluxkit and the Event)
> for primary experiences. In offering opportunities to gain
> knowledge by multisensory and performative means, Fluxus
> has political implications in the unfixed, unassigned, per-
> haps anarchic sense. Sometimes the compression of shared
> experience, form, and content is called concretism, but to
> avoid confusion with concrete poetry, I will call it "matter-
> ing" henceforth.[43]

Higgins's version of direct perception is not concerned with Bud-dhist phenomenology; in her discussion of Cage and the influence of chance operations in Fluxus, she notes that apart from Robert Fil-liou, "no Fluxus artist has been publicly committed to Buddhist doc-trine, although Philip Corner, Alison Knowles, and Willem de Ridder, to name a few, did follow Buddhism sporadically. It is for this reason that I look to the Western philosophical tradition to help explain the significance of chance and indeterminacy in Cage and Fluxus."[44] Her use of the term *direct perception* signifies Fluxus's deliberate target-ing of "primary experiences," instances in which we are in effect left alone feeling ourselves feeling, with a directness (although not nec-essarily a simplicity) that offers a provocation to read this "primary experience of matter as art."

The koan is frequently wheeled out as that popularly unsolvable Zen riddle that is offered to make instant nonsensical sense of vari-ous Fluxus events. "The Zen koan," writes Alexandra Munroe, "offer another correspondence to [Yoko] Ono's event scores. These brief phrases—some a single character long and others such cryptic state-ments as 'To turn a somersault on a needle's point'—are used as con-templative tools between master and disciple whose meaning, once grasped, leads to an experience of satori (enlightenment)."[45]

In fact *ko-an* is the Japanese pronunciation of the Chinese *kung an,* which means "public case." The term comes from Chinese legal discourse and was used to describe the awakenings of Zen masters: "Just as a judge studies a previous legal case to get his bearings on the complexities of a present case, so can the Zen student study the public case to get his bearings on the complexities of the present 'case' of his or her own existential dilemma."[46] In a 1992 interview, Fluxus artist Ben Patterson said:

> Perhaps the one thing that everyone forgets or represses is that I, and my generation of Fluxus artists, were all more or less twelve to fourteen years old when the first atomic bomb exploded and left its mark on civilization. Perhaps only Zen or existentialism could begin to deal with such finality.[47]

In a text titled "To the Wesleyan People," which Yoko Ono wrote following a performance on January 13, 1966, at Davison Art Center Gallery, at Wesleyan University, in Middletown, Connecticut, she says that she thinks of her "music more as a practice (*gyo*) than a music." She explains, "The only sound that exists to me is the sound of the mind. My works are only to induce music of the mind in people."[48] In this remarkably obliquely explanatory text, Ono gives her reasons for her use of this form:

> There is no visual object that does not exist in comparison to or simultaneously with other objects, but these characteristics can be eliminated if you wish. A sunset can go on for days. You can eat up all the clouds in the sky. You can assemble a painting with a person in the North Pole over the phone, like playing chess. This painting method derives from as far back as the time of the Second World War when we had no food to eat, and my brother and I exchanged menus in the air.
>
> There may be a dream that two dream together, but there is no chair that two see together.

She explained to the people of Wesleyan why she chose not to refer to her work as "happenings," and why, though she did on occasion use the word *event,* she did not do so regularly. "Event, to me,

214

is not an assimilation of all the other arts as Happening seems to be, but an extrication from the various sensory perceptions. It is not a 'get togetherness' as most happenings are, but a dealing with oneself. Also, it has no script as happenings do, though it has something that starts it moving—the closest word for it may be a 'wish' or 'hope.'"

Ono closes her address with the famous tale of the debate between Shen-hsiu and Hui-neng. Their dharma duel is expressed in two short passages:

The body is the Bodhi Tree
The mind is like a bright mirror standing
Take care to wipe it all the time
And allow no dust to cling. —Shen-hsiu

There never was a Bodhi Tree
Nor bright mirror standing
Fundamentally, not one thing exists
So where is the dust to cling? —Hui-neng[49]

In his account of Ono's work, David T. Doris invokes this legend, suggesting, "It is with Hui-neng that Ono has the greatest affinity."[50] He fleshes out Ono's choice of *gyo* to describe her work, explaining that the term originates from Zen practice: "Expressed more fully, the term is Gyo-ju-za-ga. Translated literally, this means 'practice-walking-sitting-lying'": one's daily life should not be other than one's practice.

Doris explores this "bare, undivided attention" further in his discussions with Fluxus artist Takehisa Kosugi, who refers to such practice as "opening the eyes to chaos." Kosugi says:

The sound object is not always music, but action, action. Sometimes no sound, just action. Opening a window is a beautiful action, even if there's no sound. It's part of the performance. For me that was very important, opening my eyes and ears to combining the non-musical part and the musical part of action. In my concerts, music became this totality, so even if there was no sound I said it was music. Confusing. This is how I opened my eyes to chaos.[51]

What is at stake here, Kosugi feels, is "self-revolution": "Before opening eyes, there's a stage of consciousness of normal eyes. Beyond that, we have another consciousness. My idea was to open consciousness."[52]

Returning to Wijers's use of the notion of direct perception in her discussion of Flynt's Concept Art as part of her reflections on Fluxus (recall: "Roughly said, 'Conceptual Art' could be called idea art, whereas 'Concept Art' is based on direct visual perception. This direct perception is experienced mentally in a level of consciousness more subtle than language cognition"), I find it important to note that though she speaks of Concept Art's basis in direct visual perception, given Flynt's emphasis on a practice that attends to the materiality of concepts, direct perception could easily be mediated by any other sense or indeed a synesthetic mesh of many. That is to say, one can conceive of concepts whose bearing is not primarily visual but rather sonic (as in the case of Cage's silences, for example), others that are tactile, olfactory, and so forth.[53] This point is important to make in the context of a broader discussion of Fluxus, given the full-body and multisensory engagement of its output.

But what is at issue in Wijers's remarks is less the centrality of the visual in her formulation of direct perception than the importance of her engagement with Buddhist philosophy and practice in shaping her view of the work of her contemporaries. That is, even though any one of those artists might not have even flirted with Buddhism, Wijers's use of Buddhist concepts in articulating the nature and efficacy of their work has nevertheless seemed appropriate to her.[54] Put differently, for Wijers the connections among her work, the art of her contemporaries, and the Tibetan Buddhist tradition of which she has been a student are not only thinkable but also genuinely productive. Furthermore, while Tibetan Buddhism might offer some of its dilettante adherents the chance to undergo exotic initiations, certain historians and theorists' general suspicion of Tibetan Buddhism's embrace by Western artists and intellectuals does not in and of itself detract from the fact that Tibetan Buddhism offers some of the most rigorous and sophisticated models available for the critical analysis of consciousness.[55] Apart from its potential in this regard as an object of inquiry, one that has been

probed and pursued by a number of contemporary scientists and philosophers,[56] the interest that a number of artists in the postwar world have shown precisely in Buddhism's potential as a practice of transformative self-investigation and experimentation underscores the need to take it seriously.

In his discussion of the relationship of his work to his dharma practice, Filliou told Wijers that what became apparent to him was that "so-called conceptual art" tended to elide what was so powerful about working with concepts. He said, "We can think in the past of examples of magnificent artists . . who were spiritual beings . . and who never forgot that art is a spiritual thing. . That is my little problem with so-called conceptual art. . I am not afraid of concepts . . but art is a spiritual thing." To which Wijers replied, "But even conceptual art finally becomes spiritual." Filliou: "Exactly . . Our generation has tried . . we have tried . . many, many of us . . in many ways . . to put art back on the right track, through an intuitive understanding of what it is all about. . Namely, that art is a spiritual adventure. . And once we put it back . . again the whole field is open . . while it looked like art was coming to a dead end."

Wijers agreed. Filliou continued: "By putting it back on the right track, the whole thing is open again. . So, that's where our friend John Cage comes in . . our friend Joseph Beuys . . and George Brecht . . and people in Japan . . and men and women from here, from there, from everywhere."[57]

In her essay on Fluxus, Wijers quoted George Brecht's version of this spiritual–conceptual fabric: "Human solidarity is in its feeling the same for all, namely to combat the immense simplicity, sadness and lack of insight, and create a world in which spontaneity, joy, humour and a new form of higher wisdom bring real social prosperity with the same self-evidence as the green of my wife's eyes."[58]

## RECONCILIATION

Despite Wijers's faith in her own hunch that she could invent the conceptual toolkit necessary to bridge the radically different kinds of experimentalism taking place in the works of artists on either side of the Atlantic, not until years later would she articulate this in terms

of a notion of nondual thinking and direct perception. In 1969, she felt unable to reconcile this intuition with her everyday life and her work. Some years before, shortly after coming to Amsterdam, she had befriended the young artist Bernard (Ben) d'Armagnac. In a decisive encounter in 1969, he persuaded her to stop writing about art and return to making it. She describes this shift as the most difficult task of her life. He invited her to come to Zeeland, south of Amsterdam, where he was living and working with his friend, another young artist named Gerrit Dekker. They would live together; if she had no money, it was no problem; he had enough for them to live on.

> He put me in a little house, and I'd been sitting in that house
> on the stone floor, wood stove, cemented wall with cracks
> falling off . . . I was just sitting in a wooden chair looking
> at the wall for one year, and I'm just thinking about what I
> had seen in New York, and what my original idea of art [had
> been]. I couldn't bring it into one being . . . I had to think
> about it so long, it was a real inner crisis for me. . . . There was
> something happening that I couldn't follow.

According to Wijers, Beuys had been happy to see that d'Armagnac had helped her to get herself out of what she describes as the cynicism of Amsterdam's art scene.

Despite Anny de Decker's similar dissatisfaction with the trends toward commercialism and predictability in 1970s European Conceptual Art, that decade did produce a number of extraordinary artistic experiments that must not be written off. Apart from the fame of figures like Ger van Elk, Jan Dibbets, and Marinus Boezem,[59] and despite major exhibits outside Holland,[60] most of the artworks of that decade have largely been either deliberately ignored or unnoticed by English-speaking scholars.

Works by many of these artists were brought together in a 1978 exhibition called Mit Natur zu tun (To Do with Nature). Co-organizer Gijs van Tuyl wrote that this project grew out of artist Gerhard von Graevenitz's interest in Dutch artists' increasing engagement with the "natural" environment from the late 1960s to the mid-1970s and his suggestion that a show be created specifically to address this. (We should note here the paradox of speaking about the Dutch landscape

in particular as "natural.") Along with Piet van Daalen, Jan van Munster, and van Tuyl, von Graevenitz gathered a range of artists according to three criteria: those who worked directly with "nature" (for instance, artist Sjoerd Buisman experimented with the growth processes of plants and the effects on them of environmental factors, such as changes in light and gravity, and recorded various data related to them); those who made "incidental use of nature, usually indirectly, by means of photography" (artist Nikolaus Urban presented an eight-day performance in which he attempted, unsuccessfully, to teach a parrot to say the last line of Wittgenstein's *Tractatus Logico-Mathematicus:* "What we cannot speak of, we must be silent about"); and those whose "starting point [was] nature or a natural way of life."[61]

In this third category were artists who committed themselves to living and working in nature, such as Ben d'Armagnac and Gerrit Dekker, who, following their mentor, painter Anton Heyboer, began their poststudent careers by dressing in traditional Dutch farmer- and fisherman-wear, living off the land, and working strictly with found objects from the Dutch landscape.[62] Though d'Armagnac's work made in the late 1960s, on the heels of his time spent with Heyboer, consisted largely of etchings, he and Dekker soon after began to work primarily with found pieces of wood.[63]

Ben d'Armagnac was born in France in 1942, the son of a nobleman from whom he inherited the title of count. His mother was Dutch, and when the war broke out his parents moved to Amsterdam with their two children, Ben and his sister. When he was in his twenties, his mother committed suicide in their home. His sister persuaded the owner of the house to divide it into two parts and to permit d'Armagnac to live in the upstairs section and to rent out just the downstairs section. D'Armagnac went to art school in Amsterdam, and in 1966 he and his girlfriend Lotti, along with Dekker, left the city for an old farmhouse in the hamlet of Lewedorp, in South Beveland, Zeeland, where d'Armagnac and Dekker worked on their sculpture. Here they met the artist Anton Heyboer, with whom d'Armagnac lived for several months and with whom both studied.[64]

In a 1967 letter written to friend Piet van Daalen, Dekker explained:

> I must preserve all my intensity for myself, cherishing and cultivating it; only then can I offer myself to society, not in

the accepted guise of an artist fitting into society, but as a man who tries as an individual to adopt an attitude towards "life" in as objective a fashion as possible, and to hope that this intensity, which I must keep perfectly pure, will pass on a spark to our hunted, murderous, child-shunning society.[65]

In this he continues the variety of existentialism found in Heyboer's autobiographical statements: "Concentration camp was no worse than my parents' home," Heyboer once remarked to an interviewer, "and society is no worse than both for me, too uncreative." He told one writer, "I can only exist as an artist. It would be impossible as a man. Normally there is no sense for me in things, I don't have enough feelings. I can live abnormally. Creation is the only eternal life. It is the resurrection."[66]

Heyboer's life and work provided "a powerful example for a generation of young artists who, encouraged by him, question our technified and changed world." He was considered by many young Dutch artists to be a "pioneer of this mentality" that sought a withdrawal from urban life in favor of creative isolation. In the early 1960s Heyboer "turned his back on the technological progress and affluence of western society and withdrew to the seclusion of a hamlet called Den Ilp, where he found the right ascetic conditions to enable him to concentrate on his inner self and on human relationships. He reported his findings in his etchings, using a symbolic sign language."[67]

Through Heyboer's influence, many young artists "moved away from the city to live in the country in the way that fishermen and farmers used to. For these artists, art and daily life form an indivisible whole."[68] Heyboer had come to believe in the importance of maintaining selected elements of traditional Dutch life, particularly through his dressing in workers' clothing and compelling the young students who now came to him to do the same. The accompanying figure is a photograph of d'Armagnac and Dekker taken in 1968; it shows them standing in front of their untitled sculpture in the garden of the Zeeuws Museum, in Zeeland, and they are clad in traditional fishermen's clothing made from pilo, a thick and sturdy but flexible double-knit fabric with a plush, feltlike outer layer.

After leaving Heyboer's tutelage, d'Armagnac and Dekker continued to live and work together. At first they made series of etchings whose symbolic script echoed Heyboer's work, but they soon began

Anton Heyboer, ca. 1965. Reproduced by permission of Louwrien Wijers.

to create art that engaged with their lived experience of their local environment, using "discarded planks and odds and ends to build wooden huts which were meant to be a kind of meditation space."[69] They said, "The construction of these huts had nothing to do with art in our opinion, which is why we built them. We had a lot of fun doing it, and we lived in them as well."[70]

Wijers lived in one of these huts too, in 1970, following her first year with d'Armagnac and Dekker, the one in which she sat looking at the wall, deep in thought; she describes this as "the year that I was starting to think how to work, you know."

Then the work began.

I was very influenced by the conceptual, so the first things I made were just words. I don't know if I've ever told you, but for, oh, I think two years, I just lived one word. I never knew [in advance] what word it was, but as soon as [the word came to me] I would write it down on a piece of paper, with the date, and then just go on living. Because the idea was [that] life and art are one. But how to get to the essence of it, I had no idea. So [later] I made the series *40 Words,* and

Ben d'Armagnac and Gerrit Dekker in their fisherfolks' attire, with an untitled sculpture in the garden of the Zeeuws Museum, Zeeland, 1968. Reproduced by permission of Louwrien Wijers.

they came out on big cards of just one word, and it was the first thing that I sold to the system that we had at that time, the artists' system; you had to bring in the work, and then you got money for a period of time to live, then you had to bring a new work and you got money again, you know. That was the system. So from 1970 I was in the system of artists. And the working of words was 1970, 1971, and '72. But in '72 I had an installation, you could say, with [this work]. But [it could] almost [be called] performance. I've never realized that I thought of these things rather early, even compared to

Ben d'Armagnac and Gerrit Dekker, *Huisjes,* Zeeland, 1968. Reproduced by permission of Louwrien Wijers.

(below) Louwrien Wijers, Prinseneiland studio, 1971. Reproduced by permission of Louwrien Wijers.

Ben. My performance—I didn't know it was a performance,
but I did it earlier than he did! I was working on these sheets,
then I had a period that I was working on sentences—sen-
tences that you could use anytime, you know. Like I had one
sentence, something like:"the bay, that is the water here, the
ships are passing," you know, things like that, very much like
Lawrence Weiner, although I didn't know that he was doing
these things. . . . But I had done that in '71 I think; I did
the sentences, sentences that can always be said, you know.
They're always good. I never work with those anymore. And
then I started to do pictures of things, photographs of things
that are always good: like the flowers that come out of the
snow, you know, a picture of a crocus, many things like that,
and every year again you see [the flowers come back] and
you think, "Wow," you know. In '72 I started, as I said, to do
the installations, so I made this piece [at] the Goethe Institut.
I had a room there, and I just made it in a way that I could
live in the room, so everything that I would need for my
living was in that room. That means the food was there, the
table, and papers and pencils, and you know, it was just as
if I could step in, and be there. You know, lamps and some
kind of crochet work that I was working on. So I just made
a room, and it looked quite nice, you'll see it some day on a
photograph. And then I went to the United States.[71]

In 1972 Wijers returned to New York. A friend of a friend whom
she had met while staying in the Chelsea Hotel in the late 1960s had
a gallery on Fifth Avenue, near Washington Square Park, and asked her
to do a piece there. The piece involved Wijers sitting in the window
in traditional Dutch women's folkwear.

The influence of Ben d'Armagnac and Heyboer comes in
here, eh? Heyboer lived in the folkwear of Holland, so there-
fore we started living in the folkwear, and actually in New
York I was wearing Dutch folkwear, when I was there in '72.
I was wearing wooden shoes and the clothes and ... incredi-
ble! There must be a few people who can tell you about that,
[about me] actually walking up and down Fifth Avenue [and]

sitting in that installation, and it was about women, because I felt that women were not seen as they were. I was actually very much against women's liberation, but I was very much for looking at women, as they should be looked at, you know. I didn't like them to be more male, like in women's lib. I was a little bit against that.[72]

It was also during her 1972 visit to New York that Wijers had her first encounter with Tibetan Buddhism. She occasionally traveled to Freewood Acres, New Jersey, to visit Geshe Wangyal's Lamaist Buddhist Monastery of America, which also attracted the young Robert Thurman, among others.[73]

This period was also the beginning of her work in metal sculpture; within a few years what she calls "mental sculpture" would come to take precedence and would unfold almost directly out of her attempt to use metal to sculpt concepts.

I was very intrigued [with] how you could work with metal, because the metal did make me think of the marzipan that my father was working in [the bakery when I was a child], because you could bend it in all ways, and I thought, Aha! Nice! you know. And my idea was, again, like in the '70s, I wanted to solidify things. Time, actually, I wanted to solidify, and I think I'm still doing that. The first thing I made there was not of metal; it was wood, a wooden thing and a person lying on it, and out of the person flowers are growing. So that was the piece. And the person was me, full length, made in a compost kind of material. I don't know whether that thing still exists, but it was a nice thing that we brought to Arnhem. And the next thing was the metal. So, the first thing I made of metal was a table and chair. And the idea of the table and the chair came because you were sitting, and there was some stillness, and then in the table I made a text, because I was always working with text. And so the idea of being at rest is what I wanted to show. But wrapping the table in aluminum, and screwing that together, is something I've done more, like with the copper bed, [to] take it out of its normal presence. Just the shape of the table, and the

idea of table and chair, because the table and the chair are of something that one day will not exist anymore, but now to wrap it, like Christo. Christo was of course very important in my time, in my influence. So I started wrapping up things to show their existence in a different way and used the shape of the thing in a meditative way, so the table and the chair, if you look in here [looks down at the kitchen table where we were sitting], and you're reading a text, I called it *Going Inside*. And that stairway, of lead, [and] the bed of red copper was the same idea. I called the bed *Prayer*. So the bed is a place, I find, where you can really have your prayers. It's a very nice place where nobody can disturb you, you know. You can have your real prayer, so that's why I called the bed *Prayer*, and I put the prayer on the cushion of the bed, with words. And [the] stairway of lead is a thing that Beuys also ... How did I call the stairway? Stairway must have a title but ... [she said the word *overgave* in Dutch, almost inaudibly] now I remember! Ah, ah, what would the word be in English, *overgave*? It would be like you give yourself to something, without holding back. That is the idea. So the staircase would be ... you have to step one, two, three steps ahead of yourself, from the ground, and then you can read the text, which says, "If I'm ..." What's the word, *overgave*—what does it mean, in English?[74]

I replied, "I don't know if there is just a ... one word for that."

Gave up, gave up yourself, is what it means. So that was written on the highest step of the stairway, you could say, on the top part. If I live in *overgave* then I am much more real. It is actually the same thing as Beuys said: "If you create space around yourself, and you live in that space" ... it's that kind of thing. Don't stay within your own, your confined feelings and thoughts. *Trust* whatever is there, and *live*, live your *trust*. So actually all the things that I've done in the '70s have come through these phases of making known to yourself what you actually want to ... how you actually want to live, or be. But it became very religious, almost. It became ... the struggle

came when I saw that, ah! the real things that you want to show or make are much nearer to reality if they could be religious, you know, if they could have a religious context. And ... but, we don't have that. I mean, when I saw the first sculpture in Dharamsala of Padmasambhava, made in metal, ah! I felt that for a culture like that to make a Padmasamb-hava can be very helpful, whereas in the West, we don't have such icons, and its very hard to make a sculpture that could be an icon for many people. So I thought, it is actually better to leave that kind of sculpture that I'm doing, I was doing at the time, to leave that to cultures that still have an icon tradi-tion, and I shouldn't force my time to go on in icon-thinking. And I actually thought that, apart from using the material, which I became more and more against—because how did I know whether the copper sheets, or the lead, were com-ing from safe places, you know? Maybe there was lots of blood hanging on all these materials, because mostly they came from places where people didn't get much pay, and where there was slavery and terrible situations. So also that aspect I really disliked about working with metal. The creat-ing of icons—that could maybe never be carried through in our society—I felt was not a right thing to do. So that, I got fed up with the whole idea. Also I wanted to work not with material but with mental. Now we are talking late '70s. So I thought I must do a completely different thing. And I must go into the mental instead of the material. And that is the start of mental sculpture. And I stopped doing these strange [sculptures], because I had done so many by that time, maybe twenty-five pieces, and I was really coming to the end of the visual part of it. I didn't think that [it] was the visuals, that you had to show people, today. And then as you know I started to talk to people, about art, so that is where the Beuys interview, '78, starts.

It was d'Armagnac who helped her, after several years of making sculpture, to return to her writing, not as a writer, but as a maker of mental sculpture.

Yeah, it was Ben who told me in 1977, "Why don't you pick up your typewriter again, and see whether you can make something with that now, after nine years of not looking at it?" "Hm!" I thought, "good idea!" you know. So I must say he actually pulled me out of this game, before he died. A year before he died, he wanted me to change; I don't know why, but he just came in and said, "Stop," more or less, you know? And it's not easy to work as a sculptor with a typewriter. But I found I had to do that. So I came to the interviews first, and then from there to Art Meets Science [and Spirituality in a Changing Economy], and I think I can say that it was just keeping on with the work, you know. It looked like I was working as a journalist again, but I don't think I ever did. I think I found the way to go beyond normal writing and normal media work. And I think that what came out of it, Art Meets Science and Spirituality in a Changing Economy, I couldn't have taken that further I think, that idea of mental sculpture. I think it was my utmost, you know. I really felt like a Rembrandt when I was doing Art Meets Science. I felt that, only later, people would see that this was a *Nightwatch,* you know—something like that. There is not much material of Art Meets Science, really, visual material. But if we had more, it would have spread much more easily around the world. But it still can, you know. And I don't mind that the work is not famous. It has always been a little bit outside the art world. But then of course in 1973—I have to mention that—I had an exhibition again at the Goethe Institut here in Amsterdam, and one way or the other, it was a wonderful exhibition. It was all about writing. It was three rooms. The day before it opened I made a carpet, like paper, almost as big as this floor [about the size of her kitchen, fifteen by twenty feet], and I wrote on it with very big letters that I never wanted to enter the gallery circuit in the art world and that this was my last show, because I felt that if I wanted to enter the gallery world, I would have to be dishonest to myself, and I said I'd had a few shows, and I was grateful to the people who gave me the shows, but this was the last

show that I did. Because I didn't feel that this could help me, in doing my work, so I've always worked very concealed, you could say. And that also was the beginning of the mental sculpture. There was a whole game, so what I just wanted to say that I never went in. Lawrence Wiener always says that, "You know, Louwrien, I went into the art circuit, and that was easy. But what you do, without going into the art world," he says, "that is much more difficult."

## MORE DIFFICULT

On the kitchen table in front of us, Wijers's catalogue raisonné of d'Armagnac's life's work is open to an image of his work *Buiten de perken,* shown at Sonsbeek in 1971.[75] The image shows two mannequins seated at a table. Each of their heads is smashed in by a pile of books crushed into the chessboard that sits between them. I read aloud:

At a table, two big dolls, a man and a woman, are facing each other. Between them on the table is a chess set with some of the pieces turned over. The heads of the dolls are [I stumble over the words:] bloody, battered . . . "bloodly battered"? It's nice, it's not English, but it's . . . [Wijers, laughing, asks, "Oh, no?" as I continue:] it's even more poetic. "Bloodly battered"—that part of it sounds like Shakespeare. [I continue to read:] At the entrance a text explains that people talking to each other are often competing about knowledge without trying to understand each other.

Wijers smiled and said:

It is me. In the time that I was living with Ben here in Amsterdam. And I had friends from before who wanted to see me, you know, and then I would come back home and I would be completely changed, because I was so tortured, that . . . and then he made this piece. And it's my books, too! [she laughs]

I guess Ben thought, "Okay," you know, "it's your head, so it's your books."[76]

While Wijers had been in New York, in 1972, d'Armagnac had performed *Witte ruimte* at the Goethe Institut, in Amsterdam. Wijers returned from New York in order to see it. It was one of his earliest performances, although it was only the traces of the action that were put on view; d'Armagnac had performed the piece itself in isolation. The entire room had been covered with white canvas. Wijers explains that he had enacted the process of suffering, struggling with "some difficult subject within himself." The walls are covered with bloody handprints, most of which are layered over with white cloths that d'Armagnac affixed as a partial covering. He had walked back and forth between two parts of the room; one "seems to be the corner of suffering," and in the other corner, over the sink, "he seems to be cleaning that cloth with blood. And here sees in the mirror a clean face. It was very, very impressive, because there was an enormous atmosphere in that square, especially when you were there alone."

I remarked to Wijers that I was struck by the technique of laying cloth over the marks, so that what is underneath the attached sheets does not erase them or wipe them away but permits d'Armagnac to mark them, deal with them as if in a calming gesture—soothing a wound by laying a thin, clean sheet on top. The marks remain visible, and while they can perhaps be reactivated, the wounds reopened, d'Armagnac has made the first move toward healing.

Wijers replied:

It doesn't harm you anymore, heh? You've dealt with it. It is also [a] very loving-kindness thing to do.[77] Beuys has that same soft touch to wound healing, almost, heh? . . . Yeah, they're very, very near to each other, these two guys. That is what makes Beuys much younger than, for instance, Heyboer. Heyboer didn't get rid of his painting, he just kept painting, but Beuys went into all these other things, and that is where Beuys and Ben are much nearer to each other in a way. Although when you look at the drawings of Beuys and the drawings of Heyboer they're very near to each other. I

Ben d'Armagnac, *Witte ruimte,* Goethe Institut, Amsterdam, 1972. Photograph by Oscar van Aephen.

told you, when I brought Heyboer the Beuys book?—do you remember?—and he slept on it, and next day he called me and he said, "Come and pick up your Beuys book. I can't live with it. It's just like me; it's ruined my life, because [it's] so similar—the only similar thing to what I'm doing—and its too near." [She laughs.] There they are very similar, Beuys and Heyboer, but here, it's almost like Beuys lived another generation, too, you know, the German younger generation.[78]

D'Armagnac took this concern with the enactment of healing further in a second work, in his untitled performance with Gerrit Dekker at the Neue Galerie, in Aachen, in 1975. The two of them lay side by side and face down on a hospital table, blindfolded and bandaged, with their arms stretched overhead. Each has one hand on a single bloody cow's heart. Whereas in the previous work the focus is upon the work of healing that must be undertaken by d'Armagnac himself, here the focus is upon the negotiation of a shared condition. Wijers's description of the piece picks up on this dialogical rhythm:

Yeah, he's almost like putting your hands inside the body of someone else and holding his heart, you know, to caress the heart—that is what Ben is doing. He is going inside, you know, to help you, soothing the pain. And with Ben, the blood, you know—when he found out that [Hermann] Nitsch was using blood (I may not have told you this before), he stopped using blood. Because he saw that Nitsch was using the blood in a completely different way, and all the Wiener Aktionisten, they said, "Oh! Ben d'Armagnac is like the Wiener Aktionisten!" and then he met Nitsch, in his castle, together with Wies Smals, who went there [and her voice trails into a whisper] and was so amazed that he stopped working immediately, like that, you know. It's—he never [again] used the same materials, not even the organs.

Although d'Armagnac ceased working with animal organs in order to cut any perceived connection with Nitsch's work,[79] I told Wijers that d'Armagnac's use of organs to signify the practice of responsibility for another seemed to remain consistent in his work.

She replied:

Yeah! That is what it is. It's responsibility; it is: if I take care of you, others will take care of me. It doesn't matter how it comes, but it's: the first thing is you, the other, you know? Yeah, this is very bloody, heh? This is of course two people holding, taking care of the heart, yes. Yeah they are holding that heart together. Looks great, heh? It was done in Aachen, Germany, and they could hardly get out of the museum, peo-

ple were so angry at them. They almost jumped on them. Yes, people reacted very violently.

Marina Abramović recalls, "The first time I saw Ben was in his performance in Paris, 1975. I looked and I said: it is not possible, it is just too open. That was an incredible reaction to me. It was like you show completely your inside to the outside. Later I met him and all his work was just too open. He had not any defence and that hurts. He was so vulnerable."[80]

In light of Abramović's remarks, Wijers's connection of d'Armagnac and Beuys makes it interesting to recall Beuys's critique of "openness" in his famous interview with Enzo Cucchi, Anselm Kiefer, and Jannis Kounellis, in which he said:

> Openness is, of course, a somewhat obsolete concept. Many people think they are quite progressive and "with it" if they speak about so-called openness. But openness has to be precisely defined. Otherwise, openness means nothing more than that everything is possible. However, I claim nearly nothing is possible. In order to have access to every single point of view, you really need an astute sense of perception. But if one wants to arrive at a consensus, openness must take on a totally determined form, a condensation, and that's the opposite image of openness.

To which Kounellis responded, "But we're individuals who don't let ourselves be influenced." Beuys's reply had an intriguing ethical charge that cuts directly to the substance of d'Armagnac's performance: "Openness should be human, related to the individual anthropologically; open for what the other means."[81]

## NEUE YORK

In 1978, d'Armagnac went to New York as part of an international studio art and exhibition program sponsored and subsidized by the International Committee of an organization called the Institute for Art and Urban Resources, Inc.[82] Under the auspices of the Interna-

tional Program at P.S. 1, a subcommittee made up of individuals from a sponsoring city or country proposed one or more artists for consideration by the international committee, composed of New York critics, art historians, and artists, who then issued formal invitations to selected artists. The residencies were granted for visits between six and twelve months' duration and were to culminate in the Open Studio Exhibition at the conclusion of the working period. Said the official press release, "The aim of the International Program at P.S. 1 is to provide a working environment for artists from other countries in New York City, in a community of artists and art-world professionals (critics, art historians, museum directors, etc.)." Whereas today, over a decade after P.S. 1's grand 1997 reopening, the P.S. 1 studio residency program makes a point of hosting artists from every corner of the earth, when d'Armagnac participated in it, the program was very much an American–western European exchange. In 1978, the only international sponsors were the Netherlands and the two German cities of Berlin and Düsseldorf. That year, in addition to d'Armagnac, three others participated, all of them from Düsseldorf: Monika Baumgartl, Volker Anding, and Thomas Struth;[83] d'Armagnac was the only artist of the four billed as a performance artist by P.S. 1. All of the Düsseldorfers had open studio exhibitions. Baumgartl had hers on April 16, and both Anding and Struth held theirs on the following days: May 6, 7, 13, 14, 20, 21, 27, and 28. D'Armagnac was scheduled to perform in P.S. 1's auditorium on May 14.

D'Armagnac was the first person that Holland sent abroad as part of this program. "So he was so excited," recalls Wijers. "Ben told me how enormously he wanted to go to New York. I had never thought of him that way; I always thought that he was more of a recluse, you know. But by that time he was—he really wanted to see the real art world and see what was happening in New York! And then he did get that [chance]."

This chance came to d'Armagnac largely through the support of Wies Smals, proprietor of Amsterdam's influential de Appel performance space. But, says Wijers laughingly, "he was so disappointed about P.S. 1, how it looked, and where—it was so far away from Manhattan [that] he never went there. He hated the place.[84] He said he couldn't go there. It was terrible; he didn't know what to say to the Dutch people; he said he got choked immediately as soon as he saw

[a particular staff member], or entered his space, he found it, a disgust, you know, to offer such terrible spaces to artists." So d'Armagnac wrote a letter to P.S. 1 telling them that he could not do a performance there. He wrote another letter to the funding body, which Wijers describes as a plea: "Could he please make a performance any—somewhere else in the city, because this was a place that he couldn't stand." Wijers laughed and explained:

> Everyone was very upset, of course, you know, that this Dutch guy—finally they had given him lots of money to live in New York, and then he said it was awful, where they had sent him to! And he was so disappointed about the galleries in New York. He was completely disappointed. Because it looked like everything there was better, but in fact it was better here; especially de Appel was the best place in the world [for performance] at that time.[85] But nobody understood until they had seen the difference, of course. So Ben did make a performance of which we don't have any photographs, a first performance, but people I think threw it out, because they thought it had no value.

P.S. 1 does not have records of this performance. Grounds for speculation about it, however, are provided by the text of Wijers's interview with d'Armagnac on May 2, 1978, when d'Armagnac told her what he intended to do at P.S. 1. The degree of resemblance between his preview and what actually transpired is uncertain. So, too, is whether his performance transpired on the date that the press release had specified, which was also issued in advance of May 14 and even perhaps in advance of d'Armagnac's decision not to spend his time at P.S. 1.

In their interview, d'Armagnac explained a kind of "divinity" that he had in mind as he worked. To elucidate this, he posed a question to Wijers:

> Would you mind if I explained to you what kind of a videotape I am going to make for P.S. 1. If you see it then you know what I have been doing, don't you. Well, I can easily talk about that video-tape. The Brooklyn Museum [see

below] that is really something ... that is more complicated, bigger, for me. Also because I do not yet know exactly what I think in that tape I am really. . . . . And I only realized that much later, because that video-tape I had written down quite quickly . . . and then I thought: hey, that has indeed to do with where I want to go to. I'll say more about it later, about that divinity. . . . . But when I am thinking about that video-tape I am thinking it will be a tape on which I am very much involved with my body. I am going to show parts of my body on that video-tape. But first I am going to sit somewhere on a very beautiful spot. And that spot I still have to find of course here in New York. I take then a tape-recorder with me and I am going to look very well at all the different parts of my body, which I will show later on that video. And then I name them all. After that I'll go to PS 1 and there you will hear that tape where I name the parts of my body. . . . So you hear that from a very different space than the PS 1, you hear those words coming from the very beautiful spot, and in the PS 1 I will answer. So you hear for instance "feet," that is "voeten" (Dutch) isn't it. And then I answer "feet" there and I show part of my foot. And in such a way I will go around my whole body. And perhaps I will of my foot or my hand only show one nail ... I probably do not even want you to see my whole hand. I have a feeling that I will keep the camera very close to my body? Showing small parts. But it strikes me that I do have the urge to go to that other spot first, because there I will answer the divine. I am then somewhere in a kind of divine atmosphere; something very beautiful and I will be answering the divinity in myself in fact later in PS 1, in that studio. So it strikes me that I am occupied by such things. I thought myself that this must be the beginning of something. You know, that I may want to work on this in the future.[86]

The first performance he did in New York was at the 112 Greene Street gallery in SoHo. There appears to be no available documentation of this performance, which Wijers remembers having happened sometime in April 1978. She does not know the title but says it was

"a beautiful performance . . . it was very simple, but with sound and light."[87] In their interview, d'Armagnac described it, if only obliquely: "a performance on my own with water, in my room [ . . . ] with nobody there [ . . . ] a very private performance [that is] in fact between a performance and an installation."[88]

However subtle it would appear to his spectators, the privacy of his experience in the 112 Greene Street gallery provided a connective tissue with his early "between performance and installation" works, such as *Witte ruimte,* performed at the Stedelijk Museum in 1972. The 112 Greene Street piece also reconnected him with the use of water, which would reemerge in his Brooklyn Museum performance in a matter of weeks. Wijers listened as I read the catalogue description of that final performance aloud to her:

> On a pavement in a garden of the museum lies a plateau of white tiles. Ben d'Armagnac is lying on it while wearing a black costume. A jet of water is pointed at his heart. Out of the loudspeaker comes the sound of someone breathing. Ben d'Armagnac moves slowly his arms and legs. His chest heaves rapidly. After about an hour he lies there motionless for a moment then he gets up and walks off.

"Yeah," she said, after a pause. "Of course it was much more dramatic than [ . . . ] you will find in this thing [referring to the catalogue]."[89]

## FULL DRAFT

Between May 10 and 14, 1978, the Brooklyn Museum held a week-long event titled the European Performance Series (EPS). An initiative conceived by Sharon Avery of the Sharon Avery/Redbird Gallery in Brooklyn, by the Brooklyn Museum, and by Jan Brand of the Netherlands, the series invited nine "performance artists" from Europe, most of them from the Netherlands, to stage their works for the American public. In addition to and in conjunction with the program at the Brooklyn Museum, the Sharon Avery/Redbird Gallery held what Avery dubbed the Performance Retrospective. This opened on the evening of April 29 and ran until May 26, consisting of "photography, video/

sound tapes, objects, books and editions" from the prior performances of the artists participating in the EPS.[90] All of them—Ben d'Armagnac, Marina Abramović and Ulay, Gerrit Dekker, Hans Eykelboom, Barbara Heinisch, Marten Hendriks, and Reindeer Werk (Thom Puckey and Dirk Larsen)—had also performed in the previous year's Documenta VI, in Kassel, Germany. In a press release for the Brooklyn Museum, dated April 28, 1978, David Katzive, assistant director for Education and Program Development, explained, "[Just as] museum visitors come across sculpture, paintings, and period rooms, this week they will encounter artists as well." He expressed his pleasure "to be able to provide a platform for these artists' performances" and believed that they represented "provocative points of view rarely encountered in this city. The direct and indirect presence of artists in a gallery compells a response from the spectator that adds another level of perception to 'the experience of art.'"[91] A prior draft of this document explained, "Each artist has been asked to examine the interior space of the Museum and to respond with a work appropriate to their own personal aesthetic and to the environments or objects which they have discovered in the building. The physical presence of each artist is a key aspect to the work which they create." This procedural description was not included in the final press release. Nor was the entirety of Katzive's original statement, which was revised in order to appear in the official museum press release (as above). The full draft had said, "The direct and indirect presence of artists in the gallery compells a personal response from the spectator which is difficult to avoid, and while I'd like to think all of the works on display in the Museum are equally compelling, there is no doubt in my mind that these artists will be adding another level of perception to the 'experience of art.'"[92]

The temporary inclusion of European performance artists among the Brooklyn Museum's public displays was expected to shake things up a bit. One writer for a New York daily newspaper, in a short piece titled "EXTREMIST ART," seductively warned, "Six volatile groups of European artists are right now plotting a bizarre series of performances that are making the Brooklyn Museum extremely uptight. The avant-gardists, due here in a few days, are out to push audiences to the limits. . . . They mean to disturb."[93]

Ben d'Armagnac was the first of the EPS performers. Seventy-five people, by the official count, gathered in the Brooklyn Museum's out-

door Sculpture Garden at three o'clock on the afternoon of May 10. D'Armagnac's performance, not titled, was to be his last.[94]

In addition to writing Ben d'Armagnac's catalogue raisonné in 1995, Wijers also contributed to a catalogue published to coincide with a 1981 exhibition of his work at the Stedelijk Museum, in Amsterdam, a little less than three years after his death on September 28, 1978. For each of d'Armagnac's performances throughout his life, the catalogue provides photographs and a short descriptive summary. The text provided for his performance at the Brooklyn Museum reads:

> On a pavement in a garden of the museum lies a plateau of white tiles. Ben d'Armagnac is lying on it while wearing a black costume. A jet of water is pointed at his heart. Out of the loudspeaker comes the sound of someone breathing. Ben d'Armagnac moves slowly his arms and legs. His chest heaves rapidly. After about an hour he lies there motionless for a moment then he gets up and walks off.

After I'd read this aloud, Wijers elaborated:

> Of course it was much more dramatic than you will find in this thing. I said [to Ben], "What are you going to do?" I helped him to get, you know, different things, the sand that is here around this [surrounding the tiles he lay upon for the performance] and ... and I helped him to find a place where he could buy this suit, because all these suits and things he was—of course buying second hand, in secondhand shops, and he said, "Louwrien, I'm going to do something that the doctor is very—doesn't agree with. But I'm going to do it anyway. Because I may end up dead," he said. "Its a very" ... what do you call it?

I filled in the gap for her: "Dangerous."

She continued, still in Ben's words: "'dangerous to do.' And he said, 'You'll see it.' But," and here she began to whisper, "in a certain way he, he didn't move anymore. The whole audience became so upset. Because the heart gets so cold, from the cold water, that first he

was shivering ... and then," she sighed, "nothing happened. Nothing happened. He was completely dead. And people were really worried. But then he realized that ..."[95]

Here our conversation gave way to silence as the tape recorder continued running for over a full minute.

In a letter to co-organizer and liaison Jan Brand written a few days after the conclusion of the EPS, Katzive said, "Although I will try and contact each of the artists individually, I would be grateful if you would share with them the museum's sense of overall satisfaction and excitement for what they were able to accomplish and perform during this past week."[96] Each artist was paid $150 for his or her participation.[97]

Wijers continued, "You know he ... people were getting upset, so he jumped up and walked away. And people were throwing clothes on him, you know, they take off their own coat, and ... to make him warm, and then ... it was a very nice thing, really."[98]

Eight days before d'Armagnac's performance at the Brooklyn Museum, he and Wijers had discussed his plans for it over dinner at Magoo's restaurant in Manhattan. She titled the transcript of this talk "Ben d'Armagnac Talks to Louwrien Wijers," following her deliberate use of "talk" to label all of the interviews she has conducted—with Beuys, with the Dalai Lama, with Andy Warhol, and others—perhaps to emphasize both their informality and her viewpoint that, while they may appear in print, they are nevertheless events of mental sculpture.

The two of them talked about the relationship between his experience of living for several months in New York and the dynamics of his performances. Wijers posed the possibility that his performances embodied his feeling of responsibility for his audience. He replied, "That could be. With me those people are very near. And I do find that I am very responsible for that, for the fact that there are people. I even find I have to reckon with how the people are entering; where they can enter. In the first instance I go from myself of course, but then immediately the others are there."[99]

In these days before his final performance, d'Armagnac began to feel he was onto something new. Discussing the performance they had seen a few days earlier of the Dutch collective Reindeer Werk, who like himself had been invited to participate in the EPS, Ben com-

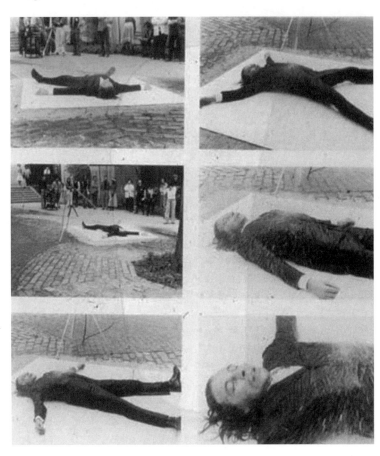

Ben d'Armagnac, untitled performance, Brooklyn Museum, 1978. Photograph by
Cathrien van Ommen. Reproduced by permission of Cathrien van Ommen.

mented on his problem with the "emotionality" of their work. In their
discussions with Wijers at the Chelsea Hotel on April 29, 1978, Rein-
deer Werk's Thom Puckey and Dirk Larsen explained their current
preoccupations with the exploration of emotional and psychologi-
cal contradictions in anticipation of their May 13 performance at the
Brooklyn Museum.[100] Puckey told her:

> I think that we are getting deeper and deeper into contradic-
> tions. I think now, that it is good for us to work within the
> context of art still, but in terms of being not art. And even

though that might seem a sort of impossible thing to do. I think we find that we can in actual fact get things done, you know, through that. This as against saying okay, because we can't now see our work as being art, than we should now cut ourselves out from the whole situation that the work has come up in.[101]

Larsen added, "That would be rejecting it, and it is not anti-art." Puckey continued, "It is not anti-art, it is just work which has come up within the context of art, but now it feels as though it can't be art, at the same time it is still within that context somehow, it might as well come out of that context through its own terms, you see." Wijers responded by highlighting the way that such an approach can permit a "breakthrough into an open area."

Puckey responded:

Yes, I think that is so, but then you catch the shit, off all the orthodox art-world people. I am saying that we, I feel, are now catching that in the same way that people who come to what they come to through working in the field of psychology and who now come to the same standpoint as us, but that they say that their work now can't be termed as psychology, in the same way as we say that our work can't be termed art. Now you see [they] are cut off from the world of paid psychology.

And Larsen added, "Which in a way is more strict than the world of paid art." Wijers here took an intriguing detour: "I do not know if I go too far, but can you place punk in the same situation?"

LARSEN: Well, you can see how, I think a lot of the bands were very good performers and the whole thing of the culture of people being there all at the same time was very good, but then a lot of them seem to have completely given up, in terms of developing that culture; they have become music, whereas performing, I did not see as music. But a lot of them have become music. With some of them it is very good music. But that is not the same medium. It is like a reflection of it.

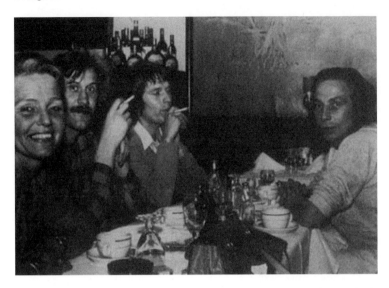

Louwrien Wijers, Hans Eykelboom, Jan Brand, and Ben d'Armagnac in the Chelsea Hotel, 1978. Photograph by Cathrien van Ommen. Reproduced by permission of Cathrien van Ommen.

PUCKEY: I think it is not so good to compare art to music, as it is to compare art to psychology. I think that art has much more in common with psychology. I don't think that people can ever get past the fact that they have a heartbeat, and that they pick up on things which bounce back their heartbeats to them. But I think that the ties between art and that very deep aspect of a person is not so strong and therefore I wil[l] go so far as to say that I feel that people can now push art out and still be people, without having to concern themselves with art. Well I don't see how they can ever push out music. I must say that what punk rock has done is, that it has brought people back to their heartbeat.[102]

Although d'Armagnac did not yet know the form his final performance would take when he spoke to Wijers, this was precisely what, by stopping his own heartbeat, he had attempted to do in it. In this same discussion with Wijers, he continued to describe his difficulties with Reindeer Werk:

In fact I find it okay what those guys are doing. But perhaps I revolt for a moment against it because part of it, the emotionallity I know very well, but I find one has to go past that. Then you arrive somewhere, where indeed for me things are much more pure. . . . Where perhaps that emotion is used every now and then [but] as soon as that emotion comes in one should allready be at work on banishing it.[103]

Wijers then asked, "To keep the people clean?" to which d'Armagnac replied, "Yes, yes. Exactly. Yes and I think that that is a very difficult path to take. I also think that this is for me perhaps going to be the essence for a new series of performances and that I will probably be working on that again for two years or maybe longer!"

The Brooklyn piece was to be the beginning of this attempt not to resist the emotive but to allow it to arise without clinging to it and to move past it to something else. Wijers asked d'Armagnac about the extent to which this "transition in style" had to do with his experience of living in New York. He explained to her:

I felt that already in my last five performances; that there was something somehow twisted, you know what I mean. As a matter of fact it is very dangerous, tricky, because you can at a certain point handle very well. Emotion you can, if you know the way it works within yourself, and you know the tracks within yourself that lead to emotions . . . then you can from one minute to the other switch the points and emotions just pour. . . . I believe emotions are such a strong source, that you really never have to be afraid that they won't come. [ . . . ] And if you have a sort of training to keep that path towards your mind clear and you know how to utter it, than I feel, at a certain point it is too easy a way. I think I was myself confronted with that in my last four or five performances. I did find myself thinking: well, Bernard you are doing that very easily, perhaps a little too easily.[104]

As Wijers and I flipped ahead in the catalogue a few pages, we came to a reproduction of a hand-written letter d'Armagnac had sent

to Wies Smals. She had been instrumental in arranging for d'Armagnac to go to New York. Wijers read the letter, in Dutch, and then translated it in condensed form.

244

> It's a very simple letter. It just says that he . . . he couldn't write to her because he was too busy fitting into the New York situation, and he felt that he had to change his work completely, and that's why he was quiet for a few months. But now that he's done the Brooklyn performance, he could tell Wies that, really he started a new phase in his work, and New York has been very essential for him, for his development, and that as soon as he comes home he will tell her all about it.[105]

His decision to go to New York was a deliberate attempt to push himself into a raw state and to live in it. "I knew that beforehand in Holland, that I would in New York be able to create a situation in which I would be putting myself absolutely threadbare; I would absolutely arrive at the impossible, concerning the work. And in fact I like that."[106]

In his essay "Mediators," Gilles Deleuze spoke about creation "as the tracing of a path between impossibilities. . . . A creator who isn't seized at the throat by a set of impossibilities is no creator. A creator is someone who creates his own impossibilities, and thereby creates possibilities." Without having a "set of impossibilities, you won't have the line of flight, the exit that is creation, the power of falsity that is truth."[107]

D'Armagnac's work can be imagined as a methodical push toward a state of emotional, physical, and intellectual exposure—a state of *overgave*. He said, "I hope I can be a stronger counterbalance for what I feel around me. And at that point I mean to say: I don't think we can still save it with emotion. We are past saving it with that. Then I do hope that my ripening goes on so smoothly and so strongly that I indeed arrive at that point where I am myself but at the same time the exact counterbalance for what is happening around me."[108]

## ALL FELL DEAD

I asked Wijers if d'Armagnac's Brooklyn performance had been his last. "It was the last performance, yes. It's a pity that we didn't take photographs of him here, in the . . . that corner there." She pointed toward the kitchen window of her home in Amsterdam. Outside, where two canals meet just opposite her front door, is hung a convex mirror. It was there that d'Armagnac had died. He had been living on a boat that was moored there, anchored in between Wijers's house on one side of the canal and the house of his wife, Joanna, and their two children on the other. On the night of September 28, 1978, he slipped on the sideboard, hit his head, fell unconscious into the water, and drowned.

An image that Gerrit Dekker made for his 1988 Gerrit Dekker/ Sheets exhibition at the Museum of Fine Arts in Chandigarh, India, consists of a loosely framed photograph of Dekker's 1978 EPS performance, in which d'Armagnac led him by the hand, silent and blindfolded, "through the empty corridors of the Brooklyn Museum in New-York."[109]

In Wijers's interview with Dekker on May 7, 1978, two days after d'Armagnac's own EPS performance, Dekker told her, "I would not dream of bringing about something in people."

On September 1 and 2, 1978, almost four months after Dekker's Brooklyn performance and nearly four weeks before the death of his closest friend, he did a forty-five-minute sound performance at de Appel, in Amsterdam. The flyer offers a fittingly bare description:

In a dark space the audience heard the pre-recorded sound
of a fluorescent lamp.
    Starting from silence, Dekker increased very gradually the
volume to a maximum, after which he reversed the process
to complete silence again. As the volume got stronger, all
other sounds in and outside the space fell dead.[110]

In the dark, the sound of light, recorded from another time and place, is brought, at a creeping pace, from an unnoticed silence to an almost unbearable volume and back to a silence now entirely different from

the one at its outset; "all other sounds in and outside the space fell dead." Though he stood in the same spot in the same room for forty-five minutes, Dekker did not bring the sound of this absent light full circle; rather, he brought it full spiral: even though he never left, he did not return to the point of departure, did not close the loop, but underlined the impossibility of such closure, because "each moment has to be lived again and again."[111]

The last time that Dekker performed in public was in the Gemeentemuseum, in Arnhem, in 1978, shortly after d'Armagnac's death. "For an hour he stood still, facing the wall."[112]

After his 1988 exhibition in Chandigarh, India, Dekker ceased making art entirely—until 2005, when the Basis voor Actuele Kunst (BAK), in Utrecht, the Netherlands, held a retrospective of his work. In his statement for that show, he revisited his life and work with d'Armagnac, d'Armagnac's death, his own divorce from his wife (the two primary milestone moments in his life, he says), and his practice over the ensuing three decades. Of curator Maria Hlavajova's inclusion in the BAK show of the image of his 1978 Brooklyn Museum performance with d'Armagnac, he writes:

> It was fine with me, but with all respect to that piece, it was indeed in the past tense for me. I put it in a nice frame and looked for a spot to hang it. And then I do something with the given space: a piece of cardboard on the floor, ensuring that connections are made between interior and exterior. The space should have the character of a passage. The piece hung fairly high and inconspicuously on one of the walls and could not possibly be noticed by the passing visitors. It was not just a question of the photo. I translate the meaning that the photo has for me into this space. I make it my space. Well, how can you think about this? I had absolutely no wish to repeat the old pre-1988 artistic practice. On the one hand the piece leaned on the past and at the same time it forced me to think about whether I really felt the need to show things to a public, and if so, then in what way. Fortunately Maria has said that she wants to make a one-man exhibition with me and now I feel that I can do things with my images

that are much closer to what's actually in my mind: no top,
no bottom, no sides.[113]

Wijers had not been in Amsterdam when d'Armagnac died. She
spoke of that time:

> But it, actually [it should have been photographed]. Oh, we
> should have done that, you know; he looked fantastic. I didn't
> see, because I was in Arnhem talking to Beuys, you remem-
> ber? [She laughs.] I, it's impossible, heh? So that, immediately
> I left, which meant I also missed a little part of Beuys, and
> I went to Amsterdam, and by the time I came here it was
> afternoon, Thursday, and Ben was already in the hospital. In
> a fantastic room, it was all tiles. He was so fond of tiles, you
> know. All around, it was tiles. Even the thing that he was
> lying on, the table kind of thing, was tiles. And he was there,
> on the tiles, and his head was smashed. It was blue, because
> you could see that his head had fallen on the boat, you know;
> it was completely blue. So, that was the beauty of it—that
> this face . . . that he had worked with so often, you know
> . . . [She points to one of a series of blue-pigmented prints
> he had made before he died.] Over here, I mean, was now
> almost like giving the picture, you know. It was blue and yel-
> low, it had all colors, it was bruised all over.

Wijers paused for a moment and then continued:

> Also the fact that he was, that so many people saw it,
> you know, that when [his wife] Joanna came, they were all
> hanging over the railing, looking at this figure in the water
> going up and down on the waves. A very good performance,
> I think. And he wanted to . . . this one [pointing to the pho-
> tograph of the Brooklyn performance] was already . . . death
> was his subject. It became his subject, because what hap-
> pened in New York—I told you maybe that he was living in
> New York. I was living in the Chelsea [Hotel], he was living
> in the Chelsea. One day he comes out, [and] one person has

Joseph Beuys playing "In Memoriam Ben d'Armagnac," Theater aan de Rijn, Arnhem, September 30, 1978. Photograph by Cathrien van Ommen. Reproduced by permission of Cathrien van Ommen.

just jumped from a thing—that happened quite often—had jumped from the tenth floor, on the pavement, and fell in front of Ben. Ben was coming out, and the person fell. And the head was completely smashed [ . . . ] on the pavement, and it was in front of Ben. So that is why I think death became something for him to work with. I think it made such a big impression on him. And to me it was the same as happened during the war. During the war [Ben's family] had nothing to eat, and they were with the Alliance Française. Amongst themselves, they spread all the children. They could go to the different families, so every evening they went to another family to eat, while the mother was taking care of her sick husband and had nothing to eat for him. [After dinner, Ben and his older sister] went out, into the street, and there was a curfew. You had to be home in time. And so it was always a very hectic thing—how could his elder sister get the young boy home before eight o'clock after food?—because sometimes they had to walk, you know, long stretches. There was no tram, of course, there was no rail, it's 1944. On the way home one night, they find the Germans, and they're just playing games with their—what is it called?—pistols or rifles.

And they were shooting doves. Pigeons. And one pigeon fell in front of Ben, dead. And actually this happened again then in New York but in a different way. So that I think was why he was so obsessed with death. But maybe he was already dead himself, I mean preparing for his own death. So, all of these things came together, so his life story is just magnificent in every aspect. It fits, you know.

Soon the Theater aan de Rijn, in Arnhem, would be full of people who had come to attend the upcoming session of the Behavior Workshop, which had begun on Wednesday, September 28, 1978, and would run through October 3.[114]

Now, it was just before noon on Friday, September 30, and the room was empty except for Beuys, Wijers, and the ghost of Ben d'Armagnac, who had died not two days before. Wijers had left the workshop on Thursday, to see d'Armagnac's body a final time. She returned to Arnhem that Friday morning with images from Ben's performances. On a table beneath the large poster of his 1976 performance at the Stedelijk Museum, she and Beuys lit a tall candle and surrounded it with daisies; rows of empty seats sat anticipating the arrival of the workshop's participants. Taking advantage of the few moments of silence, Beuys played a memorial piano piece for Ben d'Armagnac.[115]

Soon after, people began to rearrange the chairs into a circle and set up microphones for the group discussion. Wijers suggested to Beuys that they take a moment and record a short interview. He accepted, and they relocated to, in Wijers's words, "a quiet corner at the back of the hall."

Once she had her tape recorder ready, he began: "Perhaps the best thing is that you put some questions."[116]

# Acknowledgments

I wish to thank Blythe, Quinn, and Erica—for everything; the rest of my family, for the rest; and Louwrien Wijers, for everything else.

Thanks to Geoffrey Hendricks, Sarat Maharaj, Irit Rogoff, and above all Howard Caygill for their support of this project, from its earliest stages as an unwieldy and, initially, improbable Ph.D. thesis.

Then, in random order, I want to thank Egon Haupfstingl, John Shaw, Sally Alexander, Rob Stone, Jorella Andrews, Scott Lash, Jean York, Carol Granger, Lorna Glenister, Damien Keown, Margarita Karkayani-Doukidou, Poli Cárdenas, Tanya Evans, Antonio Sonessa, Hiroki Ogasawara, Soyang Park, Stephen Batchelor, Ken Friedman, Sam Richards, Marianne Filliou, Gerrit Dekker, *Inge's Alt Kleve,* Michael Berger, U We Claus, Marcus Mielke, Owen Smith, Alison Knowles, Hannah Higgins, Emmett Williams, Ann Noël, MaryPat Warming, Larry Miller, Sara Seagull, Lauren Raiken, Christina Spellman, Wilmara Henriquez, Stacy Pies, Gerald Pryor, Arnold Mesches, Riley Brewster, Robert Rosenblum, Bella Mirabella, Scott McPartland, Pamela Kort, Karen Kelly, Jenny Prebor, Robert Gober, Jim Schaufele, Steven Evans, Dave Colossi, Natsuko Fujiyo, Deborah Wythe, the Library of Westminster Abbey, Tenzin N. Takhla, Tsering Dorjee, the Office of His Holiness the XIV Dalai Lama of Tibet, Mark and Aimée Bessire, Sean and Cindy Foley, Garrick Imatani and Ellen Lesperance, Dana Sawyer, Agnes Bushell, Gan Xu, Beata Niedzialkowska, Gwen Allen, Margo Halverson, Miek Bertus, Sam Pfeifle, Jeff Inglis, Lauren Fensterstock, Andrea Kleinhuber, Judith Larsen, Katherine Jackson, Katarina Weslien, Iain Kerr, Leon Johnson and Megan O'Connell, Rachel Katz, Adriane Herman and Brian Reeves, George Smith, Bonnie Marranca, Claire MacDonald, Eda Cufer, Roger Conover, and Clayton Crummett for binding it all.

Finally, great thanks to all of my current and former students at the Maine College of Art, the Institute for Doctoral Studies in the Visual Arts, and Goldsmiths College.

# Notes

## Prefaces

1. Lee Siegel, *City of Dreadful Night: A Tale of Horror and the Macabre in India* (Chicago: University of Chicago Press), 16-17.

2. The word *happen*, like the word *happy*, comes from the Icelandic word *happ*, which means "chance" or "luck" (H.H. the XIV Dalai Lama and Howard C. Cutler, M.D., *The Art of Happiness: A Handbook for Living* [New York: Riverhead Books, 1998], 14).

3. David Bohm, "Interview with David Bohm," in Louwrien Wijers, ed., *Art Meets Science and Spirituality in a Changing Economy* (Amsterdam: SDU Publishers, 1990), 62-63.

4. J. D. Salinger, *Franny and Zooey* (New York: Little, Brown and Co., 1991), 176-77.

5. Marcus Aurelius, *Meditations* (New York: Penguin, 1964), 158.

6. Salinger, *Franny and Zooey*, 65-66. Joseph Beuys took part in this advertising campaign for Nikka Whisky while in Japan, with Wijers, in 1984. In a televised "Commercial Message," as he "trudged silently through a snowy forest for Nikka Whisky, an on-screen credit line [appeared] reading 'CM appearance fee will be used for the Greens'—a reference to Beuys' involvement with Green party fundraising." See Sei Keiko, "Japan's Highest Artform: 'If It's Not Doublethink, It's Not CM,'" trans. Alfred Birnbaum, *Kyoto Journal #46: Media in Asia*, http://www.kyoto journal.org/media/sei.html (accessed September 30, 2005).

7. For any study that engages with the work of Joseph Beuys, it would, for obvious reasons, be ideal to include photographs of his work. In the case of this project, I was unable to secure permission from the estate of the deceased artist to reproduce photographs of his work. As many of his works are easily viewed online, I hope the interested reader will endeavor to find them there. Failing that, the reader may easily imagine *Cosmos and Damian* by visualizing the postcard image of the World Trade Center towers that Beuys transformed by coloring the towers yellow to appear as if parallel sticks of butter, and then signed it in the Beuysian hand with the words "Cosmos und Damian."

8. Beuys performed this action as part of the 24-Stunden (24 Hours) event organized at the Galerie Parnass in Wuppertal in 1965 by Charlotte Moorman, Nam June Paik, Ekhard Rahn, Tomas Schmit, Wolf Vostell, and Beuys himself; running over a twenty-four-hour period, it began at midnight and concluded the following midnight on June 6, commemorating the anniversary of the D-Day Allied invasion in 1944.

9. Beuys, in Axel Murken, *Joseph Beuys und die Medizin* (Münster: F. Coppenrath Verlag Murken, 1979), 149.

10. No thorough or accurate record of this important visit exists in English. A series of writings dealing with Beuys's work, with texts in both Japanese and English, prompted by the 1984 visit, was published by Watari-um under the title *Joseph Beuys—Beyond the Border to Eurasia* in 1991. The tapes of Beuys's discussions, lectures, and so on have yet to be transcribed. Beuys made the trip in order to raise money to support his *7000 Oaks* project, which was already under way but which ultimately was not completed in his lifetime; the final oak was planted in 1987 by his son Wenzel Beuys. In his visit to Japan, Beuys gave a series of lectures, spoke extensively with students and with the Japanese public, and made an immobile multiple when he signed the sidewalk in front of the Tokyo airport. He also performed a duet with Nam June Paik. The Seibu Museum had invited Beuys to come in conjunction with a retrospective exhibition of his work, and at the same time, though independently, the Tokyo Metropolitan Museum, with the backing of Sony and the Japan Foundation, had planned a retrospective exhibition of Paik's work. For Paik's touching narration of their duet and their trip to Japan, which began when they accidentally found themselves on the same Lufthansa Airlines flight, see Nam June Paik, "BEUYS VOX PAIK," in Johann Pijnappel, issue ed., *Fluxus Yesterday and Today, Art & Design* (special issue) 28 (January–February 1993): 66.

11. Louwrien Wijers, unpublished interview with the author, January 1998.

12. On the dissolution of the Sex Pistols and the death of Sid Vicious, see John Lydon, *Rotten: No Irish, No Blacks, No Dogs,* with Keith and Kent Zimmerman (New York: Picador USA, 1994), 260.

13. For a full discussion of the reasons behind the practice of not translating Sanskrit mantras, see Donald S. Lopez Jr., *Elaborations on Emptiness: Uses of the Heart Sutra* (Princeton, N.J.: Princeton University Press, 1996), 15; quote also appears on 15.

14. Ibid., 5, 5 n. 2.

15. Donald S. Lopez Jr., *Prisoners of Shangri-La: Tibetan Buddhism and the West* (Chicago: University of Chicago Press, 1998), 13.

16. Robert Filliou, *Teaching and Learning as Performing Arts* (Cologne: Verlag Gebr. König, 1970), 24.

17. Thierry de Duve, *Kant after Duchamp* (Cambridge, Mass.: MIT Press, 1998), 6–7, 7 n. 4.

18. Ibid., 6.

19. Filliou, *Teaching and Learning as Performing Arts,* 87.

20. Robert Filliou, *Research at the Stedelijk, 5 november t/m 3 december* (Amsterdam: Stadsdrukkerij van Amsterdam, 1971). Filliou's endeavor during the month he spent at the Stedelijk Museum in 1971 for his "research on research" experiment was to develop a research agenda that would permit him to discover what was worth researching and to invent a methodology that would help him to determine a useful methodology for researching research.

21. In addition to the sources mentioned earlier, important texts include Owen Smith, *Fluxus: History of an Attitude* (San Diego, Calif.: San Diego State University Press, 1998); Geoff Hendricks, ed., *Critical Mass: Happenings, Fluxus, Performance, Intermedia and Rutgers University 1958-1972* (Amherst, Mass.: Mead Art Museum, and New Brunswick, N.J.: Mason Gross Art Galleries, 2003); Julia Robinson, "The Sculpture of Indeterminacy: Alison Knowles's Beans and Varia-

tions," *Art Journal* 63 (Winter 2004); and Ken Friedman and Owen Smith, eds., *On Fluxus*, issue of *Performance Research* 7, no. 3 (September 2002).

22. A few years ago, the Chinese critic Hou Hanru made the argument that speaking about culture in terms of something called postmodernism simply does not do justice to the forms of culture that are produced across much of the planet. He suggests that the idea that we must look at history as a progression of one "-ism" after another, or some assemblage of "-isms," needs to be rethought entirely; what we need according to Hanru is not a new "-ism" but rather a process of "de-ism-ization" (Hou Hanru, "Entropy—Chinese Artists, Western Art Institutions: A New Internationalism," in Jean Fisher, ed., *Global Visions: Towards a New Internationalism in the Visual Arts* [London: Institute for International Visual Arts/Kala Press, 1994], 79–88).

23. Paulo Freire, *Pedagogy of the Oppressed* (New York: Continuum, 1993).

24. Gilles Deleuze, "Mediators," in Jonathan Crary and Sanford Kwinter, eds., *Zone 6: Incorporations* (New York: Zone Books, 1992), 285.

## Intrigue

1. John Armleder, in "How Has Art Changed? A Survey," *Frieze*, issue 94 (October 2005): 60.

2. Andrea Fraser, ibid., 162.

3. Paul Mann, *The Theory-Death of the Avant-Garde* (Bloomington, Ind.: Indiana University Press, 1991).

4. William Pope.L, in "How Has Art Changed? A Survey," 168.

5. Emmanuel Levinas, "Reality and Its Shadow," in *Emmanuel Levinas: Collected Philosophical Papers*, trans. Alphonso Lingis (Dordrecht, the Netherlands: Martinus Nijhoff Publishers), 10.

6. The term *retro-garde* is taken from Alexei Monroe, *Interrogation Machine: Laibach and NSK* (Cambridge, Mass.: MIT Press, 2005), 44–79, where he uses it to describe a critical engagement with the past and its futurity.

7. William Pope.L, in "America's Friendliest Black Artist: William Pope.L Interviewed by Chris Thompson," *PAJ: A Journal of Performance and Art* 72 (September 2002): 68–72, quote from 72.

8. Over five years ago, I wrote a letter to Filliou's widow Marianne in the hopes of speaking with her about her husband's and her work. Some months later, I received a postcard from her. On the front of it was a reproduction of one of Filliou's drawings, a circle of figures drawn in blue ink, holding hands and dancing as if straight out of a Matisse painting. Above their heads he had written a string of words: ART IS WHAT MAKES LIFE MORE INTERESTING THAN ART. On the back, she wrote that she was very busy but that if I wanted to speak with her I was welcome to call her at home in France. When we spoke, I asked her how their practice as Buddhists had influenced their work. She gave a warm chuckle and said, "Buddhist ... yes ... but of course you know that the Buddha himself was not a Buddhist" (telephone conversation with Marianne Filliou, May 1999).

9. Léo Bronstein, *Fragments of Life, Metaphysics and Art* (New Brunswick, N.J.: Transaction, 1995), 35.

10. Emmanuel Levinas, in Florian Rötzer, *Conversations with French Philosophers*, trans. Gary F. Aylesworth (Atlantic Highlands, N.J.: Humanities Press, 1995), 59. In his *Ethics and Infinity: Conversations with Philippe Nemo*, Levinas casts this in radical terms:"I am responsible even for the Other's responsibility," though he followed with a caution that his were "extreme formulations which must not be detached from their context," explaining that "in the concrete, many other considerations intervene" (95-101).

11.The term *interhuman intrigue* is from Emmanuel Levinas,"Transcendence and Intelligibility," in Adriaan T. Peperzak, Simon Critchley, and Robert Bernasconi, eds., *Emmanuel Levinas: Basic Philosophical Writings* (Bloomington: Indiana University Press), 158. Here it is important to underscore what is at work in such a "conceptualizing." In their book *What Is Philosophy?* Gilles Deleuze and Félix Guattari explain,"Every concept has an irregular contour defined by the sum of its components, which is why, from Plato to Bergson, we find the idea of the concept being a matter of articulation, of cutting and cross-cutting" (Gilles Deleuze and Félix Guattari, *What Is Philosophy?* trans. Hugh Tomlinson and Graham Burcell [New York: Columbia University Press, 1994], 163-99). Interestingly, in "Reality and Its Shadow," Levinas defines concepts as the muscles of the mind, the sinews by means of which the mind makes thinking happen. In both cases, the concept is presented as an entity that carries within it a kind of action: in the first case, the cutting and cross-cutting movement of articulation; in the second, the relays of flexion and release that constitute the movement of the thinking body. So we find that articulation is a perpetual project, one that always involves rethinking the problem that gives rise to the concept and using the concept to reformulate the problem with greater clarity.

12. Levinas, "Transcendence and Intelligibility," 158. In this essay Levinas conjoins this task of phenomenology with two supplementary ones: "to guarantee ...against the surreptitiousness, sliding, and substitution of sense ...the signifyingness of a language threatened in its abstraction or in its isolation" and "to control language by interrogating the thoughts which offend it and make it forget" (158).

13. In Jacques Derrida's essay "Violence and Metaphysics," his critique of Levinas's *Totality and Infinity* argues, "It could doubtless be shown that it is in the nature of Levinas's writing, at its decisive moments, to move along these cracks [in the surface of philosophy], masterfully progressing by negations, and by negation against negation" (Jacques Derrida, "Violence and Metaphysics: An Essay on the Thought of Emmanuel Levinas," *Writing and Difference,* trans. Alan Bass [London: Routledge, 1978], 90).

14. Levinas, "Transcendence and Intelligibility," 158.

15. Alain Badiou attempts to limit Levinas's philosophy to theology when he reduces the power of Levinas's work to a purely religious imperative: "To put it crudely: Lévinas's enterprise serves to remind us ... that every effort to turn ethics into the principle of thought and action is essentially religious" (Alain Badiou, *Ethics: An Essay on the Understanding of Evil,* trans. Peter Hallward [London: Verso, 2001], 23).

16. Gillian Rose, *Love's Work* (London: Vintage, 1997), 135.

17. Emmanuel Levinas, "Meaning and Sense," in Peperzak, Critchley, and Bernasconi, eds., *Emmanuel Levinas,* 56.

18. Gilles Deleuze, *Expressionism in Philosophy: Spinoza,* trans. Martin Joughin (New York: Zone Books, 1992), 218, 383 n. 14.

19. Andy Goffey, "Nature = x: Notes on Spinozist Ethics," in John Wood, ed., *The Virtual Embodied: Presence/Practice/Technology* (London: Routledge, 1998), 68, 72.

20. Levinas calls this movement "infinition": "infinity, overflowing the idea of infinity" (Emmanuel Levinas, *Totality and Infinity: An Essay on Exteriority,* trans. Alphonso Lingis [Pittsburgh: Duquesne University Press, 1998], 51, 59–60).

21. In her "Questions to Emmanuel Levinas," Luce Irigaray has asked this question in terms of the erotics of the ethical encounter: "But how are God's commandments brought to bear in the relationship between lovers? If this relationship is not divinized, does that not pervert any dignity, any ethics, any society which does not recognize God in carnality?" (Luce Irigaray, "Questions to Emmanuel Levinas," in Margaret Whitford, ed., *The Irigaray Reader* [Oxford: Blackwell, 1991], 86).

22. Howard Caygill, *Levinas and the Political* (London: Routledge, 2002), 1.

23. Michael Hardt and Antonio Negri, *Multitude: War and Democracy in the Age of Empire* (New York: Penguin Press, 2004), xvii; see also Michael Hardt and Antonio Negri, *Empire* (Cambridge, Mass.: Harvard University Press, 2000).

24. Hobbes, in Hardt and Negri, *Multitude,* 6–7.

25. Ibid., 7.

26. Caygill, *Levinas and the Political,* 1.

27. Remember him?

28. Levinas, quoted ibid., 192.

29. Ibid., 192–93.

30. Emmanuel Levinas, "Peace and Proximity," in Peperzak, Critchley, and Bernasconi, eds., *Emmanuel Levinas,* 167.

31. Goffey, "Nature = x," 72–73.

32. Adriaan T. Peperzak, "Preface," in Peperzak, Critchley, and Bernasconi, eds., *Emmanuel Levinas,* xiv.

33. Goffey, "Nature = x," 73.

34. Manuel DeLanda distinguishes extensive properties—such as "length, area and volume . . . amount of energy or entropy . . . which are *intrinsically divisible*"—from intensive properties, "such as temperature or pressure, which cannot be so divided." He notes Deleuze's point that "an intensive property is not so much one that is indivisible but one which *cannot be divided without involving a change in kind*" (Manuel DeLanda, *Intensive Science and Virtual Philosophy* [London: Continuum, 2002], 26–27).

35. In mathematics, *inflection* denotes a curvature's change from concave to convex or vice versa.

36. Emmanuel Levinas, *Existence and Existents,* trans. Alphonso Lingis (The Hague: Martinus Nijhoff, 1978), 53. In his discussion of that book, Howard Caygill links Levinas's aesthetics and the theme of lostness in sensation, opened in "Reality and Its Shadow," to the theme of exhaustion and horror, crucial in Levinas's early philosophical writing. We find the intimations of this connection in "Reality and Its Shadow," where for Levinas "art brings about just this duration in the interval, in that sphere which a being is able to traverse, but in which its shadow is immobilized. The eternal duration of the interval in which a statue is immobilized

differs radically from the eternity of a concept; it is the meanwhile, never finished, still enduring—something inhuman and monstrous" (11).

37. "Writing is born," writes Trinh T. Minh-ha, "when the writer is no longer. Which does not mean that he/she withdraws, but he/she dies within himself/ herself in order to exist simultaneously within the text" (Trinh T. Minh-ha, "The Plural Void," in *When the Moon Waxes Red: Representation, Gender and Cultural Politics* [New York: Routledge, 1991], 219).

38. Hardt and Negri, *Multitude,* xv.

39. For an analysis of the dynamics of networks and the cultures sustained by them, see Tiziana Terranova, *Network Culture* (London: Pluto Press, 2004).

40. Hardt and Negri, *Multitude,* xv, emphasis added.

41. Levinas, "Transcendence and Intelligibility," 158, emphasis added.

42. Hayden White, *Tropics of Discourse: Essays in Cultural Criticism* (Baltimore: Johns Hopkins University Press, 1978), 252.

43. Brian Massumi, *Parables for the Virtual* (Durham, N.C.: Duke University Press, 2005), 4–5.

44. Anonymous author quoted in Suzanne Pufpaff, ed., *Nineteenth Century Hat Maker's and Felter's Manuals* (Hastings, Mich.: Stony Lonesome Press, 1995), 67.

45. Ibid.

46. Ibid., 68.

47. Deborah McGavock and Christine Lewis, *Feltmaking* (Ramsbury, Marlborough, U.K.: Crowood Press, 2000), 7.

48. J. Kay Donald, *Creative Feltmaking* (Kenthurst, Australia: Kangaroo Press, 1983).

49. M. E. Burkett, *The Art of the Felt Maker* (Kendal, Cumbria, U.K.: Abbot Hall Art Gallery, 1979).

50. Pufpaff, *Nineteenth Century Hat Maker's and Felter's Manuals,* 136. I recently asked Kendra Rafford, a Maine feltmaker, to comment on Pufpaff's claim. She noted, firstly, that there is in fact a felt-making process that does not require moisture—synthetic felts can be made by a process called needle felting, whereby a number of needles agitate the fibers. But she went on to add, however, that "whether or not it is true to assert that 'no one completely understands why animal fibres make felt' depends upon what level of understanding you're talking about. At one level," she said, "it *is* mysterious in that at one moment you have a chaotic mass of fibers and suddenly you have a material with intense structural integrity" (conversation with Kendra Rafford, Halcyon Yarns, Bath, Maine, October 2001).

51. Mary L. Joseph, *Introductory Textile Science* (New York: Holt, Rinehart and Winston, 1986), 259.

52. Ibid., 257.

53. Agnes Geijer, *A History of Textile Art: A Selective Account* (London: Pasold Research Fund in association with Sotheby Parke Bernet Publication, 1979), 3–4. For a comprehensive history of early textiles, see E. J. W. Barber, *Prehistoric Textiles: The Development of Cloth in the Neolithic and Bronze Ages, with Special Reference to the Aegean* (Princeton, N.J.: Princeton University Press, 1991).

54. McGavock and Lewis, *Feltmaking,* 10.

55. Donald, *Creative Feltmaking,* 65, 61.

56. Donald points this out in *Creative Feltmaking,* 57, 61.

57. McGavock and Lewis also mention the story of Noah's Ark as an early felt factory; they point out that Mount Ararat, in eastern Turkey, is the likely location where felt first appeared. McGavock and Lewis, *Feltmaking,* 9.

58. Donald, *Creative Feltmaking,* 62.

59. McGavock and Lewis, *Feltmaking,* 9.

60. Ibid., 30.

61. Burkett, *The Art of the Felt Maker,* 30.

62. Ibid., 30.

63. Donald, *Creative Feltmaking,* 27-28.

64. Gilles Deleuze and Félix Guattari, *A Thousand Plateaus: Capitalism and Schizophrenia,* trans. Brian Massumi (Minneapolis: University of Minnesota Press, 1994), 475-76. Deleuze and Guattari proceed to consider everything from knitting to crochet in their characterization of "smooth space" as "an *amorphous,* nonformal space" (477).

65. Deleuze and Guattari's notion of nomad science, their way of posing its relation to the state apparatus, and their use of Monge as figure owe much to Anne Querrien's suggestion that the state is founded upon the collapse of experimentation. She writes, "An installation is made to function, not to be socially constructed: from this point of view, the State involves in the construction only those who are paid to implement or command, and who are obliged to follow the model of a preestablished experimentation" (*A Thousand Plateaus,* 554-55 n. 29). Felt figures strongly in Deleuze and Guattari's effort to cast the tribes of Mongolia as a stateless band of experimentalists: "Even the technologists who express grave doubts about the nomads' powers of innovation at least give them credit for felt: a splendid insulator, an ingenious invention, the raw material for tents, clothes, and armor among the Turco-Mongols" (476).

66. See Donald Reid, *Whose Pharaohs? Archaeology, Museums, and Egyptian National Identity from Napoleon to World War I* (Berkeley: University of California Press, 2002), 32.

67. Napoleon had made him a grand officer of the Legion of Honour in 1804, president of the Senate in 1806, and count of Péluse in 1808. This and other information about Monge in this essay, unless otherwise specified, comes from the following site: http://www-gap.dcs.st-and.ac.uk/~history/Mathematicians/Monge.html (accessed March 2004).

68. Deleuze and Guattari's interplay between striated and smooth space provides the model for Manuel DeLanda's use, in his *A Thousand Years of Nonlinear History,* of the meshwork-hierarchy pairing. He distinguishes "self-organized *meshworks* of diverse elements, versus *hierarchies* of uniform elements. But again, meshworks and hierarchies not only coexist and intermingle, they constantly give rise to one another" (Manuel DeLanda, *A Thousand Years of Nonlinear History* [New York: Zone Books, 1997], 32).

69. James Clifford, *Routes: Travel and Translation in the Late Twentieth Century* (Cambridge, Mass.: Harvard University Press, 1997), 39. Clifford notes that this nomadology is "often generalized without apparent resistance from non-Western experiences."

70. This fiction and its style derive not so much from Deleuze and Guattari's characterization of the Mongols as from their concept of nomad thought, which according to Brian Massumi "moves freely in an element of exteriority. It does not repose on identity; it rides difference" (Brian Massumi, in *A Thousand Plateaus,* xii). DeLanda contends that "spontaneous structural generation" shows us a world "more variable and creative than we ever imagined" and that "this insight into matter's inherent creativity needs to be fully incorporated into our new materialist philosophies"; this radical claim enables the argument, which the book goes on to substantiate, that "human history did not follow a straight line, as if everything pointed toward civilized societies as humanity's ultimate goal. On the contrary, at each bifurcation alternative stable states were possible, and once actualized, they coexisted and interacted with one another" (*A Thousand Years of Nonlinear History,* 16).

71. David Chambers, *The Devil's Horsemen: The Mongol Invasion of Europe* (London: Weidenfeld and Nicholson, 1979), 115.

72. The great heath outside Pest "had become a mass of riderless horses and for thirty miles beyond it the road back to Pest was littered with Hungarian dead. . . . What had begun as a fierce contest between two extraordinary armies" — the Hungarian army was then arguably the mightiest in Europe— "had ended in a rout, and the most conservative estimate of the Hungarian men [killed] was sixty thousand," of one hundred thousand who had taken the field. One survivor described the way the vast number of dead lay: "like stones in a quarry" (Chambers, *The Devil's Horsemen,* 101–3).

73. Far from the simple sprawling tent village we might be led to imagine, thirteenth-century Karakorum was a cosmopolitan imperial center. For more information, see Chambers, *The Devil's Horsemen;* on the travels of the papacy's emissaries to Karakorum, see I. De Rachelwitz, *Papal Envoys to the Great Khans* (London: Faber and Faber, 1971).

74. Burkett, *The Art of the Felt Maker,* 21.

75. De Rachelwitz, *Papal Envoys to the Great Khans,* 47. De Rachelwitz notes, "Mongols made idols of felt and other stuff and believed that the spirits dwelt in them. They were kept inside the yurt as tutelary gods, or placed outside in special carts for general worship"; he contextualizes the Mongols' religious practice in terms of a series of beliefs that "revolved around the hazy notion of an all-powerful Tengri . . . or Heaven" (46–47). His understanding of the Mongol concept of heaven (*tengger*) and of the "spirits" that "dwelt" in felt is itself rather hazy. It suggests quite problematically that Mongols' cosmology was beyond their own comprehension, whereas what seems more likely, as Caroline Humphrey and Urgunge Onon suggest, is the existence of a worldview that was pragmatically open-ended and "epistemologically and ontologically versatile." See Caroline Humphrey and Urgunge Onon, *Shamans and Elders: Experience, Knowledge, and Power among the Daur Mongols* (Oxford: Oxford University Press, 1996), especially sections 1, 3, and 5.

76. Donald, *Creative Feltmaking,* 63.

77. Burkett, *The Art of the Felt Maker,* 21.

78. Ibid., 22.

79. Geijer, *A History of Textile Art,* 227.

80. Ibid., 114-15, 124.

81. Stephen Batchelor, *The Awakening of the West: The Encounter of Buddhism and Western Culture* (Berkeley, Calif.: Parallax Press, 1994), 92–93. In 1578, with the *pax mongolica* a distant memory, Altan Khan, leader of the Tumed Mongols, who "had political aspirations of the order of Genghis Khan," invited Sonam Gyatso, the most renowned lama of the Gelugpa sect, to his "nomadic outpost on the Mongolian steppes" (ibid., 188). "Recalling the encounter between Sakya Pandita and Godan Khan more than three hundred years before, the two men came to an understanding. In return for his teachings, Altan Khan bestowed on Sonam Gyatso the title 'Dalai Lama' ('Dalai' meaning 'Ocean' in Mongolian—as does 'Gyatso' in Tibetan). In return Sonam Gyatso gave Altan Khan the title 'Religious King, Brahma of the Gods' and concluded with the ominous prophecy that within eighty years the khan's descendants would dominate Eastern and Central Asia. . . . Sixty-four years later (in 1642) Gushri Khan, leader of the Qoshot Mongols and head of an alliance of Mongol tribes, invaded Tibet, defeated the rulers of Tsang, displaced the Karmapa, and installed Ngawang Losang Gyatso, the 5th Dalai Lama, as ruler of the land" (ibid., 188–99).

82. Manuel DeLanda, *War in the Age of Intelligent Machines* (New York: Zone Books, 1991), 11.

83. Clayton Newell, *The Framework of Operational Warfare* (London: Routledge, 1991), xi.

84. Sun Tzu, *The Art of War: A New Translation,* trans. Denma Translation Group (Boston: Shambhala, 2001), 174. Though ultimately published with what has come to be the "traditional" translation of the title, the Denma Translation Group had submitted their book to the publisher with a different title, one that in their view was more faithful to the spirit and the letter of the original. This was "Victory over War: the Wisdom of Taking Whole." Though more accurate, the title would most assuredly have doomed the book to poorer sales. Thanks to Kidder Smith for making this early draft available.

85. Ibid., 19.

86. Ibid., 27.

87. Francis Woodman Cleaves, ed. and trans., *The Secret History of the Mongols,* vol. 1 (Cambridge, Mass.: Harvard University Press/Harvard-Yenching Institute, 1982), 43–44. Cleaves explains that this "yea" is "an oral promise which takes the place of an oath" (44 n. 16). Those passages of *The Secret History of the Mongols* that appear in brackets in the quotations above are taken directly from Cleaves's translation. The *Secret History* is an extraordinary work of literature, written during the reign of Ögödei, Chingis's grandson—sometime between the years of 1228 and 1240. It is rarely remembered that one of Chingis Khan's most important legacies was the introduction of writing to the Mongol people, without which the maintenance of a vast empire would have been nearly impossible.

88. Subedei was the mastermind of the Mongol's European campaign. He was in fact from the area that is now called Tuva, across the mountains from northwestern Mongolia. The Tuvans are today best known for their world-renowned throat singers, and though Tuva is now part of Russia, the Tuvans consider themselves neither Russian nor Mongolian but Tuvan, as they have done since well before the rise of Chingis Khan. Indeed Chingis himself recognized the Tuvans'

cultural autonomy from the Mongols, perhaps in large part thanks to his loyalty to Subedei. The 1999 documentary film *Genghis Blues* traces the journey of blind blues singer Paul Pena to Tuva to meet and sing with throat-singing legend Kongar-ol Ondar. At the close of the film and the end of their visit together, as the two sit on a dried-out log on a riverbank, Kongar-ol puts his hand on Paul's shoulder. "Paul, my friend ... now, a very significant moment has arrived." Turning to address the camera, Kongar-ol says, "I am deeply moved by the fact that Paul came to Tuva and participated in the [triennial throat-singing] symposium, where he won the Kargyraa [one of six major kinds of Tuvan throat singing] Division. Even more importantly, that it was his dream to come to Tuva, to Chadanaa, and most importantly to the village where I was born on the shore of the river Hemchik. What I want to say is ... the beauty which surrounds us, he cannot see ... but through my *hoomei, sygyt,* and *kargyraa* I would like to help him understand and feel that beauty. Okay?" He begins to play, and with Paul's hand on his knee, to sing. Paul begins to sing too, and as the music keeps time the most striking blend of human voice tones hover in the air: deep, rusty, robust guttural sounds bound up with, but separate from, a high-pitched boiling metallic whistle and a smoother, transitional tenor tone—all maintained simultaneously and yet varied in a kind of collaborative jazzlike back-and-forth, as if by vocal bagpipes. As Kongar-ol sings with Paul accompanying him, shots of the Tuvan landscape unfold on-screen: panoramas of the fields, pastures with grazing sheep, mountains, woods, and of course the river, which Paul could not see but in which Kongar-ol had helped him take his symbolic bath. Kongar-ol reaches the end of his song, plucking the strings with gusto. As the notes hang awaiting his utterance of the final, closing syllable, he raises one hand, ready to bring it down with a gesture of finale. Having sung the world into being for the blind musician, he ends the song, and as he sweeps his arm downward, Paul at the same time swings his hand to Kongar-ol's heart, which surprises Kongar-ol, and he lets out a loud guffaw and moves quickly to embrace his friend. They continue to laugh together even as the image fades. At one moment, earlier in the film, Kongar-ol said, "If people live in friendship, then peace prevails and life becomes good for everybody" (*Genghis Blues,* dir. Roko Belic, 1999).

89. Cleaves, *The Secret History of the Mongols,* 57.

90. Burkett, *The Art of the Felt Maker,* 23.

91. In the passage prior to making this renewal of their brotherhood, the *Secret History* explains that they recalled the words of the elders who had said that for "persons [which are] *anda,* [their] lives [are] one. Not forsaking one another, they are [the one for the other] a protection for [their] lives" (Cleaves, *The Secret History of the Mongols,* 50, 49).

92. Urgunge Onon, trans., *The History and Life of Chinggis Khan (The Secret History of the Mongols)* (Leiden, the Netherlands: E. J. Brill, 1990), xii.

93. Ibid., xii.

94. Cleaves notes, "The liver denotes intimacy and close relationship" (*The Secret History of the Mongols,* 39 n. 4). Jamuya, Temüjin's *anda,* said upon hearing of Temüjin's despair, "My liver did pain" (41).

95. Ibid., 39.

96. Onon, *The History and Life of Chinggis Khan,* xiii. Chambers notes, "Chingis never saw himself as the aggressor; with the exception of the reconnaissance

into Europe, which Subedei persuaded him to allow, whether in defence of an ally or as the result of a threat or a broken treaty, the Mongol army always marched in answer to at least some provocation" (*The Devil's Horsemen,* 44).

97. Ibid. Sun Tzu also considered the use of spies to be essential; this approach is the only way to attain reliable "foreknowledge." The information that spies can provide is invaluable, because it enables the general to accede to the knowledge of "the nature of the enemy," without which it is impossible to avoid resorting to killing or death (Sun Tzu, *The Art of War,* 174).

98. Brian Massumi, in *A Thousand Plateaus,* xiv. It is interesting to take note of the ease with which the Western world forgets how close it came to being an extension of the Golden Horde.

99. Massumi, ibid., xv.

100. Similarly, in his reading of Walter Benjamin's essay "On the Mimetic Faculty," Michael Taussig criticizes the poverty inherent in "assuming a contemplative individual," which should be replaced instead with "a distracted collective reading with a tactile eye." He considers this notion to be "Benjamin's contribution, profound and simple, novel yet familiar, to the analysis of the everyday, and unlike the readings we have come to know of everyday life, *his has the strange and interesting property of being cut, so to speak, from the same cloth as that which it raises to self awareness*" (Michael Taussig, *The Nervous System* [New York: Routledge, 1992], 147–48, emphasis added).

101. Beuys, in George Jappe, "Review: *Fond III* von Joseph Beuys," *Frankfurter Allgemeine Zeitung,* February 11, 1967.

102. Perhaps making felt would unfold as a scripting that commingles the analytic and the poetic, enacting an attention to what Deleuze and Guattari consider to be the aim of art, namely, "to wrest the percept from perceptions of objects and the states of a perceiving subject, to wrest the affect from affections as the transition from one state to another: to extract a bloc of sensations, a pure being of sensations." Percepts they define as "no longer perceptions; they are independent of a state of those who experience them. Affects are no longer feelings or affections; they go beyond the strength of those who undergo them . . . [they] are *beings* whose validity lies in themselves and exceeds any lived." For this wresting and extraction, they say, "a method is needed, and this varies with every artist and forms part of the work. . . . It should be said of all art that, in relation to the percepts or visions they give us, artists are presenters of affects, the inventors and creators of affects. They not only create them in their work, they give them to us and make us become with them, they draw us into the compound" (Deleuze and Guattari, *What Is Philosophy?* 164, 167, 175).

103. Joseph Beuys, in Charles Wright, ed., "Statements from Joseph Beuys, 1967–1986," *Joseph Beuys* (New York: Dia Art Foundation, 1987), 16.

104. Beuys, in "'Death Keeps Me Awake': Interview with Achille Bonito Oliva," in Carin Kuoni, ed., *Energy Plan for the Western Man: Joseph Beuys in America* (New York: Four Walls Eight Windows, 1990), 168–69, emphasis added.

105. Hardt and Negri, *Empire,* 57–58, emphasis added.

106. Paul Mann, *The Theory-Death of the Avant-Garde,* 66.

107. Ibid., emphasis added.

108. Ibid.

109. Deleuze and Guattari, *What Is Philosophy?* 173.

110. Louwrien Wijers, unpublished interview with the author, January 1998.

# 1. Interhuman Intermedia

1. Guy Davenport, in Ian Robinson, "Guy Davenport: Fictions for Our Time," *Shearsman* 7 (1982), http://www.poetrymagazines.org.uk/magazine/record. asp?id=2496 (accessed October 18, 2005).

2. Donald Preziosi, "Glossary," in Donald Preziosi, ed., *The Art of Art History* (Oxford: Oxford University Press, 1998), 583.

3. See Bernd Jager, "Theorizing, Journeying, Dwelling," in A. Giorgi et al., eds., *Duquesne Studies in Phenomenological Psychology*, vol. 2. (Pittsburgh: Duquesne University Press, 1975).

4. Plato, *The Republic*, part 1, book 1, "Some Current Views of Justice," trans. Francis MacDonald Cornford (Oxford: Clarendon Press, 1941), 2–3.

5. Jean Lall, unpublished seminar notes, January 13, 2005, paraphrasing Bernd Jager, "Theorizing, Journeying, Dwelling," *Review of Existential Psychology and Psychiatry* 8, no. 3 (1974): 213–35; Bernd Jager, "Theorizing and the Elaboration of Place: Inquiry into Galileo and Freud," *Duquesne Studies in Phenomenological Psychology*, vol. 4 (Pittsburgh: Duquesne University Press, 1983), 153–80.

6. Susan Stewart, *On Longing: Narratives of the Miniature, the Gigantic, the Souvenir, the Collection* (Durham, N.C.: Duke University Press, 1993).

7. In a recent dialogue among moderator Janet A. Kaplan, Fluxus artist Geoffrey Hendricks, his son Bracken, art historian Hannah Higgins, and her mother, Fluxus artist Alison Knowles, Knowles characterized Fluxus as "a very loosely associated group of friends without a political direction who are nonjudgmental of one another." The refusal of most of Fluxus's participants to operate as a unified group with a cohesive politics indeed sets it apart from other reliably avant-garde projects, such as the Italian Futurists or the French Dadaists—collectives whom Knowles names specifically as connections to Fluxus performance that should nevertheless not be seen as too closely linked to it. Part of what makes Fluxus intriguing politically is its capacity to link individuals with differing notions of what counts as "political direction" and with differing views of whether or not Fluxus has had one or many such political directions. In response to Knowles's point, Bracken Hendricks explained that within Fluxus, "you will find that different people mean very different things by the word *politics.*" Hannah Higgins elaborated upon this: "My mother [Knowles] may say that politics is not the point. I think for some [Fluxus] artists it is. Geoff [Hendricks] tends to function on a more political plane. Others don't" (Janet A. Kaplan, "Flux Generations," with Bracken Hendricks, Geoffrey Hendricks, Hannah Higgins, and Alison Knowles, *Art Journal* [Summer 2000]: 7–17, quotation on 14).

8. Text from a placard accompanying the display of *Film No. 5 (Smile)* at the YES YOKO ONO exhibition, Japan Society, New York, October 18, 2000–January 14, 2001.

9. For a closer study of the tensions between George Maciunas's desires for an organized political agenda and structure for Fluxus and the aversion to this felt

by many of his friends, see Owen Smith, "Developing a Fluxable Forum: Early Performance and Publishing," in Ken Friedman, ed., *The Fluxus Reader* (Chichester, U.K.: Academy Editions, 1998). See also Hannah Higgins's study of the results in the Fluxus community of Maciunas's efforts to coordinate the picketing of a concert by Karlheinz Stockhausen in 1963 and of his 1964 newsletter that sought to establish a political program for Fluxus; she argues that Fluxus's "social cohesion [is] based on shared experience—and [is] decidedly not unified by a specific interpretation of that experience, or by a coherent political or aesthetic program" (Hannah Higgins, *Fluxus Experience* [Berkeley: University of California Press, 2002], 12–13; for the discussion of Stockhausen and the Fluxus newsletter, see 69–99). Many have questioned the legitimacy and the efficacy of the tendency to trace all Fluxus activities to the guiding hand of George Maciunas. Hannah Higgins's work (1998 and 2002) is crucial to the historiography of Fluxus for its criticality of the Maciunas-centric model of Fluxus. Of course, in keeping with the anarchic dynamism of Fluxus and its histories, any number of positions on this issue stand squarely in contrast. George Brecht wrote, "Fluxus is a Latin word Maciunas dug up. I never studied Latin. If it hadn't been for Maciunas nobody might ever have called it anything. We would all have gone our separate ways, like the man crossing the street with his umbrella, and a woman walking a dog in another direction. We would have gone our own ways and done our own things: the only reference point for this bunch of people who liked each other's works, and each other, more or less, was Maciunas. So Fluxus, as far as I'm concerned, is Maciunas" (Brecht, in Emmett Williams and Ann Noël, eds., *Mr. Fluxus: A Collective Portrait of George Maciunas, 1931–1978* [London: Thames and Hudson, 1997], 41). For more about Maciunas's life and work, assembled in epistolary fragments from various friends, enemies, associates, and family members, Williams and Noël's book is a crucial source; see especially the narrative of Fluxus's "beginning" as a cultural club for Lithuanian émigrés in the chapter titled "An Immigrant Invents Fluxus." Their forthcoming book *Fluxus Fibs and Fables* debunks many of the great myths about Fluxus's history, as well as touching on the grains of truth that they are predicated upon (Emmett Williams and Ann Noël, *Fluxus Fibs and Fables* [London and New York, forthcoming]). For an important collection of accounts of and accountings for Fluxus, see Friedman, ed., *The Fluxus Reader.*

10. On Filliou's service, see Claude Gintz, "From Madness to Nomadness," *Art in America* 73, no. 6 (June 1985): 132; on Levinas's service, see Peperzak, "Preface," in Peperzak, Critchley, and Bernasconi, eds., *Emmanuel Levinas*, xiii.

11. Levinas's dissertation was first published as *Théorie de l'intuition dans la phénoménologie de Husserl* (Paris: Félix Alcan, 1930). The English translation was published four decades later as *Theory of Intuition in Husserl's Phenomenology,* trans. A. Orianne (Evanston, Ill.: Northwestern University Press, 1973). The Alliance Israélite Universelle was, in Peperzak's words, "an important philanthropic and educational institution whose mission was to promote the 'emancipation' of Jews living in Mediterranean lands such as Morocco, Tunisia, Algeria, Turkey, and Syria" (Peperzak, "Preface," viii).

12. Peperzak, "Preface," xii; Rötzer, *Conversations with French Philosophers,* 63.

13. *Robert Filliou: Das immerwährende Ereignis zeigt—The Eternal Network Presents—La Fête permanente présente* (Hannover: Sprengel Museum; Paris: MAMVP; and Bern: Kunsthalle Bern, 1984), 50.

14. Wolfgang Becker, "The Continents: A New Iconography," http://continental shift.org/exhibition/concept/concept_en.html (accessed October 14, 2005).

15. The details of this conversation between Levinas and Batchelor were relayed to me by Batchelor in a telephone conversation in May 1999 and reconfirmed in an e-mail dated July 7, 2001.

16. Levinas, in Rötzer, *Conversations with French Philosophers,* 63.

17. Ibid.

18. For a short critical history of the birth of Buddhism as an academic object of knowledge, see Donald S. Lopez Jr., "Introduction," in Donald S. Lopez Jr., ed., *Curators of the Buddha: The Study of Buddhism under Colonialism* (Chicago: University of Chicago Press, 1995), 1–29. See also the chapter titled "Eugène Bernouf: The Construction of Buddhism," in Batchelor, *The Awakening of the West,* 227–49.

19. Hannah Higgins, "Fluxus Fortuna," in Friedman, ed., *The Fluxus Reader,* 57.

20. Gillian Rose, *Mourning Becomes the Law* (Cambridge: Cambridge University Press, 1996).

21. On the Vietnamese Buddhist resistance to the Vietnam War, which the Vietnamese call the American War, see Frances Fitzgerald, *Fire in the Lake: The Vietnamese and the Americans in Vietnam* (Boston: Little, Brown and Co., 1972).

22. Among these central tenets is the one, common to the various forms of Mahayana and Vajrayana Buddhism, of the vow of the bodhisattva. The bodhisattva is a being that, having attained awakening, vows to forgo final enlightenment in order to work for the enlightenment of all other beings. See Santideva, *Bodhicharyavatara,* trans. Amarasiri Weeraratne (Colombo, Sri Lanka: Metro Printers, 1979); and Santideva, *A Guide to the Bodhisattva's Way of Life,* trans. Stephen Batchelor (Dharamsala: Library of Tibetan Works and Archives, 1979).

23. These are the vows of Refuge in the Three Jewels: the Buddha, the dharma (the teaching and the path), and the *sangha* (the dharma community).

24. Filliou had performed this score in Paris in 1964 and with Alison Knowles at Café au Go Go in New York in 1965.

25. Robert Filliou, "Yes—an Action Poem," in *A Filliou Sampler* (New York: Something Else Press, 1967), 5–6.

26. Ibid., 8.

27. Ibid., 9. This is followed by "Part Two—His Poem," "Le Filliou ideal," and "The Secret of Absolute Permanent Creation."

28. On the extension of Filliou's thought in general and the ideas in *Teaching and Learning as Performing Arts* in particular to contemporary pedagogy, see Hannah Higgins, "Teaching and Learning as Art Forms: Toward a Fluxus-Inspired Pedagogy," in *Fluxus Experience,* 187–208.

29. This root *autre* has been used recently by Sarat Maharaj, who, in his introduction to the writings of Eddie Chambers, describes Chambers's writing as an autrebiography: "an overspill of sources and origins, a network of neural nodes and criss-crossing pathways . . . a volatile performative process, a spasmic mesh of self-building, self-demolishing connections" (Sarat Maharaj, "Black Art's Autrebiography," in Gilane Tawadros and Victoria Clarke, eds., *Run through the Jungle: Selected Writings by Eddie Chambers,* Annotations 5 [London: Institute of International Visual Arts, 1999], 8, 4).

30. Rose, *Love's Work,* 134–35.

31. Robert Filliou had been sharing this story with Wijers. He explained to her, "The more Marianne and I go into the Vajrayana, the more we cannot help wondering at times, whether our actions are the right ones, or not. .The big problem for an artist in particular is this: Should I go on with my work . . or should I stop for a while, and go as deep as I can into the doctrine . . and only after that eventually start again?" Both quotes are from Louwrien Wijers, *Writing as Sculpture, 1978–1987* (London: Academy Editions, 1996), 129. The use of ". ." rather than the usual ". . ." occurs throughout *Writing as Sculpture;* quotations from that book keep to that format. Bracketed ellipses signify my omissions from Wijers's text as distinguished from her particular use of ellipsis dots and, elsewhere, from those that signal a pause in speech.

32. It is worth noting that for Levinas, too, the relationship between teaching and learning constituted one of the central modes of the ethical relationship; see *Totality and Infinity,* 98–101, 180.

33. Sarat Maharaj has grappled with this notion of nonknowledge at the core of the endeavor of artistic research: "Could it be the artist's 'lack of competency' is index of quite another think-read-map—more in tune with 'non-knowledge'? To name the later, I have used the ancient Sanskrit term Avidya. Its opposite, Vidya (to see-know) gives us the Latin cousin 'video.' By adding 'A' to vidya— Avidya—signals not just its polar opposite 'ignorance'—it's closer to the privative than to negation. It expresses the middle term as in moral<amoral>immoral or typical<atypical>untypical—the 'neutral gear' of knowing that is neither that of the 3D disciplines nor its conventional opposite 'ignorance.' Perhaps something approximating 'crazy wisdom'? Avidya stands for that in-between space explored by a long line from Sankara backwards to the Buddha's celebrated description by non-affirmation—'Neti, Neti, Neti.' The 'no, neither, nor' oscillations in Avidya 'delay' polar thinking involved in 'knowing/not-knowing.' Let's note this as the rough frame for John Cage's 'sonic research'—his 'in-between' noise-sound-silence constructions" (Sarat Maharaj, "Unfinishable Sketch of 'An Unknown Object in 4D': Scenes of Artistic Research," *Lier en Boog* 18, no. 1 [February 20, 2004]: 39–58, 49).

34. Dick Higgins, "Intermedia," *Something Else Press Newsletter* (February 1966); reprinted in Lisa Moren, ed., *Intermedia: The Dick Higgins Collection at UMBC* (Baltimore: Albin O. Kuhn Library and Gallery, University of Maryland Baltimore County, 2003), 38–42; for thorough discussions of the genealogy and implications of the concept of intermedia, see Lisa Moren, "The Wind Is a Medium of the Sky," in Moren, ed., *Intermedia,* 11–19; Ken Friedman, "Dick Higgins, 1938–1998," in Judith A. Hoffberg, ed., *Umbrella: The Anthology* (Santa Monica, Calif.: Umbrella Editions, 1999), 157–63; and Ina Blom, "Boredom and Oblivion," in Friedman, ed., *The Fluxus Reader,* 63–90, especially 65–66.

35. Higgins, "Intermedia," 41. Higgins goes on to touch on several other forms of intermedia with respect to various contemporaries—Philip Corner, John Cage working between music and philosophy, Joe Jones working between music and sculpture, Emmett Williams and Robert Filliou working between poetry and sculpture.

36. Ibid., 42.

37. "Beginning in 1967, Alison Knowles began each day to eat the same lunch—a tuna fish sandwich on whole wheat toast with butter, no mayo, and a cup of buttermilk or the soup of the day—at the same time and location, at the Riss Foods Diner in Chelsea. With Philip Corner, this became an extended meditation, score, and journal. Repeating the gesture made the meal a self-conscious reflection on an everyday activity. Friends and interested artists joined in. Receipts were kept, and slight differences in the meal noted" (Higgins, *Fluxus Experience,* 47).

38. Miller made this comment during his presentation in the "Fluxus and Duchamp" session, chaired by Geoffrey Hendricks, at the 2002 College Art Association Annual Conference, Philadelphia, February 23, 2002.

39. This show, curated by Lisa Moren, opened at the Albin O. Kuhn Library, University of Maryland Baltimore County, Baltimore, October 14, 2003.

40. Chris Thompson, "Tao te Dick: Finding Fluxus, Part Two: Dick Higgins Plays Carnegie Hall," *Portland Phoenix,* March 8, 2002, 14.

41. In formulating her discussion of the sorts of experiences around which Fluxus has cohered as a social organism and artistic endeavor, Hannah Higgins draws specifically from what Owen Smith has called the "non-hierarchical density of experience" that characterizes Fluxus's event-making activities. See Smith, *Fluxus.*

42. Telephone interview with Alison Knowles, August 13, 2003.

43. Stephen Batchelor, *Alone with Others: An Existential Approach to Buddhism* (New York: Grove Press, 1983).

44. Telephone interview with Alison Knowles, August 13, 2003.

45. Higgins, *Fluxus Experience,* 58.

46. See Friedman, "Dick Higgins, 1938-1998," 157-63. For more detail on his engagement with Coleridge, see Moren, "The Wind Is a Medium of the Sky," 12-13. Though this deviation appears not to be addressed in print, Higgins's friend and former colleague John Boyd has said that Dick Higgins told him that the key inspiration for the idea of intermedia came from the work of William Blake (John Boyd, discussion with the author, University of Maryland Baltimore County, October 14, 2003).

47. "Conceptual Art and the Reception of Duchamp," panel discussion in Martha Buskirk and Mignon Nixon, eds., *The Duchamp Effect* (Cambridge, Mass.: MIT Press, 1996), 210-13.

48. Ibid.

49. Brecht, in David T. Doris, "Zen Vaudeville: A Medi(t)ation in the Margins of Fluxus," in Friedman, ed., *The Fluxus Reader,* 124. For a discussion of Fluxus, and Brecht's action in particular, within the context of Conceptual Art, see "Conceptual Art and the Reception of Duchamp," 210-13. For a thorough study of Brecht's score, see Julia Robinson, "The Brechtian Event Score: A Structure in Fluxus," *Performance Research* 7, no. 3 (September 2002): 110-23.

50. "Conceptual Art and the Reception of Duchamp," 210-13.

51. Robert Filliou, in Louwrien Wijers, "Robert Filliou Talks about Dharma and His Work as an Artist," in Wijers, *Writing as Sculpture,* 132.

52. Emmett Willams, in Williams and Noël, *Mr. Fluxus,* 91. Williams suggests that Maciunas's idea was "derived mainly from his interpretation of the works made by George Brecht in the early 1960's, La Monte Young's 1960 compositions, and to

some extent [Emmett Williams's] own verbal and performance works and those of Dick Higgins" (ibid.). Jackson Mac Low says that in the early 1960s, Maciunas "was a peculiar kind of Marxist-Leninist—even, in his own way, a 'Russianist'"— and remembers Maciunas once showing him a letter he'd just mailed to Kruschev "in which he urged the Soviet ruler to encourage 'realistic art' (such as G. Brecht's, La Monte's, and to some extent [Mac Low's]) as being more consonant with a 'realistic economic system' such as that of the Soviet Union than the old-fashioned 'socialist-realist' art then in favor." Mac Low speculated:"I think his politics changed later, but I'm not sure" (Mac Low, in Mr. Fluxus, 91-92).

53. George Brecht, in Doris,"Zen Vaudeville," 97. Brecht's comment refers specifically to his *3 Telephone Events,* from spring 1961.

54. Higgins,"Fluxus Fortuna," 57.

55. Published by Something Else Press, *Ample Food* is Filliou's first work to be published in English.

56. The collection begins with Filliou's note:"These friendly introductions are introduced by my friend Daniel Spoerri, who suggested them," and, in addition to Mac Low and Spoerri, it includes introductory offerings from Arman, Kickha Baticheff, George Brecht, William Burroughs, Christo, Diane di Prima, Brion Gysin, Dick Higgins, Ray Johnson, Joe Jones, Allan Kaprow, Alison Knowles, John Herbert McDowell, Jackson Mac Low, Nam June Paik, Benjamin Patterson, Dieter Roth, and James Waring.

57. Why a *stone* wall?

58. For a full discussion of *Hurlements* and its screening, see Greil Marcus, *Lipstick Traces: A Secret History of the Twentieth Century* (Cambridge, Mass.: Harvard University Press, 1989), 331-45.

59. Ibid., 332.

60. Ibid., 329-31.

61. Sarat Maharaj,"A Double-Cressing Visible Grammar: Around and about the Work of Alighiero e Boetti," unpublished transcript of a lecture given at Dia Center for the Arts, New York, 1996, 22.

62. Sam Richards, *John Cage As ...* (Oxford: Amber Lane Press, 1996), 92, 97.

63. Cage attended Suzuki's classes at Columbia University in the late 1940s, when Suzuki was near the height of his fame. In addition to this and to reading Suzuki's books, Cage also visited Suzuki twice in Japan (ibid., 92). For a discussion of Suzuki's role in packaging a Zen that was arguably crafted by and for Japanese nationalism, see Robert H. Sharf,"The Zen of Japanese Nationalism," in Lopez, ed., *Curators of the Buddha.*

64. Richards, *John Cage As ...,* 93.

65. Ibid., 96.

66. There has often been confusion on this point. Most recently, for instance, in his discussion of Cage and Duchamp's chess matches, Sylvère Lotringer has written,"[Cage] told me the Chess Master had found him a real disappointment.'Don't you ever play to win?' Duchamp had kept asking, exasperated. Cage was a Zen Buddhist to the core: why should anyone *have* to win? He had already won what he wanted: spending time with Duchamp" (Sylvère Lotringer, "Becoming Duchamp," *Tout-Fait,* May 2000, http://www.toutfait.com/issues/issues_2/Articles/lotringer.html, 2 [accessed February 2002]).

67. Richards, *John Cage As ...,* 95.

68. Ibid., 101.

69. John Cage quoted in Gijs van Tuyl, *Mit Natur zu tun/To Do with Nature,* with essays by Piet van Daalen and Jörg Zutter (Amsterdam: Visual Arts Office for Abroad, 1979), 7.

70. George Maciunas, in Larry Miller, "Transcripts of the Videotaped *Interview with George Maciunas,* 24 March 1978," in Friedman, ed., *Fluxus Reader,* 196.

71. Yoko Ono, in Alexandra Munroe, "Spirit of YES: The Art and Life of Yoko Ono," in YES YOKO ONO, exhibition catalogue, with Jon Hendricks (New York: Japan Society and Harry N. Abrams, 2000), 17.

72. John Cage quoted in Louwrien Wijers, "FLUXUS YESTERDAY AND TOMORROW: An Artist's Impression," in Pijnappel, ed., *Fluxus Yesterday and Today,* 9.

73. Maciunas, in Williams and Noël, *Mr. Fluxus,* 121.

74. Higgins, "Fluxus Fortuna," 222–23.

75. Ken Friedman, "Fluxus and Company," in Friedman, ed., *The Fluxus Reader,* 242.

76. Mieko Shiomi, in Ken Friedman, Owen Smith, and Lauren Sawchyn, eds., *The Fluxus Performance Workbook* (Performance Research e-Publications, 2002), 97. Credit: Mieko Shiomi and Fluxus.

77. Lotringer, "Becoming Duchamp," 3. For a discussion of the Toronto event, see Lowell Cross, "*Reunion:* John Cage, Marcel Duchamp, Electronic Music and Chess," *Leonardo Music Journal* 9 (1999): 35–42.

78. *Marcel Duchamp: A Game of Chess,* dir. Jean Marie Drot, 1987.

79. Michael Taussig, *Mimesis and Alterity: A Particular History of the Senses* (New York: Routledge, 1992), 40, 198.

80. Brecht, in Doris, "Zen Vaudeville," 104.

81. Geoff Hendricks, in Kaplan, "Flux Generations," 12.

82. Smith, "Developing a Fluxable Forum," 6.

83. Higgins, in Kaplan, "Flux Generations," 12.

84. Higgins, ibid., 9. As Higgins suggests, Fluxus's history is far too complex and colorful to try to totalize. Only in treating it as "this or that Fluxus" can justice be done to this complexity. As many have noted, there are as many stories about how Fluxus got its name as there are Fluxus artists.

85. Larry Miller, "Maybe Fluxus (a Para-Interrogative Guide for the Neoteric Transmuter, Tinder, Tinker and Totalist)," in Friedman, ed., *The Fluxus Reader,* 212.

## 2. Rate of Silence

1. Gregory Ulmer, *Applied Grammatology: Post(e)-Pedagogy from Jacques Derrida to Joseph Beuys* (Baltimore: Johns Hopkins University Press, 1984), 227–28.

2. For a full description of this event, see Antje von Graevenitz, "Breaking the Silence: Joseph Beuys on His 'Challenger,' Marcel Duchamp," in Claudia Mesch and Viola Michely, eds., *Joseph Beuys: The Reader* (Cambridge, Mass.: MIT Press, 2007), 31–33. Von Graevenitz speculates that even at the level of his materials Beuys was engaging with Duchamp, drawing a connection between his *braunkreuz* paint and Duchamp's chocolate grinder from *The Bride Stripped Bare.* Her essay docu-

ments a number of thematic connections between Beuys's later work and Duchamp's, tracing their shared concerns with alchemy, immateriality, and energy.

3. Ibid., 29.

4. The London office and shop of Wisdom Publications (though now headquarters have moved to Boston, Massachusetts) used to be located in the same building as the d'Offay Gallery, just an elevator ride up from d'Offay's ground floor. Wisdom Publications was founded in 1975, initially as a "publishing organ" (Lopez, *Prisoners of Shangri-La,* 177; Lopez refers to Lama Yeshe as a *tulku;* though a lama, Yeshe is not an incarnation of another lama, so this is inaccurate) for the work of the Tibetan Gelug lamas, Lama Thubten Yeshe and Lama Thubten Zopa, the founders of the Federation for the Preservation of the Mahayana Tradition, which now has 154 centers in thirty-three countries. According to Louwrien Wijers, the staff at Wisdom Publications' office recalls Beuys making several visits to the shop while he was installing *Plight* at d'Offay, amassing armloads of books on Tibetan Buddhism. Lama Zopa and Lama Yeshe were also Louwrien Wijers's teachers beginning in 1979, when she started following their classes at the Maitreya Institute. In addition to the writings of these two lamas, Wisdom Publications also published works by the Dalai Lama and, among others, Jeffrey Hopkins, whose important contribution to Tibetan Buddhist studies, *Meditation on Emptiness,* was first published in 1983, making it conceivable that this book was among Beuys's purchases.

5. For *Plight,* Beuys lined "the walls of the gallery with large rolls of felt, two rolls high, in specially manufactured groups of five. The two rooms of the gallery were thus padded, insulated and isolated. In the centre of the larger room a grand piano was positioned, with a blackboard and a thermometer on top of its closed case.... As the felt rolls were lifted, positioned against the walls and fixed in place, the temperature in the room began to rise. The walls and windows were gradually covered in, and the felt, a mixture of rabbit's hair and sheep's hair, dominated, creating a dull, grey, womb-like, but also tomb-like, space" (Sandy Nairne, *State of the Art: Ideas and Images in the 1980s,* with Geoff Dunlop and John Wyver [London: Chatto and Windus, 1987], 93–95). Beuys died three months later, on January 23, 1986.

6. Von Graevenitz, "Breaking the Silence," 30.

7. Beuys, in ibid., 31.

8. Ibid., 43.

9. Ibid., 43–44.

10. Alain Borer, "A Lament for Joseph Beuys," in Lothar Shirmer, ed., *The Essential Joseph Beuys* (London: Thames and Hudson 1996), 29. Beuys's reflections on his and his work's relationship to Christianity, rarely taken seriously in academic discussions of his work, constitute a series of discussions far too complex to do more than touch upon here. See his dialogues with Friedhelm Mennekes, *Beuys zu Christus: Eine Position im Gespräch* [Beuys on Christ: A Position in Dialogue] (Stuttgart: Verlag Katholisches Bibelwerk, 1989); and Friedhelm Mennekes, "Joseph Beuys: *MANRESA,*" trans. Fiona Elliot, in David Thistlewood, ed., *Joseph Beuys: Diverging Critiques* (Liverpool: Liverpool University Press and Tate Gallery Liverpool, 1995). A Jesuit, a professor of pastoral theology and the sociology of religion at Frankfurt am Main, pastor since 1987 of Sankt Peter, in Cologne, and director of its Kunst-Station, Mennekes has also served as editor of *Kunst und Kirche,* an

ecumenical publication for art and architecture. See also Beuys's interviews with Wijers, especially in *Writing as Sculpture,* 38–58.

11. Beuys, in Kuoni, *Energy Plan for the Western Man* (1990), 19.

12. Beuys, in Mennekes, *Beuys zu Christus,* 51.

13. Ibid., 51–53.

14. Merilyn Smith, "Joseph Beuys: Life as Drawing," in Thistlewood, ed., *Joseph Beuys: Diverging Critiques,* 180.

15. Caroline Tisdall, *Joseph Beuys: We Go This Way* (London: Violette Editions, 1998), 44.

16. Carin Kuoni, ed., *Energy Plan for the Western Man: Joseph Beuys in America* (New York: Four Walls Eight Windows, 1990), 19.

17. Irit Rogoff, "The Aesthetics of Post-History: A German Perspective," in Stephen Melville and Bill Readings, eds., *Vision and Textuality* (Basingstoke, U.K.: Macmillan, 1995), 121.

18. "It should be noted here what Beuys had to say about fat—that people ate it, yet had a horror of it" (Andrea Duncan, "Rockets Must Rust: Beuys and the Work of Iron in Nature," in David Thistlewood, ed., *Joseph Beuys: Diverging Critiques* [Liverpool: Liverpool University Press and Tate Gallery Liverpool, 1995], 86).

19. Rogoff, "The Aesthetics of Post-History," 121.

20. Beuys, in Caroline Tisdall, ed., *Joseph Beuys* (New York: Solomon R. Guggenheim Museum, 1979), 23.

21. Beuys, in "'Death Keeps Me Awake': Interview with Achille Bonito Oliva," in Kuoni, *Energy Plan for the Western Man,* 160.

22. Ibid., 165–66.

23. Ibid., 168–69. Beuys's formulation is quite close to Levinas's "non-synthetic" notion of peace, particularly its articulation as love, in his late essay "Peace and Proximity"; see Levinas, "Peace and Proximity," 166. Regarding the vehemence of Beuys's rejection of peaceful coexistence as a model, it is important to note that this was also a term with cold war political currency describing the ideology of containment between the United States and NATO on the one hand and the Soviet Union and its satellites on the other. In 1982 Beuys gave this critique of Reaganite rhetoric a hilarious, microphone-swinging form in his musical performance *Sonne Statt Reagan*—a play on the closeness of the president's surname to the German word for rain, *regen* ("we want sunshine instead of rain/Reagan")—in which he cried out the refrain "Rockets must rust!" To view the performance, see http://ubu.wfmu.org/video/Beuys-Joseph_Sonne-Statt-Reagan_1982.mov (accessed June 2008).

24. Beuys, in "'Death Keeps Me Awake': Interview with Achille Bonito Oliva," 169.

25. Lotringer notes that Duchamp went yearly to Cadaqués, Spain, to visit Salvador Dalí, bringing with him his wife, Teeny, as well as Cage, who was baffled and "mystified by the reverence Duchamp kept showing Dalí whom he himself disliked intensely like so many others" (Lotringer, "Becoming Duchamp," 1).

26. Beuys, in "'Death Keeps Me Awake': Interview with Achille Bonito Oliva," 169.

27. For this and the following quotes of Beuys and Bonito Oliva, see ibid., 160–71.

28. Beuys, ibid., 170–71. Beuys often compared Duchamp's overestimation with the underestimation of figures he felt deserved more attention. In his interview with Richard Hamilton, Beuys said, "The silence of Marcel Duchamp is overestimated and [Richard] Wagner is underestimated" ("Gespräch zwischen Joseph Beuys und Richard Hamilton," in Ewa Beuys, Wenzel Beuys, and Jessyka Beuys, *Joseph Beuys: Block Beuys* [Munich: Schirmer-Mosel, 1997], 12).

29. Eugen Blume, "The Poetic Physics of the Multiples and Editions of Joseph Beuys," in Heiner Bastian, ed., *Joseph Beuys—Editions: The Collection of Reinhard Schlegel* (Berlin: Nationalgalerie im Hamburger Bahnhof Museum für Gegenwart; Edinburgh: Scottish National Gallery of Art; Vienna: MAK—Österreichisches Museum für angewandte Kunst, 1999), 19. For a thorough discussion of this multiple, see 26–28.

30. Ibid., 19.

31. Antje von Graevenitz has also argued that Duchamp had a continuous influence on Beuys, noting that his 1984 Venice Biennale installation, *Is It about a Bicycle?* undertaken with student Johannes Stüttgen, grapples directly with Duchamp's ready-mades (Antje von Graevenitz, "Breaking the Silence: Joseph Beuys on his 'Challenger' Marcel Duchamp," in Rainer Jacobs, Marc Scheps and Frank Günter Zehnder, eds., *In Medias Res. Festschrift zum siebzigsten Geburtstag von Peter Ludwig* [Cologne: DuMont, 1995]).

32. Beuys, in "'Death Keeps Me Awake': Interview with Achille Bonito Oliva," 168–69.

33. *Marcel Duchamp: A Game of Chess,* dir. Jean Marie Drot, 1987.

34. Gianni Vattimo, *After Christianity,* trans. Luca D'Isanto (New York: Columbia University Press, 2002), 2.

35. The critic who made this link was Monsignore Otto Mauer, whom Christopher Phillips calls "one of Beuys's most perceptive early critics" (Christopher Phillips, "*Arena:* The Chaos of the Unnamed," in Lynne Cooke and Karen Kelly, eds., *Joseph Beuys: Arena—Where Would I Have Got if I Had Been Intelligent!* [New York: Dia Center for the Arts/Distributed Art Publishers, 1994], 58, 62 n. 27).

36. Vattimo, *After Christianity,* 2.

37. Benjamin Buchloh, "Beuys: The Twilight of the Idol—Preliminary Notes for a Critique," *Artforum* 18 (January 1980).

38. Beuys, in Wijers, *Writing as Sculpture,* 38–39. In their introduction to their recent critical anthology *Joseph Beuys: The Reader,* Claudia Mesch and Viola Michely declare that one of their goals in producing their book is "to reinitiate discussion of the work of this artist as a figure who challenges and destabilizes the categories established for modern and postmodern art by American art history since the late cold war." They go on to point out, "Art history has generally constructed a secular—and modern—'Beuys,' a position Beuys himself had established in his art by the 1970s and 1980s. In line with the recent sweep of art history that it includes, the Beuys put forward by *The Reader* is secular and modernist. There are most certainly other 'Beuys' that remain to be uncovered or constructed. Another 'Beuys' would have to do with Beuys' engagement with the sacred. This aspect of his work arguably positions him as pre-modern, or at a cultural point before the secularizing thrust of the modern" (Claudia Mesch and Viola Michely, "Editors' Introduction," in Mesch and Michely, eds., *Joseph Beuys: The Reader,* 4). Now, just

as the distinction between the modern and the sacred is utterly artificial (the centrality of religious experience, faith, and spirituality in constructions of the modern and in the living of "modern life" make it impossible to sustain this position, for all the reasons that Vattimo, for example, discusses with such passion and clarity), so too is it crucial *not* to allow the gravitational pull and power of American art history since the late cold war to force a reading of Beuys that believes in the possibility of teasing out his engagement with religion ("the sacred") from the rest of his life and work. Mesch and Michely's *Reader* is an extraordinary resource, but to the degree that it reifies this division between the "spiritual" or "religious" Beuys and the properly secular "art historical" Beuys—and indeed allows the powerful sweep of American academia's art historical imperatives to underwrite this artificial split—the book poses a deeply problematic premise. Bracketing Beuys's commitment to these theological and spiritual engagements is not so simple; what is crucial is to read his formal, political, and ostensibly secular imperatives as fundamentally entangled with these engagements.

39. Beuys in Wijers, *Writing as Sculpture,* 38–39. The use of the term *mysticism* is, of course, still hard at work in discussions of Beuys's work; see, for example, Paul Parcellin, "Joseph Beuys at Harvard's Busch-Reisinger Museum," *Art New England* 22, no. 1 (February/March 2001): 18–19, 87.

40. Unpublished interview with Louwrien Wijers, Amsterdam, January 1998. Here she is referring to philosopher and theologian Raimon Panikkar's comments on the subject of mysticism in their interview for the 1990 Art Meets Science and Spirituality in a Changing Economy conference.

41. Wijers, *Writing as Sculpture,* 39.

42. Arthur Danto, "Foreword: Style and Salvation in the Art of Beuys," in Mesch and Michely, eds., *Joseph Beuys: The Reader,* xvii.

43. Vattimo, *After Christianity,* 2.

44. Mennekes, "Joseph Beuys: MANRESA," 155. Terry Atkinson is one among many critics who has little patience for Beuys's forays into the supersensible. Responding to Beuys's cohabitation with the "wild" coyote in *I Like America and America Likes Me,* Atkinson notes that this "is one of Beuys' *pièces de résistance.* As an exercise in supersensibility this will take some beating, as it will as an exercise in vainglorious metaphysical posturing" (Terry Atkinson, "Beuyspeak," in Thistlewood, ed., *Joseph Beuys: Diverging Critiques,* 175). Atkinson's indictment of Beuys is scathing: "He alleges he made good contact with the coyote—whatever this might mean. Whatever it might mean, we can be sure it will be of a more profound character than when I consider I have made good contact with our cats, Heidi and Snowy" (Atkinson, "Beuyspeak," 174). In "Mystical Elements in Art," Sixten Ringbom engages with the unwillingness of most scholarship to deal with that which seems to fall under the rubric of mystical, visionary, and occult experience—in short, the "supersensible" (Sixten Ringbom, "Mystical Elements in Art," in Peter Fuller et al., *Abstract Art and the Rediscovery of the Spiritual* [New York: St. Martin's Press, 1987], 73).

45. Antje Von Graevenitz, "The Old and the New Initiation Rites: Joseph Beuys and Epiphany," in Lynne Cooke and Karen Kelly, eds., *Robert Lehman Lectures on Contemporary Art* (New York: Dia Center for the Arts, 1996), 69–71, quotation on 71. Von Graevenitz considers *Eurasianstaff* "a kind of staged story that had noth-

ing in common with the reality of the room in the gallery. It was a story told in fragments that included healing materials, fragments of movement, sacred objects, and written words."

46. Duncan, "Rockets Must Rust," 83.

47. In *Mimesis and Alterity,* Michael Taussig quotes from Roger Caillois's 1935 essay "Mimicry and Legendary Psychaesthenia" to describe what Taussig calls the mimetic faculty: "He is similar, not similar to something, but just similar. And he invents spaces of which he is the convulsive possession" (Caillois, in Taussig, *Mimesis and Alterity: A Particular History of the Senses* [New York: Routledge, 1993], 33). This is, for him, the extreme case of a world in which "slipping into Otherness, trying it on for size," is possible; "mimesis is not only a matter of one being another being, but with this tense yet fluid theatrical relation of form and space with which Caillois would tempt us." We might think of Beuys's work as forms and gestures that invent spaces of which both he and his work are the convulsive possession.

48. Duncan, "Rockets Must Rust," 86, 91.

49. Ibid., 86.

50. Tisdall, ed., *Joseph Beuys,* 92.

51. "Conceptual Art and the Reception of Duchamp," 209-10.

52. Duchamp, in Blume, "The Poetic Physics of the Multiples and Editions of Joseph Beuys," 9.

53. *Marcel Duchamp: A Game of Chess.*

54. Ibid.

55. "Gespräch zwischen Joseph Beuys und Richard Hamilton" (1997), 7-16, 10.

56. Götz Adriani, Winfried Konnertz, and Karin Thomas, *Joseph Beuys: Life and Works,* trans. Patricia Lech Woodbury (New York: Barron's, 1979), 77-78.

57. Ibid. For a discussion of Beuys's early Fluxus involvement, see 77-130.

58. "Gespräch zwischen Joseph Beuys und Richard Hamilton" (1997), 10.

59. Ibid., 10-11.

60. Smith, "Developing a Fluxable Forum: Early Performance and Publishing," 5.

61. Ibid., 9. One of the more important of these was the 24 Stunden (24 Hours) event at the Gallerie Parnass in Wuppertal on June 5, 1965. This included events by Bazon Brock, Charlotte Moorman, Nam June Paik, and Eckhart Rahn, as well as Schmit, Vostell, and Beuys; for a description of Beuys's contribution, *24 Hours ... and in Us ... under Us ... Landunder ...,* see Tisdall, ed., *Joseph Beuys,* 95-96.

62. Blume, "The Poetic Physics of the Multiples and Editions of Joseph Beuys," 8-9.

63. Thanks to Ken Friedman for this point. Ken Friedman, e-mail to the author, January 8, 2002.

64. Alison Knowles, http://aknowles.com/couers.html (accessed October 16, 2005).

65. Emmett Williams, unpublished conversation with the author, Ann Nöel, and Mary Pat Warming, Berlin, November 29, 2005.

66. Elaine Sturtevant, in Bruce Hainley, "Erase and Rewind: Bruce Hainley on Elaine Sturtevant," *Frieze,* issue 53 (June/July/August 2000): 86.

67. Joseph Beuys, in Kuoni, ed., *Energy Plan for the Western Man,* 169.

68. For an account of the episode, see Heiner Stachelhaus, *Joseph Beuys,* trans. David Britt (New York: Abbeville Press, 1991).

69. Martha Buskirk, "Thoroughly Modern Marcel," in Buskirk and Nixon, eds., *The Duchamp Effect,* 191.

70. Beuys, in Kuoni, *Energy Plan for the Western Man,* 80.

71. Ibid., 87.

72. Ibid.

73. Higgins, "Fluxus Fortuna," 32–33.

74. Lotringer, "Becoming Duchamp," 3.

75. For a thorough analysis of the role of Joyce in Beuys's work and thought, see Christa-Maria Lerm Hayes, *James Joyce als Inspirationsquelle für Joseph Beuys* (Hildesheim: Georg Olms Verlag, 2001).

76. Pamela Kort, "Joseph Beuys's *Arena:* The Way In," in Cooke and Kelly, eds., *Joseph Beuys:Arena,* 24.

77. Ibid., 19, 31 n. 17.

78. Ibid., 20.

79. Joseph Beuys, "Life Course/Work Course," in Kuoni, *Energy Plan for the Western Man,* 265.

80. Pamela Kort, e-mail to the author, July 29, 2001.

81. Beuys, "Life Course/Work Course," 262–63.

82. Kort, "Joseph Beuys's *Arena:* The Way In," 23.

83. This was the German edition: Richard Ellmann, *James Joyce,* trans. Albert W. Hess, Klaus and Karl H. Reichert (Frankfurt am Main: Suhrkamp, 1959).

84. The editions were: *Ulysses* (New York: Penguin, 1972); *Ulysses,* trans. Georg Goyert, 6th ed. (Zurich: Rhein-Verlag, 1956); and *Finnegans Wake* (London: Faber and Faber, 1939), the last of which would have been the edition Cage picked up in Seattle.

85. Richard Ellmann, in Kort, "Joseph Beuys's *Arena:* The Way In," 24, 25.

86. Ibid., 24.

87. Ibid., 32 n. 45.

88. On the Guggenheim exhibition, see Tisdall, ed., *Joseph Beuys.* According to its curator Lynne Cooke, Dia Center for the Arts holds records in its archive indicating that "Beuys may once have planned to continue updating *Arena* by adding further photographs in new panels. In fact, he never did. This proposal reaffirms, nonetheless, the open character this work retained for him" (Lynne Cooke, "Installing Arena: An Introduction," in Cooke and Kelly, eds., *Joseph Beuys:Arena,* 17 n. 2).

89. Cooke, "Installing Arena," 12.

90. Beuys and Christiansen performed another version of the action in a bomb shelter at the Stadion St. Jakob in Basel in 1971. See Cooke, "Installing Arena," 12.

91. Ibid.

92. Richard Hamilton, in Kort, "Joseph Beuys's *Arena:* The Way In," 32 n. 35.

93. For a trenchant critique of Beuys's "self-regarding homilies to the Irish in Belfast," see Terry Atkinson, "Beuyspeak"; two other essays look specifically at Beuys's engagement with Irish history and Celtic lore: Caroline Tisdall's "Beuys and the Celtic World," a celebratory set of snapshots of Beuys and his use of Celtic

themes, his affinity for James Joyce, and so forth; and Ullrich Kockel's "The Celtic Quest: Beuys as Hero and Hedge School Master," which explores Beuys's work and thought in relation to the figure of the hedge school masters who taught Irish children the Gaelic language and other subjects forbidden by the British; see these essays in David Thistlewood, ed., *Joseph Beuys: Diverging Critiques*.

94. See Joseph Beuys and Heinrich Böll, "Manifesto on the Foundation of a Free International School for Creativity and Interdisciplinary Research," in Kuoni, *Energy Plan for the Western Man*. Despite great efforts on behalf of the Free International University, including much traveling and speaking by Beuys, a major feasibility study commissioned by Ralf Dahrendorf, former head of the London School of Economics, and written by Tisdall, and a symposium dedicated to the project held at University College, London, on December 1, 1976, the necessary funds to make the university a reality were never secured (Tisdall, "Beuys and the Celtic World," 119).

95. Beuys, in Tisdall, "Beuys and the Celtic World," 113.

96. Kort, "Joseph Beuys's *Arena:* The Way In," 22.

97. Cooke, "Installing Arena," 16.

98. Ellmann, *James Joyce*, 66.

99. Ibid.

100. Ibid.

101. Beuys, in Cooke, "Installing Arena," 17.

102. Von Graevenitz, "The Old and the New Initiation Rites," 69–71.

103. Ellmann, *James Joyce*, 1.

104. John Cage, *Writing Through Finnegans Wake* (Tulsa, OK: University of Tulsa Press, 1978), not paginated.

105. Stachelhaus, *Joseph Beuys*, 16. Cage had himself discovered Satie's *Vexations*, composed in 1893, while he was in Paris in 1949, several years after he had begun to be interested in Asian philosophy and music. *Vexations* was produced along with an instruction: "In order to play this piece 840 times the performer should prepare beforehand in deep silence and serious immobility." In 1963, Cage premiered a version of *Vexations* that was performed by eleven piano players, in shifts, for nearly forty-three hours between 6:00 P.M. on the evening of September 9 and 12:40 P.M. on September 11 (David Toop, *Ocean of Sound: Aether Talk, Ambient Sound and Imaginary Worlds* [London: Serpent's Tail, 1995], 199–200). The significance of Satie's work for Cage complicates the tendency to speak of Cage's work in the more simplistic terms of the introduction of "Asian" in general and Zen in particular into Western music. An example of this reductive approach to Cage's work is found in Alexandra Munroe's claim that "Suzuki's disciple John Cage was widely influential through creating and transmitting an alternative modernist aesthetic founded in Asian thought" (Munroe, "Spirit of YES: The Art and Life of Yoko Ono," 17). Though it is of course accurate to stress the importance for Cage of Asian thought in general and Suzuki in particular, Munroe's statement forgets that Cage had a range of eclectic sources, as many of them European as Asian.

106. Beuys, in Kort, "Joseph Beuys's *Arena:* The Way In," 32 n. 53.

107. Henning Christiansen, in ibid., 25.

108. Beuys, in Blume, "The Poetic Physics of the Multiples and Editions of Joseph Beuys," 23. In 1985 he recycled this same text, coupling it with a quick

loose sketch of a sled, as the multiple *Joyce mit Schlitten (Joyce with Sled)* (Kort, "Joseph Beuys's *Arena:* The Way In," 32 n. 52).

109. Jacques Derrida, "Two Words for Joyce," in Derek Attridge and Daniel Ferrer, eds., *Post-Structuralist Joyce* (Cambridge: Cambridge University Press, 1984), 156. Sarat Maharaj has suggested that "Duchamp's portmanteau words," Duchamp's love for what he called the "fabricated word," are of a piece with Joyce's own words "made up of language's leftovers," that each had the effect of unsettling the tongue into which his neologisms were sutured and injected, "disrupting its norms and unhinging its regimes of sense and style" (Sarat Maharaj, "'A Monster of Veracity, a Crystalline Transubstantiation': Typotranslating the *Green Box,*" in Buskirk and Nixon, eds., *The Duchamp Effect,* 85). In his "Two Words for Joyce," taking his cue from Joyce's phrase "he war," Derrida argues that what is at stake in Joyce's writing "is the contamination of the language of the master by the language he claims to subjugate, on which he has declared war" (Derrida, "Two Words for Joyce," 156).

110. Joyce, *Finnegans Wake,* 258.12.

111. Derrida, "Two Words for Joyce," 156.

112. For Cage's quoted term, see Richard Kostelanetz, *Conversing with Cage* (New York: Limelight Editions, 1988), 238.

113. Ibid., 153.

114. Gilles Deleuze, in Dana Polan, "Translator's Introduction," in Gilles Deleuze and Félix Guattari, *Kafka: Toward a Minor Literature,* trans. Dana Polan (Minneapolis: University of Minnesota Press, 2000), xxv.

115. Beuys, in Wright, "Statements from Joseph Beuys," *Joseph Beuys* (New York: Dia Art Foundation, 1987), 19.

116. Deleuze and Guattari, *Kafka: Toward a Minor Literature,* 28.

117. John Cage, "For the Birds," in Chris Kraus and Sylvère Lotringer, *Hatred of Capitalism/A Semiotext(e) Reader* (New York: Semiotext[e], 2001), 170.

118. Ann Temkin, "Joseph Beuys: Life Drawing," in Ann Temkin and Bernice Rose, eds., *Thinking Is Form: The Drawings of Joseph Beuys* (Philadelphia: Philadelphia Museum of Art; New York: Museum of Modern Art, 1993), 49, 50.

119. Cage, in Kostelanetz, *Conversing with Cage,* 183.

120. Temkin, "Joseph Beuys: Life Drawing," 49.

121. Cage, in Kostelanetz, *Conversing with Cage,* 151.

122. Joseph Beuys, "I Am Searching for Field Character," in Kuoni, *Energy Plan for the Western Man,* 21–23.

123. Joseph Beuys, "Interview with Willoughby Sharp," in Kuoni, *Energy Plan for the Western Man,* 87. Before Sharp posed his question, Beuys had just told him, "At the moment art is taught as a special field which demands the production of documents in the form of artworks. Whereas I advocate an aesthetic involvement from science, from economics, from politics, from religion—every sphere of human activity. Even the act of peeling a potato can be a work of art if it is a conscious act." Later on in this interview, he paired Korean artist Nam June Paik with Cage as his other important contemporary (87). It is important to note again that this discussion took place in 1969, when Beuys's friend Robert Filliou was compiling material for his 1970 publication *Teaching and Learning as Performing Arts.* This contained interviews with several of Filliou's artist friends, and Beuys and Cage were among them, which is perhaps what had put Cage in the forefront of Beuys's mind.

124. Blume, "The Poetic Physics of the Multiples and Editions of Joseph Beuys," 19.

125. Joseph Beuys, *Joseph Beuys: Words Which Can Hear* (London: Anthony d'Offay Gallery, 1981).

126. Uwe Claus, ed. *Joseph Beuys: Übersinnliches Gelächter—aus der Sammlung Ute & Michael Berger im Fluxeum Wiesbaden* (Wiesbaden-Erbenheim: Herausgegeben von Harlekin Art, 1998), 154-55, 189.

127. Klaus Staeck, ed., *Ohne die Rose tun wir's nicht: Für Joseph Beuys* (Heidelberg: Edition Staeck, 1986), 330-31.

128. As it is reproduced in Eugen Blume's essay "The Poetic Physics of the Multiples and Editions of Joseph Beuys," Cage's mesostic is rendered such that the following line, "Thoroughness like Water," appears to be the poem's first line rather than its title, thus losing the visual impact of the balanced cruciform effect of the original and also muddling its overall meaning (Blume, "The Poetic Physics of the Multiples and Editions of Joseph Beuys," 19).

129. Filliou, "Yes—an Action Poem," 8.

130. Yve-Alain Bois and Rosalind Kraus, *Formless: A User's Guide* (New York: Zone Books, 1997), 143.

131. Maharaj, "'A Monster of Veracity, a Crystalline Transubstantiation,'" 83.

132. See no. 59 in Lother Shirmer, ed., *The Essential Joseph Beuys* (Cambridge, Mass.: MIT Press, 1997).

133. As for example in Irit Rogoff, "The Aesthetics of Post-History," 123.

134. Beuys, quoted in Ichiro Hariu, "Revolutionary Actions," in Shizuko Watari, ed., *Joseph Beuys—Beyond the Border to Eurasia* (Tokyo: Watari-Um, 1991), 54.

135. Rogoff, "The Aesthetics of Post-History," 121.

136. Beuys, in Tisdall, ed., *Joseph Beuys,* 10.

137. See Maharaj, "'A Monster of Veracity, a Crystalline Transubstantiation.'"

138. Marshall McLuhan, "Joyce, Mallarmé, and the Press," in Eric McLuhan and Frank Zingrone, eds., *Essential McLuhan* (New York: Basic Books, 1995), 61.

139. Ibid., 61-62.

140. Beuys, "Life Course/Work Course," 261.

141. Tisdall, "Beuys and the Celtic World," 120.

142. Joyce, *Finnegans Wake,* 619.20-26.

143. Joseph Campbell and Henry Morton Robinson, *A Skeleton Key to Finnegans Wake* (New York: Harcourt, Brace and Co., 1944), 355.

144. Ibid., 365.

145. Ibid.

146. Joyce, *Finnegans Wake,* 628.14.

147. Friedrich Nietzsche, *Thus Spoke Zarathustra,* trans. R. J. Hollingdale (Middlesex, U.K.: Penguin, 1967), 336.

148. Friedrich Nietzsche, "What Is Religious?" *Beyond Good and Evil: Prelude to a Philosophy of the Future,* trans. Walter Kaufmann (New York: Vintage, 1989), 68, 68 n. 16.

149. Tisdall, "Beuys and the Celtic World," 120.

150. Campbell and Robinson, *A Skeleton Key to Finnegans Wake,* 365.

151. Tisdall, "Beuys and the Celtic World," 120.

## Entanglement

1. Lama Sogyal Rinpoche, *The Tibetan Book of Living and Dying* (San Francisco: Harper, 1992), 167–69. Beuys's first prototype for the *Fettecke/Fat Corner* was made in 1963. On April 28, 1982, when Lama Sogyal Rinpoche visited Beuys's atelier at the Düsseldorf Kunstakademie, Beuys made an improvised *Fat Corner for Room 3* and installed it in the upper corner of the room. See Wijers, *Writing as Sculpture,* 162–73.

2. Sogyal Rinpoche, *The Tibetan Book of Living and Dying* (San Francisco: Harper, 1992), 167–69. Other instances of this miraculous light body are found in Tibetan tales of enlightened beings; see Batchelor, *The Awakening of the West,* 95. References to this variety of transubstantiation also occur in the Western tradition. Jacques Barzun writes, "Salvation in the 16C[entury] and long after was understood as 'resurrection of the flesh.' The promise of the gospel was literal: the body would come into being again. As the learned told those who asked, St. Augustine had explained that the hair shed in life and the fingernails cut would be restored in full, though invisibly, in the new heavenly body" (Jacques Barzun, *From Dawn to Decadence: 500 Years of Western Cultural Life—1500 to the Present* [New York: HarperCollins, 2000], 25).

3. Sogyal, *The Tibetan Book of Living and Dying,* 167.

4. See the 1997 edition of Beuys, Beuys, and Beuys, eds., *Joseph Beuys: Block Beuys.* For the full edition, see Eva Beuys, Wenzel Beuys, and Jessyka Beuys, eds., *Joseph Beuys: Block Beuys* (Darmstadt: Hessiches Landesmuseum, and Munich: Schirmer–Mosel, 1990), 200.

5. Borer writes, "The meditative wealth provided by [Joseph Beuys's *Bicycle,* Venice, 1984] symbolizes his idea of the path to be taken, and as such represents the entire body of his work, to which in 1964 he gave the general title—with strong Buddhist overtones—of *vehicle-art*" (Borer, "A Lament for Joseph Beuys," 23).

6. "*Silnyen* is the Tibetan word for cymbals, which are held in the hands and played in pairs. There are two kinds of cymbals: the flat ones . . . which are held vertically and are played for peaceful practice, and the rounded ones (called *rolmo*) which are used in wrathful (energetic) practice and are held horizontally. Cymbals are generally played to a beat, to give percussive rhythm to a chant; but they are also played in a series of clashes and accelerating rolls, usually at the end of an offering or prayer. In this latter context, they symbolize the offering of pure music (Skt. *shabda*) to enlightened beings" (http://members.tripod.com/%7ELhamo/Nuns/KGmusic.htm#RealAudio [accessed January 2006]).

7. http://typo.kunstsammlung.de/en/collections/navi-k20-sammlungen/joseph-beuys/index.html (accessed January 2006).

8. http://www.p-g-a.org/lakshmi-shank.html (accessed September 21, 2010). In Indian mythology the conch connotes authority and power, and when sounded it was thought to dispel natural catastrophes, frighten away malevolent spirits and venomous creatures. For his part, Beuys had long been interested in the sculptural quality of sound and had conceived of the phenomenology of hearing as a sculptural event whose structure could be represented by the image of the spiral. In his 1979 series *Words Which Can Hear,* a block of ninety-two calendar drawings begun in 1975, Beuys wrote various words in spiraling layers, referencing the

shape of the cochlea, imaging the interpenetrating waves of sound and the cork-screwing movement of hearing.

9. Beuys, in Tisdall, ed., *Joseph Beuys,* 16.

10. Many critiques of the Beuys tale have been written, most notably Benjamin Buchloh's vitriolic "Beuys: The Twilight of the Idol—Preliminary Notes for a Critique," *Artforum* 18 (January 1980). For a balanced and thorough account of Beuys's changing relationship, over the course of his career, to this legend of his crash and rescue by the Tartars, see Peter Nisbet, "Crash Course: Remarks on a Beuys Story," in Gene Ray, ed., *Joseph Beuys: Mapping the Legacy* (New York: DAP, and Sarasota, Fla.: John and Mabel Ringling Museum of Art, 2001), 5–18. What is never remarked in the various accounts of and accountings for this important episode in Beuys's personal mythology is the commingling of signifiers of healing and food preparation—such that the two are virtually indistinguishable and functionally inextricable—at what would have been Beuys's first moment of awareness after awakening, however slightly, from his trauma. Though he sought to describe the commotion of a scene unfolding around desperate efforts to keep him alive, the first sentence in Beuys's account could just as well chronicle his and the Tartars' first meal together. Also crucial in Beuys's narration is the way that his body is not so much treated as it is kneaded and worked, smeared with fat, rolled in felt, *cured* in both the medical and the culinary senses of the word, baked back to health in a makeshift oven—producing, literally, a rising from death. And in Beuys's tale the healing scene has the same ending as would a certain kind of satisfying meal: it concludes with the enactment of communion in the sharing of food and the enmeshing of the guest in a palpable sense of kinship and belonging.

11. The thirteenth-century Mongols played an important role in the Beuysian imaginary, particularly early on in his work. As Wijers has noted, "From the beginning the work of Joseph Beuys has shown his interest in the ancient cultures of the Eurasian continent, and looking back at his oeuvre we can already discern some early connections with Tibet too. Several pieces refer to Genghis Khan, the Mongolian nomad leader who conquered large parts of Asia and Europe in the thirteenth century. The biography [*Life Course/Work Course*] of Joseph Beuys lists: 1929 Exhibition at the grave of Genghis Khan, 1958 Watercolour of Genghis Khan's daughter riding on an elk, 1960 Watercolour of Genghis Khan's daughter" (Wijers, *Writing as Sculpture,* 151). Gregory Ulmer refers to Beuys's "childhood fantasies about Genghis Khan (he carried a cane with him everywhere and imagined himself to be a nomad herdsman)" (Ulmer, *Applied Grammatology,* 234).

12. Many of these Kalmyks, rather than be forced to repatriate and thus have "to suffer Stalin's revenge," were permitted to settle in the United States, in Freewood Acres, New Jersey. Having established this community in exile, in 1955 the Kalmyks called upon an established Tibetan Buddhist monk and scholar, Geshe Wangyal, then in Sikkim, to be their religious leader. Geshe Wangyal was instrumental in the subsequent development of Tibetan Buddhist studies in America, counting Jeffrey Hopkins (who, as is discussed in chapter 3 of this book, served as translator for Louwrien Wijers's 1981 audience with the Dalai Lama) and Robert A. F. Thurman as his student. For a more thorough discussion of Geshe Wangyal and his pivotal role in the emergence of Tibetan Buddhist studies in American higher education, see Lopez, *Prisoners of Shangri-La,* 163–80, especially 163–65.

## 3. What Happens When Nothing Happens

1. Tisdall, ed., *Joseph Beuys.*

2. He was referring to Beuys's *7000 Oaks* project. Years later, after Beuys's death, in 1986, His Holiness was to support this project through the Tibetan Buddhist monastery Samye Ling in Scotland, which made an official purchase of seven oaks "commemorating Joseph Beuys, his *7000 Eichen* project, and his permanent cooperation with H.H. the Dalai Lama" (U We Claus, *Der Baum, der Stein* [Nordrhein-Westfalen: Stiftung Museum Schloss Moyland, 1998], 25-26).

3. Wijers, *Writing as Sculpture,* 156. As explained previously, Wijers's use of ". ." rather than the usual ". . ." has been preserved in quotations from this source.

4. H.H. the XIV Dalai Lama quoted ibid., 156.

5. For a thorough discussion of this performance, see Tisdall, *Joseph Beuys: We Go This Way.*

6. H.H. the XIV Dalai Lama, in Wijers, *Writing as Sculpture,* 156-57.

7. Louwrien Wijers, unpublished interview with the author, Amsterdam, February 2000.

8. Ibid.

9. Fernando Groener and Rose-Maria Kandler, *7000 Eichen—Joseph Beuys* (Cologne: König, 1987).

10. Details of this action come from a discussion with Beuys's former student U We Claus, who was present at and assisted Beuys in this action. U We Claus, discussion with the author, Wiesbaden, January 1999.

11. Beuys and Böll, "Manifesto on the Foundation of a Free International School for Creativity and Interdisciplinary Research," 149-53.

12. Joseph Beuys, "An Appeal for an Alternative," in *Documenta VII,* vol. 2 (Kassel: D&V Paul Dierichs GmbH und Co. KG, 1982), 370.

13. Wijers, *Writing as Sculpture,* 201. The capitalization of certain words in Wijers's text is intended to indicate correspondence between Beuys's ideas and the responses of the Dalai Lama to the questions Wijers asked him in their audience. For the transcripts of the 1981 audiences, see "His Holiness the Fourteenth Dalai Lama Talks to Louwrien Wijers," in Wijers, *Writing as Sculpture,* 96-117; for the transcript of a later audience on April 12, 1982, discussed below, see "His Holiness the Dalai Lama Reflects on Points from the Work of Joseph Beuys," in Wijers, *Writing as Sculpture,* 150-61.

14. Louwrien Wijers, *Joseph Beuys Talks to Louwrien Wijers* (Velp, the Netherlands: Kantoor voor Cultuur Extracten, 1980).

15. His Holiness the XIV Dalai Lama, *My Land and My People: The Original Autobiography of His Holiness the Dalai Lama of Tibet* (New York: Warner Books, 1997).

16. Wijers, *Writing as Sculpture,* 201.

17. Ibid.

18. Wijers, interview with the author, February 2000.

19. Louwrien Wijers, unpublished interview with the author, Amsterdam, January 1999. Earlier—in Beuys and Wijers's interview on November 4, 1981, of which more below—in considering the possibility of his meeting with the Dalai Lama and the idea that together they "could reach a very modern information on spiritu-

ality. At least one can think about a fantastic network, which has its roots in Asia." Beuys had said to Wijers, "Now we can realize Eurasia ... my old concept Eurasia"; see "Interview with Louwrien Wijers," in Kuoni, *Energy Plan for the Western Man,* 202. In her report on the Beuys–Dalai Lama meeting in her book *Writing as Sculpture,* Wijers drew from and elaborated a bit on this interview: "On his urge for a permanent co-operation with the Dalai Lama of Tibet Joseph Beuys remarked: 'In a co-operation with the Dalai Lama we can realize Eurasia. My old concept Eurasia . .'" (Beuys, in Wijers, *Writing as Sculpture,* 202). The notion of Eurasia and its place in Beuys's work is a vast and amorphous subject, and Wijers's essay looks only at one manifestation of it, namely, Beuys's meeting with the Dalai Lama. If there is a central component in Beuys's shape-shifting Eurasia puzzle, it takes the form of his often cited and more often misunderstood narrative of his rescue by nomadic "Tartar" tribespeople after the crash of his Luftwaffe airplane in the Crimean during the Second World War. For an incisive account of this tale, its changing function in the artist's career, and its comparatively monolithic treatment in the literature on Beuys, see Nisbet, "Crash Course: Remarks on a Beuys Story," 5–18.

20. Wijers, interview with the author, February 2000.

21. Beuys, in Wijers, *Writing as Sculpture,* 13.

22. See ibid., 28–59, 60–75, respectively.

23. Ibid., 16. A thorough discussion of the relationship between Beuys and Warhol is beyond the scope of this book. For an alternate perspective on their friendship, one that uses Warhol's diamond dust portraits of Beuys to suggest that Warhol's view of him was substantially more critical, see Terry Atkinson, "Warhol's Voice, Beuys's Face, Crow's Writing," in John Roberts, ed., *Art Has No History! The Making and Unmaking of Modern Art* (London: Verso, 1994), 156–79. Though Wijers's view of Warhol as a committed humanist is hardly shared by most accounts of his and his Factory's work, the important point here is that both Beuys and Wijers did indeed consider Warhol to have played a significant role in bringing about the meeting with the Dalai Lama and did not view the aims of Warhol's work to be anything but sympathetic to Beuys's own, however differently deployed and indirectly connected. Wijers's and Beuys's conception of Warhol challenges received notions of his work, which has implications that are impossible to pursue here. Warhol's name appears again in an interview between Beuys and Wijers on November 4, 1981—an interview that is included in Kuoni's *Energy Plan for the Western Man* in the form of a reproduction of an undated press release for Ronald Feldman Fine Arts in New York, where the interview had previously appeared. In this interview, after Beuys had said, "Now we can realize Eurasia . . . my old concept Eurasia," Wijers then asked, "Do you think that in a further stage Andy Warhol might want to cooperate?" to which Beuys replied, "I think so. I think he would be very interested in the moment when the Dalai Lama appears, being involved in such a kind of idea. Andy has always difficulties with this kind of political activities, because he works in another kind of world. . . . Also again when he was here last week, he is very interested to hear a lot of new information. He has a kind of observing sense in the back of his mind. So, he is always interested to follow the development, and there is really a kind of imaginative process going on, I think" ("Interview with Louwrien Wijers," in Kuoni, *Energy Plan for the Western Man,* 189). Strangely enough, this interview from November 4, 1981, is not

reproduced in *Writing as Sculpture,* though some of it is paraphrased there in Wijers's introductory comments preceding her transcript of the January 29, 1982, Beuys-Lama Sogyal meeting (Wijers, *Writing as Sculpture,* 135). Its absence is surprising given the detail and enthusiasm of Beuys's speculations about the possibility of meeting with the Dalai Lama as part of the programming for Documenta VII and his *7000 Oaks* project (Beuys, in Kuoni, *Energy Plan for the Western Man,* 183–90). In addition to this interview, Kuoni's *Energy Plan for the Western Man* includes two interviews that also appear in Wijers's *Writing as Sculpture.* The first is the January 29, 1982, "Conversation between Lama Sogyal Rinpoche and Joseph Beuys" (Wijers, *Writing as Sculpture,* 135–49; Kuoni, *Energy Plan for the Western Man,* 183–210—Kuoni's index erroneously gives the page numbers as 163–90). The second, "Interview with Louwrien Wijers," is a reproduction of the Wijers-Beuys interview from November 22, 1979 (Wijers, *Writing as Sculpture,* 134–49; Kuoni, *Energy Plan for the Western Man,* 215–58—again, Kuoni's index is incorrect, giving page 195 rather than page 215 as the start of this text).

24. See Wijers, *Writing as Sculpture,* 76–91; this is rumored to be the longest interview on record with the notoriously reticent Warhol.

25. Though these questions are not enumerated in her text, they appear to have included the following: "Do you think that there is a possibility for a one-world government in the near future, or in the future?" Another asked about the possibility of a unified Europe. The third and what Wijers says is "the last question I asked Andy Warhol, because he is working with people so much: 'Who are the most important people in the world right now?'" (Wijers, *Writing as Sculpture,* 92–95).

26. Ibid., 135.

27. Ibid.

28. According to Wijers, when Filliou planned his trip to Amsterdam in 1981, a friend of his, one of the members of the Canadian collective Western Front, said, "'I'll give you the address of Louwrien, you should meet her.' And Robert said, 'I don't need an address. I will meet her.' Anyway, he did take the address, but he said, 'If I am supposed to meet her, I'll meet her.' Okay: there was a meeting of IACA, International Art Critics, you know? So I was sitting next to somebody. He said, 'Aha!' Robert Filliou was sitting [next to me]. He said, 'You must be Louwrien!' I said yes. So that is how we came together. It was just ... I had no idea I was sitting next to Robert, at that time. [ ... ] So the next day, we immediately said, 'Okay, let's meet, we must make an interview, we should do things,' and then that Sunday morning, Marianne and Robert came here [to Wijers's home]. I made them breakfast, and we didn't ... I was macrobiotic, so I thought, I cannot make them macrobiotic, they will not like it. So I went to the shops to buy normal food. And they kept looking at the plate and nobody touched anything! And then they said, 'We are macrobiotics too!' It was very nice, a very nice meeting with Robert. Lovely" (Louwrien Wijers, unpublished conversation with the author, October 2004).

29. Wijers, *Writing as Sculpture;* for Beuys's talk with Lama Sogyal Rinpoche in January 1982, see 134–39; for Wijers's talk with Filliou in October 1981, see 126–33; for Lama Sogyal Rinpoche's visit to Beuys's atelier in April 1982, see 162–73.

30. Wijers, *Writing as Sculpture,* 200–221.

31. Ibid., 226–31.

32. These conferences are discussed in more detail below. *Writing as Sculpture* was published in English in 1996, and the original German edition had come out in 1987. This locates the book somewhere in between the Art-of-Peace Biennale and the still only partly conceived AmSSE project.

33. All details of the meeting come from my unpublished interviews with Louwrien Wijers in Amsterdam, Holland, in January 1998, January 1999, and February 2000.

34. From a letter to the author from Tsering Dorje, now an official at the Tibet Office in Switzerland, dated January 13, 1999. In response to my first inquiry, sent to the Office of His Holiness the Dalai Lama in Dharamsala in early October 1997, Deputy Secretary Tenzin N. Takhla replied, "I am sorry to inform you that we do not have any information about this meeting or this person. You may want to try to contact our office in Geneva which would have been in charge of organizing His Holiness' visit to Bonn in 1982. They may have some information for you. Sorry for not being able to help" (letter to the author from Tenzin N. Takhla, October 29, 1997). I wrote a second letter to the Office of His Holiness the XIV Dalai Lama in Dharamsala nearly two years later, presenting all of the facts I had gathered regarding the dates, those present, and so forth. The reply came again from Mr. Takhla: "I am sorry to inform you that we do not have any information about the audience. Actually, His Holiness meets with literally hundreds of people during his visits and unfortunately, no records were kept of His meetings with people during any of the visits in the early '80s. We do hope you will understand our position" (letter to the author from Tenzin N. Takhla, December 26, 2000). Though all of my letters—as well as the penultimate draft of this chapter, as recently as 2007—have been addressed to His Holiness himself, it is of course unlikely that any of them will have actually made it into his hands; none of the letters sent since 2001 has received reply.

35. In his *Awakening of the West*, Stephen Batchelor writes of the Dalai Lama's "unofficial" visit to East Germany on the eve of the fall of the Berlin Wall to meet with the temporary radical East German government; Batchelor's source for this information, Petra Kelly, the German Green Party cofounder (as was Beuys), told him that "both the Dalai Lama and the aspiring government were deeply moved by the meeting. But she also remembers the nervousness of his staff, some of whom wanted to cut the meeting short and hasten back to the safety of the West." Batchelor continues: "Petra's respect for the Dalai Lama often clashes with her frustration with his political advisors, whom she considers reactionary and ill-informed. The [Dalai Lama's] autobiography's failure to mention the meeting with the Citizen's Action Movement might simply reflect a concern of the Dalai Lama's staff that His Holiness be associated with a failed political movement" (Batchelor, *The Awakening of the West*, 375-77). On Beuys's involvement with the Green Party in Germany, see Lukas Beckmann, "The Causes Lie in the Future," in Ray, ed., *Joseph Beuys: Mapping the Legacy*, 91-111, which includes a photo of Beuys and Kelly cozied together at a press conference in Germany in 1984 (see 106).

36. All details of the discussion between Beuys and the Dalai Lama and of the subsequent discussions later that day in Bonn, apart from those taken from *Writing as Sculpture*, come from my unpublished interviews with Louwrien Wijers, Amsterdam; in this case the account comes from an unpublished interview with the author, Amsterdam, January 1998.

37. Wijers, *Writing as Sculpture,* 201.

38. See note 2 above.

39. For a discussion of His Holiness's five-point plan for a negotiated settle-
ment with China, which was instrumental in his being awarded the Nobel Peace
Prize in 1989, see John Powers, "Human Rights and Cultural Values: The Political
Values of the Dalai Lama and the People's Republic of China," in Damien V. Keown,
Charles S. Prebish, and Wayne R. Husted, eds., *Buddhism and Human Rights*
(Richmond, Surrey, U.K.: Curzon Press, 1998), 185; on China's colonial presence
in Tibet and the ongoing attempts to arrange a meeting between the Dalai Lama
and the Chinese government, see *China's Tibet—the World's Largest Remaining
Colony: Report of a Fact-Finding Mission and Analyses of Colonialism and Chi-
nese Rule in Tibet* (Amsterdam: Unrepresented Nations and Peoples Organiza-
tion, in cooperation with Tibet Support Groep Nederland and the International
Campaign for Tibet, 1998); on the changes in Tibetan cultural politics since the
Chinese invasion of 1959, viewed with particular attention to the visual culture of
the Tibetan community in exile, see Clare Harris, *In the Image of Tibet: Tibetan
Painting after 1959* (London: Reaktion Books, 1999).

40. For a partial list of those present, see Wijers, *Writing as Sculpture,* 204.

41. Ibid.

42. Wijers, interview with author, February 2000.

43. Recall Filliou's steps toward a Poetical Economy discussed in chapter 1's
section "Fray," above.

44. This was the Art & Brain conference in Jülich, November 1994.

45. Filliou had long been interested in the relationship between considerations
of "lifestyle" (including food, health, and religious or spiritual practice) and art
making. Over a decade earlier, in his *Research at the Stedelijk,* he had written,
"The most interesting artistic research going on now is research into ways of liv-
ing. However, this most important art form is now outside the field of regular art
information. I think museums should subsidize it, make it known. They could do
it by getting + showing information on experiments—private and public—that
go on everywhere—the art circuit will follow. Art that makes only references to
art is in trouble" (Filliou, *Research at the Stedelijk, 5 november t/m 3 december,*
not paginated).

46. Filliou, in Wijers, *Writing as Sculpture,* 205.

47. Ibid.

48. Ibid., 204.

49. Ibid. In her unpublished lecture notes for her talk on April 7, 1995, at the
Considering Joseph Beuys symposium at the New School for Social Research, New
York, Wijers mentions that she had "invited the oldest Hopi Indian lady, Carolyn
Tawangyowma to refer to Coyote 1974 [*I Like America and America Likes Me*]
and the US." It is interesting to note that, in his discussion with Tawangyowma in
the hotel café that day, Beuys made a show of demanding answers from her that
would have the concreteness that he himself had been unable to provide to His
Holiness: "As a practical question from me, how can we help? How can we sup-
port your aims?" (Beuys, ibid., 208).

50. Ibid., 204.

51. Ibid.

52. Thanks to Geoff Hendricks for pointing out the importance of this connection between Beuys's notion and the Nazi dreams of a Eurasia; for a short discussion of the Nazi's infatuation with their Aryan roots that might be hidden and preserved in Tibet, see Alex McKay, "Hitler and the Himalayas: The SS Mission to Tibet 1938–39," *Tricycle* 10, no. 3 (Spring 2001): 64–68, 90–93.

53. Molina, in Wijers, *Writing as Sculpture,* 204.

54. Beuys, ibid.

55. Ibid.

56. Beuys and Filliou, ibid., 204–5.

57. Wijers, *Writing as Sculpture,* 210.

58. Wijers, interview with the author, January 1999.

59. Jean-Paul Sartre, *Nausea,* trans. Lloyd Alexander (New York: New Directions, 1964), 14.

60. Wijers, *Writing as Sculpture,* 210.

61. Wijers, interview with the author, February 2000.

62. Ibid.

63. Ibid.

64. Walter Benjamin, "The Work of Art in the Age of Mechanical Reproduction," in Hannah Arendt, ed., *Illuminations,* trans. Harry Zohn (London: Fontana Press, 1992), 211–44, quotation from 214.

65. Susan Stewart has noted that the ordinariness of "the everyday and its concomitant languages, inhabitants, and temporalities" permits it to be employed to fill "at least two" functions: to "quantitatively provide for history" and to "qualitatively provide for authenticity" (Susan Stewart, *On Longing: Narratives of the Miniature, the Gigantic, the Souvenir, the Collection* [Durham, N.C.: Duke University Press, 1996], 14). For an encounter or event to have a chance at being authentically extraordinary, it must be subjected to experiment in the real-time laboratory of the everyday.

66. Wijers's *Writing as Sculpture* is the only publication to cover it in any detail. Apart from the reproduced interviews in Kuoni's *Energy Plan for the Western Man,* mentioned above, and other lesser-known prior publications of the same material by Wijers, such as her *His Holiness the Fourteenth Dalai Lama Talks to Louwrien Wijers,* and her revisitings of the meeting as an impetus for her later projects in the introduction to Wijers, ed., *Art Meets Science and Spirituality in a Changing Economy: From Competition to Compassion* (London: Academy Editions, 1996), little discussion can be found elsewhere of any part of the Beuys–Dalai Lama meeting or any of the events leading up to it. However, Terry Atkinson's essay "Beuyspeak," though it does not mention the Beuys–Dalai Lama meeting itself, does speak of the Beuys–Lama Sogyal talks (169). (Unless otherwise indicated, citations to Wijers's *Art Meets Science and Spirituality* are from the 1990 edition.)

67. The relationship between contemporary Western artists and Tibetan Buddhism is a subject that has seen little discussion by art historians, even in comparison to the relatively few substantive considerations of Zen Buddhism's influence upon contemporary artists, but a thorough treatment of this topic is well beyond

the scope of this book. In addition to the interviews in *Writing as Sculpture,* see also Robert Filliou's conversation with Wijers about his and Marianne's practice of Tibetan Buddhism, in "Robert Filliou Talks about Dharma and His Work as an Artist," in Wijers, *Writing as Sculpture,* 126–33; see also John Cage's discussion of the Tibetan Buddhist saint Milarepa in his interview with Robert Filliou in *Teaching and Learning as Performing Arts,* 116. Most of the serious treatments of the role of Buddhism in general in Western arts appear in discussions of Fluxus and the artists associated with it. An important source here, one that focuses primarily upon Zen Buddhism, is Doris, "Zen Vaudeville"; see also Ken Friedman's discussion of the parallels between Fluxus and Buddhism, in "Fluxus and Company," *The Fluxus Reader,* 237–53, especially 246. The list of accounts of artists for whom Zen Buddhism has played a significant role in their practice is too vast for enumeration here; for accounts of two of the artists most credited with the introduction of Zen Buddhism into postwar Western art, John Cage and Yoko Ono, see Kostelanetz, *Conversing with Cage;* and Munroe, "Spirit of yes: The Art and Life of Yoko Ono," 11–37.

68. Sartre, *Nausea,* 1–2.

69. Beuys, in Wijers, *Writing as Sculpture,* 227.

70. Ibid., emphasis added.

71. In his January 29, 1982, discussion with Lama Sogyal Rinpoche, Beuys made a case for the depth of his spiritual concern for Tibet, one that combined a desire to make a personal connection with this Tibetan lama, on what Beuys may have presumed to be the proper terms, with a strange mix of surface understanding of tantric practice (perhaps gleaned through discussions with Filliou or Wijers) and a deep but oddly misplaced understanding of anthroposophy: "My personal relationship to these plans is an interest in the Buddhist philosophy as a special personal fate. . I could say that I am a friend of the tantric intention, and . . I could say that . . from the point of view of my astral body I was already in Tibet. . I won't speak about incarnation and reincarnation, which is also a necessity to bring to the people, in order to come to another understanding of the values of life and death . . and death and life . . and again. . The Free International University is an organisation that has a lot of offices in Germany, in the Netherlands, in England, Scotland, South Africa, Scandinavia, and so on. . I think, what we should do . . is not to make a little thing. . It should be a big . . a great idea." Lama Sogyal: "I agree with you." Beuys continued: ". . that has the kind of will power that will bring about some new spiritual intention on this planet firstly . . not to speak about other planetarian states in the future . . other later states of the planetarian unit. . For that the necessity is, in my understanding, to prepare a kind of living body on this planet, which could transform towards future existences. . Maybe this is my first sentence" (Beuys and Lama Sogyal Rinpoche, in Wijers, *Writing as Sculpture,* 136). On Beuys's discussion of his prior "visitations" from the astral plane, see Joseph Beuys and Peter Brügge, "Mysteries Happen in the Main Railway Station, Düsseldorf, May 10, 1984" (an interview, 1984—originally printed in *Der Spiegel* 23 [1984]), in Bastian, ed., *Joseph Beuys—Editions,* 37–38.

72. Beuys, in Wijers, *Writing as Sculpture,* 228.

73. Ibid.

74. Ibid.

75. Who this "they" and "them" are remains unclear, but these pronouns seem to refer to those supporting the establishment of Tibetan Buddhist centers in the West. Given Beuys's commitment to education and dialogue, his lack of interest in supporting such initiatives is surprising. This comment is likely more of a frustrated blow, not at the Dalai Lama himself, but at certain members of his entourage: "venerable persons."

76. Beuys, in Wijers, *Writing as Sculpture*, 231.

77. Ibid.

78. Many of Beuys's supporters have argued for such parity; the cultural industry that has been built up around Beuys's afterlife certainly benefits by his comparison to a figure of the Dalai Lama's prominence. Thanks to Ken Friedman for pointing out this important detail.

79. Beuys, in Tisdall, *Joseph Beuys: We Go This Way,* 44.

80. Beuys's intuitive connection of Brecht and Buddhism is as suggestive as it is underdeveloped. It is precisely this connection that Stephen Batchelor explores in his inquiry into what Buddhism can offer in its encounter with, and its transformation both of and by, Western culture. He argues against a notion of Buddhism as a kind of spiritual technology that must be imported with its ritual trappings intact and applied uncritically by its adherents. For him, the most productive way for the West to approach the encounter with Buddhism is in terms of a kind of "existential, therapeutic, liberating agnosticism" (Batchelor, *Buddhism without Beliefs: A Contemporary Guide to Awakening* [London: Bloomsbury, 1998], 15). This attempt to think of the connection between Buddhism and Western thought and culture in terms of a critical existentialism has been the central current in Batchelor's writing. See Stephen Batchelor, *Verses from the Center: A Buddhist Vision of the Sublime* (New York: Riverhead Books, 2000); *The Awakening of the West; The Faith to Doubt: Glimpses of Buddhist Uncertainty* (Berkeley, Calif.: Parallax Press, 1990); and especially his *Alone with Others.* This approach has led to a mixed reception from the Buddhist community; Bhikku Bodhi has expressed the concern of many in the Buddhist (and Buddhist studies) establishment in cautioning, "Batchelor is ready to cast away too much that is integral to the Buddha's teaching in order to make it fit in with today's secular climate of thought" (Ven. Bhikku Bodhi, "Review of *Buddhism without Beliefs: A Contemporary Guide to Awakening," Journal of Buddhist Ethics,* issue 5, www.gold.ac.uk/jbe/5/batch1.html, 1998, 3 [accessed February 1998]).

81. Wijers, interview with the author, January 1998.

82. A preliminary version of AmSSE had been planned for Amsterdam in December 1987, as a continuation of the 1985–86 Art-of-Peace Biennale in Hamburg, of which more below, with Art Meets Science and Spirituality as a kind of subtitle. A third Art-of-Peace Biennale had tentatively been planned for 1989, in "Oslo (or London or wherever)." In fact the 1990 Amsterdam AmSSE conference was the first to be realized. These details are mentioned in the last letter (undated) that Filliou sent to Wijers before he and Marianne began their retreat. Unless otherwise noted, all details regarding the planning of these events come from Louwrien Wijers's personal papers.

83. Filliou's reference is to Benson's *The Peace Book,* first published in 1980, an illustrated tale of a young boy whose refusal to understand why the leaders of the world persist in preparing for and thereby ensuring war ultimately leads the leaders and their people to understand the collective lunacy with which we allow ourselves to go on living. The boy's innocent questions ultimately lead him to succeed in his quest for peace, as we are told in the introduction, where a group of children asks a storyteller what "Peace Day" is and how the world came to celebrate it. "Sit quietly and I'll tell you, 'cause without it ... or what lies behind it, you wouldn't be here, nor would I!" (Bernard Benson, *The Peace Book* [New York: Bantam Books, 1982], 8–9). It is interesting to note the closeness between the style of Benson's writing and Filliou's writing style in his letters to his fellow artists. Toward the end of *The Peace Book,* the little boy produces a handwritten letter whose words could equally have come from one of Filliou's Art-of-Peace invitations: "Protecting ourselves from our neighbours is the path of Arms and leads to WAR! Protecting our neighbours from *ourselves* is the path of disarmament, and leads to *PEACE*" (179).

84. Robert Filliou, unpublished invitation to AmSSE, May 1987. Filliou sent Wijers the text from his retreat so that she might share it with the organizing group (which went by the names "Kuratorium" as well as "Study Group"), along with a letter to her, dated May 13, 1987. In it, he told her that she should decide whether "the invitation should be signed by name, or merely from 'a fellow artist'—from here, it's difficult to realize whether there is a need of personalization or not." For the final version of this invitation, see Wijers, *Writing as Sculpture,* 272–73.

85. Here Filliou inserted the following footnote: "The War/Peace duality (peace being defined as the absence of war, and vice-versa) is the product of restless minds. Hovering above is peacefulness. 'You cannot have a peaceful world without having a peaceful mind,' the 14th Dalaï Lama reminds us. Intuition tells us he is right. How can we achieve peaceful minds? I believe in asking those who know, and live according to, the true nature of mind: living masters of perennial Wisdom like, in the Tibetan tradition for example, H.H. the Dalaï Lama himself, H.H. Dudjom Rinpoché, H.H. Khyentze Rinpoché, Kalu Rinpoché, and so on" (Filliou, in René Block, ed., *Zugehend auf eine Biennale des Friedens* [Hamburg: Woche der Bildende Kunst, 1985], 6, 7 n. 3).

86. Here Filliou inserted the following footnote: "Yes, intuition tells us, provided the age-long fatalistic advice 'if you want peace, prepare for war' is dropped in favor of the realistically authentic 'if you want peace, prepare for peace'" (Filliou, ibid., 6, 7 n. 4).

87. Filliou, ibid., 6. Here Filliou inserted the following footnote: "Intuition tells us that science cannot provide answers to questions its very applications have raised, like the ones related to bio-engineering, artificial intelligence, 'star wars,' etc. ... without going back to its roots in intuitive wisdom. This probably applies as well to fundamental theoretical breakthroughs" (Filliou, ibid., 6, 7 n. 5); for the full text of Filliou's proposal, see ibid., 6–7.

88. Filliou, unpublished draft of "FROM LASCAUX INTO SPACE: An Instant Trip," November 1983, from archive of Louwrien Wijers, Amsterdam.

89. Richard Kostelanetz and David Cole, comps., *Eleventh Assembling: Pilot Proposals* (Brooklyn: Assembling Press, 1981). Kostelanetz and Cole refer to them-

selves as compilers rather than editors; no contribution was refused, and the only reason that the arrangement is not purely alphabetical is that late submissions were all placed at the end of the volume.

90. Letter from Filliou to the European Space Agency, European Space Operation Center, Darmstadt, Germany, February 15, 1983, in archive of Louwrien Wijers, Amsterdam.

91. Apparently Emmett Williams was not aware of this visit when, in his 1985 introductory lecture to the Art-of-Peace Biennale, he said, "The European Space Operation Center in Darmstadt took the matter lightly, one supposes. Lighter, certainly, than Robert took it. In any case, there was no reply. Yet I cannot but wonder, as I look out into this packed auditorium, if some solitary somebody from the Space Center is out there listening, if not from conviction, then simply out of curiosity. Yes, welcome to the Fly-in!" (Williams, in Block, ed., *Zugehend auf eine Biennale des Friedens*, 14).

92. For her record of the Other Realities conference and her interviews with its participants, see Wijers, *Writing as Sculpture*, 233–55. Scientists Rupert Sheldrake, David Bohm, Francisco Varela, and Fritjof Capra took part, as did the Dalai Lama, who officially opened it.

93. Louwrien Wijers, in Wijers, ed., *Art Meets Science and Spirituality in a Changing Economy*, 19–20.

94. In her notes, Wijers lists two functions of the 1984 preview: a meeting (1) "where artists will be regarding peace" and (2) "where Lama Sogyal Rinpoche will guide the art and tantra project for which a museum space and funds are needed." The art and tantra project seems not to have emerged as a reality before the 1990 AmSSE project, in which Lama Sogyal participated. In her notes, she lists George Brecht, "American artist, scientist, lives in Köln, former student of John Cage," as a key figure in the genealogy of the project. She mentions specifically his 1982 *Freedom in Art* project: "How about drawing common law prisoners into the mail art/ telefax network, making it available to them. Simply from now on include in your mailing lists your fellow women and men prisoners, publish their contributions alongside others." In her collection of notes is the following early fragment of a draft, which appears to have been cowritten by the committee: "The Art-of-Peace Biennale proposes international gatherings where artists from all countries and all arts are meeting with scientists (Rupert Sheldrake, David Bohm, Francisco Varela and Fritjof Capra) and with accomplished spiritual masters (the Dalai Lama, Lama Sogyal, Raimon Panikkar) contributing to the weaving back together of the three threads of art, science and wisdom into a new tradition, a 'nouvel art authentique' let's say. Kunstverein Hamburg, the Biennale de Paris delegation and the Stedelijk/ Fodor Museum have offered Art-of-Peace Biennales. A full-fledged biennale with many artists invited, thousands of proposals explored cannot be organized without trials" (from Wijers's unpublished notes for AmSSE). Wijers kept these notes together with her extensive annotations to Filliou's *Teaching and Learning as Performing Arts*.

95. In her introduction to the catalogue for the 1990 AmSSE conference, Wijers notes that "no fewer than 391 artists from thirty-three countries" attended (Wijers, *Art Meets Science and Spirituality in a Changing Economy*, 20). In this introductory essay, she notes that it was Dr. J. R. M. van den Brink, the former minister of economic affairs in the Netherlands and subsequently the director of AMRO Bank,

who added "the element of current economics" to the discussions of art, science, and spirituality. Van den Brink had told her, "The dialogue will open people's eyes to the necessity of a broader framework. Currently, the biggest problem is that the globalization of the economy is considerably ahead of the globalization of policy frameworks, which should be based on world-wide cultural awareness. In that case an unbridled competitiveness is going to reign, which is what is happening right now. I fully agree with Joseph Beuys that the true capital is human creativity. This applies to art, science, spirituality, but also to economy. For the businessman, market signals are the dabs of paint on his palette" (J. R. M. van den Brink, in Wijers, *Art Meets Science and Spirituality in a Changing Economy*, 22).

96. This was Beuys's *Klavier, Telefon, Sauerstoff-Flasche*, 1985.

97. Wijers, unpublished interview with the author, Amsterdam, February 2000.

98. The word *spiritual* here is crossed out with *tradition* replacing it, in Filliou's handwriting.

99. Michio Kushi is referred to in Filliou's final 1987 Art-of-Peace Biennale invitation as a "Ying Yang philosopher/therapist/food expert"; Wijers had hoped to invite him to the 1990 AmSSE conference but was discouraged from doing so by John Cage, who told her that Kushi was so devoted to the Kushi Institute that he would leave the proceedings at the drop of a hat to return to the Berkshires if anything were to go even slightly wrong there while he was participating in the conference. The Kushi Institute is the world's foremost macrobiotic educational center, founded in Becket, Massachusetts, in 1978 by Michio and Aveline Kushi. It seems that Kushi had been a choice for the biennale but because of budget restrictions could not be invited; nor could "such precursoring scientists as Bernard Benson, Fritjof Capra, Rupert Sheldrake, philosopher of science Raymond Ruyer, Francisco Varela, Hubert Reeves, David Bohm, René Thom . . . together with master of meditation Sogyal Rinpoche" (Wijers, *Writing as Sculpture*, 273). Sheldrake, Capra, Bohm, Varela, the Dalai Lama, and Lama Sogyal Rinpoche all took part in the 1990 AmSSE conference. The details of the 1990 conference are too complicated to discuss here; for transcripts of these dialogues, see Wijers, ed., *Art Meets Science and Spirituality in a Changing Economy* (1996). For transcripts of interviews with all of the participants, as well as others who, like Cage, took part in the project but did not attend the conference itself, see the earlier and less thorough Wijers, ed., *Art Meets Science and Spirituality in a Changing Economy* (1990). The tapes from the 1996 AmSSE conference in Copenhagen have yet to be transcribed.

100. The word *religion* is here crossed out with *wisdom* added in its place, again in Filliou's handwriting.

101. Here the following footnote is inserted: "previews only, for a full-fledged Biennale, with many artists invited, thousands of proposals explored, realized or sampled, cannot be organized without trials (and errors). Hence our request for advice and comments."

102. Here the following footnote is inserted: "*Tradition masters might be asked* what is peace? What is the relationship between inner and outer peace? Is peace something to attain or a state (of mind?) to go back to? In other words, is the irresistible movement towards unity forward or backward? passive—a prayer—or active—a tangible goal—? . . . *Scientists might be asked* if peace is a meaningful concept in a world of strife where aggressivity seems to be at the root of the grati-

fication of the twin hungers (for food and sex), and where the growth of science itself (and of technology and material 'progress') is based upon competition and conflict. Is the age-long state of neither-total-peace neither-total-war we live in the only middle way opened to humanity, between mass suicide and utopic dream? … *Artists might be asked* what peace is for. What would a peaceful world (galaxy) look like? What is the architecture of peace? The Music? etc.…War, as Jean Renoir saw it, is 'la grande illusion.' Isn't peace 'the great abstraction'? WHAT SHAPES PEACE? What are we for is the question, not what we are against. We know everybody is against war. But what are we for? Peace? What form would you give to peace? …And so on. Let's hope some sort of synthesis will arise. It might, or it might not. We'll see. It's worth trying, we think. Do you?"

103. Here the following footnote is inserted: "this is 1 way to start working together. This is 1 way to send artists into space, pending the real thing."

104. This appears to be the date and location settled upon for what Wijers referred to above as the 1984 Amsterdam "preview."

105. Here the following footnote is inserted: "For our guidance—and bibliography—do you know of some contemporary contributions to an art of peace we should know about (for inst., Terry Riley's *A Rainbow in Curved Air,* the 1980 *Art and Survival* Berlin meeting, Lili Fischer's *Peace Trees,* Clemente Padin's *Pan/ Paz,* Emmett Williams' *white for governor wallace,* Keinholz's *Idaho Peace Sculpture,* etc.…, etc.…)."

106. Final annotated draft of the first *Towards an ART-OF-PEACE Biennale* newsletter, not dated, courtesy of Louwrien Wijers.

107. Wijers, ed., *Art Meets Science and Spirituality in a Changing Economy,* 12.

108. Ibid.

109. Williams, in Block, ed., *Zugehend auf eine Biennale des Friedens,* 12.

110. Ibid.

111. Henry Martin, "Fluxus and the Humanistic Tradition," in Sandro Solimano, ed., *The Fluxus Constellation* (Genoa: Museo d'Arte Contemporanea di Villa Croce & neos edizioni, 2002), 71–77, quotation from 75.

112. Ibid.

113. Williams, in Block, ed., *Zugehend auf eine Biennale des Friedens,* 13.

114. For details of this conference and its participants and proceedings, see Wijers ed., *Art Meets Science and Spirituality in a Changing Economy.*

115. Wijers, unpublished interview with the author, Amsterdam, February 2000. It is possible that Block's idea for the fax project came from George Brecht's 1982 *Freedom in Art* project. At the end of the 1990 AmSSE catalogue, the names are listed of all of the artists who participated in the art initiatives; the fax project is not mentioned specifically. For the full listing of participants in the Fodor Museum show (which included General Idea, Tim Rollins and K.O.S., and many others) see Wijers, ed., *Art Meets Science and Spirituality in a Changing Economy,* 416–21.

116. In all of her writings on the AmSSE conferences, Wijers speaks of the import of the Beuys–Dalai Lama meeting. See ibid., 11–12 (this publication also contains a poem John Cage wrote specifically for AmSSE, titled "Overpopulation and Art," 14–21); Wijers, *Writing as Sculpture,* especially 7–10; and Wijers's introduction to *Art Meets Science and Spirituality in a Changing Economy,* 10–23.

117. Of this yet-unrealized AmSSE in New Zealand, she says, "I am hoping that the Dalai Lama will come. . . . What I don't like about Art Meets Science as it is working now is that it is too white and too Western. So for the first time I will have a chance to bring in the indigenous people. And they have been hoping to meet the Dalai Lama for a long, long time" (Wijers, interview with the author, January 1998).

118. Wijers, interview with the author, February 2000. From November 20, 1996, to January 19, 1997, a show titled *discord. sabotage of realities,* whose promotional material portrayed it as a reincarnation of Filliou's Art-of-Peace Biennale, was organized as part of the 1996–97 Week of Visual Arts in Hamburg, also at the Kunstverein and the Kunsthaus. The project argued that since "utopian and moral expectations no longer stand in the foreground of the art-scape," a contemporary engagement with questions of peace on the part of artists would need to be able "to visualize increasingly unpeaceful realities. It should intervene in existing structures, and expose mistaken handlings of private, social and political realities so that they can be experienced in a suggestive or reflexive way" (http://www.v2.nl/~arns/Archiv/Discord/concept.html [accessed September 27, 2002]).

119. Here she is paraphrasing her discussion with the Dalai Lama from April 2, 1982; see Wijers, *Writing as Sculpture,* 159.

120. Wijers, interview with the author, February 2000.

121. Louwrien Wijers, "A Practical Outline for the Compassionate Economy," unpublished paper, 2005. In September 2002 Lama Doboom Tulku, director of Tibet House, Cultural Centre of His Holiness the Dalai Lama in New Delhi, organized a lecture by Professor Menshikov as well as a seminar on Compassionate Economy in cooperation with the India International Centre. In September 2002, at the behest of the Dalai Lama and with Wijers's participation, Lama Doboom Tulku, director of the Tibet House in New Delhi, organized a lecture by Menshikov titled "Compassionate Economy Has a Future," followed by a seminar on the Compassionate Economy project in cooperation with the India International Centre. Seminar participants were Dr. L. C. Rain, Dr. Jairam Ramesh, Dr. Larissa Klimenko-Meshikova, Dr. Ravindra Varma, Professor Krishna Nash, Dr. B. B. Bhattacharya, Professor Naushad Ali Azad, Dr. N. Chandra Mohan, Menshikov, and Wijers. Both events took place at the India National Centre in New Delhi. A full discussion of this complex project, currently in its early stages, is outside the scope of this book.

122. Stanislav Menshikov and Louwrien Wijers, from a not-yet-published dialogue in the forthcoming book *Compassionate Economy.*

123. Powers, "Human Rights and Cultural Values," 196.

124. "When you recognize that all beings are equal and like yourself in both their desire for happiness and their right to obtain it, you automatically feel empathy and closeness for them. You develop a feeling of responsibility for others: the wish to help them actively overcome their problems. True compassion is not just an emotional response but a firm commitment founded on reason. Therefore, a truly compassionate attitude towards others does not change even if they behave negatively" (H.H. the XIV Dalai Lama, speech for the "Forum 2000" conference, Prague, September 1997, http://www.tibet.com/dl/forum-2000.html [accessed June 2008]).

125. Ibid. For the most comprehensive collection of essays on the topic of Buddhist ethics and human rights, see Keown, Prebish, and Husted, eds., *Buddhism and Human Rights.*

126. Jay L. Garfield, "Human Rights and Compassion: Towards a Unified Moral Framework," in Keown, Prebish, and Husted, eds., *Buddhism and Human Rights,* 111.

127. H.H. the XIV Dalai Lama, in Wijers, *Writing as Sculpture,* 124–25.

128. Barrington Moore Jr., *Reflections on the Causes of Human Misery and upon Certain Proposals to Eliminate Them* (Boston: Beacon Press, 1973), 11.

129. Ibid.

130. Irit Rogoff, *Terra Infirma: Geography's Visual Culture* (London: Routledge, 2000), 3.

131. Mohandas K. Gandhi, *An Autobiography: The Story of My Experiments with Truth,* trans. Mahadev Desai, foreword by Sissela Bok (Boston: Beacon Press, 1993), 70.

132. Ibid., 504.

133. Garfield, "Human Rights and Compassion," 111.

134. His Holiness the XIV Dalai Lama, *Ethics for the New Millennium* (New York: Riverhead Books, 1999), 20.

135. Ibid., 22.

136. Ibid.

137. Ibid., 23. The privileging of the spiritual does not imply that "all we need to do is cultivate spiritual values and [all of the other problems of the world] will automatically disappear. On the contrary, each of them needs a specific solution. But we find that when this spiritual dimension is neglected, we have no hope of achieving a lasting solution" (ibid., 24).

138. Jean-Luc Nancy, *Being Singular Plural* (Stanford, Calif.: Stanford University Press, 2000), xiii. Irit Rogoff draws upon Jean-Luc Nancy's conception of compassion in her blog essay "WE: Collectivities, Mutualities, Participations" (http://theater. kein.org/node/95 [accessed July 2008]), which echoes the notion of "com-passion as a form of entanglement" and proposes "a clear sighted position of mutual imbrication" that entails, again borrowing from Nancy, investment in a politics of intersection, in "acting without a model," in a practice without a script.

## 4. Overgave

1. Louwrien Wijers, unpublished interview with the author, Amsterdam, February 2000. Any undocumented quote that follows is taken from this interview.

2. In an explanation of the differentiation made in Tibetan Buddhist *mahamudra* literature between the notions of the "ultimate" and the "conventional" levels of reality, Tibetan lama Khenchen Thrangu Rinpoche also turns to the fateful wooden table, saddling it with the burden of nonexistence in order to expound the truth of impermanence. He explains that although we experience the mind as "an unbroken stream of awareness, thoughts and feelings" and the mind cannot be seen to be nothing, neither we nor our minds have a locatable essence or a permanent reality; it is through the process of meditation that we can "come to

appreciate that on a relative level our mind's thoughts, sensual experience and appearances come and go through a play of interdependence. . . . We find that nothing has a nature we could ever seize, no ultimate, lasting nature, and so on." Enter the wooden table: "If we look at a wooden table we see a solid object of a brown color. This is the conventional truth and everyone will agree with us that that is what it looks like. However a physicist would tell us that the table is made of atoms moving at high speeds and that the table is actually 99.99% empty space with the color being nothing other than a certain wavelength of radiation. This then is closer to the ultimate level" (Lama Khenchen Thrangu Rinpoche, *The Twelve Links of Interdependent Origination,* trans. Ken Holmes [Boulder, Colo.: Namo Buddha Publications, 1997], 1, 36–40). Though the point extends to all things, including our perceptions of ourselves, the wooden table—at the hands of everyone from phenomenologists and popular scientists to artists and Tibetan lamas—seems to have been singled out as the object most exemplary of its own suspect reality status. In his introduction to His Holiness the Fourteenth Dalai Lama's teachings on "the Four Noble Truths" at the Barbican Centre in London in 1997, Robert A. F. Thurman also used the wooden table to demonstrate the same point, though in less detail; see the four-volume audio recording *The Four Noble Truths: His Holiness the XIV Dalai Lama,* Mystic Fire Audio, 1997.

3. See Mondrian's "Natural Reality and Abstract Reality: An Essay in Trialogue Form," a remarkable short text first published serially in Dutch in *De Stijl* between June 1919 and July 1920; Piet Mondrian, *Natural Reality and Abstract Reality: An Essay in Trialogue Form,* trans. Martin S. James (New York: George Braziller, 1995), 55–57.

4. This was the year before his fellow professors at the Düsseldorf Kunstakademie filed their first "mistrust manifesto" against Beuys, which led to his eventual dismissal and his subsequent successful lawsuit to keep his place there. Cooke and Kelly, *Joseph Beuys: Arena,* 278–79.

5. Louwrien Wijers, unpublished journal entry, courtesy of Louwrien Wijers.

6. Wim Beeren was curator of the Stedelijk until 1992, when Rudi Fuchs took over the position. Ingeborg Walinga, "Rudi Fuchs Grabs His Chance," trans. Julian Ross, in Jozef Deleu et al., *The Low Countries: Arts and Society in Flanders and the Netherlands—a Yearbook* (Rekkem, Flanders, Belgium: Flemish–Netherlands Foundation "Stichting Ons Erfdeel," 1994), 304–5.

7. Gwen Allen has documented the rise of the artist-led critical publication in the 1970s and of the interview as a means of generating "a radical counterpublic." See Gwen Allen, "Against Criticism: The Artist Interview in *Avalanche* Magazine, 1970–76," *Art Journal* (Fall 2005); and Gwen Allen, "In on the Ground Floor: *Avalanche* and the SoHo Art Scene, 1970–1976," *Artforum* (November 2005). Though the focus of Allen's observations is "the politicized alternative-arts community centered in SoHo in the early 1970s," and this focus unfolds around an account of *Avalanche* magazine in particular, her argument that this period catalyzed the emergence of the artist interview "as a form of anticriticism: that is, their meaning and their effect on the reception of art took place in opposition to the dominant models of criticism and publicity operating within the mainstream art world at that moment," is useful in contextualizing Wijers's practice as an art critic who, as will be discussed below, considered her writing to unfold around and as a practice

of conducting "talks" with fellow artists. (By the late-1970s she would come deliberately to refrain from using *interview* to describe her conversations.) This began with her visit to New York in 1968.

8. Tony Godfrey, *Conceptual Art* (London: Phaidon, 1998), 257.

9. It was here that on February 9, 1968, Beuys had performed the *Eurasianstab 82 min fluxorum organum* action with Henning Christiansen. They had performed an earlier version on July 2, 1967, at the Galerie nächt St. Stephan, in Vienna. Christiansen, in Cooke and Kelly, eds., *Joseph Beuys: Arena*, 268–69.

10. De Decker, in Godfrey, *Conceptual Art,* 257.

11. Wijers, interview with the author, February 2000.

12. Ibid.

13. Bohm, "Interview with David Bohm," in Wijers, ed., *Art Meets Science and Spirituality in a Changing Economy,* 62–63.

14. Beuys, in Charles Wright, ed. and comp., "Statements from Joseph Beuys," in *Joseph Beuys* (New York: Dia Art Foundation, 1987), 20. It is important to point out that by the late 1970s Beuys had surpassed Robert Rauschenberg in fetching more money per year in sales than any other artist in the world; though this does not of itself neutralize his criticism of the art world as a pseudocultural ghetto, it does qualify his suggestion that he might be somehow outside it.

15. See Louwrien Wijers, "FLUXUS YESTERDAY AND TOMORROW: An Artist's Impression," in Pijnappel, ed., *Fluxus Yesterday and Today,* 7–13.

16. The Zen Buddhism that is known to the West is not an ancient institution but a reinvention of various pan-Asian traditions and practices that were given a new cohesion during Japanese modernization. Zen Buddhism in general and the role of D. T. Suzuki in particular almost never receive substantive critical and historical consideration in the context of discussions of Zen's relation to the Western postwar avant-garde. On the early twentieth-century construction by Japanese intellectuals—in the face of the multifront attack known as *haibutsu kishaku,* or "abolishing Buddhism and destroying [the teachings of] Sakyamuni"—of a purged and reinvigorated "New Buddhism . . . 'modern,' 'cosmopolitan,' 'humanistic,' and 'socially responsible,'" see Robert H. Sharf, "The Zen of Japanese Nationalism," in Lopez, ed., *Curators of the Buddha.* Suzuki's work has had what is now pictured as a legendary role in communicating a Zen packaged for American consumption to a generation of artists from Jack Kerouac to John Cage. The last few years have seen the emergence of serious critical attention to the relationship of Zen and other Buddhist traditions to contemporary Western art; among the more important of these works is the anthology *Buddha Mind in Contemporary Art,* ed. Jacquelynn Baas and Mary Jane Jacob (Los Angeles: University of California Press, 2004)—the result of a several-year interdisciplinary research and development initiative called Awake: Art, Buddhism, and the Dimensions of Consciousness; for information on the project and its chronology, see http://www.artandbuddhism.org/ (accessed November 5, 2005). See also Jennie Klein's critical review of that project and its publications, which, in its discussion of Jacobs's interviews in *Buddha Mind,* notes that those "interviews, conducted with artists of all ages, genders, ethnicities and backgrounds, do quite a bit to counter the earlier and rather depressing masculine-centered emphasis on Marcel Duchamp and John Cage as the fathers of Zen Buddhism in Western art." In her response to the Awake proj-

ect as a whole, Klein laments its lack of coverage: "The idea of sponsoring contemporary art inspired or influenced by Buddhism is not only timely but necessary, a welcome infusion of spirituality and seriousness into an art world that has become obsessed with careerism and visibility." She also takes Awake to task for its apparent haphazardness: "Lacking clear direction, the projects and the book taken together look a bit like Buddhist soup for the soul: a little bit of historical and traditional Buddhist art . . . some exercises designed to facilitate meditation, some references to Daisetz T. Suzuki and Alan Watts, homage to the Duchamp/Cage axis (the same axis invoked by postmodernists), and contemporary work that has been influenced by Buddhism" (Jennie Klein, "Being Mindful: West Coast Reflections on Buddhism and Art," *PAJ: A Journal of Performance and Art* 79 [January 2005]: 82–90, quotations from 84, 87). Klein's desire to displace the "Duchamp/Cage axis" is important given the way accounts of Buddhism's impact on postwar Western art have been routinely reduced to these two figures. Given the importance of that axis—which is of course not an abstract relation across disparate times and spaces but a lived, intimate, recerebratory friendship between these two figures, Duchamp and Cage, and their works—not only to the ideas but also to the individuals in this study, creating an alternative picturing of Buddhism's impact upon the "post-Cage generation" is not so simple as underscoring how depressing it is to find the Duchamp/Cage lineage repeatedly emphasized in contemporary art history. This is what makes Wijers so interesting and important a figure in this generation of artists: she at once embraced what that "axis" had to offer her and, in her life and work, opened up to multiple alternative traditions—especially Tibetan Buddhism, postwar European performance (mediated through the work of Beuys and d'Armagnac especially), and the American avant-garde in the 1960s and 1970s European modernism—in an attempt to negotiate among them.

17. Lopez, "Introduction," in Lopez, ed., *Curators of the Buddha*, 8.

18. Flynt, in Williams and Noël, eds., *Mr. Fluxus*, 92.

19. For Flynt's own essay and his revisions and revisitations of the notion of Concept Art with respect to his philosophical and critical writings, see www.henry flynt.org (accessed November 5, 2005); for a discussion of the production of *An Anthology*, including Robert Morris's early participation and his subsequent withdrawal from the project as it was going to print, see Flynt's 1993 essay "Against 'Participation': A Total Critique of Culture," http://www.henryflynt.org/aesthetics/Apchptr10.html (accessed June 2008).

20. Wijers, "FLUXUS YESTERDAY AND TOMORROW," 12. Again, because this chapter focuses on the genealogy of Wijers's thinking, her own usage of *conceptual art*—though she was and is highly aware of the group of artists associated with Conceptual Art as a quasi-canonical genre in contemporary art history—is intended to be read here as an idiosyncratic term with a set of resonances and associations (to Fluxus, Flynt, Filliou, Beuys, d'Armagnac, Warhol, and Rauschenberg especially) that are unique to her use of it. Though some of the artists that she considers part of the so-called conceptual art crowd, such as Joseph Kosuth, are also associated with the more widely known version of Conceptual Art, there is otherwise little overlap with Conceptual Art as such in the context of this discussion; a proper tracing of this overlap is outside the scope of this book, though well worth undertaking. Essential resources on Conceptual Art and its genealogies are Alexander Alberro and Blake Stimson, eds., *Conceptual Art: A Critical Anthology* (Cambridge,

Mass.: MIT Press, 2000); and Godfrey, *Conceptual Art*. What is important to note with respect to a discussion of Wijers's thinking is that, *for her,* Conceptual Art and conceptual art are distinguished by Conceptual Art's lack of engagement with nondual thinking.

21. Wijers, interview with the author, February 2000.

22. For a short history of the Gelugpa tradition, see Batchelor, *The Awakening of the West,* 184–204; and John Powers, *Introduction to Tibetan Buddhism* (Ithaca, N.Y.: Snow Lion Publications, 1995), 402–30.

23. Anne Klein, *Knowledge and Liberation: Tibetan Buddhist Epistemology in Support of Transformative Religious Experience* (Ithaca, N.Y.: Snow Lion Publications, 1986), 89.

24. Ibid.

25. Ibid.

26. Stephen Batchelor, "Nagarjuna's *Verses from the Center,*" *Tricycle* 9, no. 3 (Spring 2000): 25–30; 29. See also Batchelor, *Verses from the Center.*

27. Batchelor, "Nagarjuna's *Verses from the Center,*" 29.

28. Klein, *Knowledge and Liberation,* 89.

29. Ibid.

30. Ibid., 89–90.

31. Ibid., 90; see 89–114.

32. Nagarjuna, in Batchelor, "Nagarjuna's *Verses from the Center,*" 29.

33. Ibid., 29–30.

34. Nagarjuna, ibid., 30.

35. Ibid., 30. William S. Cobb offers a useful characterization of emptiness in his essay on the game Go, in which the "player discovers that the absence of an absolute fixed structure or of ultimate limits on reality is not the disaster you might expect. On the contrary, it makes things much more interesting" (William S. Cobb, "The Game of Go: An Unexpected Path to Enlightenment," *Tricycle* 8, no. 3 [Spring 1999]: 64).

36. Henri Lefebvre, *The Production of Space,* trans. Donald Nicholson-Smith (London: Blackwell, 1997), 28.

37. Rogoff, *Terra Infirma,* 3, 24.

38. Henri Lefebvre, *The Production of Space,* 29.

39. Rogoff, *Terra Infirma,* 24.

40. Lefebvre, *The Production of Space,* 30.

41. Donna J. Haraway, *Simians, Cyborgs and Women: The Reinvention of Nature* (New York: Routledge, 1991), 195–96; see Rogoff, *Terra Infirma,* 25.

42. Batchelor, "Nagarjuna's *Verses from the Center,*" 25–30.

43. Higgins, *Fluxus Experience,* 58.

44. Ibid., 55, 217 n. 64.

45. Munroe, "Spirit of yes: The Art and Life of Yoko Ono," 18.

46. Batchelor, *Alone with Others,* 51.

47. Benjamin Patterson, in Doris, "Zen Vaudeville," 114.

48. This information comes from wall text in the yes yoko ono exhibition at the Japan Society, New York, 2000. The letter is dated January 23, 1966.

49. Hui-neng is an important and colorful character in the history and legends of Ch'an Buddhism. See Hui-Neng, *The Sutra of Hui-Neng, Grand Master of Zen—with Hui-Neng's Commentary on the Diamond Sutra,* trans. Thomas

Cleary (Boston: Shambhala, 1998); Batchelor, *The Faith to Doubt,* 77; and Joan Rothfuss, "Somewhere for the Dust to Cling: Yoko Ono's Paintings and Early Objects," in Alexandra Monroe and Jon Hendricks, eds., YES YOKO ONO (New York: Japan Society and Harry N. Abrams, 2000), 93.

50. Doris, "Zen Vaudeville," 115.

51. Kosugi, in ibid., 110.

52. Ibid., 111.

53. Hannah Higgins, in discussing Fluxus's offering of alternatives to a visi-centric model of experience, notes Heidegger's contention that the "ideal sensory organ for 'openness of Being' is the ear—identified with speech, listening, and music" (Higgins, *Fluxus Experience,* 58).

54. To this end, Higgins's contention that the scarcity of Fluxus artists publicly committed to Buddhism justifies not exploring the convergence of their work with Buddhism must be rethought, even though it is a legitimate view relative to the scope and aims of her book.

55. One extreme example of a "suspicious" theorist is Slavoj Žižek, who in a public lecture at Goldsmiths College, University of London, in 1999 described himself as "so anti–Tibetan Buddhism that I am almost pro-Chinese."

56. Apart from the AmSSE projects, and Baas and Jacob, eds., *Buddha Mind in Contemporary Art,* see, for instance: Jean-François Revel and Matthieu Ricard, *The Monk and the Philosopher: A Father and Son Discuss the Meaning of Life,* trans. John Canti (New York: Schocken Books, 1999); Francisco Varela, Evan Thompson, and Eleanor Rosch, *The Embodied Mind: Cognitive Science and Human Experience* (Cambridge, Mass.: MIT Press, 1993); Jeremy W. Hayward and Francisco J. Varela, *Gentle Bridges: Conversations with the Dalai Lama on the Sciences of Mind* (Boston: Shambhala, 1992); and Francisco J. Varela, *Ethical Know-How: Action, Wisdom, and Cognition* (Stanford, Calif.: Stanford University Press, 1999).

57. Filliou and Wijers in Wijers, *Writing as Sculpture,* 128.

58. Brecht, in Wijers, "FLUXUS YESTERDAY AND TOMORROW," n.p. Here we might recall John Armleder's response to the question "How has art changed . . . over the last forty or so years?" with which this book's introduction began: "I am personally quite grateful to have been around long enough to now experience eternity limited to a couple of weeks. The significant changes are: more people, more venues, more publications, more artists, more words—and less duration. If only—and sorry for being such a retarded hippy—we could stop war, disease, and poverty" (Armleder, in "How Has Art Changed? A Survey," 160).

59. In 1969, van Elk exhibited a shaved cactus, a year after Boezem had exhibited a weather report and begun to conceive of "air as a plastic material." In 1967, Dibbets had abandoned his method of painting and stacking his square canvases and turned instead to creating piles out of squares of sod grass (van Tuyl, *Mit Natur zu tun/To Do with Nature,* 1).

60. In addition to various appearances by a number of Dutch artists (and artists living in Holland, such as Marina Abramović and Ulay) at major international events, including Documenta VI, the Cologne Art Fair, and the Performance Week in Bologna in 1977, one major exhibition was held in the United Kingdom. This was the show Eleven Dutch Artists, organized by Herman Swart and Caroline Tisdall at the Fruit Market Gallery in Edinburgh, Scotland, during August and Sep-

tember 1974. On June 2, 1977, d'Armagnac also performed in the International Performance Week in Bologna. Other participants in this event included Marina Abramović and Ulay, Vito Acconci, Laurie Anderson, Joseph Beuys, Chris Burden, Gilbert and George, Dan Graham, Geoff Hendricks and Brian Buczak, Allan Kaprow, George Maciunas, Hermann Nitsch, Nam June Paik, Katharina Sieverding, Ben Vautier, and Wolf Vostell. See Daolio, in Louwrien Wijers, *Ben d'Armagnac* (Zwolle, the Netherlands: Uitgeverij Waanders, 1995), 159; and the exhibition catalogue for Performance Week in Bologna, June 1–6, 1977, *La Performance Oggi: Settimana internazionale delle performance* (Bologna: Galleria communale d'arte moderna di Bologna, 1977); many thanks to Geoff Hendricks for providing this source.

61. Van Tuyl, *Mit Natur zu Tun/To Do with Nature*, 28, 1.

62. We might be tempted to speculate that Filliou's attention to this trend in Holland and to these artists' experiments contributed to his interest in focusing on artists' ways of living in his 1971 *Research at the Stedelijk* project.

63. In this they followed, probably not unknowingly, Dutch artist Axel van der Kraan, who in 1969 "regarded the beach as his studio, where he built tables of driftwood which were washed away by the rising tide" (van Tuyl, *Mit Natur zu Tun/To Do with Nature*, 1).

64. Zutter, in ibid., 21.

65. Gerrit Dekker, in ibid., 21.

66. Anton Heyboer, in Zutter, ibid., 21.

67. Zutter, ibid., 21, 3. Heyboer died in 2005. For a catalogue of his recent work and writings, see the self-proclaimed Zen master's Web site: http://www.anton-heyboer.org.

68. Zutter, in van Tuyl, *Mit Natur zu Tun/To Do with Nature*, 21.

69. Ibid., 21, 3.

70. d'Armagnac and Dekker, in van Tuyl, *Mit Natur zu Tun/To Do with Nature*, 21, 23.

71. Wijers, interview with the author, February 2000.

72. Ibid.

73. Louwrien Wijers, unpublished interview with the author, October 2004. Thurman and Hopkins had both left their studies at Harvard in 1963 to live and study at Geshe Wangyal's monastery. Geshe Wangyal traveled to India with Thurman, "where in 1965 he was the first American to be ordained as a Tibetan Buddhist monk" (Lopez, *Prisoners of Shangri-La*, 164).

74. This quote and the following ones of Wijers in this series all come from her interview with the author, February 2000.

75. Wijers, *Ben d'Armagnac*.

76. Wijers, interview with author, February 2000.

77. It is in the specific sense of the Buddhist practice of loving-kindness, *metta*, that Wijers uses the term to describe d'Armagnac's work. See Damien V. Keown, *Buddhism: A Very Short Introduction* (Oxford: Oxford University Press 1995), 96.

78. This and the following quotes of Wijers are from her interview with the author, February 2000.

79. Nitsch had been performing his *Orgien Mysterien, Theatre* in Vienna since the early 1960s. For a thorough discussion of Nitsch's and the Viennese Action-

ists' work, see Philip Ursprung, "'Catholic Tastes': Hurting and Healing the Body in Viennese Actionism in the 1960s," in Amelia Jones and Andrew Stephenson, eds., *Performing the Body/Performing the Text* (London: Routledge, 1999); and Thomas McEvilley, "Art in the Dark," *Artforum* 21, no. 10 (Summer 1983); see also the extensive writings of Nitsch, Günter Brus, Otto Muehl, and Rudolf Schwarzkogler, many of which are collected along with a range of documentation of their performances in Malcolm Green, ed., *Writings of the Vienna Actionists* (London: Atlas Press, 1999).

80. Marina Abramović, in Wijers, *Ben d'Armagnac,* 14.

81. Joseph Beuys, Jannis Kounellis, Anselm Kiefer, and Enzo Cucchi, "The Cultural-Historical Tragedy of the European Continent," in Charles Harrison and Paul Wood, eds., *Art in Theory, 1900–2000: An Anthology of Changing Ideas* (Malden, Mass.: Blackwell, 2003), 1146.

82. From a spring 1978 press release from P.S. 1 Education Department. Subsequent references to the P.S. 1 International Program come from this lone press release. Great thanks to Natsuko Fujiu for locating this document.

83. At the time of their residency all three of the others were students at the Düsseldorf Kunstakademie, where Joseph Beuys was then its most distinguished and still-controversial professor.

84. According to Wijers, d'Armagnac had also had differences with certain of P.S. 1's staff, which added to his reluctance to spend his time on-site.

85. For an intriguingly inverted version of this itinerary, one in which he left New York for Amsterdam to meet Wies Smals and had a similarly disconcerting experience, see Al Hansen, "They'd Love to See You There: A Teacher Is a Navigator through Particular Areas of Information," 2001, http://www.alhansen.net/love.htm (accessed June 2008).

86. Wijers, "Ben d'Armagnac Talks to Louwrien Wijers," trans. Louwrien Wijers, unpublished interview, courtesy of the Records of the Education Department, Brooklyn Museum of Art Archives (unprocessed records, box 18, programs), 1978, 2–3. Quotes from Wijers's texts reproduce her spellings and punctuation marks exactly, for instance, the use of extended ellipses (. . . . .), in order to preserve accuracy.

87. Wijers, interview with the author, February 2000.

88. Wijers, "Ben d'Armagnac Talks to Louwrien Wijers," 1.

89. Wijers, interview with the author, February 2000.

90. Promotional material from Sharon Avery/Redbird Gallery, Brooklyn Museum of Art Archives, Records of the Education Department, European Performance Series (unprocessed records, box 18, programs); all subsequent references to material from the EPS series at the Brooklyn Museum come from the Records of the Education Department.

91. Press release, Brooklyn Museum of Art, April 28, 1978.

92. Draft version of press release, Brooklyn Museum of Art.

93. From a clipping of an undated review from an unspecified New York daily newspaper, Brooklyn Museum of Art.

94. His May 14 piece for P.S. 1 was not a performance but rather a film of a performance.

95. Wijers, interview with the author, February 2000.

96. Letter from David Katzive to Jan Brand, May 17, 1978.

97. Brooklyn Museum of Art memorandum, 1978.

98. Wijers, interview with the author, February 2000. Discussing this performance, Antje von Graevenitz notes that, while theories of spectatorship abound, few mention "the involvement of the viewer when the artist really dies within the rules of his work" (Antje von Graevenitz, "The Death of the Artist: Extreme Performances in the Art of the 20th Century," conference paper, 31st Congress of the AICA, Belfast, Ireland, September 1997).

99. Wijers, "Ben d'Armagnac Talks to Louwrien Wijers," 2.

100. No written description of this performance exists. Less than a year earlier, on June 6, 1977, Reindeer Werk had performed, along with d'Armagnac and Dekker, at the Cornexchange in Arnhem. Wijers was present and wrote a thorough description of the piece, in which she describes a frenetic series of improvised gestures intended to play upon the audiences' emotional and psychological identification with and empathy for the performers. See Louwrien Wijers, "Reindeer Werk: At the Cornexchange (Arnhem)," trans. Louwrien Wijers, unpublished interview, courtesy of the Records of the Education Department, Brooklyn Museum of Art Archives (unprocessed records, box 18, programs), 1977, n.p.

101. This and the following quotations in this passage are taken from Louwrien Wijers, "Reindeer Werk Talks to Louwrien Wijers," trans. Louwrien Wijers, unpublished interview, courtesy of the Records of the Education Department, Brooklyn Museum of Art Archives (unprocessed records, box 18, programs), 2–3.

102. When at Jan Brand's request Wijers sent Katzive copies of her 1977 interviews with d'Armagnac, Dekker, and Reindeer Werk, she sent him a letter—written from the Hotel Chelsea on May 5, five days before d'Armagnac's performance—with a postscript that hinted at the new direction she had taken in her mental sculpture, a kind of early example of experimental writing-with-art: "You may be astonished by the way I do interviews and how I write about performances, because it does not have the normal style of someone writing about art. That is because I consider these writings literature at the same time. L. W." (letter from Wijers to Katzive, May 4, 1978).

103. Wijers, "Ben d'Armagnac Talks to Louwrien Wijers," 3.

104. Ibid., 2–3.

105. Wijers, interview with the author, February 2000.

106. Wijers, "Ben d'Armagnac Talks to Louwrien Wijers," 3.

107. Deleuze, "Mediators," 292.

108. Wijers, "Ben d'Armagnac Talks to Louwrien Wijers," 6.

109. Alex de Vries, in Jan Brand and Gerrit Dekker, eds., *Gerrit Dekker/Sheets* (Chandigarh, India: Foundation Chandigarh, 1988), not paginated. This catalogue accompanied the exhibition Gerrit Dekker/Sheets at the Museum of Fine Arts, Chandigarh, India, December 2–22, 1988.

110. "Gerrit Dekker," invitation to "A Performance/Installation" at de Appel, September 1–2, 1978, Amsterdam. Thanks to Gerrit Dekker for providing this.

111. Maharaj, "A Double-Cressing Visible Grammar," 23.

112. Brand and Dekker, *Gerrit Dekker/Sheets.*

113. Gerrit Dekker, "Texts by Gerrit Dekker: From an Interview," in Jan Brand, ed., *Over geen benden, geen boven, geen zijkanten/About No Below, No Above,*

*No Sides* (Utrecht: BAK, and Frankfurt am Main: Revolver—Archiv für Acktuelle Kunst, 2005), 18.

114. This had included performances by Beuys, Marina Abramović and Ulay, Carolee Schneemann, and a series of workshops and discussions.

115. It is tempting to guess that he played Satie, who was one of his favorite composers (Stachelhaus, *Joseph Beuys,* 16; Paik, "BEUYS VOX PAIK," 64); in his 1976 review for *Studio International,* Hein Reedijk compared d'Armagnac's Stedelijk performance to Satie's *Vexations* (Reedijk, in Wijers, *Ben d'Armagnac,* 144).

116. Wijers, *Writing as Sculpture,* 13.

# Publication History

Part of the Introduction appeared, in different form, in the chapter "The Look of Ethics: Emmanuel Levinas, Léo Bronstein, and the Interhuman Intrigue," in Anna Fahreus and AnnKatrin Jonsson, eds., *Textual Ethos Studies: Or Locating Ethics* (Amsterdam: Rodopi, 2005), 315–32; and in the review "Strange Fire: Howard Caygill's *Levinas and the Political*," *Radical Philosophy* 118 (March/April 2003): 44–46.

Portions of the following essays appear in chapter 1: "Still Hungry: Robert Filliou's *Ample Food for Stupid Thought*," in Lisa Moren, ed., *Intermedia: The Dick Higgins Collection at UMBC* (Baltimore, Md.: Albin O. Kuhn Library and Gallery, University of Maryland Baltimore County, 2003), 47–48; and "Responsible Idiocy and Fluxus Ethics: Robert Filliou and Emmanuel Levinas," *a-r-c* 5 (July 2001): 1–8.

Portions of the following articles appear in chapter 2: "Voicing Joyce: Crossmess Parzels from Cage to Beuys," *Performance Research* 8, no. 1 (March 2003): 5–22; and "Silence and Savant-Garde: Beuys, Fluxus, Duchamp," *Performance Research* 7, no. 3 (September 2002): 15–25.

Selections from the following interview appear in chapter 3: "Anne Frank's House: Louwrien Wijers at the Maine College of Art," *Portland Phoenix*, June 24, 2005, 16.

Portions of the following article appear in chapter 4: "Appropriate Ending: Ben d'Armagnac's Last Performance," *PAJ: A Journal of Performance and Art* 78 (September 2004): 45–60.

**CHRIS THOMPSON** is associate professor of cultural history at the Maine College of Art in Portland, Maine.